Performing Motherhood

Performing Motherhood

Artistic, Activist, and Everyday Enactments

EDITED BY

Amber E. Kinser,
Kryn Freehling-Burton
and Terri Hawkes

DEMETER

DEMETER PRESS

The publisher gratefully acknowledges the the financial assistance of the Government of Canada through the Canada Book Fund.

Demeter Press
140 Holland Street West
P. O. Box 13022
Bradford, ON L3Z 2Y5
Tel: (905) 775-9089
Email: info@demeterpress.org
Website: www.demeterpress.org

Demeter Press logo based on the sculpture "Demeter" by Maria-Luise Bodirsky <www.keramik-atelier.bodirsky.de>

Printed and Bound in Canada

Library and Archives Canada Cataloguing in Publication

Performing motherhood : artistic, activist, and everyday enactments / edited by Amber E. Kinser, Kryn Freehling-Burton and Terri Hawkes.

Includes bibliographical references.
ISBN 978-1-927335-92-5 (pbk.)

1. Motherhood. 2. Mothers. 3. Performance. I. Kinser, Amber E., 1963-, author, editor II. Hawkes, Terri, author, editor III. Freehling-Burton, Kryn, 1970- author, editor

HQ759.P47 2014 306.874'3 C2014-908226-6

MIX
Paper from
responsible sources
FSC® C004071

*With deep affection for my early mentor, Bill Rawlins,
who was the first to encourage me to write about
performance and motherhood.*

—A. K.

*In memory of my dear friend, Melodie Narramore Yocum,
who dramatically and lovingly showed me how to
blend theatre performance and mothering.*

—K. F. B.

*A standing ovation for my cherished late mother,
Joanne Hawkes (née Herriot), whose distinctive performance
of motherhood taught me the joys and import of
both mothering and theatre.*

—T. H.

Table of Contents

Acknowledgements

AS WITH ANY MAJOR PRODUCTION, it takes an enormous amount of energy and a sizable cast and crew to bring the thing to fruition. We wish to extend the sincerest of thanks to Andrea O'Reilly, who didn't miss a beat when we introduced the idea to her at the National Women's Studies Association conference in Atlanta in 2011, who was exceedingly generous with time and deadlines, and who, as always, put great faith in her editors. From Demeter, we credit Renee Knapp, who helped us in the initial stages of the publishing work and we are grateful to our copy editor Katherine Barret. We thank our manuscript reviewers for their careful time, keen insights, and frank recommendations, as they were key to the book's strengths. Thank you to our proofreader Lori Ann Manis for her meticulous and skilled attention to every line of every page of the manuscript; she is a word wizard and an MLA maven.

So many people worked in the wings, backstage, and in the "shops" that are our workplaces, helping us piece things together, rehearse ideas, and build platforms for our arguments; we hold a place for each of you in the performance archives of our minds. From the vibrant Department of Communication and Performance at East Tennessee State University and the surrounding region's hallmark focus on families, to the galvanizing collaboration between Women, Gender, and Sexuality Studies and Theatre at Oregon State University, to the interdisciplinary discourse percolating between Theatre and Performance Studies and Gender, Feminist, and Women's Studies at York University in Toronto, we want to acknowledge our colleagues for stimulating conversations in

the halls, over lunch, and walking between classes—all of whom played essential supporting roles in creating this performance text.

To our co-actors/co-contributors: we so appreciate your intelligence, talent, expertise, attention to detail, passion, patience, and hard work in giving birth to this anthology. You are the definition of maternal agency. On behalf of all the contributors, we thank our mother subjects—for your bravery, candour, and willingness to share your experiences of the maternal. And let us not forget our stellar chorus, singing gloriously from the wings at the appropriate moments: thanks to Kim Eaton, Christine Waxstein, Allison Smith, Meylin Mejia, Paige Polcene, Carol Griffitts, Patti Duncan, Janet Lee, Susan Shaw, Mehra Shirazi, Jim Hawkes, Rhoda Sackman, Eva Almario, Michele Landsberg, Richard Rose, Howard Suber, Meg Luxton, Laura Levin, Robert, Michael and Andrew Hawkes, Susan Cullen, Beth and Vic Bryant.

To our families, who play the starring roles in contributing to our great joy and growth in mothering and co-parenting: Patrick Cronin and Chelsea and Isaac Kinser; Ethan, Luke, Esther, Sophia, and Eric Burton; and Alexa and Jake Hawkes-Sackman and Jeff Sackman. The irony of our stepping out of our mothering scenes so we could write about performing motherhood was never lost on us. We thank you from the bottom of our maternal hearts. And to our friends in motherhood, performance, and life, as well as our kids' caregivers, we are grateful for your presence, nurturing, and support.

Introduction

AMBER E. KINSER, KRYN FREEHLING-BURTON AND TERRI HAWKES

IT MAY SEEM STRANGE to think about "performing" motherhood when so many cultural images of and social discourses about mothering work to locate it within cellular structures. Social constructions of "mother" imply that, like breathing, mothering just gets done, with little conscious thought, deliberate intention, acquired knowledge, or developed skill. Unless something obstructs them, beings breathe and mothers mother. Paradoxically, mothers of various cultures remain ever under scrutiny, their ostensibly natural mothering needing to be no less directed and choreographed from the outside, even while their maternal behaviour radiates from some place deep within. Under these lights, it can be difficult to allow for "real" motherhood or "good" motherhood to be something that is "performed." In *Performing Motherhood,* we aim to expand space for considerations about and enactments of maternal performance, and to break that "fourth wall" by blurring distinctions between audience and performer, stage and life, scripts and improvisations. We also seek to broaden academic, artistic, and activist explorations of motherhood to imagine, engage, and contest the ways that social performance(s) and maternal life are mutually infusive.

Our contributors arrive at the intersection of motherhood and performance having travelled from a variety of social and disciplinary locations. They may have come by way of academic inquiry, professional practice, or artistic creation. The authorship as a whole also represents a range of professional and creative interests and experiences in North America. Collectively, we

1

offer, examine, and embody music, poetry, dance, and theatre; narrative and other qualitative methods of inquiry; public space performance/art; queer, adoptive, intergenerational, interracial, and differently-abled mothering; and archival and everyday life performance. Whether academic, artistic, activist, or some blending of these, we suggest that each contribution in this book functions as performance of the maternal.

We begin with the understanding that scholarly and lay observers alike have long recognized the relationship between everyday life and performance. Some hold to a sharp split between that which is authentic, true, or real, on one hand, and that which is contrivance, facade, or "mere" performance on the other. Others indicate that any lines separating "performance" from "life" are indistinguishable or not useful, that all of life is performance, that human interaction of any sort is a text to be read in a variety of ways, that all of social meaning and identity are, in fact, performatively constituted.

A number of critical thinkers have directed attention to performativity and the way it can contest and disrupt accepted meanings, truths, and values; notions and movements function as factualities through embodied repetition. In the performing arts, artists have questioned, theorized, represented, and troubled social meanings and subjectivities, and have deployed performance in the service of resistance and change. Many performance studies scholars have analyzed culture through the study of performance practices, aligning with a number of feminist theorists and activists, interpretive ethnographers, and autobiographical researcher-performers in their view of performance as both a way of knowing and a way of re-presenting knowledge.

In creating *Performing Motherhood*, we sought to place these ideas center stage in maternal studies. In doing so, we struggled to arrive at shared meanings for performance(s), given that any such effort implicates, as Elizabeth Bell has argued, "the challenge of describing human experience in its lived, embodied, participatory, and always dynamic processes" (53). We assumed performance to be both process and outcome, activity and event, interpreting and interpreted. Here, performance runs the gamut from improvised to carefully considered to meticulously scripted

and rehearsed. We suggest that some of the numerous nuanced considerations about performance offered by Ron Pelias help illuminate the spectrum of texts to which *Performing Motherhood* gives form:

> Performance is ... an act of becoming, a strategy for discovering oneself by trying on scripts to test their fit, a means of clothing oneself in various languages until one believes what one says ... the mundane activity of being, actions ... that take us through the day, always filled with personal significance, always insignificant ... a method of understanding, bodily, located in the experience of doing things ... a corrective, a righting of wrongs ... an aesthetic encounter, a seductive coalescence that catches you in time, a luscious lure that pulls you in close and pushes you away, over and over ... a random guess about human nature, a lucky turn, a spinning wheel where you might get named, an estimate rounded off to the nearest person. (109-111)

As we thought about the relationships between performance and motherhood, we were curious about how women and families enact/perform mothering in ways inconsistent with widely accepted norms, whether those be broad social norms or assumed "feminist" or "progressive" ones, and how they make these ways work for them, personally and socially. Several of us struggled as critical and feminist writers, some mightily, to push beyond the limits of a myopic focus on oppression; on how standards of mothering are unrealistic, unjust, unfulfilling; on all the social structures and practices that constrict women and their families. From the beginning, we committed to showcasing maternal *agency*. We investigated mothers' micropractices/microperformances to discover how these helped to shape individual, familial, and social meaning, highlighting maternal cunning and agility. We asked about how maternal identity is performatively constituted through the multiplicity of ways that people mother beyond biological ties.

We also sought to spotlight performance beyond family life per

se that implicated or was inspired by maternal connection, asking how particular ritual or theatrical or activist performance suggests or embodies affirmations of motherwork, maternal agency, or marginalized maternal voices, and what it might have to say to and about broader audiences. We also interrogated how mothers make sense of their world and experiences through performing, visual, and media arts, as well as how artist-mothers negotiate multiple identities.

In our investigations and elaborations, we followed Norman Denzin's aim to "reject the search for absolute truth," and directed our attention to narrative and other performative truths that are "suspicious of totalizing theory" (*Interpretive* 215). We wanted to bridge the experiential differences between writer and reader and the emotional distance between sanitized academic knowledge and the muck of everyday maternal experience. We attempted to identify how our various social locations offer ways of knowing that could be, to use Gregory Bateson's phrase, "a difference that makes a difference" (453) or how they might offer intellectual matter that epistemically matters in a larger feminist sense, beyond our own worlds. Recognizing that "performance is sensuous and contingent" (Denzin, *Performance* 10), we were not particularly interested in work that made claims of clarity and certitude. We preferred to craft, and hope that we have offered, a collection that ends questions with more questions, responds to uncertainty with ambiguity, and resists the pull of resistance narratives that keep us forever tied to that from which we seek to be free (Richardson 78).

In the spirit of resisting the persistent narratives of maternal struggle and framing this volume with agency at its core, the act of naming becomes critical. In our titles for the book's four sections, we center performative action to reflect what each contributor demonstrates in her writing: that mothering is active. Mothering requires intelligence, self-realization, and creativity (Rich 42), and motivates women to write their own subtexts, direct their own stage movements, and project their voices so that they hear themselves even when the worldwide audience does not listen. In what follows, we offer a public preview of *Performing Motherhood*, an anthology in four acts.

ACT I: PERFORMING SPACE/LOCATION

Act I centers around mothers engaging space and location on various performance stages. The illusory divide between "masculine" public and "feminine" private spheres has long been a site for feminist and maternal resistance; movement across this divide can depend on employing one in the service of accessing the other. Virginia Woolf's private room of one's own is strategically utilized to gain access to the public world of publishing and idea transmission. The resurrection of the daily ephemeralness of mothers' lives challenges the very placement of women's experiences solely in the private sphere (Aptheker). As an engaged, intentional practice, maternal thinking (Ruddick) can lead mothers to write their own lives (Heilbrun) from the space and location of their very bodies (Cixous) and experience.

Bronwyn Preece and Courtney Brooks each examine mothers' positions in spaces and locations outside the literal hearth and home. Preece explores the environment, both internally through her experience of discovering and living with disability as well as externally through her connection to and advocacy for the land on which she lives with her child and community. Similarly, Brooks identifies ways that Appalachian women utilized the maternal in visible, public spaces to confront gender-based obstacles through songs of protest about the treatment of coal miners and the conditions of their lives. Preece and Brooks each identify the maternal as the catalyst for engagement in political action and resistance in both the public and private spaces in which these mothers find and insert themselves.

At first glance, Martha Gonzalez appears to be occupying the maternally gendered space of kitchens, while Laura Endacott seems to be creating within the traditionally private and female practices of craft and fiber arts. But both contributors use these feminine tropes to expand the agency mothers can employ. By subverting the kitchen space typically reserved for women and mothers, Gonzalez resists the isolation of mothering, the isolation of living on *la frontera* or borderlands (Anzaldúa), and the isolation of music creation. Mothers cross the border—both literal and figurative border—to write, sing, and record songs around a kitchen table

in ways that subvert not only the institution of motherhood but also the rigidity of the music recording industry. In similar ways, Endacott utilizes fiber arts, a long-established feminine craft, to usher a physical representation of children and mother into the public world. The artist and her children occupy public locations with knitted dolls to challenge the notion that the maternal is only permitted in prescribed, private, domestic spaces. Not content with merely performing these acts once, Endacott records the performances with photography that is then exhibited, thereby becoming a permanent record of the resistance. This permanence directly challenges the historic impermanence of mothers' acts of nurturing and reproductive labour, connecting her artistry to larger conversations in performance studies that interrogate the validity of archiving performance.

Performing Space/Location pays attention to the ebb and flow of occupying spaces, deliberately leaving those spaces when mothers themselves need to protect, retreat, protest, and prioritize self. This engagement with space and location is thoughtful and purposeful; the mothers described in each of these essays expressly use a variety of places in their maternal performances, on publicly viewed stages and in private, offstage wings.

ACT II: PERFORMING INTENTION/IN TENSION

In Performing Intention/In Tension, we look at the deliberateness of maternal performances alongside the friction that sometimes results within and from renderings of the maternal. Maternal theorist Sara Ruddick contends that "mothers themselves often suffer from a sense of fragmentation as they experience, within and between their homes and more public places, rapid shifts of power and powerlessness, recognition and invisibility, nearly awesome love and routine contempt" (92). Performance studies professor Richard Schechner notes that "a hallmark of performance studies is the exposition of the tensions and contradictions driving today's world" (3). In the electric intersection between the disciplines of maternal studies and performance studies, many of our contributors remind us of the often milky tensions between authenticity and masquerade, theory and practice, the intellectual and the

emotional, as well as other antagonisms that generate catalyzing and intentionally diverse performances of motherhood.

In Joani Mortenson's evocative trilogy of poems based on her interviews with families and birth attendants, we sense a heightened awareness of maternal and/or partner erotics. Mortenson's visceral images, sensual sketches, nods to ancient philosophies, and celebrations of queer and trans birth culture evoke tensions around gender, identity, family, "seeing," and significance, all of which tenderly guide the reader on an emotional journey from throat to gut. Our senses are assaulted, challenged, queered, and piqued. Finally, Mortenson leaves us in a delicious state of erotic maternal ambiguity. Lisa Sandlos taps into the current zeitgeist and palpable tensions of competitive dance by problematizing sexualized dancing performed by young girls and examining ways that gender performativity of mothers correlates with, and may contribute to, the current trend toward hypersexualization in many North American dance studios. This friction is evident in Sandlos' intentional discussions about gendered role-play, sexual objectification, femininity, self-image, and motherhood as a performance. The author also provides the reader with thought-provoking options for maternal agency.

Amber Kinser's autoethnographic piece deconstructs the tensions that emerge in her family's dialogue around sexuality and the body. Her playful use of metaphor incorporates a favourite Dr. Seuss character, a nice play on the literal and literary tensions that can result between generations in life as well as in prose/poetry. Kinser is intentionally unabashed and passionate in her use of sexual tension, wise humour, and honesty while examining feminist positions of parenting around sex and embodiment. Kelly Dorgan uses dynamic dramaturgy to share her personal narrative of fostering and adopting a special-needs son, a range of emotions exacerbated by social constructions like the "good mother," the "militant mother," and the "Monster Mom." Dorgan's intentional and moving essay bravely juxtaposes the tensions that result when the clarity of the author's lived experience is placed alongside government agency edicts and social expectations about maternal behaviour. The result is a refreshing insight into the transparent "messiness" of maternal performance with a child who has special needs. Natalie Loveless

contrasts maternal-themed contemporary feminist performance, including her own, with that of early performance art by Mary Kelly and Mierle Laderman Ukeles that is grounded in maternal experience and identity. Loveless fuses practice and theory as she weaves a feminist new materialist perspective with description of a three-part daily practice and web-log piece completed since the birth of her son, in concert with web-logs by other mothers. Loveless' use of photographic documentation evokes familiar and fraught tensions between lived experience and idealized representations of motherhood. All five contributors to Act II cleverly weave their intentions through a labyrinth of maternal tensions, performing motherhood with panache, presence, and power, and leading the way to strong identities of motherhood.

ACT III: PERFORMING IDENTITY/RELATION

The essays that form the third section of this volume center identity and relation as sites for empowered maternal performance. Maternal identity is interrogated and recreated when mothers engage themselves as individuals who are intricately in relationship with their children and the larger community (Collins). Mothers' intellect and thought are critical to subverting the social scripts of feminine mothering as passive, a particularly important task for mothers of colour and those mothering children of colour. Indeed, as Ruddick explains, "To claim a maternal identity is not to make an empirical generalization but to engage in a political act" (56). The authors in Act III offer a range of maternal scripts, using dialogue and story to claim their own identities as mothers and to name the relationships they maintain with the children they raise.

Kryn Freehling-Burton's poignant script is based on oral histories gathered from women telling their mothers' stories. Addressing the importance of motherlines and the impact that mothers' and grandmothers' narratives can have, actor-mothers perform the maternal through a theatrical script. Mothers may follow the individual and gendered mother script they were socialized to absorb and adopt, but they also write their own identities, sometimes as acts of resistance. Also examining relation by way of story, Christine Davis focuses on the narratives of grandparents, adoptive parents,

2

and foster parents about their relationships with their children who have been identified as having serious emotional disturbances. This provocative study of liminal families and their performed familial relationships illuminates how mothers who provide kinship care "tell stories of performing the family into being" by responding to the scripts of traditional family events and "normalcy." By so doing, they create a gift of identity for the mother, child, and family. Kelly Jeske's inspiring narrative examines mother-daughter identity in an adoptive mixed-race family that actively maintains connections to the child's first mother. Jeske notes that she sees her daughter "exist[ing] in the borderlands—the overlapping places where relationship is complex and origins aren't obvious." These borderlands of culture and nation, birth and adoption, are not defined by a distinct boundary arbitrarily drawn by those outside the family. Instead, they are persistently negotiated by the mothers through their often hard-won engagement with their children.

Elyse Warford and Lynne Webb address the identities of adoptive mothers by spotlighting the ways in which these mothers are constantly in the process of rewriting their children's adoption story scripts. The changing contexts of different audiences and situations demand that these mothers continually reconsider their identities as adoptive mothers through their narration of family relationship stories—creatively answering questions that biological mothers are rarely asked to consider. Pavna Sodhi's examination of maternal identity formation through the searing, personal narrative of raising third-generation Punjabi-Canadian daughters addresses the culturally complex ways that "belonging" depends on cultural and linguistic preservation, a task that is often understood to be a mother's responsibility.

These performances of and about motherhood are examples of feminist or empowered mothering, characterized as they are by "agency, authority, autonomy, and authenticity" (O'Reilly 21). The personal narrative style of Sodhi and Jeske, and the mothers' words revealed by Freehling-Burton, Warford and Webb, and Davis, echo with reminders that individual mothers do not mother in the abstract; they are daily in the process of creating and performing their identities as mothers, women, partners, daughters, and citizens.

ACT IV: PERFORMING PRESENCE/VISIBILITY

In this section, authors illustrate the links between agency and having visibility or claiming presence. Peggy Phelan cautions against the overvaluing of visibility as a path to women's agency in various mediums of performance, and argues that there is power in remaining less socially visible, or "unmarked" (7). We certainly acknowledge the complexity of visibility issues and the potential sparks of interdisciplinary discourse that may accompany our offering of the "performance of motherhood" as an incomplete representation of mothers. Collectively, the contributors to Act IV weather this storm, and raise questions about whether it is better to be "re-marked" and visible, or remain invisible and less vulnerable to attack. Ultimately, we suggest that, however imperfect, performance = presence = visibility = agency, and that each representation of mothering here is the incomplete archiving of one (or more) perspectives(s) on maternal truth. Our extension/disruption of Phelan's queries offers an opportunity for reflecting on maternal subjects' intra- and inter-gazes, and how this scrutiny of performance illuminates possibilities for maternal agency.

Terri Hawkes shines a necessary spotlight on performances of "mother-actors" during their exacting negotiation of motherwork and theatre work. Using candid qualitative interviews and forthcoming ethnography, the author argues that three major factors affect mother-actors' lack of visibility or opportunities in the work force: money, logistics, and body. Hawkes rewrites this narrative by performing innovative dialogue for maternal presence, visibility, and agency squarely on center stage. Ultimately, Hawkes challenges theatre workers to resist systemic marginalization of mothers—a compelling script for a "sold-out house." Sheilah Wilson's evocative photographic installation and critical analysis explores the ambiguous identity of mother and artist, and suggests that motherhood is paradoxical, an institution moving between celebration and erasure. Wilson, along with her mother and daughter, creates devised performance that straddles the line between visual and performance art, confronting mother-blame, mother-invisibility, and documentation through her aesthetic representation of the ambiguous space between maternal "existence and erasure."

Jennie Klein expertly theorizes on maternal subjectivity as she playfully probes the work of performance artists Barbara T. Smith, Alejandra Herrera Silva, and Courtney Kessel. Her subjects collectively use irresistibly imaginative techniques such as juxtaposed Xeroxed body images of mother and children, tactile and semi-clad performances involving edible fluids, and the use of baking and art supplies to literalize language. Klein examines their performances in the context of visibility/invisibility, and public/private spheres, and prods us to explore the matrixial borderspace as a site of non-knowing, the "grains and crumbs" of a lost pre-verbal identity that ghosts the present. J. Lauren Johnson utilizes videographic inquiry and composite narrative to examine unplanned motherhood. Working with co-participants from a small sample group, Johnson illuminates the divide between lived maternal experience and its "performance," bringing unplanned motherhood from the shadows into the key light of autoethnographic performance. Johnson argues that the grand narrative of unplanned motherhood as "woe and misfortune" is false for some mothers, while acknowledging that no one narrative captures the breadth of maternal experience. She contributes a feminist-informed perspective, celebrating, she says, the "love stories, comedies, and fairy tales" of unplanned motherhood, giving her subjects presence and visibility onscreen and off. These contributors thus align in challenging maternal invisibility by contributing to the artistic and academic presence of mothers while offering script notes for future maternal acts of agency and visibility.

The eighteen contributors to this volume offer an exciting production of *Performing Motherhood*. We have thought and acted and written from varied academic, artistic, and activist backgrounds as we portray the complex work of mothering, motherhood, and maternal identities. In the various stages of editorial rehearsal for each act, we tried always to think in terms of maternal abundance rather than lack—abundance of soul, creativity, and stimulation. Our texts span a range of motivations and eventualities for women, from constitution and grit to fascination and inspiration.

As co-editors, we have learned from our fellow authors and peers as we simultaneously engaged in our own individual performances on personal, family, community, and professional stages,

while we collectively crafted this book. Amidst late-night Skype meetings, detours to deal with other academic and professional commitments; pubescent, teenage, and young adult developments; eldercare, parental loss, and partner maintenance; efforts to attend to personal health and spirit—and to pursue it all from a position of personal agency—we have been deeply inspired by the stories, images, and soul of this anthology. In collaboration with our contributors, we, as co-editors, present *Performing Motherhood,* a multi-layered critical, representational, archival, exploratory, and celebratory textual performance of the maternal. Thank you for granting audience to our ideas, experiences, and imaginations.

WORKS CITED

Anzaldúa, Gloria. *Borderlands/*La Frontera: *The New Mestiza.* San Francisco, CA: Aunt Lute Books, 1999. Print.

Aptheker, Bettina. *Tapestries of Life: Women's Work, Women's Consciousness, and the Meaning of Daily Experience.* Amherst, MA: University of Massachusetts Press, 1989. Print.

Bateson, Gregory. *Steps to an Ecology of Mind.* Chicago, IL: University of Chicago, 2007. Print.

Bell, Elizabeth. *Theories of Performance.* Los Angeles, CA: Sage, 2008. Print.

Butler, Judith. *Gender Trouble: Feminism and the Subversion of Identity.* New York, NY: Routledge, 1990. Print.

Cixous, Helene. *Coming to Writing and Other Essays.* Cambridge, MA: Harvard University Press, 1991. Print.

Denzin, Norman K. *Interpretive Ethnography: Ethnographic Practices for the 21st Century.* Thousand Oaks, CA: Sage, 1997. Print.

Denzin, Norman. *Performance Ethnography.* Thousand Oaks, CA: Sage, 2003. Print.

Heilbrun, Carolyn G. *Writing a Woman's Life.* New York: Ballantine Books, 1988. Print.

Hill Collins, Patricia. *Black Feminist Thought: Knowledge, Consciousness, and the Politics of Empowerment.* New York, NY: Routledge, 1999. Print.

O'Reilly, Andrea. *Rocking the Cradle: Thoughts on Motherhood,*

Feminism and the Possibility of Empowered Mothering. Toronto, ON: Demeter Press, 2006. Print.

Pelias, Ronald J. *Writing Performance: Poeticizing the Researcher's Body.* Carbondale, IL: Southern Illinois University Press, 1999. Print.

Phelan, Peggy. *Unmarked.* New York, NY: Routledge, 1998. Print.

Rich, Adrienne. *Of Woman Born: Motherhood as Experience and Institution.* New York, NY: W.W. Norton, 1986. Print.

Richardson, Laurel. *Fields of Play: Constructing an Academic Life.* New Brunswick, NJ: Rutgers University Press, 1997. Print.

Ruddick, Sara. *Maternal Thinking: Toward a Politics of Peace.* Boston, MA: Beacon Press. 2002. Print.

Schechner, Richard. *Performance Studies: An Introduction.* 3rd ed. Media editor: Sara Brady. New York, NY: Routledge, 2013. Print.

Act I:
Performing Space / Location

1.
Performing Ecological Motherhood through/as Disability

Performing Disability as/through Ecological Motherhood

BRONWYN PREECE

I AM LABELLED. Some labels I have earned, some I have chosen, some have been branded upon me, and some I have birthed. I am mother. I am daughter. I am improviser. I am eARThist. I am disabled. I am performer. I perform and I am performed. I am the embodiment of metaphor, continuously negotiating, unearthing, and expressing these multiple and interlinked (maternal) relationships within the context of living in a time of unprecedented metaphorical *and* material ecological/social crises. I find myself seeking ways of exploring the continuously shifting, layered ambiguities, complexities, and overlapping dimensions of social and ecological "responsibility" with myself, my daughter, her father and others. How does one—or first, how can one—come to gain an *embodied* understanding of our interconnectedness as a people, as a planet ... and how do I position myself within this question as a mother? And from what centre do, or can, I or we *act* and/or re*act*? If indeed "All the world's a stage," as a mother, how do I perform my response(s) evocatively and ethically ... and how does my disability enlighten and/or impede my actions within this context?

I have Wilson's Disease, a rare genetic disorder whose neurological, physical and social symptoms began to emerge for the first time while I was transitioning into motherhood. My disability has touched and informed our families lives in a diversity of ways: with moments that have held beauty, humour, and grace; but often exasperating, confusing, and trying times that have left indelible impressions in our continuously unfolding relationships with the

17

disease and with, and amongst, ourselves and our surroundings as we have all had to take on many roles in this ever-changing drama. I will look at how the/my line between performance/life/art has been both blurred and made distinct through motherhood and now is enacted through a deeply felt metaphor: my performance of ecological motherhood is embodied through and as disability, and my disability is a performance of our current ecological state.

If I ever have a little girl
I am going to name her Similkameen....
At the age of five, I was captivated by a complete sense of magic that overcame me around the headwaters of the Similkameen River in British Columbia. As my parents and I would follow the river, by car, descend into the valley, and continue traveling through, my heart remained with the river, with the valley.

Words could not describe the stirrings inside me. I was mesmerized. The best way I was able to try to share this sense of awe and wonder was the thought that I may be able to capture, convey and communicate these sentiments by giving a child I might one day birth the name of this special place. By naming a daughter Similkameen, my five-year old mind was marrying the qualities of a child with those of the Similkameen: wonder, mystery, fragility, strength, freedom, wildness, beauty, movement, spirit, enchantment ... magic. I did not know what Similkameen officially meant, but at the same time I knew exactly what the name meant.

Then and there, I announced out loud to my parents, and I remember it clearly to this day, that it was my intention to bestow the name Similkameen to a future daughter. And that is exactly what I did.

On April 13, 2001, Similkameen Shannon O'Rourke was born at home on Lasqueti Island, British Columbia.

Her name accurately captures the magnificence of her being (as well as our journey of mother/daughterhood): at times wild and frenzied, at times calm and peaceful; possessing a balance between strength and determination, tranquility and pensiveness. Above all: a unique child, with a unique name.

We do not live in or near the Similkameen, but my daughter holds a special connection, unique to herself, to the place of her

namesake. To this day, the same stirrings, the same strong, yet indefinable connection overwhelms me whenever I first see the Similkameen River.

The First Nations of the Similkameen are the People of the Eagle. In our coastal home, eagles circle us, and come to rest on an old snag beside the cabin where Similkameen was born. The connection extends beyond the place, beyond the name, and into the essence....[1]

HOW THE/MY/OUR STORY BEGINS…

My performance of motherhood began as a child. Throughout years of childhood role-play, I always played the mother. There was never any question that I would play the mother. Cast and self-cast in this role, the "children" I took care of in the play of these plays were never bestowed with the name Similkameen. I was, at such a young age, drawing the line of naming between the real and imaginary, the metaphor and materiality of roles for what it means to be "mother," and realizing that the reifying of motherhood may or may not begin with the physical birthing of a child. At such a young age, my withholding of the name Similkameen was perhaps an acknowledgement of sanctity, of a notion of felt connectivity that needed to be (re)established for such a naming to occur.

By choice, at the age of twenty-four, I birthed at home: remotely, off-the-grid, on a coastal island. I wanted to birth my child with a connectivity to place, to home. And, almost surprisingly, upon the birth of my child, I wrestled with the notion of naming a person. I was fraught with the layered dimensions of what choosing a name for another meant and the significant imprint that this choice of mine would have on her. The art of naming became a delicate social/legal/cultural performance:

> Although our names may seem only to represent who we are, their repetition makes the name more than just a way of distinguishing us. The name takes on a power of its own, making it somehow a part of us. It becomes us—our bodies, our faces, our voices, our expressions see, to cap-

ture the name.... Names have this power—they grow in symbolic power until our bodies and our names become indistinguishable. (Warren and Fassett qtd. in Fassett and Morella 141)

As I wrestled with the notion of branding or potentially pigeon-holing this fresh person with(in) a name, what clearly emerged was *Similkameen*. This choice, however, was not free of its own irony: choosing to birth at home, valuing a connection to place, while naming my daughter after another place. How would these/my deep connections to these places inform her as she navigated through life ... and where, how, and what role would this name play in our unfolding relationship as mother/daughter?

Several years later, at the same time my illness was identified and labelled, the Similkameen River became listed as one of British Columbia's most threatened rivers. Metaphor was meeting materiality in an embodied dispute of boundaries. Disability thus became its own ecology: embodied and interpreted simultaneously, by both myself and my daughter. The "boundaries" of this term and their associated ownership were being interrogated continuously through this contextual exposition ... and whose were they to own: mine, hers, ours, the world's, earth's? How should I, and would I, continue to respond?

ANSWERING...

Trying to write my performance of motherhood has been/is the most difficult thing I have ever tried to write. My ideals of motherhood have come up for endless, relentless personal scrutiny, meeting head on with decisions on presentation, format, style, syntax, language, and voice, and questions about audience. Who was I writing this for? It has been difficult, and scary, and revealing about how perspective and truth are so truly subjective, and how easy it is to slant honesty. Fluidity punctuated the writing of the easier times. And yet, I found myself being able to sugarcoat the trying and difficult times, waxing poetic with an extreme awareness of (the unseen, unknown) audience ... all the while wondering how I frame these within an academic narrative. The delete button has

been well-used throughout this process, yielding both a beautiful and painful examination of how I have *act*ually performed the "mother." Motherhood has been a continuous improvisation of factors and this journey of writing has generated more questions than reported absolutes.

The journey of motherhood has stymied, catalyzed, and ultimately morphed my artistic ... "theatrical"... expression. Through time, what has emerged is the birthing of a new synergy between art/life and ultimately a new system of quantification for what personally constitutes performance and theatre. I have had to, and continue to need to, enlarge my definition of art and performance and the ecology inherent within them, and birthed because of, or in spite of them. They could no longer be something "specialized," a stand-alone separate aspect of my life as they had largely been pre-child. Performance lurked in the mundane, in the taken-for-granted nooks of the everyday, and motherhood fostered a recognition of such. Motherhood has forced a butting up against, a wallowing between, and a sinking into an examination of both the metaphor and materiality embedded in the constructs and (Western) definitions of theatre and ecology, set against/amongst a backdrop of both personal and multiple social states of disability. What were the roles of these classifications, these identifiers, these names? Una Chaudhuri notes that to "use ecology as metaphor is to block the theater's approach to the deeply vexed problems of classification that lies at the heart of ecological philosophy: are we human beings—and our activities, such as theater—an integral part of nature, or are we somehow radically separate from it?" (27). Based on our actions thus far, we could argue that we are both. The marrow of metaphor, in this case, becomes disability: the backdrop and the *mise en scène* of society's functioning. The activity of motherhood has certainly played the extremes, a theatrical pendulum swing between the sense of integral connection and radical separation. However, it is indeed the process of giving birth, and of being a mother that has allowed for an even deeper recognition that we are unequivocally an "integral part of nature." Art and performance have been treated in Western culture as something separate from, rather than implicitly integrated within, our culture. After a couple of years of very focused and connected parenting, I began to fall

victim to these trappings, at times resenting motherhood for deny-
ing me the chance to "perform," to be an "artist," to create. This
attitude was nothing short of debilitating ... though at the time,
I was unable to recognize that this same attitude I was holding,
of fracturing and dichotomizing, was indeed the same attitude re-
sponsible for the ecological/social crises facing us today. "We come
to a fundamental paradox: one of the key means of shaping and
transforming human attitudes and values is the arts, but the arts
(in the West [...]) have been traditionally conceived as the activity
that most divides humans from 'nature'" (Arons and May 1). I
was becoming my own paradox. I was pitting my values against
each other, and ultimately, as a result, though unwittingly, myself
against my daughter. But, it did not start this way....

Though now more eloquently phrased through retrospective
reflexivity, the journey towards this recognition of a blurring
between life—life as a mother, life with disability, life in this day
and age—and art has not (always) been a smooth one. I write now
from a vantage point of deeply appreciating the embeddedness of
the one within the other(s), and the tiers and years of gaining this
understanding that still continues to morph.

BE(COMING) ...

I gave birth in a small cabin, in a small and eclectic community.
Life was full and empty at the same time. My partner and I had
consciously chosen to live this life, to raise our daughter here,
largely an ethical lifestyle response to a compromised world.
When I gave birth, my disease and disability had not yet become
a presence in our lives. Motherhood was both intensely and won-
derfully all-consuming, and viciously isolating. Geographically and
performatively lonely ... the remoteness both engendered a space
for certain facets of artistic exploration, and made other forms of
expression less available. My supportive partner, my daughter's
father, worked most days. Her and my audience, day-in, day-out,
was largely the other, the surrounding forests, ocean beaches, and
dirt roads. Artistic creations of all types formed an integral part
of our everyday, as did extensive walking outdoors (in and out of
our all-terrain stroller). Together, we knew every nearly formed

spider web, where every Yew tree stood, where every little animal trail snaked off into the woods.... Our engagement with the other-than-human world informed the art that we created. Art informed by place, by context ... and our experiencing of life together. We could walk for hours and pass no one. We were surrounded by and were beauty. Our connection: intimate.

Alongside this intimacy, what began to rise slowly was my own rutting within this dynamic. My wheels were just beginning to spin.... I was keenly aware of the sanctity of our bond, but I also I recognized that I needed to enlarge both my level of input and output (at this point, the artistic merits of the output or input were irrelevant): I needed to broaden my scope of engagement with the world. Yes, we were living our ethics, *but* I did not want to live in a bubble. The world surrounded us.... I did not need the radio or newspaper or news to inform me of the crumbling world. My chosen lifestyle was not an opting out; it was an opting in. But in order for it not to become the former, I needed to ensure and encourage continuous engagement with the broader cultural unfoldings.

Correlating with, adding to, and triggering this sense of dis-ease, were two of the first as-of-yet unrecognized symptoms of my disease: depression and anxiety. (There was a synonymity with the layers of personal and ecological/social disability.) What accompanied these symptons were their narrowing and tunnelling effects that began to infiltrate every aspect of my life. They moved in slowly, leaving me/us unaware that I was falling into their grips, as it is hard to recognize from within, and hard to understand from outside. A new norm was being established. It was clear that I was seeking a way to embody an act of self-preservation, with self-preservation not being merely a selfish expression. Though depression and anxiety were skewing my perspective(s), I was able to recognize the delicate beauty between my daughter and me ... and my ability to possibly begin to turn against the relationship. *Surely every mother must feel like this at times*, I thought. I equated these feelings with a natural response to becoming isolated within the attachment-parenting bond, nothing more. In order to sustain the intimacy that I so deeply cherished and to keep it fresh, to retain a deep appreciation of this connection with my daughter, with this

place, I was propelled to examine new avenues to broaden my/
our interactions. I was a high-functioning human being: I needed
to be proactive in order to avoid a pitfall. And as a mother, I felt I
needed to ensure an attempt at a rounded exposure and response
to/with the world around us. This was not a personal decision.
"Motherhood" was making this decision. This was "Motherhood"
performing. This was the performance of *Mother* on behalf of my
daughter, myself, current and future generations. This awareness
was clear, despite the onset of *my* as-of-yet unrecognized disability.
Mother's state of disability was undeniable. I needed and wanted
to extend beyond, while at the same time, to step more deeply into
the performance of ecological (artistic) motherhood.

And so, I became involved in local politics.

And the "obvious" question was asked of me: *But Bronwyn,
why politics; we thought you were interested in theatre?*

My response: *Precisely.*

ENACTMENT(S) ...

Theatre stems from the Ancient Greek word *theatron*: "the viewing
place" or "the seeing place." Readily capturing the qualities of
viewing *and therefore* viewer, seeing *and therefore* seer, audience
and audienced, spectator and spectated, the Greek usage places
particular emphasis on the locality of such reciprocal occurrences:
the location or housing of such events. In essence, the *theatron*
spoke to the house of the theatre. The Greek etymology of *ecol-
ogy* similarly finds at its root the idea of house and home. The
theatron-cum-theatre therefore seamlessly lends itself to ecological
interpretation. From my house, my home, my chosen place to dwell,
I had found a way to remain embedded locally, while extending
my sphere of input and output, ethically, *and* instantly-evidently
and originally, fulfillingly: performatively.

Mine was the performance of being the youngest woman ever to
be elected to the Islands Trust Council (the local, municipal-level
government for the Gulf Islands of British Columbia). This was
the end result of a series of "All Candidates Meetings" and conver-
sations with community members: performances seen and judged
and deemed worthy of people's endorsement, played out in a public

theatron. The theatre of it all was the interactions between various factions of people, pitting themselves for and against each other and issues, and how I navigated the binaries of a drama filled with every character conceivable.

My daughter travelled with me to off-island meetings that occurred four times a year. We would travel with a familial entourage of support that enabled me to be simultaneously present as a mother and a politician: my/our horizons of input/output were broadening, while retaining our connection. I was particularly effective in the role of advocate and politician, striving to ensure the protection of both people and place, and found ethical fulfillment in my actions. But even though it was clearly all theatre, the art of it all was an exhausting dance with bureaucracy. My art was not only bylaws. It became clear that though I was fulfilling my sense of ethical engagement, there arose in me the desire to be and create art that involved a poeisis of performance, an ecology that strived to find a balance between the site-specificity and the local within the global, an *embodied* approach in a world where my very *body* was beginning to be compromised by the effects of my undiagnosed disability creeping in.

Nearing the end of my first term of office, my artistic tires were truly starting to spin. I was responding politically to the facts that nuclear subs were passing by in the polluted waters in front of me, that the old growth trees were disappearing, and that salmon were not returning to spawn—but performing politically was not engendering creative fulfillment. I recognized, through the effects of my still-undiagnosed disability, that my scope of engagement had to be broadened yet again. Though depression and isolation were exasperating these sentiments, I was still equally motivated to strengthen the offerings I could share with my now four-year-old daughter. How could my tools as an artist potentially be used and further trained as an effective tool of remediation with our relationships to place, to earth, to each other, to self? I decided that we would move off.

> *When the animals come to us,*
> *asking for our help,*
> *will we know what they are saying?*

When the plants speak to us
in their delicate, beautiful language,
will we be able to answer them?
When the planet herself
sings to us in our dreams,
will we be able to wake ourselves, and act?

—Gary Lawless

THE WELL-MADE (DIS)PLAY?

I entered the Theatre/Writing Program at the University of Victoria.
We relocated as a family.

Now, a mother, a partner, a full-time student, and a politician, my plate was fuller than it had ever been: life was vibrantly dynamic. By gratifying my artistic side, perspective was renewed and infused. I was happy and healthy. The depression had abated.

I was also newly able to appreciate the role I was still playing in the political sphere. I was gaining a sense of balance between my interests and values, and also navigating the divide between serving a place where I was no longer living (I still had a few months left of my term). Though we had no immediate plans to return to Lasqueti for several years (once my degree and possibly my daughter's elementary school were completed), I still decided to run for re-election. And I won.

It wasn't long after our arrival in Victoria, the beginning of school, and my re-election, however, that an odd and eclectic set of symptoms of my disability began to emerge. They began to present themselves independently and sporadically. But within months of having entered both the Theatre and Writing Departments, I was beginning to lose my ability to speak clearly and to hold a pen. I was progressively losing control over my expressive abilities ... but with enough of a finite graduated escalation, that the severity of these shifts was not evident enough to raise serious alarm. The doctor dismissed it as stress ... I was evidently an over-achiever and perfectionist. I finished my first year.

And I entered my second year. The symptoms of hand tremors and slurred speech, imbalance and drooling were now becoming evident and disconcerting. My peripheral vision and depth

perception were shifting. I was losing my train of thought easily, fumbling for word recollection and my short-term memory was failing. Psychologically, I began to be unable to control my temper, and the simplest thing could trigger me. And I was displaying increasing signs of Obsessive Compulsive Disorder. The muscles in my face were beginning to stiffen, impeding even my ability to smile. And I had absolutely no energy. I was exhausted, but my plate remained just as full as ever. I was desperately trying to cling to this new chapter of life we were endeavouring to lead; this major move made entirely because of me. I had been the catalyst for uprooting and moving my whole family on a non-existent budget. My partner and parents had made this all possible for me, for us. I wanted to realize the goals of why we had come. I did not want to let them or myself down. However, it was all of them, from the outside, who were getting increasingly concerned for me, and they were in no way placing any pressure on me to stay and finish the degree. Unrecognizable to me was the altering of my cognitive and self-reflexive abilities. Physiological changes to my brain were such that I was unable to recognize, from within, the increasing grip they were having on me. I was absorbing these neurological and psychiatric shifts, establishing them as my new norm. I theatrically deflected attention away from myself with a humorous "I'm fine." Public humor became a performative and protective shield, which diverted and tricked the attention—that of others and my own—towards the unknowns. I persevered, stubbornly.

Specialists of all kinds were called in: neurologists to eye, throat, and nose doctors, geneticists to infectious disease specialists, and more. They all scrambled to find answers to this odd mixture of symptoms. They searched and tested for over a year. They mis-diagnosed and re-diagnosed. As I increasingly lost my abilities, I equally began to lose the connection that I so cherished with my daughter.

I was accurately diagnosed days after my final class of my second year. Due to the rarity and severity of my disease, I was immediately sent to be under the care of the world specialists in the disease, at the University of Michigan in Ann Arbor. Similkameen was in kindergarten. With only days to prepare—and she already negotiating the terms of a mother who was rapidly declining before her

eyes—we said good-bye to each other. Though unspoken, there was mutual fear embedded in this good-bye.... *Would I return?*

Return I did, after six weeks of care. Return I did, still with the same symptoms and difficult manifestations of this disability. I returned on a program of chelation and medicine that I would be on for the rest of my life. Compliance was compulsory. It would be a minimum of six months before I noticed any improvements. My window of recovery would be over the next two years, and a full recovery was likely impossible. And return I did, with medical orders to take a year off school. Returning back to the remoteness of our off-the-grid island life was, in my state, an impossibility. So, return I did, but to spend the next year largely lying on the couch, and newly rutting and spinning my tires.

ART/LIFE — LIFE/ART

Life in the city was difficult. I was now not really able to take full advantage of its offerings that I had come to seek out. On the other hand, the city provided opportunities for Similkameen that were beyond the scope of small-island life (as I had so wanted and hoped for her with the original decision to move: swimming pools, ice rinks, museums). With these opportunities-turned-needed escapes came the relief from a mother/daughter relationship within which we were both desperately striving to establish a new sense of connection. Similkameen extended much compassion and understanding towards me, and I fumbled in my expression of love back to her. Just as my sense of motherhood had begun as a child, so too was hers beginning: striving to mother her own unpredictable mother. Our dynamic was stressed by ever-shifting footings, marred by my moods and uncontrollable outbursts. The already-close bond between father and daughter grew exponentially, triggering jealousy within me. I was deeply fearful of losing my daughter. Our relationship was extinguishing before my eyes, and I was the one dousing it ... and the most infuriating part of it all was that I felt like I had no control over it. My outbursts and behaviour were as foreign and upsetting to me as they were to her, and only served to exacerbate my responses to her and the world around me. I was further triggering, not resolving the

fissure. This was disability. And this was the present ecology of my motherhood.

From my vantage point on the couch, life in an urban environment became equally difficult, as my ethics—the ones that were encouraged by, revolved around, and extended beyond motherhood—of socially and ecologically responsible living were being challenged and not satisfactorily mitigated from where I was. I was not being an *active* participant in answering the very question that had transitioned my family here: *How could my skills as a performing artist potentially be used and further trained as an effective tool for remediation?* The severe sense of disconnect that I was experiencing with myself and with my daughter engendered an even further acute awareness of the precariousness of our larger social/ecological crisis.

My health began to slowly ameliorate, as did my state of mind. As the debilitating grips of my disability incrementally improved, so did my capacity to begin trying to reintegrate into the artistic/ethical worlds that I was so passionate about, fostering a hopeful renewal between mother and daughter. My moving off the couch and back into the larger *theatron* of the world stage saw me re-enter in the capacity of a drama facilitator.

I returned to school, in a part-time capacity, enlisting in courses that allowed me to explore artistic activism. Through the drama and arts-based methods, I began to work with groups, focusing on interrogating the dichotomies between culture and "nature," self and "environment," seeking ways to embody and overcome these binary constructs. My centering was the belief that we are all inextricably a part of earth, *ecological selves* (Naess) indivisible from each other and the biospheric whole that is mother to us all. A mother under assault. The ecological and social crises were/are a form of self-abuse, rendering our world disabled.

I was calling my work earthBODYment, but my own body, my own body of a mother, was still pained and confused. On the one hand, I was an effective drama facilitator, embodying all the nurturing and supportive ideals of motherhood, all the ideals that I had originally been performing so well with my daughter, the very same ideals that I now seemed to have no trouble accessing with groups, but that I still was not able to fully rekindle and realize in

practice between mother and daughter. We had ingrained a deep responsive patterning, now full of fight-or-flight scars that were hard to heal, despite the fact that my health was continuing to improve. There was undeniably a chasm between us.... At times, we were once again becoming so close that the valley edges seemed to meet in the most reciprocal and loving ways; and then as quickly as the waters were calm, raging rapids would interrupt our course.

At this same transitional time, the Similkameen River became listed as one of British Columbia's most endangered rivers. The pain was immense. The assault felt personal. Personal as mother, personal as Mother. This was a/our (social) disability. My awareness was corroborating with improvements in my condition, further allowing me to recognize that I was living, healing, and leading by example in all aspects of my life, except where it counted most: with my daughter, Similkameen.

Metaphorically, materially, and maternally the call *home* was great.

ART FOR LIFE'S SAKE ...

We would move back to Lasqueti Island. We, as mother/daughter, as a family, were collectively performing the possibility for reconnection. Before we moved back, we journeyed together to and through the Similkameen River and Valley.

After seven years in Victoria—with Applied Theatre Degree in hand and beginning a Master of Arts degree that was designed around working with my daughter—we were newly back off-the-grid and on-island. I could no longer handle any further separation between mother and daughter, motherhood and academia, motherhood and performance, mother and world. I had no interest in academically or artistically studying disability ... I wanted and needed to explore and mitigate through disability my relationships to the ecology of motherhood and my performance(s) therein.

The road of getting to *this* place has been nothing short of an experiential exposition of extremes. I would be the change, live the change, perform my change, write my change ... and I/we would walk our change. As a mother/daughter duet, we would return to our walking of old, but in a new performative light. Co-designing

a project, together we would walk the length of Lasqueti Island's Main Road: viscerally, kinetically, constitutively embodying an ephemerality of place and relationship; collaboratively writing a poem as walked.

Pacing This Place

The beginning is dark, yet light
Green and brown twisting trees
The little shacks in the woods are almost hidden.
Shadows and sun dance patterns, rimmed with
Fallen umber leaves ... alder, maple ... wrapping
Around roots of cedar, yew, and boulder...
Colourful kids on bikes come by
The banks of oh-so-rich, brown dirt
Moss is so moist at this time of year
And the distant bass beat from a musical home
Wafts over long-forgotten, stashed-in-woods vehicles
But nothing dampens the amphibian symphony.
Lucky beer cans are here, even though we're off-the-grid.
People like to party, but there is no excuse for trash.
10 people could hold hands around this tree
Or more. Or less. Numbers, people, place merge
Even with the reminder of a single brightly painted car.
A wave acknowledges volumes as we breathe together
this space.
Glittering sunshine shines into the brook,
Even though the brook is deep, the grass still grows.
You have no idea how much my feet hurt right now.
Soleful/Soul-full reminders of constant contact
Ground, Earth, Sky, Leaves, Me, You, Us, Lasqueti
The boundaries are blurred and oddly present still.
The little "wee" pond is lovely
With the chirp of bird
I love it.
Then ... a driftwood gate with a bell
Sun splashes through alder
And a telephone box: #141

31

The road ends really abruptly!
I am grateful for this journey
WE ARE HERE!

Our collaborative poem (composed with each of us alternately adding three lines at scheduled half-hour stops; seeing only the very last line that was written by the other at the time of adding your own) indirectly captures the layers of the/our journey that has brought us full circle ... indeed, *we are here*.

My performance is changing. My journey has been one of shifting perspectives.

The recognition of an improvising metaphor has enabled me to relate to myself differently, and so too, my daughter. Corroborating Fassett and Morella who argue "that performance emphasis on and commitment to performance as constitutive of identity—is a means to clear the intellectual brush and define paths for us to explore, if not to follow" (141), I/we now walk motherhood together: artistically/ethically/ecologically/evocatively through and with a recognition and embodied understanding of the macrocosm of disability.

[1]This story was previously published in the *Trumpeter: Journal of Ecosophy* (Preece).

WORKS CITED

Arons, Wendy and Theresa J. May. *Readings in Performance and Ecology*. New York: Palgrave MacMillan, 2012. Print.

Chaudhuri, Una. "'There Must Be a Lot of Fish in that Lake': Toward an Ecological Theater." *Theater* 25.1 (Spring/Summer 1994): 23-31. Print.

Fassett, D. L. and D. L. Morella. "Remaking (the) Discipline." *Understanding Disability Studies and Performance Studies*. Eds. Bruce Henderson and Noam Ostrander. London: Routledge, 2010. 139-156. Print.

Lawless, Gary. *Earth Prayers/Earth Songs*. Eds. Elizabeth Roberts and Elias Amidon. New York: HarperOne, 1991. Print.

Naess, Arne. "*Self* Realization: An Ecological Approach to Being in the World." *Thinking Like A Mountain: Towards a Council of All Beings.* John Seed, Joanna Macy, Pat Fleming and Arne Naess. Gabriola Island, BC: New Catalyst, 2007. 19-30. Print.

Preece, Bronwyn. "A Girl Named Similkameen." *Trumpeter: Journal of Ecosophy.* 27.1 (2011). Web.

2.
The Maternal is Political

Appalachian Maternalist Protest Songs

COURTNEY E. BROOKS

MUSIC IN THE SOUTHERN APPALACHIAN REGION of the United States has long been a space to craft romantic, idealistic, and also backward views of the region and its people. Mountain murder ballads place Appalachian women as pathetic victims—bruised, beaten, and buried at the hands of their lovers—while popular culture places them as examples of uncultivated femininity and collapsed motherhood. Messages from local colour writing about the region have helped affirm tired, denigrating, and harmful images of women in Appalachia, thus evidencing a disturbing disregard for accurate and empowering images. Portrayals of the ways in which Appalachian mothers, for example, have employed their regional knowledge and identities to redefine boundaries between labour and home are absent or erased. Prolific assumptions about women's traditional roles as housewives and mothers have fed perceptions that women are unlikely political activists because they are hesitant to join political activity, slow to organize, and unlikely to take on leadership roles. Instead of engaging in political action, women are assumed to perform more passive action during political and social upheaval.

Increasingly, critical scholars have reconsidered Appalachian women's roles throughout history and in popular culture as a means of challenging longstanding myths and misrepresentations, many of which are reflected in the region's music. Historical accounts from Appalachia during the 1930s and into the present demonstrate that women were hardly immobile and docile. In fact, these women have shown a remarkable ability to organize,

plan, and execute economic, political, and social change in their communities, with protest music operating as one of those vehicles for change. Bringing experiences of Appalachian women from the periphery into focus in historical/cultural studies, a number of scholars (Beaver; Engelhardt; Maggard; Massey; Smith; Tice) have provided space to contemplate both the supportive and primary roles of Appalachian women in the home as well as in contexts of labour and work.

As strikers and singers, many women violated gender conventions by invading space once solely occupied, at least in the popular imaginary, by men, creating dichotomies that split "ladyhood and lewdness, good girls and bad" (Hall 375). Shelly Romalis argues that protest songs written by women in Appalachia frame gender as political text as a "useful strategy to link domestic interests to social and political action" (181). By composing protest songs, women provided a distinctly female consciousness, politicizing the networks of everyday life, and underscoring gender rights, survival, and social concerns (Kaplan). Romalis describes their actions as "strategic and instrumental expression of maternalist political discourses, rather than simply reflection of 'essential' womanhood" (185). These women's songs channelled immediate emotional reactions into resistance narratives, connecting the women's experiences as mothers, wives, workers, and witnesses of social injustices to songs that give voice to their anger and dissent. Ultimately, their songs relocated their presence into the song texts as active agents, rather than helpless victims, and repositioned their roles of mothers and wives as advocates for justice. As a result, women like Florence Reece, Aunt Molly Jackson, Sarah Ogan Gunning, and Hazel Dickens became Appalachian emblems and enigmas who used their voices to identify specific instances of suffering, honor fallen heroes, and name and insult their oppressors.

APPALACHIAN MOTHERHOOD IDENTITY

Appalachian women's participation in labour and environmental movements demonstrates common themes of motherhood and activism, which have emerged as advantageous tools for collective action. Scholars have pointed to an especially close tie between

Appalachian women's social activism and their identities and motivations as mothers. Shannon Bell argues women's protest in this region has been rooted in a desire to preserve the well-being of family and community. For many Appalachian women, their identity is connected to their role as mothers, which connects them to other women within the region. Shannon Bell and Yvonne Braun argue that participation in a particular movement occurs because of the connection between the cause and an individual's sense of identity, which aligns with, or corresponds to, the movement's collective identity. In the case of many Appalachian women activists, a motherhood identity emerges as the motivating force behind their action.

The Appalachian Mountains have long represented a mother-figure; Barbara Smith points out that John Denver's singing of West Virginia as a "mountain mama" rather than "papa" is no accident: "the mountains call to us as a mother calls to her children: come home" (3). For Appalachian women, their motherhood identity is rooted not only in their socially sanctioned roles as mothers, but also in their deep connection to the land and culture. Bell and Braun point out that the "motherhood role" of many Appalachian women was transformed when they channeled their responsibilities to their children as "moral legitimacy" to justify activism. Within Appalachian communities, traditional family roles coincide with deeply held religious beliefs, creating distinct positions for men and women. These positions are particularly entrenched iterations of gendered perceptions that operate on a much larger scale, which, as Amber Kinser notes, view mothers' experiences as grounded in nature, producing a maternal instinct where they intuit the needs of their children. Mothers are trusted with knowing what is best for their children because mothers are by nature endowed with the ability to meet those needs. While scholars discuss the trappings of essential theory that defines womanhood, the opinion within Appalachian communities surrounding women's instincts as mothers is no less firmly grounded.

Similarly, many men's identities in Appalachia are tied to their jobs with the coal industry. Sally Ward Maggard notes that masculinity was defined by men's willingness to work in dangerous conditions in the coalmines, while women were limited to domestic

labour (1987). Men are less likely to participate in activism due to the "culture of silence" Bell and Braun describe as dictated by masculinity in Appalachian coalfields. Many men feel silenced due to their economic dependency on jobs provided by the coal companies, as well as the perception that activism is emotionally charged, and affiliated with women, and as such not a masculine activity. Men's identities as miners are connected to their identities as men, and participating in public protest risks a loss of status within the community. Gender identity is deployed by the social order as a primary tool for suppressing unrest and change: women lack the fortitude, organizational skill, and leadership for activism and men do not display the emotional involvement that would characterize activism. An overarching paternalism hangs over these sites of labour—namely, the reinforcement of traditional gender roles that distinguish men's work as being outside, and women's work as being inside the home.

The gender division in Appalachia did, however, afford women the opportunity to use their mother role as a mechanism to over-come obstacles based on their gender. Women were able to draw upon social expectations to justify their activism as evidence of good mothering. Placing their responsibilities as mothers above all else is a community asset, as it protects children who are unable to defend themselves. Many Appalachian women realized labour struggles directly impacted their lives, as they threatened family survival. As a result, the need to protect the sacredness and safety of the home became a social platform. Virginia Seitz argues that these women activists, natives to a region affiliated with deeply held myths and stereotypes, utilized popular narratives of Appa-lachian people as plain and simple hillbillies to describe their own mothers, positioning them as exemplary women. They call upon their traditional role as heads of household who create the moral and social foundations for their children as a strategy to justify and advocate for their families and communities.

Amber Kinser describes mothers and caretakers as continuously in the process of thinking, rationalizing, and choosing, thus chal-lenging a gendered "body/mind dualism" that infuses another dualism "between private and public worlds" (10-11). Appalachian women's protest songs, in particular, demonstrate the immediacy

of thinking, rationalizing, and choosing, while negotiating space both within and outside the home. Their maternal perspective can be viewed as corporeal engagement, where Appalachian women are motivated to consider how they should respond to the events taking place around them.

Appalachian women's resistance through maternalist discourse challenges the system Neil Websdale calls "rural patriarchy," a term he introduced in his research on domestic violence in rural Kentucky. His theory borrows from Sylvia Walby's notion of private patriarchy, "a system of social structures and practices in which men dominate, oppress, and exploit women" (44). Websdale argues that while patriarchy is manifested differently in rural areas, it still comprises an apparent set of gender-based power relations. Rural patriarchy helps position maternalist discourse within an Appalachian setting for the reason that it does not place blame on or cast women as inherent victims. Instead, the theory of rural patriarchy examines the specific mechanisms that systematically oppress women.

Chandra Mohanty's work on case studies of alleged "Third World" women led her to argue for the rethinking of such women as agents rather than victims. This is an approach Shulamit Reinharz also argues is crucial within the discipline of sociology in order to explore mechanisms behind women's subjugation and to discontinue the blatant sexism "that sees women primarily as stupid, sexually unexciting wives *or* objects of sexual desire and violence" (165). Similarly, Sandra Harding points to the "limitations of victimologies," noting that they are problematic because they "create false impressions that women have *only* been victims, that they have never successfully fought back, that women cannot be effective social agents on behalf of themselves or others" (5).

Judy Long's feminist approach to "telling women's lives" picks up where Websdale's examination of mechanisms of oppression concludes and considers how women can self-author their own stories and resistance. Her theoretical model transitions from addressing mechanisms of oppression into providing a proactive method that asserts the positions of women as subject, text, reader, and narrator. In terms of protest music, women emerge as female activists, whose lively songs tell not only their own stories, but

speak directly to the injustices of an entire region. Long argues that a female subject situates herself in a web of relationships, crafting an autobiography with a repertoire of narratives. In this case, the autobiographical narrative comes in the form of a song, the "text" through which the subjects' lives will be explored, and a message to those who will listen.

MATERNAL PROTEST SONG WRITERS AND PERFORMERS

In the 1930s, women's protest music inspired from the coalfields of "Bloody Harlan" in Eastern Kentucky blended lyrics with melodies of gospels and hymns, turning economic and social justice activism into a sacred act. By composing protest songs women politicized what Temma Kaplan calls "the networks of everyday life," which underscored gender rights, family survival, and labour concerns (545). The following describes the work of five Appalachian women whose lives were profoundly impacted by the injustices inflicted upon their families in the coalfields, and who used music as a tool for resistance.

Florence Reece: Bard of the Working People

Florence Reece (1900-1986), originally from Tennessee, penned arguably the most well-known union organizing song, "Which Side Are You On?" Loyal Jones, one of the founders of the formal study of the Appalachian region, calls Reece "a bard of working people" (169). Drawing from an interview in 1942 that was published in *Mountain Life & Work*, Jones includes Reece's description of the mobilizing events that led her to write her famous song. Reece's husband, miner Sam Reece, had become a leader with the National Miner's Union, making the Reece family a target for mine operators. Mine operators were known for hiring "gun thugs" from outside the region to invade homes of strikers, to coerce miners to walk off the picket lines and back into the mines. This was certainly an effort to reinforce Appalachian men's identity as miners and to demonstrate the consequences of that order becoming skewed by male participation in strikes. Reece notes that the gun thugs had come to her house several times before: "They was in all of the rooms, in the boxes and everything. They'd raise up the

mattresses and if they'd find a letter or a piece of paper, they'd take it" (Jones 69). Reece draws upon her motherhood identity to validate the song's composition: "… I felt that I just had to do something to help. The little children they'd have little legs and a big stomach. Some men staggered when they walked, they were so hungry" (69). The song was written on a calendar Reece took from the wall, simply because she "didn't even have any paper" on which to write (69).

Reece's song asks that the "good workers" listen to the "good news" of how the union "had come in here to dwell." In the midst of social and political upheaval, Reece's song urges strikers to remain loyal to the union with lyrics such as "I'll stick with the union / Till every battle's won." There is incredible power in Reece declaring her allegiance to the union in writing as her home is invaded and wrecked by gun thugs. Reece's song paved the way for Appalachian men and women to show their commitment to the miner's union, because of the workers' rights, wages, and compensation afforded to them. While Appalachian women did not go down into the mines, they demonstrated a desire to support and maintain union activity. Appalachian women's transition from working inside the home to actively protesting, particularly in coal-mining strikes, was a result of national tension growing around labour and economic issues that directly affected families. Reece's faithfulness to the union was connected to her motherhood identity; like many Appalachian women, Reece believed the union had their best interest at heart by providing wages and advocating for safer working conditions for miners, both of which ultimately sustain Appalachian families.

In her discussion of Reece's song, Shelly Romalis describes it as "one of the most poignantly familiar and lasting statements of class conflict" because it fused "domestic concerns with ideological issues" (11, 186). Reece herself describes the song's title: "I was asking all the miners, all of them, which side they were on. They had to be on one side or the other; they had to be for themselves or against themselves." In this instance, Reece challenges ways in which Appalachian men maintain their identity as miners. She uses hegemonic masculinity as a strategy to remind men that in such an important labour movement "there are no neutrals," and asks,

"will you be a lousy scab, or will you be a man?" Reece speaks with authority in her song, drawing lines between miners and mine operators, Appalachians and outsiders, and right and wrong. One of Reece's performances of her memorable song was included in Barbara Kopple's 1976 documentary, "Harlan County, USA," which documents the Brookside Coal Strike in Harlan, Kentucky, where women's activism, inspired by the women of "Bloody Harlan," helped win the miners' strike.

To ensure Reece's song would continue to resonate, Appalachian author George Ella Lyon crafted the story behind Reece's composition into a children's book, *Which Side Are you On? The Story of a Song.* In the book, Lyon retells the story of the Reece home being ransacked from the perspective of Reece's oldest daughter, Omie, who was hiding under the bed with her six siblings. In the midst of the invasion, Omie witnesses her mother scribbling and singing, telling her children, "We need a song." In this moment, Reece authored a text capturing real time events, defining her identity as a mother and singer even in the midst of an invasion, and powerfully resisting the rural patriarchy erupting around her, as people of the region and beyond soon after took up the song in enactments of solidarity and protest. While Reece wrote from a place of maternal protection of family and community, her song positioned her as an archetypal mother of protest music and social change.

Aunt Molly Jackson & Sarah Ogan Gunning: A Pistol Packin' Mama & Girl of Constant Sorrow

Arguably the most famous female singer/songwriters to emerge out of the coalfields in Appalachia were Aunt Molly Jackson and her half-sister, Sarah Ogan Gunning. Aunt Molly, or Mary Magdalene Garland Mills Stewart Jackson Stamos (1880-1960), presented herself as a wild and wily woman, and even claimed the Tin Pan Alley song "Pistol Packin' Mama" was written about her. Jackson apparently really did pack a pistol, at least in one notorious act where she held up a local grocery store at gunpoint demanding food for her neighbour's starving children. Henrietta Yurchenco (214) quotes Jackson from an album's liner notes bearing her name, where she describes the sense of urgency behind her crime:

I reached under my arm and I pulled out a pistol, and I walked out backward. And I said (speaking to the manager), "Martin, if you try to take this grub away from me, if they electrocute me, I'll shoot you six times a minute. I've got to feed some children, they're hungry and can't wait." (214)

Her songs of suffering and starvation give good reason for Jackson's hardened exterior. As a child, she lost her own mother to tuberculosis; as a young bride, she lost her first husband to a mine accident; as a re-married woman, she lost her two children in their infancy; as an adult, her father and brother lost their sight in a mine accident; and as an activist, she lost her second husband, Bill Jackson, to divorce, after the coal company gave him the ultimatum to leave his wife or lose his job. Jackson worked as a nurse and later as a midwife in the coal camps of Kentucky. Her mother-work delivering infants, only to see many of them weaken, sicken, and die from the unsafe living conditions and a lack of food, inspired the narrative in many of her songs. Her well-known "Ragged Hungry Blues" tells the story of Kentucky women: "Sitting with bowed down heads / Ragged and bare-footed" with their "children cryin' for bread." Another song, "Poor Miner's Farewell," tells the story of a begging orphan child left barefoot, ragged, and hungry after losing its father to the mines.

In her research on activist mothers in the coalfields, Bell argues that a "protector identity" emerges within many women, which encompasses motherhood identity and becomes a driving force to mobilize their action and protest (9). In the case of Appalachian women, this connection to protecting family is synonymous with preserving the land and their way of life. While Jackson never raised a child, she certainly took on the protector identity, where her mother-work led her to become enraged by the ways the mine operators would target men, which ultimately caused children to suffer.

Jackson's songs landed her in front of the National Committee for the Defense of Political Prisoners in 1931. Informally called The Dreiser Committee, the self-appointed group of left-wing writers travelled to Kentucky to learn first-hand the experiences of miners on strike. After committee members heard her perform "Ragged Hungry Blues," the lyrics of Jackson's song were printed on the

front page of their published 1932 report, *Harlan Miners Speak: Report on Terrorism in the Kentucky Coal Fields*. Presented with a public platform, and using her training as a nurse, Jackson testified on the living conditions of her fellow Kentuckians. Her account was filled with images of burying four to seven infants each week who, without milk to help them survive, had died from cholera, famine, flux, and stomach problems. When asked about the housing conditions provided by the mine company, Jackson revealed that households suffered from the flu and pneumonia, and that miners and their families lacked proper clothing and/or nutrition. In her testimony, Jackson even criticized the Red Cross—the crusade of caped women providing care and compassion as emblems of the ultimate act of motherhood—for refusing to help the children of miners on strike (National Committee).

Bearing the weight of her personal family tragedies and those of the community around her, as well as venomously attacking rural patriarchy as the system responsible for killing children, Jackson positioned herself as a quintessential source of important labour history in Appalachia, thereby placing her songs and stories as authentic representations of Appalachian cultural tradition. Jackson's songs caught the attention of scholars and musicians alike, and created a strong presence in New York City's Greenwich Village in the 1930s where her songs, like Reece's, would be considered a vital thread in the tapestry of protest music (Romalis).

While Aunt Molly Jackson was seen as a "defiant, untamable mountain woman," her half-sister, Sarah Ogan Gunning (1910-1983) entered the public eye in the 1950s as self-possessed, reflective, and even tender in her presence (Romalis 162). In 1988, Appalshop, a film company devoted to documenting Appalachian culture and tradition, dedicated a documentary to tell her life story called "Dreadful Memories." The film captures Gunning singing and explaining the inspiration for her songs, a feeling she describes as being flooded with memories of sorrow and lament for Appalachian families and children. In "I Am a Girl of Constant Sorrow," Gunning mourns:

> My mother, how I hated to leave her,
> Mother dear who now is dead.

But I had to go and leave her
So my children could have bread.
(*Dreadful Memories*)

While Jackson channeled her anger to speak out against injustices, Gunning wrote and sang from a mournful place, where families are separated for the sake of survival. To gain political power and autonomy to protest against injustices threatening their families and fellow community members, Appalachian women strategically employed the social expectations that define what is not only respectable but expected from mothers. This strategy worked and became normalized because community members were able to validate mothers' activism based on the belief that their actions are rooted in a biological, natural instinct. Gunning's songs come from such a personal, maternal place of suffering and sadness that her experience goes uncontested.

Neither Gunning nor Jackson considered their songs to be part of a broader music movement, yet their presence in the Appalachian labour movement points to how their expressed identities as women, speaking from maternal knowledge, could function as a strategy for resistance. Both women came from places of economic distress, the very circumstance that enabled rural patriarchy to grow such deep roots within the coalfields of Kentucky. Yet their musical narratives broke from the assumed silence and compliance that rural patriarchy relies so heavily upon in order to fully function, thereby uncovering the harsh reality of unsafe living and working conditions. Jackson and Gunning were granted the credibility and insight from their positions as women within a patriarchal system by performing mother-work to help women and children survive.

Hazel Dickens: The Singer and the Song

Hazel Dickens' (1935-2011) unmistakable voice has been recognized since the 1960s—a sound that Bill Malone describes not as "a pathetic wail, nor a dejected cry of despair," but rather as "an angry call for justice" (Dickens and Malone 1). Born in the coalfields of West Virginia in 1935, Dickens saw first-hand the simultaneous natural, breathtaking beauty of the Appalachian Mountains and the destitute, dreadful circumstances in which miners and their

families were forced to live. The thirteen-member Dickens family moved frequently, finally settling into a sharecropper's three-room shack. At sixteen, Dickens left home and like many of her fellow West Virginians, headed to a neighbourhood that became known as "Little Appalachia" in Baltimore, Maryland. To survive, Dickens cleaned houses and worked in textile mills, factories, and department stores ("Signs of the Times"). Yurchenco argues that while Dickens never forgot her Appalachian roots and the struggles faced by her community, she was freed of a woman's traditional role after leaving home, which created the possibility of becoming a professional singer.

However, after Dickens left home she was understandably homesick and heavy with the memories of the mountains and her mother. When Dickens became very sick as an infant, her mother would walk a long distance from their small coal community into town so a doctor could treat her child. Dickens later remarked, "I think it was a source of pride for [my mother]. I never thought about it until years later, but she brought me back home and she pulled me through" (Dickens and Malone 32).

That memory, and the special bond that developed between Dickens and her mother, inspired her to write "Mama's Hand," a song that she realized resonated with audiences each time she performed it. She recalls, "People took to this song like no other that I've ever sung almost every time I sing it, I can see people in the audience with tears in their eyes" (31). The song tells the story of a young girl who journeys from her humble beginnings in a coal town into a new life and in the process must let go of her mother's hand:

> One old paper bag filled with hand me downs
> A plain old country girl raised on gospel sound
> With only the love she gave me, pride in what I am
> And it was hard to let go of Mama's hand, my Mama's hand

Dickens' song "Hills of Home," the companion tune to "Mama's Hand," tells of a strong emotional and spiritual connection to the mountains, conceivably maternal figures in their own right, and laments the decline of the once-thriving coal towns that had

become ghost towns. Drawing on memories, pictures, and stories from the mountains, Dickens sings, "There are some things memories can't bring home." Dickens also notes that the mountains, in a sense, have been abandoned when she sings they have "been passed by" and "seen a lot of leaving in their time." While families might be lonesome for the mountains after having scattered across the country in search of a better life, Dickens' song imagines that loss echoed within the mountains, emptied and abandoned by the families that had thrived there for hundreds of years.

Dickens' music in the 1960s was made possible by the foundation laid by women like Reece, Jackson, and Gunning who served on the front lines of the coal conflict in the 1930s. Standing on the maternalist politics and mother-work that came before her, Dickens was provided the space to explore her connection to her own mother and the mountains that shaped her own identity as a singer, and as an Appalachian woman. In the 1970s, Dickens began singing with Alice Gerrard, and the duo became known as Hazel and Alice. Their music drew a large following from the county, folk, and bluegrass scene as well as from feminist activists. Bill Malone attributes Dickens' connection to her audiences to her ability to form "bonds of sympathy and recognition of common origins" (24). While Dickens never became a mother to children of her own, she served as a symbolic mother to a new generation of female musicians from Appalachia, women who were searching for their own voices while honoring the struggles of the women who came before them. Appalshop created a documentary about Dickens' life, "Hazel Dickens: It's Hard to Tell the Singer from the Song," in which contemporary musical artists like Allison Krauss and Naomi Judd discuss the profound influence Dickens' music had upon their own professional careers as female musicians. In 2001, Dickens was recognized as a recipient of the National Endowment for the Arts, and was awarded a National Heritage Fellowship in recognition of her contribution to the national musical landscape (National Endowment for the Arts).

CONTEMPORARY MATERNALIST PROTEST SONGS

Women's labour to bring cultural awareness to the struggle of the

land and people of Appalachia has not diminished. In the early morning hours of August 20, 2004, deep in the heart of Appalachia, in the small coal town of Inman, Virginia, trucks rolled over the earth that had been marked as a site for mountaintop removal. In the process of this destruction, the trucks inadvertently dislodged a one-thousand-pound boulder that rolled from the work site (which was operating illegally at night), into the bedroom where three-year-old Jeremy Davidson lay sleeping, and crushed him to death (Adams).

In 2010, Atlanta-based singer-songwriter Caroline Herring joined the Cecil Sharp project in the UK. Sharp was the most notable Appalachian ballad collector who journeyed to the southern mountains between 1916 and 1918 in search of ballads with a distinct British connection. The Cecil Sharp project continues to connect the UK to Southern Appalachia through ongoing collaborative projects where artists have the chance to explore Sharp's musical collections. Having recently learned of Davidson's senseless death and inspired by an obscure line from one of the few lullabies Sharp had collected from Appalachia, Herring composed "Black Mountain Lullaby." The song is a message from mother to son and also, Herring points out, "a lullaby to the mountains." In writing the ballad, Herring recalls in a 2011 interview with Appalachian activist and author Jason Howard: "I put myself in the position of Jeremy's mother to write that song. And I have young children. Pondering their deaths, as I had to when I wrote this, was soul-wrenching."

Herring's maternalist response to her own mother-work required her to tell another woman's story—one that young Jeremy Davidson's mother was unable to tell since the terms of the court settlement to which the family agreed prohibited them from ever speaking of the incident publically. Moreover, Herring's song challenges contemporary forms of rural patriarchy by ensuring that the story of this young boy and his mother does not go untold, and honors Jeremy's memory by creating a song for him based in the ballad tradition of Appalachia.

Feminist theory investigates constructions of power and how such power becomes divisive in relationships, households, and labour, and is residual in social and cultural contexts, such as music. However, at its core, feminist theory recognizes the importance of

focusing on women's experiences, and in doing so acknowledges that there is no singular feminism that captures every woman's story but, instead, many feminisms that speak to multiple identities and experiences. Appalachian women's protest songs capture moments in time, weaving their identities as mothers into their narratives of injustice. Self-authored protest songs enable women to use music to share their experiences from their own perspective as mothers, rather than rely on texts written by others to tell their stories.

What also emerges from these protest songs is a balance, however constantly renegotiated, between discourse and tradition, a dichotomy that can be an integral part of Appalachian feminist thought that Romalis describes as "highlighting women as creative social and political actors rather than victims" (175). Appalachian women's strategy of political maternalist discourse in response to injustices in the coalfields is a glimpse into a larger class and gender struggle that still exists. As wives and workers, Appalachian women continue to reclassify the maternal space allotted to them. Further, a new space is also created for a feminist Appalachian knowledge in which Appalachia is not, as Lydia Hamessley contends, "automatically a place where violence and misogyny are accepted" (34). For Appalachian women, crafting songs with immediate emotional reactions to the injustice around them relocates them from the margins to the center as authors of their own stories and experiences, and shapes a feminism that is distinctively Appalachian.

WORKS CITED

Adams, Noah. *Virginia Strip-Mining Death Brings Reforms.* NPR broadcast. 2005.

Beaver, Patricia D. "Women in Appalachia and the South: Gender, Race, Region, and Agency." *NWSA Journal* 11.3 (1999): ix-xxix. Print.

Bell, Shannon. *Our Roots Run Deep as Ironweed: Women and the Fight for Environmental Justice in the Appalachian Coalfields.* Chicago: University of Illinois Press, 2013. Print.

Bell, Shannon and Yvonne A. Braun. "Coal, Identity, and the Gen-

dering of Environmental Justice Activism in Central Appalachia."
Gender & Society 24.6 (2010): 794-813. Print.

Denver, John. "Take Me Home, Country Roads." *John Denver's Greatest Hits*. Bmg Marketing, 2005. CD.

Dickens, Hazel. "Hills of Home." *A Few Old Memories*. Rounder Records, 1990. CD.

Dickens, Hazel. "Mama's Hand." *A Few Old Memories*. Rounder Records, 1990. CD.

Dickens, Hazel and Bill C. Malone. *Working Girl Blues: The Life and Music of Hazel Dickens*. Chicago: University of Illinois Press, 2008. Print.

Dreadful Memories: The Life of Sarah Ogan Gunning, 1910-1983. Dir. Mimi Pickering. Appalshop Films, 1988. DVD.

Engelhardt, Elizabeth. "Creating Appalachian Women's Studies: Dancing Away from Granny and Elly May." *Beyond Hill and Hollow: Original Readings in Appalachian Women's Studies*. Ed. Elizabeth Engelhardt. Athens: Ohio University Press, 2005. 1-24. Print.

Hall, Jacqueline. "Disorderly Women: Gender and Labor Militancy in the Appalachian South." *The Journal of Appalachian History* 73 (1986): 354-82. Print.

Hamessley, Lydia. "A Resisting Performance of an Appalachian Traditional Murder Ballad Giving Voice to 'Pretty Polly'." *Women and Music* 9 (2004): 13-36. Print.

Harding, Sandra. *Feminism and Methodology*. Bloomington: Indiana University Press, 1987. Print.

Harlan County, USA. Dir. Barbara Kopple. Perf. Norman Yarborough, Houston Elmore, Phil Sparks. Cabin Creek, 1976. DVD.

Hazel Dickens: It's Hard to Tell the Singer from the Song. Dir. Mimi Pickering. Perf. Alison Krauss, Naomi Judd, Dudley Connell. Appalshop, 2001. Film.

Herring, Caroline. "Black Mountain Lullaby." *Camilla*. Signature Sounds, 2012. CD.

Howard, Jason. "Caroline Herring Sings a 'Black Mountain Lullaby.'" 2011. *No Depression Magazine*. Web. Date Retrieved Feb. 24, 2014.

Jackson, Aunt Molly. "Poor Miner's Farewell." *The Songs and Stories of Aunt Molly Jackson*. Ed. John Greenway. Folkways

Records, 1961. CD.

Jackson, Aunt Molly. "Ragged Hungry Blues." *The Songs and Stories of Aunt Molly Jackson*. Ed. John Greenway. Folkways Records, 1961. CD.

Jones, Loyal. "Florence Reece, Against the Current." *Appalachian Journal* 12.1 (1984): 68-72. Print.

Kaplan, Temma. "Female Consciousness and Collective Action: The Case of Barcelona, 1910-1918." *Signs* 7.3 (1982): 545-66. Print.

Kinser, Amber E. *Motherhood and Feminism*. Berkeley: Seal Press, 2010. Print.

Long, Judy. *Telling Women's Lives*. New York: New York University Press, 1999. Print.

Lyon, George Ella. *Which Side Are You On? The Story of a Song*. El Paso, TX: Cinco Puntos Press, 2011. Print.

Maggard, Sally Ward. "Coalfield Women Making History." *Back Talk from Appalachia: Confronting Stereotypes*. Ed. Dwight Billings, Gurney Norman, and Katherine Ledford. Lexington: University of Kentucky Press, 1999. 228-50. Print.

Maggard, Sally Ward. "Women's Participation in the Brookside Coal Strike: Militance, Class, and Gender in Appalachia." *Frontiers: A Journal of Women Studies* 9.3 (1987): 16-21. Print.

Massey, Carissa. "Appalachian Stereotypes: Cultural History, Gender, and Sexual Rhetoric." *Journal of Appalachian Studies* 13.1-2 (2007): 124-36. Print.

Mohanty, Chandra. "Women Workers and Capitalist Scripts: Ideologies of Domination, Common Interests, and the Politics of Solidarity." *Feminist Approaches to Theory and Methodology*. Ed. Sharlene Hesse-Biber, Christine Gilmartin, and Robin Lydenberg. New York: Oxford University Press, 1999. 362-88. Print.

National Committee for the Defense of Political Prisoners. *Harlan Miners Speak: Report on Terrorism in the Kentucky Coal Fields*. Lexington: University of Kentucky Press, 1932. Print.

National Endowment for the Arts. NEW National Heritage Fellowships. 2001. Web. Retrieved Feb. 24, 2014.

Reece, Florence. "Which Side Are You On?" *Harlan County, USA: Songs of the Coal Miners Struggle*. Rounder Records, 2006. CD.

Reinharz, Shulamit. "Feminist Distrust: Problems of Context and Content in Sociological Work." *The Self in Sociological Inquiry*.

Ed. David N. Berg and Kenwyn K. Smith. Beverly Hills: Sage Publications, 1983. 153-72. Print.

Romalis, Shelly. *Pistol Packin' Mama: Aunt Molly Jackson and the Politics of Folksong*. Chicago: University of Illinois Press, 1999. Print.

Seitz, Virginia. *Women, Development, and Communities for Empowerment in Appalachia*. New York: State University of New York Press, 1995. Print.

"Signs of the Times." *Appalachian Journal* 24.2 (1997): 126-43. Print.

Smith, Barbara Ellen. "'Beyond the Mountains': The Paradox of Women's Place in Appalachian History." *NWSA Journal* 11.3 (1999): 1-17. Print.

Tice, Karen W. "School-Work and Mother-Work: The Interplay of Maternalism and Cultural Politics in the Educational Narratives of Kentucky Settlement Workers, 1910-1930." *Journal of Appalachian Studies* 4 (1998): 191-224. Print.

Walby, Sylvia. *Theorizing Patriarchy*. Oxford, UK: Basil Blackwell, 1990. Print.

Websdale, Neil. *Rural Women Battering and the Justice System*. Thousand Oaks, CA: Sage Publications, 1998. Print.

Yurchenco, Henrietta. "Trouble in the Mines: A History of Song and Story by Women of Appalachia." *American Music* 9.2 (1991): 209-24. Print.

3.
Performing the Maternal in Public Space

LAURA ENDACOTT

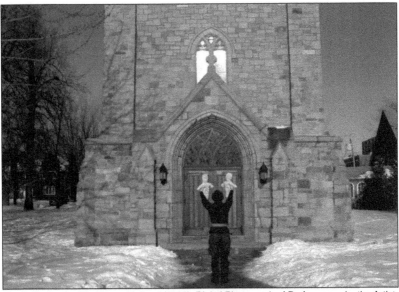

Fig. 1. *Facing the World as a Mother I* (2006), Digital Photograph of Performance by the Artist, Montreal, Canada. Photographed by Tim Jackson.

THIS PHOTO ESSAY speaks to my choice to use my training as an artist and my experience as a mother to produce a body of artworks that I used to politically engage public spaces. I have documented my performances that explored the in-between spaces I occupied as a mother artist in digital images, which I then printed on large-scale textile banners. These performances and artworks function as a site for reconsidering the value ascribed to the maternal experience and its place in both the art world and academic

circles. Through these engagements, I directed my agency toward broadening the perspective of the maternal experience and investigating the notion of the contemporary mother.

Despite advances in the areas of psychology, sociology, and women's studies, to name a few, I was shocked to find so little art work on the Canadian landscape that related to contemporary motherhood when I started my research. As I contemplated my own status as mother artist, I thus wanted to contribute to this area. I was able to use my position as a part-time faculty member at Concordia University to insert some of my concerns into discussions with students and other faculty members. As an artist, I endeavoured to produce work about this subject and gain as much exposure as possible.

What pushed me to produce this body of work were a number of observations, comments, and outcomes related to my efforts to work in paid employment after becoming a mother. I had never felt discriminated against when I was younger and never experienced a lack of opportunity to work on anything related to my interests. My time was my own and my choices were made in tandem with my projects, no one else's. Once my children were born, the freedom I had come to understand as a standard of normalcy became a privilege that I had to structure to hold on to.

The assumption that women will have the double duty of working and taking charge of all the detailed daily responsibilities of raising children contributes to this maternal identity; men who become fathers are not expected to share fifty percent of the work. History dictates that this added freedom is what allows fathers to bring home the bread and thus take care of their families. Fatherhood does not change their lives to the same extent. When men become fathers, their progeny contributes to their value as the breadwinners (Allen 6, 7). Women who are mothers, on the other hand, are deemed limited by the scope of their maternal responsibilities, as if they will neither be able to nor desire to do serious work in conjunction with their role as mothers.

The university environment is an unforgiving place. It is very much built on a male model of performance. I distinctly remember an interview I had when applying for a new position in my area during my children's younger years. Someone had suggested that I

apply, and I thought it might be a good idea. My area of specialty is a small subdivision in a larger department that is made up of two to three full-time faculty members. During this interview, I asked what amount of overtime and how many nights a week I would be expected to work—a question I would ask when applying to any position. I was told that this wasn't the army life and, in so many words, that this couldn't be answered. I remember thinking that if one cannot plan her life then indeed that *is* the army life. The overall feeling I had was that the interviewer was suggesting, *How dare you count your hours or try to foresee any kind of structure.* It appeared to me that the women in positions of power who did not have children were working within a male model of performance and choosing the same rules as the patriarchal framework that is part of the institution's history.

Years earlier, again when I had very small children and I went to another interview, this time for a fashion/creation employment opportunity, the woman who interviewed me inquired what I would do if my child was sick on a day I had to work. Again I remember thinking how ridiculous it was to expect any mother to choose to leave a sick child. Clearly mothers were an unprofitable and unreliable choice in the interviewer's eyes because the interviewer could not count on *total* dedication from mothers. This is yet another model of corporate thinking so characteristic of a new market economy that is based on the realities of workers who either do not have, or do not assume, responsibility for the care of children.

These experiences were still fresh in my mind in 2006 when I borrowed a vintage knitting pattern from a friend to hand-knit two dolls (each sixty-five cm). I then dyed the dolls a light pink hue to imitate my Caucasian skin tone and stuffed them with quilt batting. I left them faceless and sexless because, although I wanted them to represent my own two children, I also wanted them to symbolize a common child. I then produced a light brown vinyl holster in the tradition of the cowboy belt. I attached it to my waist as a body accessory and placed the dolls in the sleeves. I then set out to stage a series of performances in various public spaces, whereby I drew my dolls (rather than my guns), facing the world as a mother.

As I confronted these spaces, I was articulating and responding to how they impacted my identity as a mother and those of my two boys. In doing these performances and recording them as visual documents (digital photographs), I sought to question the commercial, social, religious, and educational spaces connected to motherhood. I wanted to debate the embedded meanings of these spaces and the idealized symbolic associations of material objects in these places. One of these ideals is the iconic representation of the Virgin Mary. This symbol continues to provide a model for motherhood that is rooted in the notion of self-sacrifice. It is, in my view, a fixed notion that shapes the female experience of motherhood. The Virgin Mary's burden of sacrifice, while it began with the crucifixion of Christ, has become an assumed female maternal trait. While I choose to consider that Mary's acceptance to carry the Messiah was filled with strength, her submission can also be viewed as an active choice to support Christ. Her action has defined her as someone who endured and resigned herself to give up everything.

In the Catholic religion, sacrifice has come to define the female condition. In that Jesus sacrificed himself for the lives of his children, it is the feminine aspect of Jesus as life-giver that has become the mother's burden. The Virgin, who is also the mother of the Church, is always depicted in a composed manner. This saintly image bears little resemblance to regular mothering. When she is not involved in the sacred responsibilities of guiding, protecting, and peacekeeping an entire people, is the woman in this image worried her income may not be sufficient for food and clothing? How long does she take to prepare dinner? When does the Virgin Mother wash clothes? Her significance was but one of the cultural symbols I began to investigate as I navigated as a new mother and woman artist (see fig. 1 and fig. 2). The history of art is fraught with images, particularly images of Mary as mother, and thus narratives of women whose lives were built on self-sacrifice. I explored how my identity had been affected by these symbols.

THE MOTHER ARTIST

By producing artwork about motherhood, I not only confirmed and celebrated my power as a mother but I also contributed my own

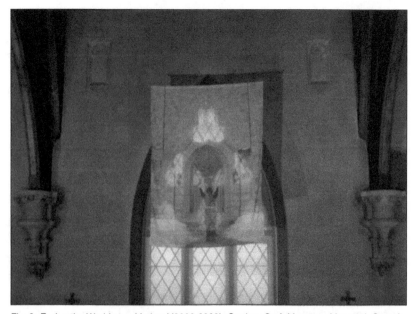

Fig. 2. *Facing the World as a Mother I* (2006-2009), Quebec Craft Museum, Montreal, Canada. Digital Photograph Printed on Textile Banner on Semi-Transparent Fabric (132 x 182 cm)

lived experience to a larger collective voice. In doing so, I linked my trajectory with history. As an artist, I was able to propose alternate images of motherhood within a museum setting. This body of work confronting the Virgin Mary (and other icons) was shown at the Musée des Maîtres et Artisans du Québec, which houses the most considerable craft collection in Quebec, from September 24, 2009, to January 10, 2010 (see fig. 4). Historically, Quebec textile practises were practised by women, while men dominated the crafts of carpentry and metal work (tinsmithing, blacksmithing), to name a few. The number of textile artifacts found in this collection situates their value in an inferior position to that of objects traditionally produced by men. The textile objects occupy approximately one percent of this collection, while the wooden furniture, sculptural religious objects such as a silver stoup, or a metal weather vane dominate at ninety-nine percent.

The images I produced brought the performances and the spaces of my community into the museum. Our neighbourhood soccer field, the façade of my house, and my children's school are some examples of these spaces. The exterior spaces of my community

resonate within the interior space of this once-sacred building and its Neo-Gothic architecture. The artifacts of the permanent collection, themselves memories of a distant past, contrasted with these contemporary images of me and my children.

My work included a second series of performances highlighting the participation of my children as they interacted with a large-scale doll, which I describe in the section on *Mother and Sons Performance Art*. The playful and more humourous aspects of my boys' interactions with the larger doll are strangely juxtaposed with these objects. The bodily presence of my children, the personal connotations of these images, and the intimacy of their interactions with the large doll, remind the viewer that at one time the objects in the Musée des Maîtres et Artisans du Québec were enlivened by people in domestic settings.

The museum structure holds a value for the histories attached to these art objects and narratives associated to Quebec culture. The validation of my experience through its inclusion in the museum space was instrumental in positioning my identity as an artist mother in my own community and in reaching toward a larger audience, that is, reaching beyond the academic environment and an intellectual following.

The museum's location in an overtly ethnically diverse locale invited women from other backgrounds, classes, and races to consider my ideas and encouraged them to reflect upon their own cultural and religious backgrounds. The museum's proximity to one of Montreal's colleges, as well as the museum director's initiative of encouraging student tours as part of its educational mission, ensured the success of my endeavour. By owning my identity so publicly and staging performances in the sphere of my family activities, I was able to activate these spaces politically and personally. I believe that the traces of my performances that were visible though the exhibited artworks presented an opportunity for each spectator to consider their feelings and thoughts about their own experiences. My performances were that of the outlaw mother (O'Reilly 801) in that I stepped out of any pre-determined category (historical, cultural, etc.) and went about taking motherhood out of the domestic space and into the public sphere. As such, I was taking motherhood out of the (domestic) closet. I wanted to give

it a spotlight and place it in a context that would attribute more value to it. I hoped that the process of questioning and reflecting on my own maternal identity would promote both discourse and analysis on the part of my audience.

These performances were of strong symbolic significance. The nature of performance work is to engage the space(s) and the people in the said spaces. More than any archival or aesthetic concern, I felt a need to reflect on the limits of these spaces and would describe my response as a timeless cry in my efforts to validate the experience of mothers like me, which almost no one in my academic circle was addressing. Although some of my artist friends were starting to make artwork about contemporary motherhood, that work constituted only a fraction of the work filling the galleries. Other mothers with whom I had contact were not artists and thus the intersection of my experience within the art world felt very individual.

The actions of my performances went beyond speaking about feelings or facts; they actively took motherhood into the public space and, by doing so, prompted discussions with a wide variety of people. The day I documented the performances of my children in the playground for instance, several mothers who had accompanied their own children came to me directly and inquired about what I was doing, allowing me to share my experience and listen to theirs. Students, artists, the curator, and other people I worked with at the museum asked me many questions and shared many common points when I elaborated about my own experiences. Women who were close to my age and had children expressed feelings similar to those I sought to invoke about the unreasonable expectations put upon them as mothers.

When documenting one of my children's performances in the park, I met a psychologist who was fascinated with my relationship to my sons. She said her son would never have agreed to partake in any interaction with a large doll and was eager to inquire about my findings. I had initially worried that people outside the fine arts, upon observing a grown woman and her children carrying an adult-sized doll in the park, would not understand what I was doing. However, this woman told me how lucky I was to have boys that were engaging in this project and she was curious about their

interest in the doll. Another woman sat close to me and asked me if I needed help cleaning the dirt from the doll's feet. The ease and comfort of being surrounded by their female energy was familiar and relaxed. It contrasted sharply with the women in my professional environment who adopted a male model of performance and who incited competition and rivalry. These interactions surrounding my performance work indicated that there was an interest in what I was investigating. A mother and two small children are not scary

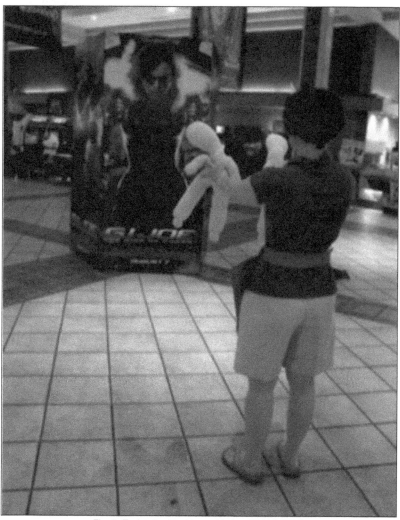

Fig. 3. *Facing the World as a Mother I* (2006-2009),
Performance by the Artist (Drawing her dolls at Pop Culture) Montreal, Canada.

or intimidating and, together with the playful nature of a large doll, created an opportunity that encouraged people to approach me and inquire about our activity. I felt connected to a collective similar to the secret societies of men, such as the Freemasons, that are found in my city. The women I met represented a sisterhood to me, acting like a location where knowledge is passed down through its membership. From an artistic point of view, the Freemasons are initiated to the "craft," just as I was employing the female craft of knitting to extend my knowledge outside my immediate social and professional circles.

The banners of documented actions of my performances led me to carve out a small space where I was able to begin a conversation and/or to promote reflection on the larger concept of motherhood. More specifically, the imagery that characterized the visual language found in my artwork revealed my commentary by placing me as both subject and object of the work. I thus became an "outed mother" on a professional level. For years, I did not draw attention to this aspect of my identity and through my performances I drew my domestic identity into the public sphere. Many women in the academy seem to share a fear of not being taken seriously in academic circles, where the domestic and family life remain quite invisible relative to other intellectual or administrative concerns.

Joan Linder states in *Reconciling Art and Motherhood* that:

> A resume, like the artist's career it stands for, is structured around institutional framings—no space granted for un-sponsored exhibitions, unpublished writing. Comparing resumes, one can see groups of artists coming together and the contexts in which they are placed by writers, galleries, curators, and museums. The interconnectedness of scenes and key players becomes evident as we see curators and writers championing an artist over the years from changing positions and institutions as their own careers advance. (229)

Linder also states that this generation is career-obsessed, striving for the benchmarks of success, and, of course, the earlier the better. (A 2009 exhibition at the New Museum in New York, *Younger*

than Jesus, exemplifies this. Each of the successful artists included was under the age of thirty-three [Linder 229].) It was affirming, therefore, to marry the domestic and academic aspects of my experience through my work. This affirmation further speaks to the relationship of my work with the history of women and their history of textile art, which retains a record of being devalued relative to more male-dominated art forms such as sculpture and painting.

The banners I produced and that were hung in a former neo-Gothic Church subverted the traditional images of the Stations of the Cross. Fourteen banners, seven hung on both sides of the museum, created a corridor for people to walk toward the nave of this former Church. I subverted the traditional images of self-sacrifice associated with Christ's iconic journey with alternative images. This journey is one of history's examples of an important pilgrimage. My banners served to strategically position my maternal journey in such a way as to consider both the history of motherhood, as well as my agency as an artist mother. In so doing, my portraits depicting me from the back or in profile, confronting specific symbolic locations, offered an image of what O'Reilly termed an "outlaw mother" (798). They testify to my rejection of the assumption that I should quietly take the same path as many mothers before me and they function to contest the prescribed social organization, by which I mean the historical tradition of the maternal relegated to the private sphere, laden with the expectation of self-sacrifice and double duty. This sociological model refers to defined patterns of relationships between groups and individuals. It also serves to confirm patriarchal power structures. Within the context of material culture, I was analyzing and rethinking my location and this further brought me to explore the structure of the nuclear family as I contemplated the male model of performance that dominated my work place. Men are socialized to push themselves forward and are rewarded for this. They are encouraged to further their careers and it is looked upon as a positive attribute. Women, on the other hand, have traditionally been conditioned to think of others first. The larger definition of motherhood as a position of caring protector or guardian points to the nurturing role inherent in this position. The university's dominant corporate model, and its "every man for himself" atmosphere that many women

were also adopting, did not coalesce with the way I was growing through my mothering. I considered my identity as a mother, as a place of welcoming and caring, and as an active contribution to the future. These two worlds seemed to be at odds with each other as I slipped between these two spheres.

FAMILY AND COMMUNITY

My status as a single mother further altered my experience. The separation from my then longtime partner, who had taken the initial photographs of my series of performances and from whom I had split a year later, was yet another element that contributed to the in-between place I seemed to occupy as an artist and as a mother. Unlike the majority of historical examples of family life, I had suddenly become the head of my family, making all the decisions, contributing financially, and leading politically. I felt that he had been part of the work as he connected to the photographs through the camera's lens. Our deep bond as a consequence was threaded into my production.

In my personal life, this body of work was perhaps the most effective way for my family to be able to connect to me as an artist. My children were able to appreciate and discover a handmade object (large doll), and witness their work featured in specialized magazines—*Spindle Shuttle & Dyepot* (2007) and *Craft Magazine* (2008)—which credited my eldest son as the photographer, while my youngest was the subject of a featured image. They attended my exhibitions along with family, community friends, other artists, and professionals. Their attendance not only helped them understand my activities and accept the idea of me as an artist, but also made them proud of my accomplishments and of their participation in the work. This body of work helped me to connect the divide between my personal and professional lives and allowed each area to feed the other. It made sense that I should speak to my maternal identity in my work, given its importance in my life. Although my eldest was quick to remind me at the onset of the project that I had given him, a boy, a large pink doll to play with, he remained fascinated with the large figure that drew him in and allowed the playfulness to come front and center.

Fig. 4. *Facing the World as a Mother I* (2006-2009), In-Situ Installation of Seven Digital Prints on Textile Banners on one side of the Quebec Craft Museum, Montreal, Canada.

MOTHER AND SONS PERFORMANCE ART

The initial seven banners of the total fourteen featured me and my performances. But as a follow-up to this work, I produced a doll in my likeness for my children to interact with as a commentary on our reciprocal relationship. Thus, the other seven banners were of my children and their performances. To produce a large-scale doll, I used a knitting machine and also dyed it a pale pink color to mimic my own. By not including features or gender, I wanted it to symbolize a common mother as well as myself. I wanted to distance myself from all the physical associations to the female body that play out in the history of art, and I attempted to connect on other levels, such as an emotional level. I then gave it to my children and explained that it was their doll and that they could interact with it in the manner they so choose. I told them it represented the mother and waited to see if they would name it, which they did not. As I watched my children's interactions with

the doll, it struck me that, as boys, they did not think to nurture it but rather thought of wrestling with it.

The immediacy and spontaneity that inhabits young children allowed my boys to carry, flop, and cuddle with the large craft object, in contrast to the traditional art object that one typically looks at but does not touch, often examining it through a display case or on a wall. The connection to textiles, with which we have both a history and an everyday relationship through our use of linen and clothes, was emphasized by the physical quality of the doll, permitting us to investigate our intimate rapport to it. At birth we are swaddled in a blanket to keep us warm, we choose garments that protect us against the elements and employ textiles to embellish our physical selves. We marry in significant costumes to give meaning to our celebrations. This history allowed us to interact with the dolls in a comfortable manner and in the context of performance art. My children were aware that I was taking photographs as they engaged with the doll in public. As such, they engaged with the camera's lens as well.

As they moved the doll through a variety of spaces, it began to take on a character of its own, different and separate from my intentions. Its soft posture became even softer as they manipulated it and I covered her feet with clear plastic bags in the playground to protect them from dirt, much like a pair of slippers. She did represent my disembodied self, but somehow my kids related to her as a separate companion. They acted with enthusiasm toward this unusual gift. It challenged their belief system about boys play-ing with dolls. It challenged their notion of family activities as no other children in their environment were given the opportunity to investigate such an object, much less in the public sphere of their activities (see fig. 5).

MATERIAL CULTURE

The presentation of my artwork as material culture was further supported by other performances each time I was asked to speak about it either in artistic or academic circles. Each visual presen-tation, accompanied by my narration, permitted me to perform both as a scholar and artist mother. These presentations in gallery,

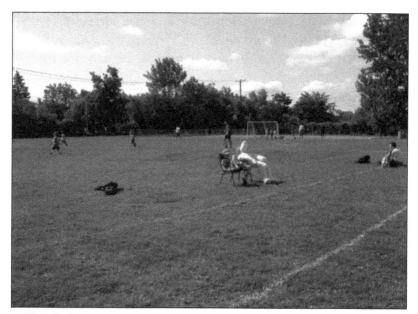

Fig. 5. *Facing the World as a Mother II* (2007-2010), Digital Photograph of Performance by Spencer Jackson, Fletcher's Field, Montreal, Canada.

museum, or classroom settings were additionally reinforced by my verbal accounts that, I argue, activated a spread of ideas. Both in the academic world as well as the contemporary art world, I feel the invitations from other faculty members to share my work were important. The conversations that arose between me and the students that attended, as well as the inclusion of my work, for example in the Faculty of Fine Arts Gallery, made the maternal experience visible. Many of my female students opened up about their desires to have families of their own and their fears about trying to balance it all. Some of my professors made insinuations about the university's unbalanced approach to the workplace or expressed their own feelings grounded in their own mothering experiences. Young men asked me many questions about the work, my kids, and my feelings as I observed them questioning their own positions in relation to my boys, fatherhood, and family. Each time I presented the work, my account changed somewhat, marking it as unique.

In many ways, the university is an exciting place. I have always been propelled by such an environment where people are dedicated

to research and producing work that includes current discourses and lively debate. I am, above all, attracted to ideas and have always felt that my endeavours were directed at some form of participation in society. Abeit the stimulating environment, I've often found myself working along the lines of a patriarchal model. This tradition speaks to some aspects of my personality and yet leaves me feeling a strong discord with my more feminine traits. As such, I consciously made the choice to resist the pressures that urge a constant artistic production and alienate the mother artist, who is caught between her desire to self-actualize creatively and the needs of her family. I felt that strong work takes time to gestate and that it would take its place within a balanced life—balanced among my family, my workload, and perhaps some more frivolous activities that are necessary for my creative spirit.

My activism had a playful aspect due to the props (dolls) I made, but its confrontational quality was very serious. I was using my performance as an artist to articulate both ideas and emotions that men and women could understand (this I say in response to the number of questions young male and female students had for me after some of my class presentations). Both my age and my position as an art educator have enabled me to have these discussions in a professional setting. From a larger viewpoint, my agency promoted a mentoring example of a mother artist to my students, and most particularly in relation to my sons. I wanted to show how mothers engage in practices other than, and often in conflict with mothering. I wanted to embody for others how, as Sarah Ruddick notes:

> Mothers, as individuals, engage in all sorts of other activities, from farming to deep sea diving, from astrophysics to elephant training. Mothers as individuals are not defined by their work; they are lovers and friends; they watch baseball, ballet, or the soaps; they run marathons, play chess, organize church bazaars and rent strikes. Mothers are as diverse as any other humans and are equally shaped by the social milieu in which they work. (17)

The question of how to balance one's life as a mother and an

artist led me to incorporate my domestic world into the deep waters of my work. The collapsing of boundaries that has become a strategy in the art world, as both institutions and artists alike explore an interdisciplinary approach to material culture, allowing for cross-overs and encouraging collaborations between disciplines (as opposed to limiting research to discipline-specific boundaries), prompted me to embrace my reality and investigate it in relation to the world around me. This allowed me to mark my mothering as a product of my work and to mark my work as a product of my mothering.

I presented my artwork as a non-traditional paper, first at the Mamapalooza Festival in New York City (2010), then in Toronto at an international conference on motherhood in 2012 that was coordinated by what is now the Motherhood Initiative for Research & Community Involvement (MIRCI). I began to encounter other scholars from various disciplines who were researching in connected areas.

I still struggle against the pressure that my environment exudes, but I believe I am an alternate model to the dominant patriarchal one. My students have expressed their appreciation of my approach and other colleagues have also articulated their support.

I am slow in my production but I make every aspect of it count. I am self-directed and concise in my goals. I have accepted that, for the moment, I cannot take part in the networking that is expected in my field by attending the endless vernissages for which I receive numerous invitations. As a single parent to adolescent children, I feel they need me just as much as they did when they were younger. My presence in the house in the evenings, and specifically at dinner, is part of a routine I value. I also need the rest that comes with the sun's setting, to regenerate as I keep my ship afloat. There is no respite from my responsibilities, so I evaluate my choices very carefully and am selective about what I leave home to attend.

I am giving a face to mother artists by beginning with my own experience and initiating exchange and debate. My research on mothering is connected to the academic milieu and I continue to locate it within this context specifically. In an effort to exhume the maternal identity from its limited domestic dwelling, I hope to bring it into the larger university setting. I take much satisfaction

from the creative energy I am investing in my children and, in turn, our reciprocal relationship that feeds my research and my practice.

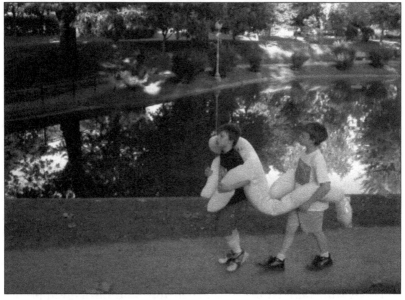

Fig. 6. *Facing the World as a Mother II* (2007-2010), Quebec Craft Museum, Digital photograph of performance by Montgomery & Spencer Jackson, Montreal, Quebec.

WORKS CITED

Allen, Jan. *Fertile Ground.* Exhibition Catalogue. Agnes Etherington Art Centre, 1996. Print.

Endacott, Laura. "Facing the World as a Mother II." *Craft Journal* 2.1 (2008): 34-58. Print.

Endacott, Laura. "Facing the World as a Mother II." *Shuttle Spindle & Dyepot* 38.4 (2007): 12. Print.

Linder, Joan. "Resume." *Reconciling Art and Mothering.* Ed. Rachel Epp Buller. Burlington, VT: Ashgate, 2012. 227-231. Print.

O'Reilly, Andrea. *Maternal Theory: Essential Reading.* Ed. Andrea O'Reilly. Toronto: Demeter Press, 2007. Print.

Ruddick, Sara. *Maternal Thinking: Toward a Politics of Peace.* Boston: Beacon Press, 1995. Print.

4.
"Mixing" in the Kitchen

Entre Mujeres ("Among Women")
Translocal Musical Dialogues

MARTHA E. GONZALEZ

I AM AN ACTIVE PRACTITIONER in a translocal, community-based, participatory music and dance practice known as *fandango*. *Fandango's* music, dance, and poetry are informed by African, Indigenous, and Spanish (Andalucian) influences that began to take shape in New Spain in the early sixteenth century. New Spain's booming economy of coffee, silver, and sugar set the demand for Indigenous and African labour, which, over time, prompted a unique cultural mixture that, at present, informs the music and dance of *fandango*. Most prominent in the region currently known as Veracruz, Mexico, *fandango* is exercised as ritual celebration in honour of a town's patron saint or other community celebrations such as weddings, baptisms, and funerals. From *fandango* ritual celebration comes the music, dance, and poetry known as the *son jarocho*. Women's presence is seen and felt in every aspect of *fandango*—from *son jarocho* music, dance, and poetry that give currency to the practice, to the organizational aspects of the event. *Fandango*, as a participatory, transgenerational practice, may also include the participation of children and the elderly. *Convivencia*, or the deliberate act of being with or present to each other, is most important to the practice. *Convivencia*, in this sense, is an aesthetic of *fandango* practice, a reason for gathering and the ideological heart of the fiesta.

Inspired by the vast participation of women and children in this practice, I initiated *Entre Mujeres: Translocal*[1] *Feminine Composition*, which took place in Veracruz, Mexico, from the fall of 2007 to the summer of 2008. My goal with the project was twofold: (1)

to document women's role in *fandango* practice, and (2) to engage in musical dialogue with the women in the practice, and possibly create original music compositions with those who were willing and able to participate.

As a professional musician from the United States, I experienced motherhood as an interruption in my work, but I also experienced it as an important catalyst for redefining the role of music in my life. Initiating the *Entre Mujeres* project became a way for me to stay connected to music in my new role as a mother, as well as a way to dialogue with other active musician mothers in Veracruz, Mexico, whom I had met through *fandango* celebrations. Musician mothers engaging in the collective songwriting process not only managed to produce multiple music compositions for the *Entre Mujeres* project but, most importantly, it also generated physical, spiritual, and ideological space from which mothers were able to theorize and imagine new realities for themselves and their families. Furthermore, through the development of the *collective songwriting process,* the *Entre Mujeres* project became both a dialectic tool and an archive.

I suggest that mothers' engagement in collective songwriting is an important act of resistance on several fronts. First, mothers engaging in music practice challenge prescribed notions of mothering solely as an interpersonal relationship focused exclusively on children's needs. Such notions position creative activity as diverting attention away from children. That is to say, being an active musician is seen as incompatible with being a "good" mother. Second, music engagement in the home challenges the notion that a domestic space fosters solely reproductive work rather than artistic output. Third, recording technology, as used by *Entre Mujeres*, disrupts conventional understanding of the boundaries of "home," as most of the music generated around a kitchen table reached across the U.S./Mexican border. Low-cost portable recording equipment facilitated the translocal music dialogues between U.S.-based Chicana musician mothers in Los Angeles and musician mothers in Veracruz, Mexico. In this way, musician mothers engaging in the composition and recording of music in the kitchen and/or other home spaces push against professional recording facilities' patriarchal use of space and time. In all of these ways, *Entre Mujeres*

fostered music engagement that actively accommodated musician mothers and their multiple involvements and relationships.

Finally, *Entre Mujeres* produced a musical archive that reflects women's experience and worldviews. The songs as "texts," or what I call "sung theories," are accessible archives that can communicate embodied knowledge across time, disciplines, borders, generations, and other ways of knowing. My intention is to contribute to the body of music, performance, and maternal theories through the introduction, development, and beginning analysis of the collective songwriting method.

SON JAROCHO IN MUSIC AND IN MY LIFE

Being pregnant was a special time for me. It was my first pregnancy and I was overwhelmed with feelings of excitement and possibility. But it was also a humbling time. In the final month, I found myself feeling vulnerable and at the mercy of more able-bodied individuals. In the last stages of pregnancy, I took morning walks. It was one of the few things I was able to do without assistance and it gave me time to think. I tried to take my walks every morning; and with every step I took, I thought about how my life would change. I was always tired in the end. Playing music was the only thing that gave me energy. On one particular morning walk, I felt energized because the great *son jarocho* musician and composer Laura Marina Rebolloso was coming to visit.

As previously mentioned, I was struck by the vast participation of women in the practice. Women play important roles as dancers and percussionists on the *tarima*, or wooden platform used for the dance. Centered in the vortex of *fandango*, there are many instances throughout the night's celebration where all musicians gather around the women, who strike their feet on the wooden platform in a percussive manner. It is here where women execute their musical contributions to the fiesta in the intricate percussive dance that is the pulse and drive of the *son jarocho*. Rooted in Indigenous, African, and Spanish cultures, *Jarocho* is the music/culture of the southern part of the state of Veracruz, Mexico. The *son jarocho* (music) is manifested and maintained through everyday practice of the *jaraneros* (small eight string guitar players),

versadores (improvising poets), *bailadoras* (dancers), and their community culminating in *fandango* ritual celebration. The most well-known *son* in the *son jarocho* repertoire is "La Bamba." Chicano Rock musician Ritchie Valens popularized this iconic version in the nineteen fifties and it has stayed in popular imagination ever since. But "La Bamba" is only one of many *sones* played in *fandango* ritual. Although people often mistake the music for the gathering, *son jarocho* is the music genre born in *fandango* ritual.

In our childless years, my partner and I made multiple visits to Veracruz, which allowed us to learn the *fandango* ritual and, on more than one occasion, work with Rebolloso, who was part of the professional *son jarocho* group *Son De Madera,* and other members of the community. I had been an admirer of Rebolloso's music and poetry since the late 1990s. By our own volition, in 1998 we initiated an informal translocal music dialogue between *son jarocho* musicians in Mexico and a handful of Chicano musicians in Los Angeles. By 2005, the *fandango* community on both sides of the border had grown tremendously.[2] The transnational collaboration between Chicanos and *Jarochos* spawned many creative music projects that brought *jarocho* groups to Los Angeles, or gathered Chicano bands, artists, and musicians to attend *fandango* events in Veracruz. By the time I became pregnant, we had already visited Veracruz countless times to work and dialogue with the community of musicians and *fandangueros* from many regions within the state. Over the years Rebolloso and I had become good friends and colleagues.

During the last month of my pregnancy, my partner, Quetzal Flores, spearheaded a concert for our band, Quetzal, which was to take place in the newly opened Japanese American National Museum (JANM) in the historic downtown area of Los Angeles known as "Little Tokyo." The funds we acquired from JANM allowed us to invite Rebolloso, as we proposed to compose original music compositions with her and perform them the night of the concert. With sadness, I realized this event would be the last time I would play music before giving birth to my son.

As a female musician who was soon to be a mother, I experienced a sense of fear and sadness. Anxiety began to set in upon realizing that the time and creative energy I once had would soon be gone.

Although motherhood can be a beautiful stage of life for a woman, I couldn't fathom the idea of relinquishing my creative time. Eventually though, I came to see music as a luxury that would have to be secondary to all parental responsibilities.

MOTHERHOOD AND THE INCEPTION OF *ENTRE MUJERES*

Laura Rebolloso arrived and we began to collaborate. Her visit quickly altered my fatalistic outlook on the balance of music and motherhood. A mother of two, Rebolloso assured me that my life would certainly change, but that I would also be, more than ever, inspired to compose music. She challenged me to write about my body and the great miracle that was happening inside me. During her two-week visit, we were able to complete one composition. Many other musical ideas took root during Rebolloso's stay, but we were unable to bring them to fruition because of my lack of energy.

Nearing the end of my pregnancy, I was often tired and needed to rest. Nevertheless, we managed to capture initial ideas (i.e. melodies and rhythmic ideas) on a Digi-01 recording system. This fairly inexpensive portable equipment helped us document the impromptu jam sessions and ideas using a recording software program called Pro-tools. We replayed the recordings and chose sections to extend into full compositions. With the benefits of technology, we were able to get the most of my fleeting energy.

The JANM performance was a success and Rebolloso returned to Veracruz the following day. Three weeks later, on April 5, 2005, after a thirty-seven-hour labour, my son Jose Maria Sandino was born. The beauty and struggle of nursing, of not sleeping, and of witnessing my son's first smile, word, step, and fall aged me. Watching my son grow before my eyes, as Rebolloso had anticipated, was inspiring. However, the responsibilities of mothering took precedence over the completion of my work with Rebolloso. The songs she and I began remained sitting on my computer's hard drive. Every once in a while, as I nursed my son, I would pull up the sessions and listen. Hearing the material was both wonderful and torturous, for I felt I was sitting on important knowledge that needed to be disseminated. I was determined to see it through.

Once I settled into motherhood, sometime in 2006, and with my partner's unwavering support and encouragement, I began to find ways to finish the project.

THE FULBRIGHT AND THE BIRTH OF *ENTRE MUJERES*

In 2007, I decided that the Institute for International Education (IIE) offered the best opportunity to complete the songs I had started with Rebolloso. In retrospect, my motivation for applying for a Fulbright Garcia-Robles fellowship was twofold. As a participant observer, I planned to better understand how women were positioned within the *fandango* tradition in Veracruz, Mexico. But ultimately, I wanted to acquire the time and funds to finish the project I started with Rebolloso. I decided to title the project *Entre Mujeres*, or *Among Women*.

In early April, I received confirmation that I was awarded the Fulbright Garcia-Robles fellowship. In September of 2007, my partner, son, and I packed some of our belongings and moved to Xalapa, Veracruz, Mexico.

Xalapa, Veracruz and Feminism

My previous contacts in Xalapa included Wendy Utrera, Kali Niño, and Violeta Romero, whom I had met in various *fandango* celebrations in Mexico and the U.S. while touring there with my band, Quetzal. As I reconnected with them and verbally explained the project, most of the women felt that my "feminist" approach was too radical. Although I was not approaching the project as a feminist venture, the women nonetheless questioned my political motivation. I was primarily interested in women's participation, which made it "feminist" to them. This was understandable because *fandango*, as a trangenerational, participatory music and dance practice, is inclusive of both genders. My request was far removed from how they understood music in *fandango*—as a participatory music and dance practice. Again, I explained that my goal was to simply *highlight* the female presence in the music movement. Although I was not actively excluding men from my project, Wendy, one of the more experienced *fandangueras,* advised that I needed to broaden my discourse to include spouses and children

in order for the rest of the *mujeres* to feel comfortable with their own participation.

Mexicanas are very much interested in activities or projects that benefit the *"mujer"* but not if they feel it is at the expense of family and spousal responsibility. Wendy's concerns regarding the discourse of *Entre Mujeres* was the initial catalyst for my reflecting on how traditional recording practices exclude women and the totality of their lives.

I hadn't initiated a formal call for the project before arriving in Xalapa; I approached women that I knew well through previous *fandango* celebrations. After many years of engaging in *fandangos*, both in Veracruz and the U.S., and knowing the community well enough, I had an idea of who would be interested in participating. Taking Wendy's advice, I rearticulated the *Entre Mujeres* project to include men, children, and/or spouses willing and able to participate. My new proposal was well-received by Wendy and the rest of the ladies. Some women volunteered after having heard about the project, and others were recommended. In the end, the final music project included eight Mexican and seven U.S.-based musicians.

Space and Sound

Being in Xalapa was challenging. We had made countless trips but never as new parents. When travelling with a child, one is met with a new set of challenges, but we were lucky. My partner and I managed to rent a small, furnished flat in the center of Xalapa on Avenida Morelos, down the hill from the historic Parque Benito Juarez. We settled in quickly, creating a kitchen, living room, and a small makeshift recording nook, all in the same one-room space. Most days we would wake up to Xalapa's orchestral city sounds. Being from a big city like Los Angeles, we were used to traffic noise. However, Xalapa city-sounds were also intermingled with the voices of *vendedores ambulantes* ("street vendors") announcing their goods and/or services, the gas company's rhythmic metal tapping, the trash collection cowbell, and the single stroke of the knife-smith's metal pan flute. All were sonic reminders that we were far from home. My partner and I would make our morning coffee and breakfast for our son, and then wait for the *mujeres* to arrive.

We had previously invited the *mujeres* to our little flat *para tocar,* to play music, hangout, and/or compose. Unfortunately, most of their time was completely taken up by *chamba* ("work"). I, on the other hand, was ready for every visit, instruments out and eager to begin. Oftentimes, one of the ladies we had scheduled a session with would call, say that something had come up with family, and cancel our writing session. Other times we would schedule many women at once, everyone would show up and we would manage to play some *sones* and/or jam for a while. I soon found it difficult to gather the women all in one place. And even if we did manage to compose something, I knew that rehearsal and recording time would also be difficult to schedule.

Per my partner's suggestion, we began documenting impromptu jam sessions in Xalapa, similar to what we had done during my pregnancy in Los Angeles. Rebolloso and I had used this technique with our first songs when I was too tired to continue. I agreed with my partner and we prepared to seize every opportunity. From that point on, in any given visit or jam session, the Xalapa kitchen became a "sound booth." We recorded every idea we came up with, and with whoever showed up. As Wendy, Kali, or Rebolloso arrived, the space would slowly transition from kitchen and living room space to a recording/home/kitchen studio. The microphones were set, wired, and ready to go at a moment's notice. Even if we could not see a song through from start to finish, this became a great way for us to document the spontaneous work that was being generated.

Having to adjust my recording methodology prompted me to realize that recording traditions exclude women's and mothers' participation by the very nature of the industry techniques. Oftentimes, recording facilities are under strict timelines and great pressure to produce. Unless you have a great deal of financial backing by a record company, you must produce music as quickly and efficiently as possible. As a member of Quetzal and via other professional music projects, my past experience in the recording studio had always been a series of stressful situations that I had accepted as part of the dynamics of the professional world of music recording. Although I was expecting to approach *Entre Mujeres* music recordings in a similar way, I was forced to reconsider the

"traditional" processes and, instead, foster a new way of engagement that actively took women and their multiple responsibilities into consideration. Ultimately, recording equipment was used in a way that benefited us, including our limited time. By using portable technology, once only available to financially resourced professionals, we advanced existing transnational musical conversations and recreated domestic spaces to incorporate both familial and musical work.

Convivencia, Fandango as "Quotient Expressions of Feminist Consciousness"

Most of the women involved in *Entre Mujeres* were very receptive to working on original compositions. However, it was still a challenge to move comfortably beyond their social and musical understanding of the *fandango* and the *son jarocho* music genre. With the exception of Laura Rebolloso, none of the women involved had ever written or composed original work. They had mostly learned and practiced music and dance within *fandango* ritual. However, the *convivencia*, or convivial moments previously shared through *fandango* had generated a sense of intimacy that made it easier for them to take risks and compose outside the familiar.

I believe that the strong *mujer*-driven tradition on the *tarima* made it easier for *Entre Mujeres* participants to interact with one another. The *fandango*—specifically the *son jarocho* repertoire—offers many instances in which it is solely mothers, other women, and girls who participate on the *tarima* during *sones de a monton* ("song for many"). The syncopated rhythmic patterns they create on the *tarima* are meant to both keep time and contribute to the polyrhythmic character of the *son jarocho*.

These moments in *fandango* offer invaluable interaction and dialogue, especially among women whose bodies and feet become conduits of individual and collective expression. The female homosocial space on the *tarima* during the *sones de a monton* provide the moments Angela Davis might site as "quotient expressions of feminist consciousness" (196). Davis uses this phrase in reference to women in Blues traditions and practices, but I extend this Black feminist consciousness to *fandango* as a

related African diasporic expression. In *fandango* the *tarima* is a space where the "collective consciousness" of women gathers in the presence of community.

Most of the mothers and women in the *Entre Mujeres* project had previously experienced a collective consciousness on the *tarima* in the midst of *fandango* practice. I believe this alleviated the difficulties of composing original works. Despite initial anxiety by some of the *mujeres* concerning music composition, the musical ideas began to slowly flow.

TESTIMONIO IN SONG: KNOWLEDGE AND ARCHIVE

For women, then, poetry is not a luxury. It is a vital necessity of our existence. It forms the quality of the light within which we predicate our hopes and dreams toward survival and change, first made into language, then into idea, then into more tangible action. Poetry is the way we help give name to the nameless so it can be thought.

—Audre Lorde

A song as a sonic and literary manifestation is life's sound-scape, a unique cathartic memento, and a powerful political tool. Without question, a song is also an important historical text. A person's *testimonio* ("testimony"), life views, triumphs, aphorisms, and struggles can be expressed in song lyrics. In this way, song lyrics can be viewed as knowledge and theory. Multiplied by community, they can be a powerful exercise in consensus and collective knowledge production. The *Entre Mujeres* project and the engagement of collective songwriting underscore what Audre Lorde has so beautifully stated. Poetry and/or creative expression is *not* a luxury but rather an important element in the lives of women and, I would argue, in the lives of *all* people.

Over the course of the project in Verarcruz, *Entre Mujeres* revealed the kinds of intimate dialogues that can take place when we create as a community. Poetry, through lyricism, became a vehicle that facilitated individual and collective expression. In all instances, there were moments of *testimonio* or life testimony and experiences that generated more dialogue and sharing during the

collective songwriting process than I would have expected.

As we began to compose, I tried to encourage an exploration of topics but, in the end, the *mujeres* chose their own themes. We would often co-write the lyrics or each take a stanza or verse to author. The songs were often driven by experiences in motherhood, love, or the state of the world. The most intimate moments of creativity in the collective songwriting process brought about discussions pertaining to participants' experiences as women, life lessons, and general life philosophies. Most participants shared and learned from other *testimonios* and this process bound the group in an intimate way.

Testimonio has been recognized as a powerful Chicana and people of colour research praxis. *Testimonio* has been an important intervention in an effort to decenter subjective knowledge and Western research paradigms that often "other" communities of colour, for *testimonio* centers firsthand knowledge and experience as an invaluable resource and a place from which knowledge can be formulated. *Testimonios,* when shared in community, may also initiate what indigenous scholar Shawn Wilson cites as "relationality," which results from moments of sharing and healing (80). Citing relationality as part and parcel to an Indigenous ontology, Wilson states that, "rather than viewing ourselves as being *in* relationship with other people or things, we *are* the relationships that we hold and are a part of" (80).

Similar to the theories around *testimonio,* the song itself is not the most important aspect of collective songwriting, but rather its ability to "engender solidarity" (Acevedo 3). *Testimonio* was used in *Entre Mujeres* as a way to create knowledge and theory through personal experiences or *sung theories*. It became a space from which to discuss and create collective ideas among women, which simultaneously created a sense of community among all *mujeres* involved.

Indeed, as I read through my journal entries, written while engaged in the project, I noted how much of the women's lives I knew due to the countless conversations that took place in the process of creating the music. Some of these discussions were eventually represented through various song lyrics in the final *Entre Mujeres* recordings.

From Testimonio to Song

As windows to the mind and soul, the lyrics often focused on the women's sharing of embodied knowledge, as well as their community knowledge. Of all the participants, the one *mujer* that spoke at greatest length about motherhood was Rebolloso.

When I was still pregnant in Los Angeles, Rebolloso was a mother of two. Now in Xalapa, two years later, she had three children. Her schedule was the most demanding of all the *mujeres*. We often stole bits of time to work on music or worked when her youngest was sleeping. Because Rebolloso often taught music in her home for extra money, her children were accustomed to sleeping through it. One of the original ideas that Rebolloso and I left unfinished during our work in Los Angeles was titled, "Nacimiento," or "Birth." She had written the lyrics in honour of my pregnant state at the time, and as a way to remind me how special the moment was.

The lyrics read:

> *Bebe duermes dentro de mi*
> *Estiras tu cuerpo creces.*
> *Sientes has nacido dentro de mi*
> *Existes desde el instante que Dios te concedió.*
> *El universo dentro de mi!*
> *Nacimiento*
> *Nacimiento*
> *Nacimiento*
>
> Baby you sleep inside me.
> You stretch your body. You grow.
> You feel. You have been born inside me.
> You exist inside me from the moment God granted you.
> The Universe inside me!
> Birth
> Birth

Years later, after my time in Xalapa, and while I was I graduate student, I asked Rebolloso for her interpretation of the lyrics. In her short response via email correspondence she explained:

Crecer es trascender el egoísmo, y dar la vida a un ser. Es romper con el esquema individualista del pensamiento moderno. Al dar la vida uno la recibe. Como la semilla que al morir, al abrir, se da. Dar el cuerpo para esa labor mística de la existencia es algo que el mundo no valora, pero en la mujer encuentra una enseñanza y algo más profundo que las necesidades egoístas. (Rebolloso)

To grow is to transcend egoism, and to give life to another being. It's breaking with the individualist thought the modern world upholds. As you give life, you also receive. Like the seed that dies as it opens to give life. To give of your body is a mystic labour, part of being in existence and that is something that the world does not value. But in women we find that teaching and something more profound than egotistical necessities. (Rebelloso)

Indeed, Rebolloso repeatedly commented during our sessions on how mothering was an unappreciated role in society. Thus, Rebolloso seized the lyrical moment to express this belief, stating through her lyrics that when a woman accepts motherhood, she transcends individualism. As the above passage states, an individualist agenda is what Rebolloso believes modern society imposes, upholds, and values most. Rebolloso was adamant about expressing this in "Nacimiento" and the lyrics uphold this view.

Mothering, birth, and the birthing process were common topics throughout the *Entre Mujeres* project. However, the sharing of community knowledge and experience was also a common trope. Participant Silvia Santos, for example, shared with the group her community experience in a piece titled "Sobreviviendo," or "Surviving."

Originally from the state of Yucatan, Santos moved to Xalapa as a young woman. She and her husband David had a *son jarocho* group named Hikuri and were active participants in the *fandango* networks mostly in the Xalapa area. A mother of a ten-year-old daughter, Santos came to my home whenever she had a free moment, which was usually during her daughter's school hours. Having played several tours in the U.S., Santos had visited California

four years prior to her participation in the *Entre Mujeres* project. While visiting the Santa Barbara area, Santos had an opportunity to meet and dialogue with various undocumented immigrants from Mexico. Aware that I was from California and that the music might reach this community, Santos seized the opportunity during the project to create a piece that expressed the effects migration can have on families on both sides of the Mexican/U.S. border. "Sobreviviendo" expresses both the views of those who migrate as well as those who stay but are affected by the loss of *los ausentes,* or those who are absent:

> *Esta pieza es una síntesis de algunas vivencias de una estancia en California, en donde me encontré con migrantes que me contaron su sensación de tener el corazón lejano y en la mente en el lugar que dejaron a sus seres queridos, y cómo eso los motivaba a seguir en un mundo diferente, en el mundo físico de las jornadas extenuantes y una cultura diferente. Creo que todos somos viajeros en este mundo, pero ser viajero con el corazón dividido es algo muy duro, y ver tantos rostros, escuchar tantas historias de desarraigo, es algo que me dejó la huella que trato de plasmar en "Sobreviviendo."* (Santos)

> *This piece is a synthesis of a lived experience I had in California. Where I found myself with (Mexican) migrants that told me how they felt the sensation of having their hearts and minds with their loved ones far away and how this motivates them to continue living in the physical world of everyday labourers...away from their homeland and in a different culture. I think that we are all travelers in this world, but to be a traveller with a divided heart is something that is very difficult, to see so many faces, and listen to so many different stories of family ruptures, is something that left its mark in me and I try to communicate this in "Sobreviviendo."*

Santos was moved by the *testimonios* she heard in Santa Barbara, but also by the families she knows in Mexico whose loved ones

have migrated to the U.S. She utilized the *testimonios* of migrant workers in the U.S. and families left behind in Mexico as a source of knowledge from which to create song lyrics for "Sobreviviendo." Through the gathering of *testimonios* on both sides of the border, Santos' composition is thus an ode to immigrant people's stories in both Santa Barbara and Mexico, and all at once a synthesis of the grand effects migration can have on more than one community. "Sobreviviendo" is a double-sided view of migration as a global phenomenon that affects those who leave, as well as those who remain.

THE HOME SPACE

Entre Mujeres is redefining the home space. Being creative in the home, alongside children and other family members, challenges the common discourse about women's work in the home, and recording in the kitchen reworks our understanding of the kitchen as cooking space. Tied to what Amalia Mesa-Bains might call a *domesticana* sensibility, composing music in the kitchen, "becomes the method by which the private space of the home is brought into the public space of creativity, not merely to reflect but to actively construct new ideologies" (Gonzalez, J. 86). In the case of *Entre Mujeres,* the kitchen became a space for mixing ingredients to prepare a family meal and for composing songs for public enjoyment and community knowledge building. Importantly, the songs and recordings were always intended for public listening in hopes to contribute to new ideologies.

Chicana popular culture theorists have theorized domestic or "folk" artistic and religious altars as the "terrain of female agency for indigenous, *mestiza* women" (Perez 93). Composing music in the kitchen adds to this liberatory discourse. Like altar building, creating music in the kitchen may offer "some religious or gender freedom, as well as creativity, for the socially marginal and oppressed" (93). Music in the kitchen, like altar building in the home, involves similar forms of resistance. For "deep within the interior of her home the woman's private altar has been a separate space dedicated to the fulfillment of her own ideology, and ideology given to the fruition of social relationships and

83

opposed to alienation" (Gonzalez, J. 85). Professional recording facilities, like many public spaces, alienate mothers as market needs take precedence, but *Entre Mujeres* music composition and recording in the home counters this arrangement. It fulfills personal and communal ideologies that resist alienation, as the songs become archives of *testimonios* and *mujeres* experiences that can be played or performed live in public spaces.

ENTRE MUJERES COMPLETED

In September of 2012, five years after completing the project in Xalapa, my partner (Quetzal) and I released *Entre Mujeres: Women Making Music Across Borders* in Los Angeles, California.[3] In the end, the mothers, women, men, and children involved participated in different ways, either through lyricism, music/instrumentation, *zapateado* ("percussive dance"), or voice. The compositions touched on familiar musical themes such as being in love ("Sirena Lanza" or "Mermaid Rising"), coping with a broken heart ("Agua del Mar" or "Ocean Water"), and hope and visions for a positive future ("Quien Nacerá," or "Who Shall be Born" and "Vida" or "Life"). Other tracks, such as "Chocolate," speak on the cocoa trade from the perspective of a small child caught up in the throes of slave labour. We also explored unconventional topics; in "En Cinta," or "With Child," for example, we explored final physiological stages of pregnancy. At present, this recording project stands as an archive or cultural product that documents one of many translocal dialogues between Chicano Latino musician communities in the U.S. and *Jarocho* communities in Veracruz, Mexico.

CONCLUSION

Entre Mujeres challenged notions of music practice in relation to gender, space, and political/physical borders. Although not part of my original intention, *Entre Mujeres* discourse incorporated children, partners, and family in the final project. Furthermore, in order to accommodate multiple schedules as well as to engage and document music dialogues across political borders, a manipulation of recording technology was central to the project's completion.

Utilizing these technologies, *Entre Mujeres* and *convivencia* in the kitchen created a space that prompted *testimonios*, discussions on music, love, mothering, politics, and overall life experience.

Although I have stressed the importance of "real time" in the collective songwriting process, I must reiterate that the archives or *sung theories* are an important element in the project, especially when one considers them over time. After all, our inevitable mortality impedes us from engaging in these processes from one generation to the next. That is to say, our mortality limits the generation of musicians that can directly engage with another. Recordings, lyrics, and performances of these songs stand to be remembered, revisited, reconstructed, critiqued, or honored by future generations. It is ultimately community in real time that shapes new consciousness and initiates what bell hooks calls a "collective falling in love" (26). For "as we work to be loving, to create a culture that celebrates life, that makes love possible, we move against dehumanization, against domination" (26).

Finally, the knowledge and theory produced through *testimonios* was transformed into collective dreams and shaped into *sung theories*, thereby combining practice with theory and contributing to new understandings of knowledge production. In this way, *Entre Mujeres* musician mothers mixed more than music in the kitchen; they mixed souls and began a process toward imagining and creating new possibilities through music practice. *Entre Mujeres* ultimately disrupts how we understand music, what music is for, and who gets to produce it.

[1]I borrow "translocal" from anthropologist Lynn Stephen. The term translocal disrupts the social science binaries—global/local, local/national, transnational—and instead offers a view of the "social field" that makes visible the material survival strategies of these communities, that abstract theorizations can miss (22). It also suggests a dialogue rather than a unidirectional cultural and social influence.

[2]In the late seventies, a resurgence of the value and thus reinstatement of *fandango* practice in rural communities in Veracruz reached the U.S. Chicana and Mexicana communities. What some

have coined as *"Fandango sin Fronteras,"* or "Fandango without borders," is at present an informal transnational dialogue between these two communities. This dialogue includes not only the sharing and participation of the *fandango* practice but also individual and community related activities and innovative recording projects.
[3]*Entre Mujeres: Women Making Music Across Borders* release was made possible by the community of supporters generated through a Kickstarter campaign (see Gonzalez, M. *Entre Mujeres*). We managed to raise $10,500 to complete the mixing, mastering, and printing of the project.

WORKS CITED

Acevedo, Luz. *Telling to Live: Latina Feminist Testimonios.* Durham: Duke University Press, 2001. Print.

Davis, Angela. *Blues Legacies and Black Feminism: Gertrude "Ma" Rainey, Bessie Smith, and Billie Holiday.* New York: Pantheon Books, 1998. Print.

Entre Mujeres: Women Making Music Across Borders. U.S. Independent, 2012. CD.

Gonzalez, Jennifer A. "Rhetoric of the Object: Material Memory and the Artwork of Amalia Mesa-Bains." *Visual Anthropology Review* 9 (Spring 1993): 82-91. Print.

Gonzalez, Martha. "Zapateado Afro-Chicana Fandango Style: Self-Reflective Moments in Zapateado." *Dancing Across Borders: Danzas y Bailes Mexicanos.* Ed. Olga Nájera-Ramírez. Urbana, IL: University of Illinois Press, 2009. 359-377. Print.

Gonzalez, Martha. *Entre Mujeres: Transnational Music Dialogues. Kickstarter.* [n.p.] 26 May, 2012. Web. Accessed March 8, 2013.

hooks, bell. *Ain't I a Woman: Black Women and Feminism.* Boston, MA: South End Press, 1981. Print.

Lorde, Audrey. *Sister Outsider: Essays and Speeches.* Trumansburg, New York: Crossing Press, 1984. Print.

Stephen, Lynn. *Transborder Lives: Indigenous Oaxacans in Mexico, California, and Oregon.* Durham: Duke University Press, 2007. Print.

Pérez, Laura. *Chicana Art: The Politics of Spiritual and Aesthetic Altarities.* Durham, NC: Duke University Press, 2007. Print.

Santos, Silvia Santos. "Sobreviviendo." Message to the author. 22 May, 2009. E-mail.

Son de Madera. *Son De Madera*. Urtext, 1997. CD.

Rebolloso, Laura Marina. "Nacimiento." Message to the author. 21 May, 2009. E-mail.

Wilson, Shawn. *Research Is Ceremony: Indigenous Research Methods*. Black Point, NS: Fernwood Publishing, 2008. Print.

Act II:
Performing Intention / In Tension

5.
She Gesticulated Wildly

Queer(ing) Conception and Birth Narratives

JOANI MORTENSON

THIS COLLECTION OF THREE POEMS represents a graceful slice of my doctoral research project that mapped the conception and birth stories of queer-identified families who accessed midwifery services. I also interviewed queer-identified midwives and doulas. I was very interested in exploring the myriad and fecund ways that midwifery offers a rich, hospitable, and queered space. I was also keenly interested in hearing how queer-identified families navigate conception and birth in what remains a predominately heterosexual and medicalized domain. These families and service providers illuminated that, while birth culture is ripe with diverse stories, there remains a paucity of narratives that reflect queer and trans experience. I also noted that both birthing families and birthing service providers tended to gesticulate—and often wildly—as an effort to extend language and account for the shortfalls in the heterosexual colonization of birth as a medical event. I aimed to frame the intention and experience of these families in an ironically sexual event (as queer conception may be more mechanical and technological, it may still proceed within the context of sex), as erotic acts laden with intention, joy, deep listening, flexed courage muscles, and sweet embodiment through performance.

These poems were initially created as an efficient, yet elegant, method to "member check" participants' stories for cogent content and integrity of emotion. The participants' reactions were so powerfully positive that I began sharing the poems as a way of "performing" my research presentations at conferences. The effect of performing these poems as interpreted narratives of the families

engaging in conception and birth was profound and numinous. I felt nourished by the eroticism expressed by these families as I listened, watched, sensed, perceived, and learned how conception and birth opened them more fully into the culture of "queer birth."

"Ir/reverent: Erotics" is about the erotics of listening, about the seduction of a story told through potent words, velvet and guttural tones, wild gesticulations, and whispers expressed through veiled eyes. I felt reverent in my listening: riveted, enchanted, and under the spell of the sensuous. The story-teller was often irreverent and raw, and this further drew me in. Her narratives were visually stunning, captivating, and transformational. I leaned into the irony of her conception and birth stories as a holy and yet commonplace event because she was describing queer conception in the context of archetypes, as a sacred and historical ritual. I heard this story as a map of desire—desire to trust in birth, desire to (re)produce, desire to be in communion with her partner at the time of conception and birth, and, most importantly, desire to be heard, seen, and known. Her desire remained palpable across years of sharing this narrative; that sense of aliveness is still so poignant, and sits on my heart more vibrantly than it resonates through my brain.

"Deaf/erential: Gesture" was culled from my research study and consists of an amalgamation of narratives as shared by three of the participants who were queer-identified mothers, and birth attendants as well. One of the participants was a midwife, one was a practicing doula who was studying to become a midwife, and the other was a non-practicing doula. Listening and "sensing in" towards each of these women's birthing stories, I realized that there were times I was so mesmerized by their gestures—either facial expressions, body gestures, or full-on, wild-armed gesticulations—that I became "deaf" to their words and more "referential" or attuned to the dance their bodies were communicating with me. Writing the transcripts long-hand also gave me the slow and salacious opportunity to welcome their words back into my being through yet more senses. In concert with the orchestra of their lyric gestures, I returned full-circle by integrating their words into the song-story-arcs of their gestures. A tender and delicious synchronistic theme occurred to me, crystallizing one of the important features of embodiment. This synchronized with my realization

that each of the birth attendants shared how important their carnal knowledge of women was to their practice of safely, efficiently, and compassionately delivering babies vaginally. Each woman noted, in their own voice and through unique and grand gesticulations, how their sexual mapping of women's intimate geography afforded them epistemic privilege that created "safer" and "queered space" from where birthing women could more effectively "open" with a minimum of intervention in the delivery of their children.

I intended "In/glorious: Queering Birth Culture" to paint a picture of how tempting it is to make assumptions based on what we "see" with our eyes when looking at family portraits, how trained we are to recognize heterosexual, and how we may miss the enriching privilege of seeing what is queered. This portrait is painted with words. This poem holds a concentrated sliver of the story of a queer and trans couple based on the narratives they shared with me. They were describing a photograph that their midwife took of them during those precious moments after the birth of their son, when they were all tucked into bed and resting in the afterglow of birth. At first glance, this couple may appear heterosexual, in that the trans partner passes quite successfully as "male," though the paradox they shared is that this "robs" them of their socially active political positioning as a queer-trans couple. If you looked more closely at this poetry portrait, you'll see that the man, as tired and relaxed as his partner, has unhinged the binding that keeps his breasts flat as he lies, both bearded and unbound, in complete freedom and ecstasy with his family, afforded by the safety and comfort provided by the accepting and celebratory midwife.

Ir/reverent: Erotics

The space between us shrinks
As her body sings in asymmetrical harmony
luminosity leaks into the interstices
Her gestures not only pepper her speech,
they make radiant and relevant the words she cannot find
Serve me an ice slice of the visual.

Showing me what she wants me to know,

her arms arc, undisciplined and unruly,
In unconscious frames of subversion

In the subtlety and nuances of her micro-expressions
I gather there is no universal
She shows me her truth is fluid and thick like honey
her truth hugs the curves of her body
firmly situated in the stories her hips long to tell

I am a hot mess with unfurled, sticky wings
 there is no flying, I am intent on her gaze
 in a moonless night
 she is a porch light

If her words quench my thirst
Then her gestures arouse my appetite
I didn't even realize I was starving
until she made me notice that I was hungry

Epicurean, in-light, I consume her and
the voluptuousness of her story

By listening to her body with my body,
I am undone
I can only see and resonate
I can barely breathe
Her corporeal presence
my feast
She stories me sublime

Deaf/erential: Gesture

Her hands are arrows, pointing towards my heart
Joy is a sound her palms make when they open like the
bible, or settle on her belly
She touches her heart when she describes inviting women
 to come home,

into themselves
She opens her hand before me, the welcoming Berber of
 her intentions
Her body extends her words beyond the limits of language
into a space where her experiences are seldom counted,
 measured or recorded
That Rumi-fied space beyond right and wrong
That field where the wise body knows and beckons me
That field where her wise body wants my wise body to know
An epistemological Namaste

 Show me how you drop the veils of comfort
 your gestures demonstrate the breeze of a blown scarf
 as you describe women cresting the waves through the
 myriad sensations of labour
This heavy fall of watched feathers

When she touches her throat in a gesture of sadness,
She shows me the burden of her censored words
Her entire body tries to pay this dept
Some economy
As the economics of her gestures take purchase; my heart
 becomes a marketplace of tears

Her entire body is a testament of willingness
This woman whose hands tests the pulse of birth's con-
tractual tides
As deftly as a mother's wrist testing the temperature of milk

This woman who assesses cervical ripening
She tends the soft fruit portal of the birth canal
She evaluates on a scale of fecundity

Her small fists have been deeply
 Within the purse of both sexing and birthing bodies
Her hands stir in the cauldron of their pelvis
Co-presencing
Journey-woman to the deep divining, she dowses;

she guides the watery birthing of newborns and Amazo-
nian selves

In/glorious: Queering Birth Culture

That queer birth of yours!

Listening to your story
I witness the movements between you
Turning towards,
 you touch his leg
He smiles all the way into your eyes
his gaze fastens onto your tossed glances
The apparent distraction in your wildly gesticulated and
academic narrative
does not unseat his gaze or patience
You are the target of his turning
He locks his reverence
Pins it to your chest, in hope

What his recently abjected womb can no longer achieve
Yours received, accepted and produced
No fallen feathers of Icarus
under the surgical spotlight
they planted your zygotian sun

You describe the emblem of your fruitful flight
The pee-stick, that tiny plastic trophy
 showcased on your glass coffee table
 collecting happy dust as the neon pink plus-sign
 spent two years in the fading

You showed me the first baby photograph
 Nested in the family bed,
You are any and all families in common repose
 You, smiling through your exhaustion, quiet tears of
elation

Babe, rosy pink and cherub chubby, tucked peaceful
under your pastoral wing
He, bends, placing tender kisses on your forehead
 he is bearded and unbound, his breasts map your back
 As they do every night

These poems are intended to illustrate a series of slender slices of queer birth culture cut from the layered cake co-created by the six participants who contributed to my research project. Each participant contributed significantly to my understanding and appreciation of their queer conception and birth experiences facilitated by midwifery services—both as they told them to me, and as I interpreted them through the filters of my ideology, experience, and desires at that time. Each story is "local" in that the remembering may be fluid dependent upon stage, age, and context. Each story is also localized in that I am a different listener now than I was at the time I collected and mapped these stories. What is most remarkable to me, given the fluidity in the subjectivity of qualitative research studies, is how emotionally evocative these stories remain, even if my ideologies, identity, and context have all shifted since I gathered them into the basket of my doctoral project. I believe fluidity matters, since word choices and poetry are political. Poetry is both purposefully vague and blurred to allow readers to apply their own lenses in order to construct personal meaning-making, but also, I believe, because it lies outside of the confines of patriarchal language. My entire project was marked by a sense of "swimming upstream" as I tentatively navigated through postmodern philosophy while I attempted to press my phenomenological heart through the logocentrism and patriarchal semiotics of graduate school in Critical Studies. My preference and penchant for poetry, a lyric winnowing of words from my research data, and my need to keep maternal erotics as a paramount theme within my work, engendered a distinct feeling of being "queered" in every aspect of my project—if you will agree that part of what defines queer is a resistance to and interrogation of boundaries: sexual, political, corporeal, and narrative.

It was never a goal to excavate themes from this work, as I tended each story with the belief that all stories are valid and contribu-

tory to the rich diversity of our social world and everyday lived experience. However, I continue to be in awe of how poignant and erotic these mothers were in the embodied and feral way they performed their stories: drawing on and sharing through multiple senses, while at the same time evoking a multi-faced sensuous and liberating experience in me as witness. Recent shifts in the culture of birth to include birthing trans men and poly-gendered midwives calls for increased qualitative research to map and interrogate the queering of birth, perhaps recasting it from *maternal erotics* to *queer-otics* of conceiving, birthing, and parenting.

I conclude with a quote from Thomas King: "You have to be careful with the stories you tell, and you have to watch out for the stories that you are told" (10). As a researcher, I appreciate this call to listen with bright awareness, and to ensure that stories I tell, co-mingled in the wilderness of my cognitive capacity and my lyrical imagination, are with mindful awareness and intention.

WORKS CITED

King, Thomas. *The Truth About Stories: A Native Narrative.* Minnesota: University of Minnesota Press. 2008. Print.

6.
Shimmy, Shake or Shudder?

Behind-the-Scenes Performances
of Competitive Dance Moms

LISA SANDLOS

A S A PROFESSIONAL DANCER, I have played many onstage and behind-the-scenes roles. At my four-year-old daughter's debut recital, I realized that assuming the part of dance mom would require me to play a new role—one in which I would perform a balancing act. I quickly learned that dance mothers often spend a great deal of time fussing over sequined costumes and fake eyelashes, not to mention scrambling to pay the substantial costs required for putting our dancing daughters in the spotlight and driving long distances to regional competitions. I shuddered at the prospect of these commitments and I felt conflicted about what was expected of me as a dance mother in a private, competitive, studio environment relative to my values as a feminist scholar and long-time dance educator. I was especially uneasy with my growing sense that, in playing the part of doting dance mom, there would be persistent pressures for me to model and reiterate both old and new standards of femininity, and that my daughter would be subjected to increasingly pervasive norms of hypersexualization within the current competitive dance environment.

My lived experiences as a dance mother have led me to conceptualize my current research in which I investigate how young female dancers are culturally and socially constructed as hypersexualized bodies in the world of competitive dance in Canada and the United States. By applying feminist research methodologies and utilizing methods of interviewing, participant/observation fieldwork, and dance/movement observation, I analyze the studio lives and onstage performances of girl dancers and the trend towards displaying

them as moving sex objects. In this paper, I theorize the complex and central roles that dance mothers tend to play in mediating the onslaught of messages their daughters often receive about female sexuality while training in dance studio settings. Although we dance mothers remain backstage as our children perform in the spotlight, I suggest that our own daily-life performances tend to be normatively gendered and sexualized as well.

Within the world of competitive dance, there is an implicit understanding that mothers will devote themselves unreservedly to their young daughters' dancing, frequently contributing much of the labour that enables the operation of competitive dance industries but assuming little authority over the manner in which daughters are trained and publicly presented. My experience of these expectations of dance mothers inspired me to look for a productive way to respond and resist, and has led me to ask the following research questions, which are central to this chapter: First, which socio-cultural factors contribute to onstage and behind-the-scenes performances of gender and sexuality by competitive girl dancers and their mothers? Second, how do/can dance mothers improvise dances of resistance around issues arising from normalized femininity, hypersexualization, and contemporary mothering within the competitive dance studio milieu? I hypothesize that while mothers, knowingly and/or unknowingly, help to sustain and recreate social forces that eroticize and objectify dancing daughters, they also have the potential to wield much more agency around these issues.

In seeking insight into the material realities and performative practices of dance mothers who choose to be highly involved in their daughters' dance careers, my investigation deconstructs the roles that mothers play within the context of what I have observed to be unprecedented hypersexualization of girls in dance training and performance. The focus of this chapter is on mothers of girls rather than of boys, not only because hypersexualization of female dancers is more common, but also because competitive dancers are predominantly female. In any given studio, there may be only one or two boys in a class or even in the entire school. Boys may feel significant pressures as a result of this gender disparity. They may receive problematic signals about their sexualities or feel bur-

dened by their sense of responsibility for representing masculinity within the studio and in dance generally. (Doug Risner's *Stigma and Perseverance in the Lives of Boys Who Dance: an Empirical Study of Male Identities in Western Theatrical Dance Training* provides a useful analysis.) However, while studies of boy dancers are of interest to me and are relevant to my work, I focus my attention for this chapter on female dancers and their mothers. I also wish to note that I consider fathers' roles to be important within families who have children enrolled in dance, but despite a noticeable increase over the past decade in the number of fathers becoming more involved in dance studios, mothers are still more actively involved by far.

I maintain that dance education and training for girls need not be overly sexualized. This assertion—rooted in my experiences as a dancer since the age of four, as a former professional dancer, as a dance educator, and as a feminist scholar—is supported by theories of the body, particularly as they have been developed by Michel Foucault and Judith Butler. These theories assist in contextualizing pervasive social forces that reinforce normative gendered/sexualized identities both as surface inscription and as deep inner embodiment. Opinions about what constitutes hypersexualization are highly subjective but I contend that eroticization within competitive dance too often becomes the main focus of competition choreographies to the exclusion of other possible themes. I do not advocate a puritanical approach to dance education, nor do I wish to deny girls opportunities to explore and express their emerging sexualities through the physically and emotionally engaging bodily practice of dance. However, I argue that many dance competition presentations restrict girls' possibilities for embodying a wide range of expression precisely because they impose rigidly normalized expectations of femininity, sexuality, and heteronormativity.

As I have continued to explore what it means to be the mother of a young female dancer over the past six years, I have become well-acquainted and quite fascinated with a piece of equipment used by many mothers of competition dancers. The Rack 'n' Roll, a collapsible wardrobe-on-wheels, allows a dance mom to transport her daughter's meticulously ironed costumes to dressing rooms with

ease. Each time I observe a mother constructing her Rack 'n' Roll from what at first appears to be a suitcase—expertly transforming it into a clothing frame on which to hang her daughter's numerous costumes and bejeweled accessories—it strikes me as symbolic of the ways in which dominant social structures of gender, sexuality, race, and class are so often supported by the willingness of individuals to build and re-build those structures. In conceptualizing this chapter, I envision the Rack 'n' Roll as a symbol of the structures that help to support hypersexualization of girls in competitive dance. One by one, I attempt to "hang up" and scrutinize some of the contributing psycho/social/cultural/economic factors at play within private, competitive dance studios. I begin by examining how forces of capitalism and consumerism are configured in competitive dance and how they contribute to hypersexualization of girl dancers. I then utilize Michel Foucault's theories about hegemonic power structures as the basis for investigating ways that normative sexualities are promoted through consumerist behaviours. In the subsequent section, I look to the field of Maternal Studies for further insight about competitive dance mothers' motivations for their high level of involvement within dance studios. Maintaining that dance moms are frequently invested in fulfilling the role of the "good mother," I apply to my inquiry the concepts of maternal thinking by Sara Ruddick and of intensive mothering by Sharon Hays. In the section that follows, theoretical work by Dance Studies scholars, including Juliet McMains, Rachel Vigier, and Judith Lynne Hanna, aid my examination of dancing bodies as highly gendered and sexualized. Judith Butler's conceptual framework for explaining ways that gendered constructions become performative develops this view further. I then move towards imagining how all of these factors may be reorganized on a symbolic Rack 'n' Roll by dance mothers who wish to contest hypersexualization of their daughters in dance. In the final section of the chapter, concepts of maternal resistance and agency as proposed by theorists Baba Copper, Andrea O'Reilly, and Erika Horwitz guide my exploration of potential ways that dance mothers can resist hypersexualization in the studios where their daughters dance.

As my daughter's participation in dance has persisted, my concerns about issues of hypersexualization have deepened. Initially,

few mothers I met within competitive dance shared my apprehensions. Those who did were unwilling to vocalize their opinions to studio owners and instructors. My efforts to initiate discussions with dance moms seemed to be repeatedly met with blank stares or resigned shrugs. In my opinion, the degree to which many dance mothers may accept sexual objectification of our daughters is problematic because, while we may intend to teach daughters the skills they need to become successful by today's accepted standards of femininity, we may also deny the potentially damaging effects of oversexualization on the self-image and self-esteem of adolescent girls. At the same time, through the relationships that we share with our daughters and from our particular positions of influence within private dance studios, I assert that dance mothers can begin to embody alternate maternal roles that will help us to contest the sexual objectification of our dancing daughters.

CAPITALISM AND PROFIT IN COMPETITIVE DANCE

Although historically the young, female dancing body has been representative of accepted norms of femininity and sexuality in Western cultures (Hanna 5), the pervasive hypersexualization of girls involved in dance has gradually developed and intensified since the early 1990s. Along with the rise of competition in dance studios, there has been a notable shift in dance training towards sexually objectifying movement patterns and practices (McMains 2). Shimmying and shaking, girls of all ages are frequently encouraged to be sexy by auditoriums full of cheering family members and are subsequently rewarded with first place trophies. This trend may be attributed more generally to normalized hypersexualization in youth culture and widespread sexualization of young female bodies in contemporary, mainstream capitalist society (Giroux 14), but the demands of competitive dance, which increasingly include sexualized movement vocabularies, prepare the young female body in particular ways for erotic objectification.

Competition circuits are immense networks and sustaining a child's participation within them is extremely expensive. In predominantly white, middle- and upper-class communities where families have the financial means to facilitate their daughters' participation,

competitive dance studios operate to increase enrollment and to turn a profit. The season of classes begins with registration charges and lesson fees. Appropriate dance attire and footwear must be acquired for each form of dance being studied (dancers often take classes in several different styles of dance). These expenses are then followed by pre-paid orders for group and individual photos of the dancers posing in their costumes. At the end of the season, recital tickets need to be purchased for the whole family and parents may wish to buy DVDs of various performances. Furthermore, many families are required to assume costs associated with competition, including entrance fees for multiple solos, duets, and ensemble pieces, corresponding costume fees and team track suits, and hotel and restaurant bills while touring.

At first, mothers may be unaware that they are participating in the hegemonic structures of competitive dance. Within these massive dance competition organizations, dancers and their families are consumers, but they are also commodities. Sexy dancers are more likely to win competition awards. Prizes won at competitions ensure that the studio gains prestige. The studio's enhanced reputation is well-publicized and the cycle of consumerism and profitability continues as more aspiring young dancers enroll in classes.

It is evident, however, through the enthusiastic participation of thousands of young dancers and their families in private dance studios across North America, that there are many things to love about competitive dance. Some mothers who do feel discomfort about their dance studio's emphasis on sexiness may be willing to overlook it so that their daughter(s) might enjoy other advantages of participation. For example, mothers often appreciate the discipline, focus, and tenacity that their daughters learn through dance training as well as physical fitness, body awareness, and reinforcement of proper posture. Furthermore, many mothers value the sense of confidence that may be instilled in girls when they achieve training and performance goals or win competition prizes. In addition, enduring social bonds are frequently established with other families through studio activities.

As I observed around the time of my daughter's first recital, sexually suggestive or explicit choreography may be accepted unquestioningly by some mothers and others often feel underqualified to

voice any concerns they may have. I have encountered a few mothers who have spoken out about skimpy costumes and suggestive lyrics used for competition choreography. However, I have also noted that the studio owner and instructors are generally trusted as authorities on how to present dance and win competitions, and thus they are rarely challenged in any way. The majority of instructors are very dedicated to their dancers. Without intending to negatively influence young girls, studio teachers pass on what they learned in their own dance training and follow current trends as depicted through media representations of dance. Because sexual portrayals of young girls in North American culture are normalized, many mothers do not see any problem with the sexualization of their daughters at a young age.

Typically, dance mothers devote many hours to volunteering for the dance school and may sacrifice other aspects of family life to enable their daughters to fulfill the requirements of competitive dancing. Some dance mothers with whom I have spoken admit to having coerced their husbands to continue honoring considerable family commitments of both time and money. Some mothers go much further, seeking out auditions and other commercial opportunities to advance their daughters' careers. In these ways, mothers help to prop up the profitability of dance studios, competition producers, and a whole host of other supporting industries, including those that sell costumes, cosmetics, shoes, flowers, photographs, and digital recordings.

My daughter, who is now twelve years old, continues to dance, as does my nine-year-old son. We currently travel to a non-competitive studio where dancers are not hypersexualized and where strict gender roles for dancers and for their mothers are intentionally de-emphasized by the directors. Without the element of competition, my level of involvement as a dance mother has become more manageable, but I still inevitably spend hours driving to classes, rehearsals, and performances, preparing costumes, and finding ways to pay the fees. Why do so many dance moms do all of this? And why does the substantial commitment that mothers make within the sphere of the dance studio not make those that are concerned about hypersexualization of girls in dance feel more entitled to protest this trend?

CONSUMERISM'S POWER OVER BODIES

Michel Foucault's work illuminates some of the ways in which power relations shape cultures of the body; his theories are helpful in understanding how social meanings are constituted and contested through embodied practices such as dance. Foucault conceives of bodily practices as forms of power exerted over the bodies of individuals and populations, and as forms of discipline and regulation (139-140). Control of bodies can be achieved by repression or, in the case of capitalist cultures, by stimulation (10-12; 140-141). From a Foucauldian model, eroticized dance in competitive dance schools can be understood, in part, to be providing the stimulation necessary to perpetuate consumerist behaviours in young girls and their mothers, and these behaviours support the needs of dance studios to expand enrollment for profitability under capitalist models of enterprise.

Industries associated with competitive dance depend on the continuation of normalized expectations of female dancers as glamorous and sexy. A Foucauldian analysis suggests that mothers participate in this project in tangible ways through consumerist behaviours. For example, they purchase certain brands of cosmetics for stage use that are required for the dancers—not just any red lipstick will do. Online costume catalogues specifically geared for competitive dancers depict the kinds of bunny, butterfly, fairy, and princess costumes that four- and five-year-old girls are expected to have, and show the inevitable progression of the older girls to wearing sequined crop tops and booty shorts. Mothers generally take responsibility for ordering and purchasing these costumes. Ensuring that daughters have all the required costumes and accessories, organizing them on their Rack 'n' Roll, and being ready to help with quick changes backstage are but a few of the ways that dance mothers fulfill their notions of their proper and productive roles. In these ways, mothers may inadvertently renew consumerism's power over the dancing bodies of their daughters.

THE GOOD DANCE MOTHER

In the context of my observations of dance mothers and through my

own process of self-reflexivity, I question the degree to which some of us may be striving to fulfill the role of what Molly Ladd-Taylor identifies as the "good mother" (660). At the same time, I ask how much dance moms are responding to social pressures to practice intensive mothering, a term used by Sharon Hays to describe mothers who set aside unrealistic amounts of their time and energy for their children while pursuing demanding careers (412-414). In this section, I argue that the paradigm of good mothering, often considered "good' by virtue of its intensity, is a factor that contributes to the frequent hypersexualization of dancing daughters. I build on this argument using Sara Ruddick's concepts of maternal thinking ("Maternal Thinking" 97) and maternal sexuality ("Preservative Love" 136). In analyzing processes by which mothers experience maternal achievement and the various approaches mothers have for coping with contradictory notions of female sexuality within twenty-first-century North America, Ruddick offers key insights about the ways mothers tend to operate within competitive dance studios.

There are plenty of benefits and rewards for mothers who commit a great deal of time, energy, and money to dance schools. Dance moms appear to value the services provided by local dance studios and show an interest in the potential that dance has to positively influence the self-esteem and confidence of their daughters. Their dedication to the studio pays off when they see opportunities created for their daughters to advance their level, to socialize, and to derive a sense of belonging. Furthermore, a daughter's onstage performances may represent the manifestation of a dance mother's long-term dreams for her daughter's success and fame by widely accepted standards of female achievement in North America. The dancing daughter image can evoke feelings of validation in a mother for the commitment she has been willing to make towards her daughter's dance career. In these ways, a competitive dance mother's aspirations to become a "good mother" may be realized.

Considered from another angle and accounting for Ladd-Taylor's assertion that the notion of a "good mother" depends on the oppositional construction of a "bad mother" (660), I contend that in the current cultural climate where mothers often sense that their maternal practices are under surveillance by other mothers,

dance mothers may compensate with copious attention directed at their daughters' dance lives. Thus, they can avoid becoming regarded within their social circles as neglectful, under-involved, or incompetent. In other words, a dance mother may make extra efforts to be a "good mother" to avoid slipping into a category of "bad mother" (Ladd-Taylor 660).

The theory of intensive mothering articulated by Sharon Hays further explains why many dance mothers make such full investments in their daughters' dancing. Hays claims that considerable tensions exist between mothers' self-perceived untouchable, private roles, and societal expectations of them as working professional women to be competitive, self-interested, and constantly visible. These tensions are often played out in the daily lives of mothers, Hays asserts, and are symptomatic of a larger struggle in Western societies to balance "values of intimate and family life ... [with] the values of economic and political life ... based solely on the competitive pursuit of self-interest" (422). On the other hand, the dance studio, even if it emphasizes competition for girl dancers, is often appreciated for offering a kind, family-like setting. Thus, by creating roles for themselves within the dance studio, dance mothers may find they are able to practice values of competitiveness and assertiveness from the world of paid work (though these roles are likely to be on an unpaid volunteer basis), but they can do so within a supportive and caring environment.

Outlined in her essay "Maternal Thinking," Sara Ruddick's theories of maternity advance discussions about the ways that dance mothers' attitudes and actions may emerge from their aspirations to embody a "good mother" model. Ruddick outlines three primary demands of child rearing that must be satisfied by mothers: preservation, growth, and social acceptability. Despite the individual variance of "style, skill, commitment, and integrity with which they engage in these practices," Ruddick claims that all mothers strive to meet these demands (99).

Dance mothers may achieve the first demand, preservation, by keeping daughters busy and "out of trouble" in what is perceived to be the safe environment of the dance studio. By involving daughters in dance and retaining a level of control over daughters' lives, dance mothers may be living up to their responsibilities to protect

them from real or imagined dangers. This can help to explain the ways dance mothers operate in what has been termed an "age of anxiety" in contemporary childrearing (Warner 197-214).

As the second demand of maternal practice, Ruddick claims that mothers engender change and growth for children. According to her, women in Western societies are not free to completely enjoy their own growth and development. Therefore, they see their mothering roles as fostering change in others and they "develop conceptions of abilities and virtues, according to which they measure themselves" (102). Because, as Ruddick argues, the task of facilitating growth in children is frequently "misdescribed, sentimentalized, and devalued" (102) in families or in communities, dance mothers may feel uniquely appreciated or gain a sense of purpose and accomplishment from managing their daughters' dancing and watching them onstage.

The third demand of maternal practice identified by Ruddick—the development of social acceptability of children—is defined either by the values of the mother's social group that have been internalized by the mother herself, or by the values of others in the group that the mother seeks to please (102). Although Ruddick sees "producing an appreciable child" as presenting mothers with "a unique opportunity to explore, create, and insist on her own values," she notes that most mothers, "out of maternal powerlessness," instead choose what she calls inauthenticity (103). Inauthenticity is a willingness to "accept uses to which others put one's children" and secondly, "to remain blind to the implications of those uses for the actual lives of women and children" (103). Thus, in attempting to be good mothers, and fulfilling their apparent obligation to train their daughters for social acceptability in a society that objectifies and hypersexualizes young women, dance mothers "fulfill the values of the dominant culture" even if these values may be at odds with their own. Although dance mothers may allow and assist the subordination of their girl children through sexual objectification, the fact that daughters have been made acceptable in a patriarchal culture that objectifies women may be "taken as an achievement" (103). This provides insight into reasons for the process by which so many dance mothers come to support or ignore the oversexualization of their daughters in competitive dance.

Ruddick's concept of maternal sexuality ("Preservative Love" 137-138) fosters further appreciation for the complexity of these issues. Ruddick describes maternal sexuality as a "diffuse eroticism that arises from and is shaped by caring for children" (136). At the same time, an important part of any mother's process of separating from her child is her recognition that her child must create an independent sexuality and that she will no longer be the object of her child's "primitive, pan-erotic desires" (136). Furthermore, sexuality for girls in our society often becomes "a source of folly, pain, and danger ... which a mother is helpless to control" (136). Ruddick claims that a mother's own sexuality, which is frequently denied and exploited, leaves her with "little power except over small children" and, as her daughter ages, she is relegated to "watching, separating, fearing, and vicariously enjoying" her daughter's emerging sexual sense of self (136). Dance studios and competition stages presumably provide a safe space for daughters to explore and express their emerging sexual selves. Dance mothers may, in turn, use competitive dance as a way to witness, control, and manage their daughters' sexuality. In this manner, dance mothers can further assume the "good mother" role, fulfilling the obligation of all mothers to preserve and protect their children from the dangers that accompany sexual development and expression in our society, especially for young females.

GENDERED BODIES, PERFORMATIVITY, AND HYPERSEXUALIZATION

Like me, many dance mothers may find themselves confronted with prevailing public perceptions of young female dancing bodies as sex objects. Bombarded with images of young, hypersexualized girls dancing in mainstream media and in competitive dance, dance mothers are further challenged by the allure of promoting their dancing daughters in consumer-based North American society where "selling" the over-sexualized image of youth, glamour, and sexualized femininity has become normalized and, indeed, valourized.

Since the latter part of the twentieth century, dance scholars have explored a range of eroticized interpretations of the female dancing

body. In *Dance, Sex, and Gender*, Judith Lynne Hanna asserts that there will always be those who view dance as sexual simply because they are attuned to the body and because dance and sexuality "share the same instrument—the human body" (xiii). "Requiring the body for its realization," Hanna further points out, dance "calls attention to one of the two types of human bodies, male or female" (xiv). Rachel Vigier claims in *Gestures of Genius: Women, Dance, and the Body*, that the necessity for the sexualization of female dancers is further sustained by patriarchal attempts to control female bodies (26). In *Glamour Addiction*, Juliet McMains poises female dancers "between virgin and vamp," noting that their dichotomous progression from innocence to eroticism "enables people to negotiate sexual dichotomies of virtue and vulgarity" (2). The virginal part of this binary of female sexuality can be seen in competitive dance through the wholesomeness of four- and five-year-old girls who appear in recitals as bunnies, butterflies, and kittens. These roles reassure parents that their younger daughters are still little girls, but they may become the very thing girls push back against in adolescence. As they grow older, sexiness becomes attractive to girls as it helps them to redefine themselves and shed earlier princess images and identities (Orenstein 6). If, indeed, mothers have any objections to overt sexual displays in puberty, they may be confronting the drive of daughters to use their sexuality as a means of establishing greater independence. Thus, dance mothers today may find themselves coming up against powerful rebellious drives from their daughters combined with the formidable forces of a long, culturally constructed history of the female dancing body as a sexual entity.

Judith Butler's theories of sex and gender, which are influenced by Foucault's concepts of hegemonic power and control over bodies, can help to explain how feminine constructs are created and recreated for both girls and their mothers within the context of competitive dance. Butler traces processes whereby sexed practices become regulatory, reinforcing the production of the bodies they govern (1). In *Bodies That Matter*, she links the materiality of the body to what she calls "the performativity of gender" (1), and asserts that "sex" should not be conceived of as "a bodily given on which the construct of gender is artificially imposed, but as a

cultural norm which governs the materialization of bodies" (3). For Butler, the very process of becoming a subject and developing a sense of identification in a predominantly heterosexual culture depends on assuming a sex (3).

The development of sexual identity is clearly an essential part of adolescence. However, it is important to carefully distinguish between expressions of sexuality that may be explored and presented by young dancers themselves and the prevailing methods of learning hypersexualized movement vocabulary through repetitive mimicry. The latter—imitative and repetitive processes of preparing the body for performance—are common to many competitive dance forms including jazz, lyrical, acro, and hip hop. Indeed, dancers rehearse the same dance choreography, as demonstrated by their teachers, for months at a time. In the backstage dressing rooms of competition venues, they also practice proper techniques for styling their hair, applying stage make-up, and warming up. The girls may also adopt hyperfeminized and hypersexualized postures, mannerisms, and behaviours by watching, imitating, and repeating what instructors and other girl dancers are doing even when they are not dancing. All of this may be considered as part of what Butler conceives of as gender performativity. Butler contests that gender performativity is "not a singular 'act,' for it is always a reiteration of a norm or set of norms" (12). From birth, she notes, "the girl is 'girled' and this gendering effect is reiterated constantly as a 'repeated inculcation of a norm'" (8). Following Butler's assertions, it is evident that a dancer may not only develop the ability, but also the compulsion to portray her body and her self as a sexual object. Furthermore, in competitive dance, a sexualized perception of self is often entangled in a community-approved environment where it may be reinforced until it becomes self-regulating.

What the body intends to signify in these embodied role-playing instances may not always match what the viewer interprets. This is certainly true for the young female competitive dancer. At once material and symbolic, her body is the product of cultural forces that endorse the female form as highly sexualized, even in childhood. Though Butler's notion of performativity is not intended to be "primarily theatrical" (12), the eroticized world of competitive

dance can be seen to engage in a "discursive practice that enacts or produces that which it names" both on and off stage (13). In other words, formulaic and reiterative approaches to creating sexy choreography for both recitals and competitions reinforce stereotypical constructs of the feminine. The more this feminine typecast is practiced in dance recitals, the more normative it becomes for performers and audience members alike, and elements of compulsory femininity and heterosexuality are performed in the daily life of the studio as well. As Butler states, this process of identification is not an "activity by which a conscious being models itself after another" (13). Not necessarily aware of the complex social forces at play, mothers who endorse hypersexualized manifestations of femininity within competitive dance environments transmit potent messages to their daughters. In these ways, mothers involved in producing hypersexualized dance performances contribute to securing and re-producing normative values of femininity.

Herein lies a potentially problematic outcome of this process. By imitation and repetition, young female competitive dancers become so steeped in sexualized movements and aesthetics that they may be denied opportunities to explore their sexualities differently from those ways that are socially prescribed. Moreover, their identities may be overwhelmingly built around themselves as sexual seductresses starting far before adolescence. This may become problematic in a multitude of ways as a brief examination of the psychosocial development of girls illustrates. In *Reviving Ophelia*, Mary Pipher discusses girls in what Freud calls the latency period (six or seven years old through puberty). However, Pipher advises that girls are "anything but latent…. Most preadolescent girls are in marvelous company because they are interested in everything—sports, people, nature, music and books" (18). In stark contrast, Pipher's description of changes in early adolescence is as follows: "Something dramatic happens to girls in early adolescence. They lose their assertive, energetic and tomboyish personalities and become more deferential, self-critical and depressed…. They report great unhappiness with their own bodies" (19). Many girls involved in dance may end up feeling even more inadequate because they cannot possibly live up to the images of dancers they see in the media. They may compare themselves with other dancers in

their class or on their team. They may see themselves as falling short and their self-esteem can suffer.

Rather than allowing some girls to descend into this place of deep dissatisfaction based on a perception of their inadequate appearance, I advocate that dance should preserve the broad interests of younger, preadolescent girls who tend to be so invested in learning about the world and who they can be in it. I have spoken with some mothers who pulled their young daughters out of dance entirely when the level of hypersexualization of girls became apparent and seemingly unavoidable to them. This is unfortunate because dance can offer so many benefits to young girls. From my own experiences as a dancer through childhood and adolescence, as a dance instructor who has worked with teenage girls, and as the mother of a pre-teen dancing daughter, I am confident that dance can be a positive medium for young girls' multifaceted explorations. However, there is work to be done to preserve these valuable benefits of dance education for girls; dance mothers can make important contributions in this direction.

MOTHERS PERFORMING GENDER

Not only girls perform gender in competitive dance. I argue that all those involved in producing hypersexualized dance performances contribute to securing and re-producing normative values of femininity and heterosexualization. Mothers, in particular, were once "girled" and trained to exhibit acceptable feminine, heteronormative behaviours that allowed us to be accepted in our socio-cultural spheres. As mothers, we may now practice the same reiteration of gender and sexuality through the bodies of our daughters. However, the landscape has changed since we were girls. Gendered codes have been transformed in the last three decades by forces of advanced capitalism, consumerism and competition, and the process of reiterating femininity now involves unparalleled public displays of the youthful hypersexualized female body.

The bodies of dance mothers, too, are stereotypically depicted in the media, particularly through the televised program *Dance Moms* first aired in 2011. In this show, glamourous mothers of dancers are frequently seen to be vicariously living their own

dreams through their children. These dreams play out in terms of gendered fantasies projected on dancing daughters. In the middle/upper class, heteronormative community featured in *Dance Moms*, the dance studio is an arena where mothers can pass on to their daughters their values and beliefs about appropriate paths for becoming women. However, mothers have very little sway with the overbearing dance studio owner, whose word is rule in all decisions about how the dancers are (re)presented in competitions ("The Competition Begins").

Ironically, though still usually operating within a societal mandate of compulsory femininity, women who have become mothers are generally expected to return to places of minimal and relatively private sexuality. Overt sexual displays of the maternal body are generally frowned upon. In *The Bonds of Love,* Jessica Benjamin points to this tendency to "elevate the desexualized mother whose hallmark is not desire but nurturance" (91). Dance mothers may continue to reiterate and perform femininity in a more sexually subdued way for themselves while transferring to their daughters their notions, memories, and fantasies of performative practices that established their own seductiveness. Thus, many dance mothers understand and accept that the path to womanhood involves sexualized bodily displays and thereby assist in their daughters' sexualized or hypersexualized performativity.

SHAKING IT UP: DANCE MOTHERS' RESISTANCE

Baba Copper's model of the close mother-daughter dyad encourages all mothers to reflect on their potential power to re-shape the patriarchal cultures in which they live by developing close relationships with their daughters. Mothers and daughters are often urged to separate in adulthood, but Copper notes that this is a "rule of heteromothering worth breaking" (187). When applied to dance training, Copper's theories offer dance mothers important ideas about how mother-daughter interactions might be used to "de-gender" young girls and guide them away from patriarchal forms of femininity. Echoing Pipher's description of girls' psychosocial development in pre-adolescence, Copper suggests that mothers can help to facilitate a process whereby daughters may be better

able to explore their individual sexualities in the adolescent years through activities that interest them. Copper recognizes that mothers themselves have been socially conditioned to conflate attractiveness with success in Western cultures (190). But the "radical potential" of mothers, she proposes, is in shaping the socio-political reality of women in the present and in the future. Resonating with Copper, in her piece titled "Feminist Mothering," Andrea O'Reilly declares that "anti-sexist childrearing depends on motherhood itself being changed" and can only be possible with the "empowerment of mothers" (793). One vital way to empower mothers, O'Reilly maintains, is to "interrupt the master narrative of motherhood" (796). So, by rejecting patriarchal mothering practices, we dance mothers might also fulfill our own radical potential and refuse to raise our daughters in hypersexualized environments.

We must be mindful, however, as Erika Horwitz emphasizes in "Resistance as a Site of Empowerment," that "the process of resistance is complex, and that women who resist the dominant discourse do so to different degrees" which, she advises, "entails the negotiation of many different, and often conflicting, discourses" (46). Thus, in examining the ways that some dance mothers embody, enact, and perpetuate certain patriarchal narratives of twenty-first-century motherhood such as intensive, self-sacrificial, inauthentic, or competitive mothering, we must also recognize that they may be concurrently acting as agents of resistance to other persistently prevailing notions that mothers should be docile, passive, domestic, hidden, and lacking in authority. Furthermore, as Horwitz points out, "empowered mothering should not only be about choice but also acceptance and respect among mothers" (55). I join Horwitz in calling for "a united sisterhood" of mothers who can "challenge societal ideals" (55). I am thus recommending that mothers of dancers who wish to resist sexual objectification in competitive dance will need to become empowered not in isolation, but together.

The solution I found for dealing with my discomfort around issues of hypersexualization for my daughter was to change my daughter's dance training to a studio that is specifically non-competitive. Without the pressure to rehearse for competitions, this studio chooses, and is able, to focus on providing a broader range

of dance experiences to its students. As a result, issues of hyper-sexualization are greatly minimized. Furthermore, now that the emphasis has shifted to a wider range of possible projects within the dance school, I am now able to initiate productive discussions with other mothers and with the studio owners about the importance of resisting wide-ranging cultural expectations of girl dancers to be perpetually sexy. Unfortunately though, not all mothers have access to alternative venues for their daughters' dancing. I contend that this is because, currently, most dance schools are competition-based and therefore subject to the structural hegemonic forces that uphold hypersexualization in competitive dance. Although many mothers are reticent to speak up, my conversations with some mothers at competitive studios revealed that they have, on occasion, voiced their dismay to studio directors about hypersexualized facets of choreography, costumes, or sexually explicit musical lyrics. Encouragingly, in most cases, they were successful at subverting these elements. In fact, this is not surprising to me considering that the sizeable investments of money and time made by dance mothers should give them a great deal of clout within studios. In addition, mothers' organizational abilities and teamwork skills could be directly applied to shaking up the issues of eroticization within local studios or even on a larger-scale political level within competitive dance circuits.

CONCLUSION

In this paper, I have demonstrated how dance mothers—through their consumptive behaviours, through their efforts to fulfill the role of the "good mother," and by endorsing normative, reiterative, and performative practices of femininity on the bodies of girls who dance—often unwittingly support structures of hypersexualization. At the same time, I assert that mothers who play central roles in dance studios possess a great deal of influence over their daughters and they hold a significant amount of untapped political power. The considerable authority and sway of dance mothers can be better channeled to address issues of oversexualization within competitive dance organizations.

As I continue to research issues regarding hypersexualization of

girls in competitive dance through more extensive interviewing, focus groups, and additional participant/observation projects, I intend to ask mothers of dancers to reflect on what it might take for them to remain involved in their daughters' dance lives, not only in the ways that are expected of them within competitive dance culture, but also politically. How might dance mothers use their own political power within the dance studio to redefine dance as less objectifying and more empowering for young girls? I urge mothers who are involved in competitive dance studios to exercise greater agency, specifically with regard to issues of hyper-sexualization of young female dancers. I believe this will ultimately create space for more enriching dance experiences for girls and contribute to expanding cultural perceptions of the dancing body. By planting seeds for greater awareness and by cultivating alternative approaches, mothers can be key players in addressing issues of sexual objectification in competitive dance. In turn, mothers can nurture a sense of agency in young female dancers, empowering them as they mature to reject the over-emphasis on sexually explicit approaches. Such a project would expand girls' understandings of what their bodies can do. Rather than perpetuating hegemonic notions of the body, dancing can become a conduit for girls' embodied explorations, helping to broaden and deepen what they can discover about themselves and their world.

As part of my ongoing research, I will continue to envision new roles that mothers can play within competitive dance. In imagining these possibilities, I return to and expand upon my opening metaphor by suggesting that just as the dance mother's key piece of equipment, the Rack 'n' Roll, can be set up, it can be dismantled and rebuilt. Choices can be made about which kinds of costumes and accessories will be hung upon the rack. So too can mothers make conscious choices about the ways they and their daughters operate within a climate of pervasive hypersexualization within many competitive dance organizations. Designed with wheels for mobility, the Rack 'n' Roll can be stationed in various locations. Similarly, dance mothers can shift their perspectives to encompass an understanding of dance movements and all elements of theatrical dance as inherently meaningful and potentially transformative. They can make choices about the ways in which their daughters

are expected to train and be represented on stages. They can exemplify and help to construct alternative models for young female dancers. Just as dance mothers can exert control over the ways they set up, organize, and locate their Rack 'n' Rolls, they may also help to maneuver and reform the structures that organize gender and sexuality within the world of competitive dance. In order to accomplish this, dance mothers need a strategy. I call upon them to begin by becoming familiar with how the mechanisms of the structures work, envisioning the direction they want to take in steering the future of dance for girls, and looking to each other for additional support.

WORKS CITED

Benjamin, Jessica. *The Bonds of Love: Psychoanalysis, Feminism, and the Problem of Domination*. New York: Pantheon Books, 1988. Print.

Butler, Judith. *Bodies That Matter: On the Discursive Limits of "Sex."* New York: Routledge, 1993. Print.

Copper, Baba. "The Radical Potential in Lesbian Mothering of Daughters." 1987. *Maternal Theory: Essential Readings*. Ed. Andrea O'Reilly. Toronto: Demeter Press, 2007. 186-193. Print.

"The Competition Begins: Episode 1." *Dance Moms*. My Lifetime. Collins Avenue Productions. Pittsburgh, Pennsylvania, 28 July. 2011. Television.

Foucault, Michel. *The History of Sexuality: An Introduction*. Vol. I. New York: Vintage Books, 1978. Print.

Giroux, Henry A. *Stealing Innocence: Corporate Culture's War on Children*. New York, NY: Palgrave, 2000. Print.

Hanna, Judith Lynne. *Dance, Sex, and Gender: Signs of Identity, Dominance, Defiance, and Desire*. Chicago: University of Chicago Press, 1988. Print.

Hays, Sharon. "Why Can't A Mother Be More Like A Businessman?" 1998. *Maternal Theory: Essential Readings*. Ed. Andrea O'Reilly. Toronto: Demeter Press, 2007. 408-430. Print.

Horwitz, Erika. *Through the Maze of Motherhood: Empowered Mothers Speak*. Toronto: Demeter Press, 2011. Print.

Ladd-Taylor, Molly. "Mother-Worship/Mother-Blame." 2004. *Maternal Theory: Essential Readings.* Ed. Andrea O'Reilly. Toronto: Demeter Press, 2007. 660-667. Print.

McMains, Juliet. *Glamour Addiction: Inside the American Ballroom Dance Industry.* Middleton, Connecticut: Wesleyan University Press, 2006. Print.

O'Reilly, Andrea. "Feminist Mothering." 2007. *Maternal Theory: Essential Readings.* Ed. Andrea O'Reilly. Toronto: Demeter Press, 2007. 792-821. Print.

Orenstein, Peggy. *Cinderella Ate My Daughter: Dispatches from the Front Lines of the New Girlie-Girl Culture.* New York: Harper Collins, 2011. Print.

Pipher, Mary. *Reviving Ophelia: Saving the Selves of Adolescent Females.* New York: Penguin Group Inc., 1994. Print.

Risner, Doug. *Stigma and Perseverance in the Lives of Boys Who Dance: An Empirical Study of Male Identities in Western Theatrical Dance Training.* Lewiston, USA: The Edwin Mellen Press, 2009. Print.

Ruddick, Sara. "Maternal Thinking." 1983. *Maternal Theory: Essential Readings.* Ed. Andrea O'Reilly. Toronto: Demeter Press, 2007. 96-113. Print.

Ruddick, Sara. "Preservative Love and Military Destruction: Some Reflections on Mothering and Peace." 1983. *Maternal Theory: Essential Readings.* Ed. Andrea O'Reilly. Toronto: Demeter Press, 2007. 114-144. Print.

Vigier, Rachel. *Gestures of Genius: Women, Dance and the Body.* Stratford, Ontario: The Mercury Press, 1994. Print.

Warner, Judith. *Perfect Madness: Mothering in the Age of Anxiety.* New York: Riverhead Books, 2006. Print.

7.
If I Could Give a Yopp

Confronting Sex, Talk, and Parenting

AMBER E. KINSER

I AM WEARIED BY SEXUAL REPRESSION in the family. I find pa-
rental obsession with virginity for its own sake tiresome. I am
troubled by the neighbour boy who, when playing some form of
truth or dare, dared my daughter, twice his age, to jump in the
air and grab her penis; she says, "That's going to be tricky, since
I don't have one." He says, "Really? Why not?" He was seven.
My own son figured this out in the bathroom with me at around
two. Admittedly, he was just as shocked as the neighbour boy, as
he grabbed my thigh to take a closer look. "What happened?" he
asked, as best he could at two, but we cleared up that confusion in
the moment. A reasonable question at two; an absurd question at
seven. I can't stand the thought of my forty-something friend who
was raising *five* daughters and who, last I heard, was still referring
to female genitalia as a "ha-ha," and the males' as a "deal." I am
discouraged by the stories my students tell me regularly about the
avoidant terms their families used in reference to issues of sex and
body. I am confused when the parents of my children's friends
ask if it's okay if my kids watch this or that movie at their house,
given the (very mild) sexual imagery, since they never ask if it's
okay if my kids are exposed to violent or misogynist imagery at
their house. I am disillusioned that academic research on family
sex communication focuses so much on what parents do to delay
onset of sexual activity, without really considering the value of
this goal, what determines that value, and whether there might be
more interesting, or at least other, research questions that could
help move children toward sexual health.

I am exhausted by parents who protest sex education in school and access to birth control on the basis that *they* want to be the ones to decide when and with whom the children talk about and learn about sexual behaviour. I am stunned by the narcissism blocking their ability to see that the conversation is already going on and that they have no control over whether it does, that the conversation is happening every day and coming from every direction, and that they can either join it in progress or get left out of it.

I have been teaching for twenty-plus years, getting the same stories from my students about how they experienced family communication as sexually repressive and I remain perplexed. Secrecy and shame about sex is comparatively foreign to me. I grew up in a very sexually charged home. My dad patted my mother's rear end all the time and made kissing noises at her from across the room, especially when she bent over to pick something up, to which she would reply in feigned protest, "Sir!" My parents were at it often. They would send my three siblings and me out of the house, lock the doors, and keep us out for at least an hour. My sibs and I rolled our eyes at each other about it of course, but no one was wondering why we were sitting on the front porch, I can tell you. And if anyone was, they could take a look at the purple velvet bedspread and the mirrors on the ceiling in my parents' room, though only after we were allowed back in, and only from within the door frame because that space was sacred for my parents and they made pretty clear we had no business in there. And then if anyone was still wondering what went on between my parents when we were locked out, they could sneak past that door frame when mom and dad were gone and past the mirrors and velvet and into the walk-in closet and up to the top shelf where one would find all manner of sexually explicit material. And if one was really industrious, one might find the hand-cranked reel-to-reel and the 35mm films in the brown paper bag in the other closet and one might figure out how to watch the dreadfully low-production-value films and then, *then,* one might get a peek at part of why we were sitting out on the front porch on those hot Florida days.

I never have been able to identify with so many of the people I have known who get the willies when they think of their parents

having sex. My children have grown up in a sexually charged home: first me with their father, now me with their stepfather. We have talked openly about foreskin and clitorises and erections forever. I wish I shared with more parents a value of open sexuality talk. I wish more of us could appreciate how much energy is left over for interesting and important things when so much of it isn't squandered trying to keep their children's metaphysical ears covered. I wish I could give a Yopp.

Now if you never have read Dr. Seuss's *Horton Hears a Who!*, you won't know what I'm talking about. But if you have read it, or have seen the animated version, think back to the scene in the climax of the book/movie where Horton the elephant is trying to keep the dust speck from being boiled, because he knows the tiny world of Who-ville sits on that speck. And he is desperately trying to get the Whos to profess their existence to the nonbelievers who conspire to boil that dust speck, and to save themselves by so doing. The Whos gather together in their microcosm within that dust speck and shout, "We are here, we are here, we are here, we are heeeere!" And again and again, "We are here, we are here, we are here, we are heeeere!" But alas they are not heard. The nonbelievers who, strangely, decide that though the Whos do not exist they should be destroyed, conspire to pull the dust speck closer and closer to the boiling pot and their demise. The Mayor of Who-ville is running about frantically trying to make sure every last voice is being utilized for the proclamation and he finds, tucked away into the farthest corner, one little, tiny Who, Jo-Jo. Jo-Jo isn't proclaiming anything, except the right to remain silent. The Mayor grabs this little Who and runs to the highest point in the city and thrusts him into the air to shout. But Jo-Jo can't decide exactly *what* to shout and pauses, in the heat of the moment, to first carefully consider whether he should contribute a "Yipp" or a "Yopp" to the symphony of voices. At last he decides on the latter and puts out a focused and purposeful "Yopp!" which punctures the microcosmic atmosphere, releasing the multitude of voices. A chorus of "We are here, we are here, we are here, we are heeeere! We are here, we are here, we are here, we are heeeere!" at last is heard, the existence of Who-ville and its inhabitants is confirmed, and the Whos are saved.

If I could give a Yopp, maybe I could break through the outer surface of parental sexuality talk and then conversations marked by the frankness and honesty that are so absolutely necessary for sexual health can finally break through and have impact. I know that such conversations do exist there, beneath the surface-level talk that occurs in families. Maybe if the ideologies that encase us could be punctured just enough, all the voices of those who do speak frankly of sex and the body could come through. So my fantasy is that one way I could contribute to the break-through is by performing the following narrative, in all its excess and in public spaces. My fantasy is that it functions as a catalyst for confronting parental terror of family sex/body talk and that a frankness of discussion is released among the parents and that, eventually, they give themselves permission to tell their children thorough truths. If my narrative could be the Yopp, here is what it would say:

You know that sex and parenting are two very tricky things to weave together. And even saying that makes you nervous, because you know it makes other people nervous. We live under the illusion that one's parenting self and one's sexual self are clearly separated from each other, even though they're not. As a parent who wants very much to teach your son or daughter about living a healthy sexuality, you really struggle with what it means to have that goal in a culture that has a very hard time discussing sexuality at all, much less asking questions about how to live it, much less being willing to actually teach and live out answers to those questions. And you struggle with what it means to have that goal in a culture that has become necessarily and mindfully vigilant about sexual abuse issues.

You think back to that mother, some time ago, who was breast-feeding her two-year-old (Umansky). She's this single parent, breastfeeding her baby, and she starts to feel aroused. (And when you hear that, you think: *Wow. What a surprise. Someone was sucking on her nipple.*) So anyway, she's feeling some sense of arousal and, as a vigilant parent, she wants to make sure that this makes sense. Wants to make sure that she's not crossing any lines just because her body happened to respond to that stimulus with some form of arousal. So she calls some kind of hotline and the

person who takes her call panics about this mention of mother-hood and arousal in the same sentence, and calls the police. But unfortunately, nobody at this place knows anything about nipples. Or women's bodies at all, apparently, because if they did, they would know that, for many women, the nipple can function as an erogenous zone, and its sensitivity to arousal sometimes isn't only contingent upon who is on the other end.

So you hear this story about this woman living in the sexually antiquated culture of the nineties, when no one knows—or, many don't know and the rest are afraid to admit what they know—about, you know, nipples. Okay. So anyway, they go right to this woman's house and take her baby away because they think it's in the best interest of a breastfeeding child to be away from its mother who is having a normal physiological response that is no different from what women have been feeling for ages. (I wonder what they'd have done with my one friend who said she had reached orgasm while breastfeeding?) And this woman has to fight for *a full year* to regain custody of her own child because people are so damned hung up about the body and its responses.

After hearing this woman's story, you're confused and upset for days because you want so badly for the story to be not true. You suspect that her being a single parent had something to do with the feverish responses. You suspect people were asking, as if it were relevant, why there is no man in the picture at this point, and there was no shortage of commentary on her prior relations with men.

There is this real life tragedy about the weaving together of parenting and sex that is always on your mind as you try to raise your own child to be a healthy sexual being. So you do simple things like let her touch her own body in her own way on her own time. And you choose not to use cop-out terms for body parts like "wee-wee" and "privates" and "pee-pee" and "down there," because there really are more useful names. We have no qualms about saying a nose is a nose and a wrist is a wrist and the left ear is the one on this side and the right ear is the one on that side and yes it is all your mouth but actually it's made up of teeth which are connected to but different from the gums which are different from the tongue which is different from the throat.

Most educated young girls get taught that boys have a penis and girls have a "vagina." And this of course is often true. But when girls start to understand their genitalia in that way, what they learn is that the female genitalia "equivalent" of the penis is the vagina. And so it's entirely possible that they become misinformed and potentially sexually unfulfilled women because they were never encouraged to consider the clitoris and the possibility that for many women, like many others, the orgasm could be centered in the thing that protrudes! So then you have men, like your second husband maybe, who get to their forties and then meet you and ask how it is that, after twenty-five years or more of being sexually active, no woman ever told *him* that? And you suspect that it may be because even they did not know it, or knew *about* it but not that it *mattered*. You suspect that those who are not women probably know where their orgasms come from.

You believe that there's a strong relationship between a person's peace and well-being and a healthy, fulfilling sexuality. And you want your child to have peace, and to be well. So along with teaching the values of truth and affection, and reading lots of books, and asking lots of questions, and being bold, and having friends, and honouring family connections, and not taking any shit, and having patience (which you have yet to find, so that one's a little tricky), and the import of solitude, and appreciation for the arts, and fascination with nature, you want your children to learn the value of healthy sexuality and all that it can mean. And as you reflect on how you might teach that, you suspend your terror that there will be a knock on the door by Child Protective Services, or some other state agency, and that they will deem it in your child's best interest to have someone else be her parent. Someone who surveils her body and what she does with it, who won't let her ask her dad how come he doesn't have labia? Someone who has the decency to reduce genitalia to at least "down there" and at most "vagina" and dear god, someone who has the decorum to leave the clitoris the hell out of the picture where it belongs.

So you reflect back on your own childhood and what your parents did or didn't do, and what your attitudes were and how much of that had anything to do with your parents at all. And you remember a few moments that surely shaped your sexuality. Like

when you stumbled upon, rather purposefully, your dad's—or hell, maybe your mom's for all you know—pornography magazines. And you saw lots of frightfully naked people sort of pawing each other or something and lots and lots and lots and lots of what you later came to know as beaver shots, or maybe just vulvas, and then there were a good many penises too. And you *loved* looking at them and did it any chance you got even though you figured you shouldn't and that if you got busted, you would *get busted*. But that, of course, neither stopped you nor made you do it less. It just made you more meticulous about putting *everything back the way you found it.*

And then you remember the times when the man down the street would send his kids—your playmates—out of the house and take you into his room and lay your five-year-old body down on the bed. And though he seemed very nervous, he was gentle and seemed kind and stopped hurting you when you told him it hurt. And was that the time you lifted your head to see his six-year-old daughter peering in through the crack of the door? And you wonder how much of those numerous experiences fed your fever for the magazines and your drive to understand it all and maybe even your desire to see similar naked and pawing things happening to someone else. You remember getting felt down by the neighbour boy in kindergarten, and you and your sister feeling each other up in the closet, and all of it so utterly fascinating but always clouded by overwhelming guilt, which also clouded your attempts to understand your very own body.

And you think now about how much simpler it must be for boys to figure theirs out, since people don't cower over giving a penis its own name, and testicles their own name, and everything being right out there and visible without mirrors. For girls it's a much more complex investigation because, first, it's *all* called a vagina on its best day (never a vulva) and, second, so much is tucked away and comparatively hidden and, so third, any attempt at discovery requires much more purposeful exploration, including locked bathroom doors, and mirrors that are placed on top of the laundry hamper so that you can crouch over them and get a good view. And then, of course, there's the label—self-imposed or otherwise—of dirty girl, or nasty, or naughty, or any of a number

of terms designed to strip you of your right to self-exploration and its value. But then there was the time you asked your mom about what an "orgzm" was—you saw it in one of the magazines and knew neither what it was nor how to pronounce it—and she told you all about it without the slightest flinch or even hesitation. But somehow climaxes and juices flowing weren't notions you could do much with in elementary school. Still, you asked for an answer and you got a forthright one and that really was the point. Because you learned about more than orgzms, you learned about being bold and asking nervy questions and expecting to get a shameless answer. And getting one.

So maybe that was one of the parental messages you got that helped to offset some of the bad stuff. And maybe that was your mother's contribution to helping you handle the times when you and your husband are making uproarious love and you turn to see your three-year-old daughter standing there. *Eyes wide open.* And you, of course, are completely mortified. So the two of you reposition and reach for the sheets which, by now, are in a knot on the floor and you try to say, as if calm and *not* mortified and not out of breath, "Um ... you forgot to knock on the door, honey," and feign a weakly composed smile, to which she responds with what you hope is not a petrified gaze. And you say, "Uh honey, we always knock when the door is closed." Not because "we" don't already know this or because the reminder is remotely useful at this juncture or because knocking is even the issue right now but because you can't seem to come up with anything else to say. *And she stares.* And your husband says, "It's early honey, not time to get up yet." *Stare.* And your husband says, "Um ... sweety, uh go on back to bed and we'll all be up in just a little bit, okay?" *Sad stare.* And so you say "It's almost time to get up. Go on back to bed and I'll come get you in a little bit, okay?" *Sad eyes and reluctant leaving of room.* Now as a mother, you want to hold her and make sure she's okay with this whole thing. And as a scholar, you know that this can be a monumental moment in a child's development and you don't want to screw it up. And as a lover, you want to know *just how long she was there and just how much she saw.* And you're trying to remember what kinds of things you were chanting and just which envelopes you were pushing as she stood

there. But there are orgasms on the horizon, though they're quickly slipping away, and more importantly there's a larger lesson for her about how the child doesn't get granted power to determine when the parents will spend time alone together and how long that will last and which sexual envelopes you'll be pushing when. And you know she already holds a portion of that power anyway. But you let her go and shut the door.

Alas, orgasms are shot now or, more accurately, aren't going to *get* shot now because there she goes again exercising that power. You've got to go talk to her, or let her talk to you, or something, you don't know, so you just go. And there you are crouching your nude and damp and almost-but-not-quite-spent body down to the height of a three-year-old. You say, "Are you okay?" She asks, "How come daddy was on you like that?" Now seriously. You *really* did think, with as much as you study this topic, and talk about it and think about it and worry about it, that you would have some earthly idea of what to say. I mean really. But words fail you. And those eyes keep staring, and you really do, in fact, need to come up with something here. So you say, "Uh, well ... daddy was lovin' on me." And you wonder how or if she'll take that and how you'll judge the efficacy of this exchange when you consider it in retrospect. And she says, always astute and on it and at least one step ahead of where you think she is, "Yeah but why he was on you like *that*?" [*Oh my god when is this going to end?*] And now you must come up with more. And you say, "Well ... because that's how moms and dads love on each other."

Now you know as fact two things about talking with children about sex. One, always answer their questions and be forthright and, two, don't give them more than they can handle. At the moment, both of these facts are swimming around furiously in your head and you can't sort them out, and there you are naked as can be, and there she is, scared and curious but bold as can be, and your heart is racing so much that you feel nauseated and you hope that she isn't picking all that up. And you can't sort out what to tell her that honours both of those facts, because it seems like doing one precludes doing the other. And she says, "Well I don't like him on you like that," and your heart gives way. You know that she is afraid of what she doesn't understand and afraid for you

therefore, and you want her not to be. Still, you don't know the right thing to say. You muster: "Uh well … I do. Honey, mommy and daddy were loving on each other; it feels very nice. Daddy was being very sweet to me and affectionate, and I like when he does that. He was loving me and being very sweet. And it makes me feel good." You can see her fear beginning to fade, as you continue telling her how nice it is when you and daddy love each other like that. So when she seems to be okay, and willing to go to her room, and seems assured that you're all right, you go back to your bedroom, where your husband waits for the report on what he thought you would probably handle better. (*Thanks a lot.*) So you both do your best to refocus on each other. And fail.

Very soon, he walks into her room to talk with her, and you lay there thinking about how overwhelming all this has been. He goes downstairs and she comes into your room and lies with you on the bed. And just when you think this experience is reaching closure, she looks at you and says, "I'm gonna love on ya," and straddles your stomach. Having just moments ago looked up at your husband in a position much like the one your daughter is in now, you are once again dumbfounded and all you can muster is a very nervous, "… You are?" "Yep," she says, and puts her hands down on the bed on either side of your head, bends her elbows and brings her body close to yours and then sits up again. You are so struck that you can't move, and you feel a giggle slip out. But she gets embarrassed and turns her head, "Don't laugh at me mommy." And you stumble over your words because you can't get out fast enough how much you're *not laughing*. Not laughing. No laughing here. None. So she does it again and you decide it's time to respond differently right about the same time she says—and this is the final kick—"Now you go 'unh, unh, unh.'" Here's the part where you roll her off of you and say playfully, "You kook! That's not how moms and kids love on each other; that's how moms and *dads* love on each other. Moms and kids love on each other like this." You kiss her neck and hold her and kiss her face. You start to tickle each other and talk about the people who live across the street.

From this first major incident regarding her parents' sex life, your daughter seems to have sustained minimal damage. You,

however, feel permanently scarred. You go the next day to talk with her Montessori school teachers to get their thoughts on it, and thankfully they thought you handled it fine. And you spend all of the next day at the library trying to find published people telling you that you did fine, and you tell and retell the story to the people you are closest to because you need to hear again and again that you did not fail her.

Two months prior it was, "What is god?" This day it's, "How come daddy was on you like that?" You wish there were some way of knowing what the next one will be, so that maybe you won't have to stumble around your terror to find something to say. But you don't. And you won't. And so you vow to always be forthright, and to not be afraid of shameless answers and to not be afraid of her hearing them, no matter how hard it is for *you*. Because you know that honest, loving sexualities are healthy ones. And though she will stand out because she will know sexual truths more than her peers, and though she will not hesitate to mention sexual and sexualized body parts in public just as comfortably as she would mention her chin, and though she will continue to stump you with questions that you thought you'd have a few more years to think about before you had to answer them, you know that the human body is truly a beautiful thing, and that understanding it is truly a beautiful thing and that honest lives are ones that are better lived.

WORKS CITED

Dr. Seuss. *Horton Hears a Who!* New York: Random House, 1982 (1954). Print.

Umansky, Lauri. "Breastfeeding in the 1990s: The Karen Carter Case and the Politics of Maternal Sexuality." *"Bad" Mothers: The Politics of Blame in Twentieth-Century America*. Ed. Molly Ladd-Taylor and Lauri Umansky. New York: New York University Press, 1998. 299-309. Print.

8.
Controlling My Voice

Producing and Performing
a Special-Mother Narrative

KELLY A. DORGAN

MOTHERING A SON WITH SPECIAL NEEDS, or special-mothering, as I call it, is often solitary, crazy-making work. Several years ago, in part inspired by DeAnna Chester's personal storied account of infertility, I started actively examining my own maternal story. Eventually, a desire surfaced in me to more openly witness (Frank), voicing my maternal experiences so that other special-parents know they are not alone. From the start, though, I wondered if I could witness in an ethical way. Granted, storytelling may be agency-generating, revealing previously unheard truths (Pitre, Kushner, and Hegadoren; Pitre, Kushner, Raine, and Hegadoren; Stevens). Still, as Kristin Langellier cautions, storytelling gives shape to, perhaps unfairly, complex social relations. In constructing and telling my own special-mothering narrative, I may freeze my son's identity, holding how he has acted as the exemplar for who he has been and who he will always be. How, then, can I tell my maternal narrative, one that is "brutal, unremittingly ugly," in a way that is also "transformative" (Shapiro 70)?

My questions about and interest in maternal storytelling led me to the approach of critical feminist narrative inquiry, a framework that holds that "the agency of the storyteller and the political role of storytelling are as important as the stories themselves" (Pitre et al., "Critical Feminist" 126).

In this article, I draw on these three important elements of critical feminist narrative inquiry to explore my special-mothering narrative: the story itself, or the "what" of the story; the agency

of the storyteller; and the politics of storytelling. Essentially, then, I expose how producing and performing my special-mothering story is enabling me to learn how to control my own voice.

WHAT'S SO SPECIAL ABOUT A SPECIAL-MOTHERING NARRATIVE

My son's name is Austin, a pseudonym, of course. He joined my family through foster care when he was six years old. When he moved into my house, he had been diagnosed already with Reactive Attachment Disorder (RAD), a condition marked by "difficulty formulating lasting relationships" (Thomas 5). Children with RAD "often show nearly a complete lack of ability to be genuinely affectionate with others," and fail "to develop a conscience and do not learn to trust" (Thomas 5). Austin is now a teenager. A few years ago, a juvenile court judge, or the Judge as I refer to her, sentenced him to his first residential treatment program (RT1). After about a half-year, RT1 discharged him to a second, more specialized facility (RT2). Austin remained at RT2 for almost one year. Upon his release from RT2, the Judge ordered my son into state custody.

THE STORY ITSELF

I gave birth to Austin through a bureaucratic process, not a biological one, in which I "pushed through the adoption paperwork, repeating the motions of a linguistic gestation: photographs, certified letters, figures, and fingerprints" (Jones 325). Each part of this "birth" process was a struggle—the training, paperwork, visitations, physical screenings, psychological assessments, meetings, and home inspections. After his move-in date, there was a brief honeymoon period, typical for children with RAD (Thomas), with Austin being charming and generally respectful at home. Almost immediately, though, behavioural problems emerged, especially at school. I rationalized his behaviours, reminding myself that he was a child grappling with loss, having been relinquished by multiple families, biological and foster. Later, as his problematic behaviours persisted, I wrote about my maternal experiences,[1]

voicing my story in an effort to sense-make (Gray).

The first six months of his placement in my family was supposed to be a formative time: those early days of parenting are crucial as trust of "self and others" develops and "the private, relational, and normative spaces of mothering" are negotiated (Pitre et al., "The Search" 260). In my private maternal space, I quickly grew to distrust myself, including how I interpreted my young son's disturbing behaviours. Also, I grew to distrust my own voice, baffled about how to talk with him, trying to be gentle and supportive, then, as his behaviours worsened, becoming tougher, transforming myself into a "militant mom."

Simultaneously, in my relational maternal space, I learned to distrust some of the very support networks that were there to guide me as a new foster mother. During those formative months, I took Austin to numerous physical and mental health appointments, seeking to obtain the necessary diagnoses for him, all in an effort to ensure proper post-adoption treatment and insurance coverage. Meanwhile, the phone calls had started almost immediately: arm-twisting via telephone by well-meaning but still bullying children's services professionals. "If you don't adopt him, we'll remove him from your home and find someone who will," the faceless woman said.

"But I need to make sure that he is fully diagnosed," I explained, my voice feeling like a weak mewl against her determined bark. Finally, after all the calls, visits, and appointments, I silenced my concerns and uncertainties, choosing to move forward with the adoption.

Since those early days, my maternal narrative unfolded in unexpected ways. As Johanna Shapiro writes, "bringing a critical mind to narrative is indisputably important in order for us to learn the lessons the author intended, as well as the lessons the author perhaps did not intend" (70). Prior to adoption, this is what I intended: my maternal narrative would demonstrate my tenacious mothering of my young, traumatized son, as well as how I helped him learn to cope with his grief, anger, and distrust. I never intended to use my special-mothering story to interrogate culturally dominant narratives and cherished assumptions about mothers and mothering. But that is what happened.

DROWNING OUT THE GOOD MOTHER & MONSTER MOM

All stories require perspective, which help tellers and listeners interpret "how things and events should be perceived" (Alonso, Chang, Robert, and Breazeal 312). When shaping my own maternal narrative and performing it for others, I did so against a backdrop of dominant narratives that guide and prescribe sense-making (Anderson and Geist-Martin; Frank). Arguably, over time, the "what" of my story, or the content (Pitre et al., "Critical Feminist" 119), revealed my struggle with the dominant narratives of Good Mother and what Barry Glassner calls the Monster Mom.

As my relationship with my son grew more complicated, I felt my own instincts and voice being drowned out by Good Mother stories. They seemed to be everywhere, promoting the intensive mothering model (Hays), seducing me with a simple promise: endlessly give emotionally, financially, and physically to my son and he will flourish; seek and heed expert advice and he will heal. The Good Mother promised to fix everything with her self-sacrifice and endless adoration of her children. When measuring myself against good mothering standards, I became despondent, similar to the experiences of women who mother while being disabled (Malacrida). The more I gave to Austin, the more he seemed to fixate on what he did not have. The more I tried to bond with him, the more he pushed away, sometimes literally. The more I loved him, the more he seemed to punish me. Over that first year, I realized, like other scholars have cautioned (Kinser; Malacrida), that the traditional good mothering ideals I aspired to were unattainable, but I still felt compelled to try and punished myself when I failed.

As my maternal narrative unfolded, I also struggled with the dominant narrative of the Monster Mom (Glassner). She too was everywhere. In private, she haunted me when I watched Sophia Coppola's film *The Virgin Suicides*. She terrified me when I read memoirs like David Pelzer's *A Child Called "It"* and *The Lost Boy: A Foster Child's Search for the Love of a Family*. Even kicking back and watching television programs seemed to expose me to Monster Mom's relentlessly whispered message: *Since a child is innocent and only misbehaves in response to an adult's—usually*

a parent's—abuse and/or neglect, then you must be to blame for Austin's behaviours. That would make you a Monster Mom too.

In my relational maternal space, I found my self-doubts emboldened, particularly in my interactions with peripheral professionals. Here, I use the term *peripheral professionals* to describe a subset of childcare workers and experts who, while having limited exposure to me or my son, had the authority to give opinions, form judgments, and render critical decisions about my son, my family, and my parenting. This subset of professionals seemed to use the cultural narratives of Good Mother/Monster Mom to guide their opinions, judgments, and decisions. Repeatedly in my interactions, I encountered one consistent "Truth": a child is never culpable; the parent, especially the mother, always is.

PERIPHERAL PROFESSIONALS INVADING MY STORIED SPACE

At the time of this writing, Austin has had two probation officers. I have appeared in court on his behalf close to a half-dozen times. I have two three-ring binders, one accordion folder, and one dozen email folders containing documentation about his behavioural and mental health needs and challenges.

Following Austin's release from RT2, the Judge ordered Austin into state custody, citing concerns for his safety and the safety of others in his family and community. In preparing him for placement in yet another therapeutic facility, Austin and I met with a professional from a children's services agency; I'll call her Wanda. Wanda had been marginally involved in my son's case for nearly a year. She had attended most court hearings, and was privy to my testimony—as well as the testimony of others intimately involved with Austin's care. She had sat in on meetings between Austin's probation officers and me. She had spoken with me directly, though briefly, a few times. What she had never done was meet my son, an attractive blue-eyed teenager with a ready smile—or ready tears, when necessary.

It was after the court hearing that Austin and I entered a conference room and sat across from Wanda. I placed my two three-ring

binders on the conference table, the ones containing documentation about some of the efforts I had undertaken to get Austin help and about his continued challenges; I left them closed but close at hand. Wanda began conducting yet another assessment. Keeping her expression flat, she looked at me and asked, "Has your son ever hit you?"

I replied, "No, but he was increasingly aggressive before being sent [to RT1]. He lunged at me, was increasingly verbally aggressive." I added, "He admitted in court he wanted to hit me several times."

Wanda smiled at me, her voice light, almost friendly. With my son present, she said to me, "But what teenager doesn't want to hit his mother?"

I wanted to remind her that he had not been a teenager during those incidents, but I kept my mouth shut for the time, not wanting to be seen as argumentative. Soon after that, another agency representative entered the small conference room and sat at the head of the table. Directing her comment to the nameless agency representative, but in front of everyone, including my son, Wanda declared confidently, "He's an angel," though she had directly interacted with him for less than an hour total. She added, "I feel sorry for him. He's not like our other children [in custody]. . . . I can't believe the Judge did this. In all my years I've never seen anything like this. This is a first."

I chimed in, "In the years I've parented Austin, I've seen a lot of firsts." I smiled gently to soften my words.

* * *

When considering my relational maternal space, I am reminded of Walkerdine's early work about how we talk differently about girls' and boys' performance in mathematics: "No matter how well girls were said to perform, their performance was always downgraded or dismissed in one way or another.... While boys, whose performance is poor, are said to possess something even when it is not visible in their performance" (54-55). Over the years, it has been my experience that—regardless of my son's behavioural performance—adults, particularly peripheral professionals, swiftly and confidently characterize him as "a good kid," "polite," "intelligent," and having "potential." In contrast,

peripheral professionals, including ones who have had little-to-no contact with me, have characterized me as "defensive," "very strict," and having "high expectations."

My maternal experiences echo what feminist scholars write about stories revealing "forces and conditions" that enable and constrain voice (Pitre et al., "Critical Feminist" 119, 120). From conference rooms to court rooms and from law offices to therapeutic offices, I have learned that I am often considered an "unreliable narrator" (Shapiro 1) when talking about my special-mothering experiences. When I have spoken with confidence about parenting my son, I have discovered later that I have been described as "intimidating" and "off-putting." Consequently, I have consciously softened my voice and asked peripheral professionals for advice about how to help my son, resulting in me being barked at on multiple occasions, with comments such as: "Have you tried [implementing] consequences?" and "If I had [Austin] for a weekend, I'd have him whipped into shape." Repeatedly, I have found myself in what has been called a "No-Win" situation for mothers of children with behavioural problems (Wollet and Phoenix 217). In the end, whatever my son does, many of these peripheral professionals conclude that he is "normal," though a bit "attention-starved," and that I, on the other hand, need additional training, compassion, understanding, and redirection, regardless of how I mother him.

My story is not an indictment of all hard-working childcare professionals. As Nancy Thomas writes, "well-meaning outsiders have no idea how ... much damage they do" when they interfere in the parenting of a child with RAD (55). For me, becoming a mother necessitated a purposeful "reorganizing" of nearly my "entire personality" (Oakley 199). Over time, for example, I shifted from being a trusting person to one who considers "very few people" as being safe enough to bring into my mothering space, not unlike mothers who experienced childhood violence (Pitre et al., "The Search" 264). Subsequently, my narrative truth (Frank) is that I must remain vigilant, protecting my son, myself, and even my maternal story from well-meaning outsiders. While my story reflects my distrust of self and others, it also highlights my search for "control, and voice" (264). By producing and reproducing my

maternal story, I am learning how to control my voice and perform in ways that enable me to be heard.

AGENCY AND VOICE IN MY SPECIAL-MOTHERING NARRATIVE

After my son entered his first residential treatment facility, I immediately started receiving phone calls from nurses, counselors, and other staff. They called morning, noon, and night, sometimes multiple times, almost like they expected me to be always and instantaneously available to them. My early suspicions were soon strengthened. One weekday morning, while I was in a meeting, I received a call on my cell phone. After I got out of the meeting, I checked my voice messages. It was Sam, Austin's new therapist at RT1. He left an abrupt message, saying, "I'm calling for our weekly family therapy session." He instructed me to call back. I was confused; I had never even spoken with Sam, let alone scheduled a session with him on a busy workday. Still, feeling like I needed to signal my compliance with and support for Austin's treatment, I called back and requested of Sam that we speak privately.

In that call, I outlined for Sam my challenges related to parenting a son with RAD. I detailed some of the therapeutic and behavioural interventions used to help Austin for years, all with limited results. Sam said, almost accusingly, "Well, Austin doesn't feel loved."

I replied, "I know." Trying to maintain an even tone, I explained the rituals, large and small, I had developed over the years to promote mom-son bonding, including the beach trips and hiking expeditions, again, all with limited results. I mentioned one minor ritual that Austin had claimed that he loved and had requested frequently over the years: mom-son movie marathons, an example, or at least I thought, of my attempts to carve out time and space for bonding.

Sam stated, "[Austin] says the movies you watched together were movies you wanted to watch."

I bit my tongue, wanting to scream, *Yes, you caught me! All those Harry Potter marathons were for me, not at all for my son!* Instead, I silenced my scream. I told Sam about my using snuggle therapy (Thomas), a technique meant to promote mother-child

attachment. Sam asked, "Is it possible Austin sensed your hugs were disingenuous?"

I was getting ready to cry or yell, or a combination of the two, so my voice quivered when I said, "Yes, [snuggle therapy] was difficult." Then I cautioned Sam about taking Austin's characterizations of me at face-value, drawing from Nancy Thomas' book *When Love Is Not Enough: A Guide to Parenting Children with* RAD:

> I have found, with the children that I have lived with, and helped to heal, if the father has stabbed, raped, beaten, or even in one case run over his own child with a truck, the children blame the mom for not protecting them. If the mother divorces the father for being abusive, drinking, or not supporting the family, the children are angry with the mom, not the father. She becomes their target for revenge. (3)

Toward the end of that first conversation, Sam asked in a now familiar terse voice, "Have you given up on this boy?"

Exhausted, I started crying and confessed, "No, but I've tried everything!" With shame, I admitted to being tired, frustrated, angry, and afraid of and for my son.

Sam asked, "Well, didn't you know what you were getting into [when adopting him]?" Months later, I read Sam's notes about that first telephone family therapy session and found his summary of his interaction with me:

> Ms. Dorgan was a little defensive about the steps she had already taken for [Austin's] mental health and building a family. I cautioned her that she was treating [Austin] more like a significant other in an adult relationship than a traumatized [child].

Sam's therapy notes bring to my mind Andrea Daley and her co-authors' research. The authors argue that during the process of psychiatric charting, health professionals become dominant narrators, stripping female patients of their complexity, removing social causes and contexts, and reducing patients to "descriptive terms and categories" (961). When I first read Sam's notes, I was

crushed. Voicing my complex maternal narrative to Sam had been grueling and shame-inducing for me; yet, the explicit details of my story had been reduced to three simple lines. All the years of hard work, relationship building, and emotional turmoil had been grotesquely distilled by a peripheral professional who did not know me and barely knew my son. Simply put, in Sam's therapeutic notes, I was reduced to the category of "problem mom" while my son's long-standing behavioural challenges were erased.

Over the next few months, my interactions with Sam remained contentious. Writing by Anna Woollet and Ann Phoenix helps me understand why:

> By virtue of the assumption that mothers have major (if not exclusive) responsibility for their children's development and behavior, psychological writing and childcare manuals (implicitly or explicitly) blame mothers when children demonstrate behavioral or other problems ... when children have problems or behave in ways considered by society as inappropriate or antisocial, it is mothers, rather than fathers, schools, and others who are blamed. (216-217)

Family therapy sessions became a horrific time for me. Each week, I would tenaciously perform my maternal narrative, my intended storytelling meant to edify and predict (Frank). For example, I shared detailed parenting experiences, hoping to help Sam notice if my son displayed early-warning behaviours toward the end of his honeymoon period at RT1. But no matter what I said or how I said it, Sam concluded in sessions and official reports that Austin's problematic behaviours were attributed to "family dynamics." To me, there seemed to be a concerted effort to rewrite my son's history, obliterating from the official narrative that the problematic behaviours Austin displayed in my household were the same that he has displayed in the households of his foster families. After multiple family therapy sessions, I discovered my maternal narrative was again evolving, or perhaps devolving, once more featuring "pervasive self-doubt" about my maternal abilities, similar to the doubt revealed in stories by mothers who had experienced childhood violence (Pitre et al., "The Search" 264).

Then, five months into Austin's stay at RT1, Sam discovered that, when unsupervised by staff, my son had been engaging in dangerous, arguably predatory behaviours at the facility. Six months after Austin's admission to RT1, Sam ordered my son's transfer to RT2, a specialized facility with higher security. One of the last times I spoke to Sam about my son, he said, "I now see what you have been talking about."

As recounted here, my maternal narrative could evidence my lack of agency and my constrained voice. It could also evidence how dominant narrators (Daley et al.) have attempted to define and control my maternal narrative. What I see revealed, however, is that fighting to tell one's story is actually fighting to negotiate one's lived reality (Shapiro). Perhaps others have tried to negate my special-mothering narrative, but in the process of my producing and performing it, I learned to doggedly voice my story in a way that is authentic to me. Ultimately, finding ways to control my voice has helped me move closer towards being what Andrea O'Reilly calls an empowered mother.

PRODUCING AND PERFORMING A POLITICAL SPECIAL-MOTHERING STORY

Through my storytelling, I "contest, resist, or defy living according to socially constructed" expectations (Pitre et al., "Critical Feminist" 123). My maternal narrative is a rejection of the silencing of non-normative mothering stories. In this way, my storytelling is a political act.

It was October. Austin was twelve years old. His behavioural problems had worsened at home and school—no matter what I or his therapeutic team tried. So when the phone call came from the school administrator, Jill, I was not surprised. "This was his third strike," Administrator Jill said. Actually, it was not his third strike. Though it was early in the school year, he had already stolen numerous times, and the previous year he had acted out so frequently, including stealing, that Austin, according to one of the vice-principals, set the school record for "alerts," a term indicating

unruly or problematic behaviour.

Over the years, I had worked with his elementary and middle schools to ensure that he—and he alone—faced the consequences of his behaviours, emboldened and informed by my work with RAD specialists. These specialists had taught me how to try to partner with school personnel, helping teachers and administrators understand that for children with RAD, inconveniencing, hurting, or otherwise negatively impacting their parents can be their well-hidden goal; therefore, consequences should be applied to the child, not the parent or parents. On this October day, though, Administrator Jill decided that my son had earned an out-of-school suspension. "I get it," I said, "but an out-of-school suspension punishes me more than him." I reminded her of our September telephone conversation in which she sought to "understand" his behavioural challenges and I had told her about his diagnoses and associated needs, especially the need for him to face consequences for his behaviours. In September, Administrator Jill had seemed supportive. But now it was October, and she sounded tired; her usual tone, lyrical with concern, had evapourated. I couldn't really blame her; I was tired too.

"He needs to learn consequences," Administrator Jill countered. I bit my tongue, wanting to snap at her about all the times school personnel had let him manipulate them into letting him off the hook, even when I asked them to hold him accountable for his actions. She continued, "We could file charges [against him], you know."

I replied, "Well, you should file charges, then." And the school did just that. At this point, I wish I could say that facing legal consequences for his stealing scared my son into recognizing how he was hurting himself and others, but that did not happen. Upon returning from the out-of-school suspension, he immediately entered in-school suspension for a separate offense.

As November approached, so did Austin's first court appearance. Still, he demonstrated to me little concern about his deteriorating personal and family life. One November afternoon, Administrator Jill called, wanting me to meet with her and the school resource officer to "go over what will happen in court." Her voice sounded uncharacteristically sharp, making me suspicious about the actual purpose of the meeting. Several days later,

I entered the school conference room, immediately observing the scene in which I would perform maternally for yet another audience. Under bright florescent lights, Administrator Jill sat at the head of the table. Noticeably removed from the rest of us was the school resource officer; Officer sat on the other side of the long conference table, his dark uniform crisp, his radiant badge affixed to his barrel-chest. When Officer spoke, his voice was blunt, his posture rigid, and his facial features flat. He seemed to study me through penetrating eyes.

I suspected what was about to happen, having been through similar situations before. So I sat straight-backed, and when appropriate, smiled, nodded, or frowned. Carefully avoiding stumbling or stammering, I answered Officer's questions, calmly recounting Austin's history. I described all his stolen items that Austin and I had returned to his school over the years, along with his numerous apology letters and his proposals for reimbursement. I outlined the attempted therapies and interventions, providing sufficient detail to establish my reliability as a maternal narrator but not so much that I came across as "intimidating" or "off-putting."

By the time I finished my story, Officer had relaxed his posture slightly, but his face still conveyed that he was disturbed. Then, Officer started telling his own story, one featuring a school resource officer who, after each one of my son's behavioural outbursts or problematic incidents, would sit down and talk with an obviously troubled boy. His story also featured my son as tearful and remorseful and as having only acted out in response to a home life of neglect, starvation, and abuse. When Officer finished, I was heart-broken, even stunned, mainly because his story was eerily close to David Pelzer's *A Child Called "It."* Months before, I had read Pelzer's memoir, then, after much consideration and after my son had continued to spiral out of control, I had given it to Austin, hoping he would see that Pelzer had survived childhood trauma, and so could he. It seemed, though, that the memoir had been used by my son as a script to explain away his behaviours at school and to, hopefully, escape consequences.

Officer finally summoned Austin to the conference room, and then he relocated to my side of the table. My son entered the room, his disarming smile falling from his face as soon as his sparkling

blue eyes fell on me. Officer directed him to sit alone on the other side of the table, a place that had my son facing Administrator, Officer, and Mother. Now, Officer interrogated Austin, beginning with, "Why did you say those things about your mother?"

Austin replied, "I don't know," his standard script after being caught in the act.

* * *

The last time I saw her, Administrator Jill said to me, "Your son is a con artist. He had me fooled." Yet, my maternal narrative exposes this: so many of us have been fooled. There is a reason that my son, even by six years old, knew how to tap into the Monster Mom dominant narrative, rallying his defenders with mere suggestions and unsubstantiated claims, and in spite of overwhelming evidence. In my private and relational maternal spaces, I too have reinforced the Monster Mom myth, pointing the finger of blame at Austin's biological mother and multiple foster mothers, using them to explain my son's plentiful and dangerous behavioural challenges. Too, I was infuriated at Austin's stories of alleged abuse by one of his foster fathers, wondering why the foster mother didn't stop the abuse. Finally, though, it occurred to me: I had never even considered the role of his absent biological father in helping wound my son. Arguably, Austin was able to exploit Monster Mom because she is everywhere, and it is through bold, complex, and brutally honest maternal storytelling that we resist.

Years ago, one of Austin's counsellors advised me, "You need to put on your big girl panties. As long as your son is acting up, you will be blamed." Initially, I recoiled from her advice, in part, resisting how she equated the complex process of maternal identity transformation with the slipping on of [girl's] undergarments. Yet, eventually, I reconsidered her advice, allowing it to inform my transformation. By repeatedly, and reflexively, producing and performing my special-mothering narrative, I have uncovered unintended lessons: (1) accept that blame will come, both justified and unjustified; and (2) receive the help of those who mean well while remaining vigilant about their motives, assumptions, and attempts at narrative domination. But my greatest lesson has

been this: if I doggedly produce and perform a special-mothering narrative that is authentic to me, eventually someone will listen and resist with me.

I wish to thank the editors and reviewers for their significant help in strengthening this manuscript. Additionally, I thank Dr. Wesley Buerkle, East Tennessee State University, for providing critical feedback during the revision process.

[1]An earlier publication further examines this subject. See Dorgan 140-151.

WORKS CITED

Alonso, Jason, Angela Chang, David Robert, and Cynthia Breazeal. "Toward a Dynamic Dramaturgy: An Art of Presentation in Interactive Storytelling." *Massachusetts Institute for Technology Media Lab*. 2011. Web. November 12, 2012.

Anderson, Jennifer Ott, and Patricia Geist-Martin. "Narratives and Healing: Exploring One Family's Stories of Cancer Survivorship." *Health Communication* 15.2 (2003): 133–143. Print.

Chester, DeAnna. "Mother. Unmother: A Storied Look at Infertility, Identity, and Transformation." *Qualitative Inquiry* 9.5 (2003): 774-784. Print.

Coppola, Sophia, dir. *The Virgin Suicides*. Paramount, 1999. Film.

Daley, Andrea, Lucy Costa and Lori Ross. "(W)righting Women: Constructions of Gender, Sexuality and Race in the Psychiatric Chart." *Culture, Health & Sexuality: An International Journal for Research, Intervention and Care* 14.8 (2012): 955-969. Print.

Dorgan, Kelly A. "All Hail the Militant Mom: Love and War in the Foster-to-Adopt Home." *Mothering in the Third Wave*. Ed. A.K. Kinser. Toronto, Canada: Demeter Press, 2008: 140-151. Print.

Frank, Arthur W. *The Wounded Storyteller: Body, Illness, and Ethics*. Chicago: University of Chicago Press, 1995. Print.

Glassner, Barry. *The Culture of Fear: Why Americans Are Afraid of the Wrong Things*. New York: Basic Books, 1999. Print.

Gray, Jennifer B. "The Power of Storytelling: Using Narrative in the

Healthcare Context." *Journal of Communication in Healthcare* 2.3 (2009): 258-273. Print.

Hays, Sharon. *The Cultural Contradictions of Motherhood*. New Haven, CT: Yale University Press, 1996. Print.

Jones, Stacy H. "Lost and Found." *Text and Performance Quarterly* 31.4 (2011): 322-341. Web. November 12, 2012.

Kinser, Amber. "Introduction: Thinking About and Going About Mothering in the Third Wave." *Mothering in the Third Wave*. Ed. A.K. Kinser. Toronto, Canada: Demeter Press, 2008. 1-16. Print.

Langellier, Kristin M. "Personal Narrative, Performance, Performativity: Two or Three Things I Know for Sure." *Text and Performance Quarterly* 19.2 (1999): 125-144. Web. November 12, 2012.

Malacrida, Claudia. "Performing Motherhood in a Disablist World: Dilemmas of Motherhood, Femininity and Disability." *International Journal of Qualitative Studies in Education* 22.1 (2009): 99-117. Web.

Oakley, Ann. "Becoming a Mother." *Women's Studies: Essential Readings*. Ed. Stevi Jackson. New York: New York University Press, 1993. 198. Print.

O'Reilly, Andrea. *Rocking the Cradle: Thoughts on Motherhood, Feminism and the Possibility of Empowered Mothering*. Toronto: Demeter Press, 2006. Print.

Pitre, Nicole, Kaysi Kushner, and Kathy Hegadoren. "The Search for Safety, Control, and Voice for Mothers Living with the Legacy of Childhood Violence Experiences: A Critical Feminist Narrative Inquiry." *Advances in Nursing Science* 34.3 (2011): 260-275. Web.

Pitre, Nicole, Kaysi Kushner, Kim Raine, and Kathy Hegadoren. "Critical Feminist Narrative Inquiry: Advancing Knowledge through Double-Hermeneutic Narrative Analysis." *Advances in Nursing Science* 36.2 (2013): 118-132. Web.

Pelzer, David J. *A Child Called "It": Once Child's Courage to Survive*. Omaha, NB: Omaha Press, 1995. Print.

Pelzer, David J. *The Lost Boy: A Foster Child's Search for the Love of a Family*. Deerfield Beach, FL: Health Communications, Inc., 1997. Print.

Shapiro, Johanna. "Illness Narratives: Reliability, Authenticity,

and the Empathic Witness." *Medical Humanities* 37.2 (2011): 68-72. Print.

Stevens, Patricia E. "Marginalized Women's Access to Health Care: A Feminist Narrative Analysis." *Advances in Nursing Science* 16.2 (1993): 39-56. Print.

Thomas, Nancy. *When Love Is Not Enough: A Guide to Parenting Children with* RAD – *Reactive Attachment Disorder.* Glenwood Springs, CO: Families by Design, 2005. Print.

Walkerdine, Valerie. "Feminity as Performance." *Women's Studies: Essential Readings.* Ed. Stevi Jackson. New York: New York University Press, 1993. 53-58. Print.

Woollett, Anna and Ann Phoenix. "Issues Related to Motherhood." *Women's Studies: Essential Readings.* Ed. Stevi Jackson. New York: New York University Press, 1993. 216-217. Print.

9.
Maternal Ecologies

A Story in Three Parts

NATALIE S. LOVELESS

...[A]n idea always exists as engaged in a matter, that is as "mattering".... As a result a problem is always a practical problem, never a universal problem mattering for everybody. Problems of the ecology of practices are also practical problems in this strong sense, that is problems for practitioners.
—Isabelle Stengers, "Introductory Notes on an Ecology of Practices"

IN MAY 2010, I gave birth to a four-pound, nine-ounce baby boy, two months prematurely. In response to the deep ways that the visceral materiality of my everyday was rearranged by this event, I began a series of daily practices organized at the intersection of feminist politics and performance art. These emerged from my need to find new ways, after the birth of my son, of thinking across practice-theory lines, as an artist-mother-theorist working

149

in the academy, both unwilling and unable to separate my status as mother from my status as artist or academic. These daily practices took the form of a three-year art research project performed with my son, from his third month to his third birthday. Taking feminist philosopher of science Isabelle Stengers' conception of "an ecology of practices" ("Introductory Notes" 193) to heart, in what follows I reflect on my life as a mother, my life as an academic, my life as an artist, and how I have worked to weave and knot the three together in responsive ways that interrogate each *through* the other.

OVERVIEW

On August 1, 2010, when my first and only child turned three months old, I began what I thought would be a three-month, daily-practice, art project. Three months turned into three years. Like many feminist artist-mothers before me, I began this project in the wake of my experience of new motherhood. The (in my case) quick and radical shift from gestation to parenthood prompted me to ask myself new questions about who and *how* I now was. Suddenly my academic-artistic life—a life characterized by a swath of intellectual and creative practices like going to art openings, writing papers, participating in art festivals, and attending academic conferences—was gone. There was little time to read or write or make, and my participation in public events dwindled.

Attempting to maintain some form of professional life, I found myself on the receiving end of what I can only characterize as a poverty of options. This poverty emerges from a set of inherited practices surrounding what it means to be an academic and/or artist in the small corner of the world that I inhabit. Despite the advantages of decades of feminist intervention in the professional sphere, I was asked, more than once, to leave the baby at home as a precondition of academic and/or artistic participation (the number of artist residencies that allow children are few, and lecturing with babe-in-hand is generally discouraged). This, more often than not, meant that I had to opt out. Instead of my forced absence being seen as a structural problem, it was characterized as a result of my choice to procreate. As a result, during these first years of parent-

hood, my ability to continue participating in artistic and academic events was dependent on my leaving the child at home—a choice that, for financial and other reasons, was not often a possibility. I tried to be creative, but even simple solutions, such as my partner and I taking turns at conferences between attending panels and wandering about with the baby, were often met with stern glances. I remember one particular symposium during which, on seeing me in the foyer with my son, a young faculty member at a U.S. "R1" university commented that she would never bring her child to work with her, even to visit, as she had been told in no uncertain terms that it would tarnish her professional status in the eyes of her colleagues. Inspired by stories like these, I developed a three-year daily practice project called *Maternal Ecologies*.

Part one, "Action A Day (Maternal Prescriptions)," was a trimester-long web-based project that used the language of performance art to recast the maternal everyday. This first year of my son's life was also the last year of my life as a doctoral student. In part two, "Action A Day (Documenting Firsts)," I documented and researched a "first" for 210 days (my best approximation of the number of days that my two-months-premature son was *in utero*), beginning on my son's first birthday. During this second year, I worked part time, as a visiting assistant professor in a different city and country than that in which I had done my dissertation. And, in part three, "An Action A Day (Gone/There)," I worked with my son to document my daily departures and returns: as I left for and returned from my first tenure-track job at a university in yet another province and city. This final part was performed in the third year for one trimester. This three-year, three-part project emerged as a response to (1) a perceived poverty of cultural imaginaries surrounding active parenting options for academics and artists uninterested in, or unable to take a career hiatus during the first years of motherhood; (2) an historical insistence on the invisibility of the professional artistic and/or academic mother (see, for instance, Bee and Schor); and (3) the sense of general isolation that I experienced as a working artist-academic with new maternal status.

I suspect that my generation of artist and/or academic mothers—many of whom are the sons and daughters of feminism's second wave (with "mothering" here understood as a social and

affective position that people of any gender can occupy)—have had a tough go of it, as the promises and insights of both second and third wave feminism fail to translate into a livable integration of career and home-life. And, while isolation may well be a common characteristic of all early motherhoods within a nuclear family culture, the professional needs of academic life and certain forms of artistic practice (for example, performance art) compound this isolation through their compulsory geographic mobility. It is the lucky academic who can find a job in a city where they already have a care network of family and friends; it is the lucky artist who does not need to travel to perform or install work and attend openings. In response to these conditions, the performance practices that I developed for *Maternal Ecologies* relied heavily on social and mobile media to stage an intervention into the daily practice of my (maternal) everyday life—a site of gentle resistance and possibility—that would span the first three years of my son's life and mark my transition from doctoral student to tenure-track professor.

A multi-year conceptual art project like *Maternal Ecologies*, operating at the intersection of feminism and contemporary art, cannot help but recall, for those familiar with twentieth-century art history and practice, Mary Kelly's infamous *Post-Partum Document* (produced between 1973 and 1979) . The connection is an important one. I first encountered Mary Kelly as author of the essay "Reviewing Modernist Criticism" during the summer of 1997, when I was just out of college. After this first encounter, I went on to discover Kelly not only as a provocative theorist but also as an artist. Motherhood being far from my mind at that point, it was Kelly's engagement with Lacan that drew me in. Her provocative use of the psychoanalytic theorist led me to pick up his famous "Mirror Stage" essay and devour it in one sitting. Reflecting from my present position, it does not seem a reach to suggest that Mary Kelly phantasmatically birthed me as a hybrid artist-academic that summer, and in ways that I could not have predicted. Little did I know at that point that the vector between artist and academic would critically expand to include mother.

While I was implicitly informed by Kelly's (*Post-Partum Document, Imagining Desire*) psychoanalytic investigation of the

warp and weft of maternal experience, explicitly I conceived *of Maternal Ecologies* as a digital reinvestigation of the propositional practices of FLUXUS instruction and action works. An amorphous mid-twentieth-century collective art movement, FLUXUS worked to recast the everyday, bringing conceptualism's focus on "art as idea" together with a turn to "art and life," indebted, amongst other things, to feminist theory and activism (Hendricks). It is a genre that has received renewed attention over the past few years in the context of a contemporary turn to "social practice" in the arts (Jackson; Bishop). Importantly, given my current research focus, this turn to social practice (also sometimes called a "pedagogical turn," [see Rogoff; Bishop]) influences developing understandings of what we in Canada call "research-creation" (Chapman and Sawchuk). A developing genre with emergent methodologies, research-creation grounds *Maternal Ecologies*—a project that asks: what forms of daily practice can I develop that do justice to the ecologies of working concurrently as a mother, an academic, and an artist?

Cultural theorist and philosopher Donna Haraway's recent work suggests Navajo string figures as ways "of giving and receiving patterns ... of relaying connections that matter, of telling stories in hand upon hand, digit upon digit, attachment site upon attachment site, to craft conditions for flourishing.... String figure games are practices of scholarship, relaying, thinking with, becoming with in material-semiotic makings" ("SF: Science Fiction, Speculative Fabulation" 13). I take Haraway's proposition to be that string figures are material-semiotic story-telling practices, in which the crafting of a story is understood as the crafting of an ethics. With Haraway's figuration as a guiding one, my aim with *Maternal Ecologies* is to tell a string-figure story of my maternal everyday in ways that might open up a *theorypractice* grounded in imaginative and deeply material connections between maternal and professional labours; a "string figure" story that invites us to live life just a little bit differently (King; Haraway, *Companion Species*).

PART 1: ACTION A DAY (MATERNAL PRESCRIPTIONS)

For the first part of *Maternal Ecologies*, "Action A Day (Maternal

Prescriptions)," I invited five mothers from three countries (the US, the UK, and Canada) and four cities (Boston, New York City, Cardiff, and Montreal), also academics and/or artists with children under two, to "perform" with me every day for three months.[1] To begin the project I sent them this brief description:

This project is about the ecologies of care that texture everyday (maternal) life.

> **Project:** I send you a performance action from my experience of daily life (e.g., "listen to baby's breath," "watch baby sucking on finger," "observe the rise and fall of breath," or whatever action I want to bring the attention of "performance" to that day). You do the same for me. I perform as many actions as are sent to me, and if none are sent, I only perform my child's action. Each day's action(s) will be documented both in video and still-form with my smartphone and uploaded to a blog we will share for the duration of the performance.

Duration: Twelve weeks, August 1 to October 23, 2010

The process was as follows: I would choose one moment every day and, using the frame of performance, both restructure and reflect on my daily maternal labours and affects. I used the FLUXUS -inspired format of the instruction piece to recast the moment as both a "performance" and as a "prescription" that might offer a new lens through which to look at the incessantly demanding materiality of the everyday in the context of my first six months of motherhood. For eighty-four days in a row, I then sent that "prescription" to my collaborators to witness (and to perform for themselves). My collaborators were then invited to send me scores from their daily lives.

For example, on one particularly difficult day, I noticed that my son stopped crying every time I flushed the toilet. I crafted an instruction from this experience (*"developing coping mechanisms: discover how flushing the toilet can stop a scream"*) and sent it to my collaborators to perform with their children, if they wished. The action reframed a moment of early maternal life (negotiating a

wk16:06 September 3, 2010

developing coping mechanisms: discover how flushing the toilet can stop a scream.

crying infant) and presented it as a moment of shared research, as each mother was invited to perform an action that was specific to my and my son's experience with their differently-aged and situated children. This exchange worked to recontextualize the individualism of contemporary (maternal) experience and encouraged us to reflect on the particularity of each of our developmental relations with our children—the ways that our *children* were developing, as well as the ways that *we* were developing relationally with them and with each other.

While I posted a "maternal prescription" every day and performed all instruction-scores sent to me, my collaborators were free to pick

and choose when and how they would participate. This meant that on some days, my son and I performed alone together, while on others we had three or four actions to perform. This performance practice inserted into the very fabric of my everyday a commitment to, and relation with, an international community of feminist mothers facilitated by internet technology. The instructions that framed the performance actions were at once coping mechanisms and invitations to share experience and affect.

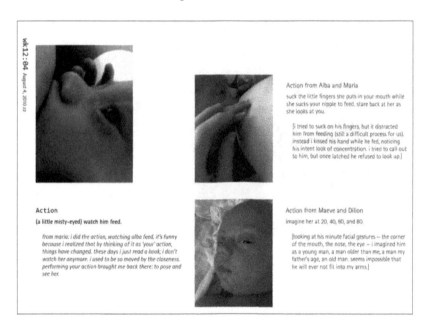

PART 2: ACTION A DAY (DOCUMENTING FIRSTS)

In my second year of mothering, I found myself entangled in a narrative of "firsts"—my son's first steps, first words, first view of the NYC skyline, first time saying "uh-oh" and pointing to something he'd dropped. My seduction with such firsts battled with my super-egoic criticism of that seduction. On one of the big "firsts"—his first birthday—I began the second chapter of *Maternal Ecologies*, "Action A Day (Documenting Firsts)." "Documenting Firsts" involved identifying a "first" every day for 210 days, taking a still photograph of that "first," and then reflecting

Day 102 August 18, 2011

One-Shoe-Walking

O. decides that the thing to do is wander around the apartment wearing only one shoe – about this he is insistent. It is a balance test, and I watch him push himself to develop more and more subtle and agile forms of stability.

I take off one shoe and walk around with him.

on the world of reference or meaning or affect that this "first" was drawing me into.

While I was critical of that narrative of human temporality marked by the language of "firsts," I also found myself so very aware of the fragile and delicious *newness* of so many moments of our daily life together—as this tiny mammal discovered the worlds surrounding him—that I felt compelled to respond. His first cold: bacteria colonizing his gut. His first word: a step towards independence from my uncanny ability to translate his every micro-gesture. That year was a dazzling and exhausting dance with the "new," both for him and for me. Paying attention to his (our) firsts was a way of seeing "firsts" everywhere and in everything, for example: my first taste of *this* cup of coffee; my first feeling of *this* breeze as it crosses my cheek. With a nod to Heraclitus ("No man ever *steps* in the *same river twice*, for it's not the *same river* and he's not the same man" [Plato: 402A]), a central side effect of this 210-day project was to pull me into a differently attuned temporality. Despite the progressive and anxiety-laden developmental drive of the language of "firsts" in Western parenting culture, instead of grounding me in the attainable future, the project of finding firsts in everything re-attuned me to the complex texture of a shifting present. The project's parameters encouraged an aesthetic relation to the performance of everyday maternal life that became a knowledge-making project as much about me as about Orion.

Throughout the fist two parts of *Maternal Ecologies*, I found myself confronted with a rich legacy of feminist concern with challenging any naturalization of feminine maternal sentiment. Rather than naturalizing sentimentality, from my current vantage point, I see the project as an exercise in both questioning *and* cherishing the bio-affective (Brennan) entanglement of maternal care work. Its ambivalent, glorious complexities colour my writing life, my teaching life, and even my practices of being a colleague. Banal as this may sound, as the mother of a still-young child, trying to work responsively between the academic, artistic, and the maternal, my capacity to dwell in any one thing has been completely recalibrated into a multi-modal dance that takes surrender, creativity, and patience. This recalibration is one that has shifted from year to year, and, accordingly, each segment of the three-year project reflects something specific about the needs of that period. While "Maternal Prescriptions" concerned itself with the overwhelming

intensity of infancy, "Documenting Firsts" was grounded in the move from infant to toddler—the move out of the arms and into the world. As I write this, now, a good nine months after the end of "Documenting Firsts," and twenty-eight months after the end of "Maternal Prescriptions," these projects exist for me as entanglements of affect, politics, and labour; they also have become a particular form of *witness*. Looking back, I see how much I have already forgotten, the power of Orion's current presence eclipsing so much of the creature he once was.

PART 3: ACTION A DAY (GONE/THERE)

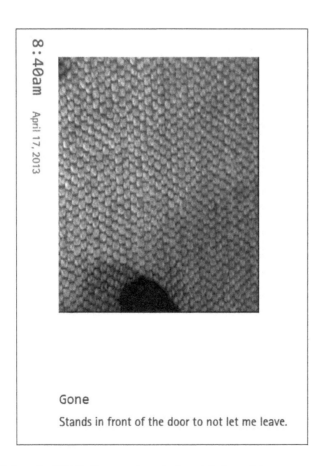

8:40am April 17, 2013

Gone

Stands in front of the door to not let me leave.

On May 9, 2013, I completed the third and last part of *Maternal Ecologies*. For part three, "Action A Day (Gone/There),"

my son and I documented my departures and arrivals over the last trimester of his second year; the project ended on the day that my son turned three. While preparing for this last part of the project, I noticed some differences that led to my declaring it the last iteration of this series. These all had to do with Orion's growing individuation. While we were still nursing, my experience of this practice had shifted. Nursing remained, during that third year, an artifact and comfort primarily tied to my return from work and nursing my son to sleep. Despite the fact that I was still producing milk and feeding him with it, the connection felt nothing like it had in year one, or even in year two. During this third year, nursing felt like something waiting to be over. My body had adjusted such that my breasts never engorged—whether I was gone for a day on campus without pumping, or away for a week at a conference. Whereas, once upon a time, nursing was characterized by urgent internal mammary pressure and the release/relief of Orion's suckle, towards the end of this third year I had to grab and squirt just to assure myself that there was, in fact, still milk, and that my son was not just sucking skin. In the weeks leading up to "Gone/There," I wrote the following in an email to a fellow mother:

> My breasts are largely limp and his suck chafes as much as it warms. The act of nursing, once a bond of ridiculous intimacy and immediacy seems mundane. It is a practice that, for us, has outlived its need and that will, no doubt, disappear before long. I will miss the unique bio-psycho-social connection that nursing has been for us, but he is stepping into such serious individuality these days—sometimes reaching new heights on a daily basis. Only last month he started using the indexical "I" to refer to himself for the first time (rather than the previous third person: "Orion wants…"). He spends time on his own, refers to himself eloquently, and has a rich internal life that he communicates endearingly ("You want to pick me up because I love you mama"). He wants me, but, in many of the previous senses, doesn't *need* me: he can walk on his own, eat on his own, and communicate his

needs in ways that others understand. (Loveless, personal email, February 26, 2013).

It was this manifest shift from *need* to *want* that inaugurated the last part of the series, and with it came necessary changes to my formal/structural choices. Whereas the first two daily practice pieces were performed in the context of a body still variably tied like an appendage to mine—his movement and communication so very dependent on my proximity and physical intervention—in this third year we could no longer relate to each other in this way, try as I might in moments of nostalgia. Responsive to this new structure of relating, for the final daily-practice piece I handed *him* the technology with the invitation to document, in video, our departures and reunions. Generally this meant that the footage was taken at odd angles, with extreme close-ups. Over the course of three months I watched him develop a relationship with my smartphone, using it as a transitional object. I would offer him the device every day as I left and would say my goodbyes while he held it, pointing the camera lens in whatever direction he pleased. Similarly, every day when I returned, I took out the phone and handed it to him, asking him about his day as he videotaped our interaction. The audio track captured our negotiation and ritualizing of our departures and reunions, and also marked a movement across the three years, from looking and touching to speaking and hearing. Some days, I would hand him the phone without incident; others he would refuse, knowing what was to come. Towards the end of the project he would grab the phone from me when he saw that it was time, do the ritual almost without me, and then turn back to whatever he had been engaged in.

CONTEXT

It is worth reflecting just a little bit further on the technological context on which all three parts of this project have been dependent: social and mobile media as a framework particularly suited to not only documenting maternal "mess," but also restructuring it. While an idea of performance that comes from a visual arts history concerned with the art/life divide was a generative of the project

(Kelly, *Post-Partum Document*; Montano; Ukeles), this project did not live in the realm of personal daily-practice performance alone. It relied upon the capacities of social and mobile media (in this case a smartphone and a blog) to create visible community surrounding everyday actions that were then recast as performance. The internet was my community lifeline, hosting a network of complex and multi-valenced solidarities at each stage of the project.

The Internet in general, and social media in particular, is said to shorten the distance between people, and when one thinks of the psychogeographical cartographic imaginary facilitated by the inter-webs, this makes sense. For example: I was Skyping with my son while away at a conference not long after completing the last part of *Maternal Ecologies*, and, as I was doing so, my eyes caressed the texture of his face, my mouth kissed the screen, my arms circled it. My son kissed back, hugged back, and cried that he missed me. It was intimate. He cried; I soothed. He cried; my breasts, still not fully dry, leaked a little. Social media facilitates a very material encounter: the materiality of breast milk; the material impact of an infant's cry; the soothing clucks of a mother's voice.

Embodiments are multiple, they are complex, and they are always transversally constituted. My son has grown up knowing his family—my sister in Brooklyn, his grandmother in Colorado—through the medium of Skype (for his first two years, we Skyped with his grandmother every morning). Skype isn't a new invention for him; it is the way the world has always been. For him, sometimes you are "in the (com)'puter" and sometimes out. When I am away and Skyping with my son, we perform a profoundly material enmeshment. Having me there on the computer seems to do something to his whole being. Acting like I am there with him, he runs around to show me things and I can see him relaxing. He communicates not my absence, but my *presence*.

MATTER::MATER::MOTHER

Each of the three installments of *Maternal Ecologies* structured, differently, my attention within an aesthetic, performative, and political frame. To use Isabelle Stengers' language, each "vector-

ized" my concrete experience ("Introductory Notes" 97). Taking the mundane seriously, *Maternal Ecologies* speaks to both ecologies of care (Puig de la Bellacasa), as well as to the complex, multi-valent, and affective textures associated with human infancy. Through the three years of the project, I worked to inhabit the thick, daily practice of mothering from a perspective resistant to idealized representation and open to affective entanglement and intensity. I performed from the presupposition of a complex material-semiotic ecology of practices at the heart of feminist mothering (Liss; Ettinger)—a conception of mothering as an affective, social, cultural, and material thinking-practice at odds with conceptions of motherhood that see it as a training relation organized around the social good. That common conception reduces motherhood to a social function—a training relation—that one can do more or less effectively in relation to agreed-upon norms. This training relation is suffused with affect, however that affect is read in the service of motherhood's normalizing social function: the mother must love unconditionally in order for the infant to thrive (Ruddick). For the mother to bask in that affect towards her own ends is often constructed as narcissistic and detrimental to the child. The mother cannot be "all about the mother," she must be "all about the child" (Edelman). I wanted to challenge the dualism of this worldview by exploring the material-tropic pleasures of the maternal without closing down the multivalence of what these can mean, particularly to those of us navigating the complex intersections of professional (artistic; academic) and maternal practice.

In the context of both second and third wave feminist suspicion surrounding a materiality aligned with determinate "essence," to return to and talk about the materiality (rather than representation) of motherhood is fraught territory (Fuss; Kelly, *Imagining Desire.*). As someone entrenched in the "string figure" practices of motherhood, and both enamored and incensed by many of my daily experiences, it seems to me that the material-semiosis of the everyday is *precisely* what needs attending. I find myself asking: what relational enmeshments are the conditions of possibility for our practices, and how are those either valued or disavowed? How do maternal practices and affects remake our professional/social

practices, and vice versa? How can bringing attention to these, as embodied material-semiotic events, suggest alternate ways of engaging in daily practices that cross public/private, personal/political lines, not collapse them into the other but to ask them to *remake* each other? And: while these are not new questions, why might it be important to ask them *anew*?

In asking these questions, I am interested in how the figures we use to think with reconfigure our internal geographies/cartographies—our psycho-geo-materio-affective spaces. From a dualistic ideological perspective, in ways that poststructuralist and feminist philosophic thought has challenged, one side of a binary structure is always undervalued, though constitutive. As is familiar to many of us, unlike its partner "spirit," "matter," with its etymological link to "mater" or "mother," is "mere," and, along with it, the messy banality of maternal labour. *Maternal Ecologies* performs familial, affective, domestic intimacy in a public context, at the feminist intersection of a historical public/private divide that is always already gendered and imbued with value. Instead of allowing this to stand as an inherited division, however, it is crucial that we open it up to its own paradoxes and flux; that we attend to the materiality of daily practice, the materiality of affect, the materiality of time, all the while recognizing that not all materialities are consonant or equivalent. A densely local and material intra-action (Barad 33), the maternal constitutes us as not *in* but *of* the world.

The last three years have moved me profoundly. My performances of everyday (maternal) life have frustrated, reorganized, and entranced me. As I write these final lines, grabbing time between teaching prep and household management, my son looks at me and says, "I want to climb on you mama." If the past three years of daily practice have taught me anything, it is to nurture the polymorphous qualities of maternal life—the insistence on a necessary and equally committed multiplicity of voice and being and care that is responsive and generous in the face of the often painfully interruptive and unpredictable aspects of early maternal life. If anything characterizes my maternal ecologies, it is this. While inhabiting the strictures of social convention—what gets to count as legitimate (writing) behaviour, where, when and how,

or, what is *too* personal, where, when, and *why*—I invoke the structure of chapter ten of *A Thousand Plateaus* to consider the daily performance iterations of *Maternal Ecologies* as both the crafting of "string figure" stories and as the weaving of *memories*. Memories of someone who can never tell when she is being an artist and when she is being a scholar and when she is being a mother, or when she is being too little or too much of each.

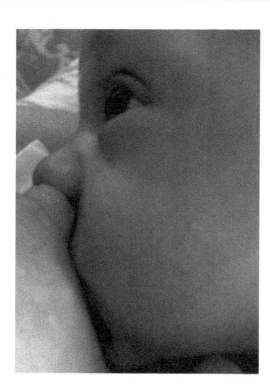

wk14:06 August 20, 2010

project yourself into a time when his nose will be bigger than your nipple.

Author note: I would like to thank Alex Metral, Shannon Coyle, Maria Puig de la Bellacasa, Krista Lynes, Dillon Paul for their maternal partnership, generosity, and care. Deep thanks are also due to Alissa Overend and Lindsay Kelly, as well as the editors of this volume, Amber Kinser, Kryn Freehling-Burton, and Terri Hawkes, for their help in crafting this essay, previous versions of which were given as talks at the following: Signal: A Symposium on Art, Network, and Technology, *organized by Julie Bacon, hosted by La Chambre Blanche, and held at Meduse, Quebec City, October 30-November 2, 2012;* In the Presence of Absence, the 4th International Biennial of Performance Deformes, *curated by Perpetua Rodriguez and held at the Museum of Contemporary Art MAC Valdivia, Chile, November 19-25, 2012; the Complicated Labors symposium, organized by Irene Lusztig and Micah Perks, and held at the University of California, Santa Cruz, February 5th, 2014. Thanks to all who participated in these wonderful events and helped me think more carefully about my maternal ecologies.*

[1]My collaborators for the project were my son, Orion Loveless LaBare (three months-six months); Alex Metral and her son Huxley Alder Metral (five months-eight months); Shannon Coyle and her daughter Zetta Coyle Rašović (seven months-ten months); Maria Puig de la Bellacasa and her daughter Alba Puig de la Bellacasa (eight months-eleven months); Krista Lynes and her son Xavier Emmanuel Lynes Weiss (twelve months-fifteen months); and Dillon Paul and her daughter Maeve Paul (thirteen months-sixteen months). The full project may be viewed at www. maternalecologies.ca.

WORKS CITED

Barad, Karen. *Meeting the Universe Halfway: Quantum Physics & the Entanglement of Matter & Meaning.* Chapel Hill: Duke University Press, 2007. Print.

Bee, Susan and Mira Schor, eds. "Forum: On Motherhood, Art, and Apple Pie." *M/E/A/N/I/N/G* # 12 (November 1992): 3-42. Print.

Bishop, Claire. *Artificial Hells: Participatory Art and the Politics of Spectatorship*. London: Verso Press, 2012. Print.

Brennan, Teresa. *The Transmission of Affect*. Ithaca: Cornell University Press, 2004. Print.

Chapman, Owen and Kim Sawchuk. "Research-Creation: Intervention, Analysis and 'Family Resemblances.'" *Canadian Journal Of Communication* 37 (1) 2012: 5–26. Print.

Edelman, Lee. *No Future: Queer Theory and the Death Drive*. Chapel Hill, NC: Duke University Press, 2004. Print.

Ettinger, Bracha. *The Matrixial Borderspace*. Minneapolis: University of Minnesota Press, 2006. Print.

Felman, Shoshana. *Jacques Lacan and the Adventure of Insight: Psychoanalysis in Contemporary Culture*. Cambridge: Harvard University Press, 1987. Print.

Fuss, Diana. *Essentially Speaking: Feminism, Nature, and Difference*. New York: Routledge, 1989. Print.

Haraway, Donna. "Cosmopolotical Critters: Companion Species, SF, and Staying with the Trouble." Arizona State University. Institute for Humanities Research. 22 March 2013. 2013 IHR Distinguished Lecture. Web. 4 July 2013.

Haraway, Donna. "SF: Science Fiction, Speculative Fabulation, String Figures, So Far." Pilgrim Award Acceptance Comments. Lublin, Poland, SFRA meetings. July 7, 2011. Lecture transcript.

Haraway, Donna. *SF: Speculative Fabulation and String Figures*, DOCUMENTA (13): 100 Notizen - 100 Gedanken No. 033 (2011a). Catalogue Publication. Print.

Haraway, Donna. *The Companion Species Manifesto*. Prickly Paradigm Press, 2003. Print.

Hendricks, Geoffrey. *Critical Mass: Happenings, Fluxus, Performance, Intermedia, and Rutgers University, 1958-1972*. New Brunswick, NJ: Rutgers University Press, 2003. Print.

Jackson, Shannon. *Social Works: Performing Art, Supporting Publics*. New York: Routledge, 2011.Print..

Kelly, Mary. *Post-Partum Document*. Berkeley: University of California Press, 1999. Print.

Kelly, Mary. *Imagining Desire*. Cambridge: MIT University Press, 1998. Print.

Kelly, Mary. *"Reviewing Modernist Criticism."* Art After Mod-

ernism Rethinking Representation. Ed. Brian Wallis. New York: New Museum of Contemporary Art. 1984. Print.

King, Thomas. *The Truth About Stories: A Native Narrative.* Toronto: House of Anansi Press, 2003. Print.

Lacan, Jacques. "The Mirror Stage as Formative of the Function of the I as revealed In Psychoanalytic Experience." *Ecrits: a Selection.* Trans. Alan Sheridan. London: Tavistock, 1977. 1-7. Print.

Liss, Andrea. *Feminist Art and the Maternal.* Minneapolis: University of Minnesota Press, 2009. Print.

Loveless, Natalie. *Acts of Pedagogy: Feminism, Psychoanalysis, Art and Ethics.* Dissertation, University of California, Santa Cruz, 2010. Print.

Loveless, Natalie. "New Maternalisms." Curator's Essay for the exhibition *New Maternalisms* (Toronto: Mercer Union Contemporary and FADO Performance Art Center); (9 pages), 2012. Print.

Loveless, Natalie. Personal email, February 26, 2013.

Loveless, Natalie. "Practice In The Flesh Of Theory: Art, Research and the Fine Arts PhD." *Canadian Journal of Communications* 37.1 (2012): 93-108. Print.

Loveless, Natalie. "Reading with Knots: On Jane Gallop's Anecdotal Theory." *S: The Journal of the Jan van Eyck Circle for Lacanian Ideology Critique* 4 (2011): 24-36. Web. 4 July 2013.

Montano, Linda M. *Performance Artists Talking in the Eighties.* Berkeley: University of California Press, 2000. Print.

Plato. *Cratylus.* Trans. B. Jowett. *The Internet Classics Archive.* Web Atomic and Massachusetts Institute of Technology, 13 Sept. 2007. Web. 4 July 2013.

Puig de la Bellacasa, Maria. "Matters of Care in Technoscience: Assembling Neglected Things." *Social Studies of Science February* 41.1 (2011): 85-106. Print.

Rogoff, Irit. "Turning." *E-flux Journal* 10 (2008): 1-10. Web. January 15, 2014.

Ruddick, Sara. *Maternal Thinking: Toward a Politics of Peace.* Boston: Beacon Press, 1995 (1989). Print.

Stengers, Isabelle. "A Constructivist Reading of Process and Reality." *Theory, Culture and Society* 25.4 (2008): 91-110. Print.

Stengers, Isabelle. "Introductory Notes on an Ecology of Practices." *Cultural Studies Review* 11.1 (2005): 183-196. Print.

Ukeles, Mierle Laderman. "A Manifesto for Maintenance Art, 1969!" Artist writing. Web. 4 July 2013.

Act III:
Performing Identity / Relation

10. Motherlines

KRYN FREEHLING-BURTON

A READER'S THEATRE for four women. Throughout the piece, the actors will represent sixteen daughters and mothers. The named women are characters who speak throughout the piece. As a reader's theatre script, lines are spoken to the audience. Imagine them as a chorus. Or women sitting around a kitchen table talking. When directed by the script, the women interact with one another as characters in a scene by stepping forward for the shared scene and then back to a more formal line or half circle at the end of the scene.

* * * * * * * * * *

WOMAN 1
In the dailiness of their lives, Between cooking and cleaning and

WOMAN 2
Birthing, schooling, laundry...

WOMAN 3
Our moms rarely had the chance to write their stories down. To record their memoirs for when they no longer remembered

WOMAN 4
Or when we didn't remember to ask

WOMAN 3
Mom, tell me a story about when you were little.

173

WOMAN 2
What was it like when I was born?

WOMAN 1
Who was your best friend?

WOMAN 4
What did you most want to be when you grew up?

WOMAN 1
From the time she was a young child, mom was a great singer. She had taken voice lessons all through high school. After her first husband died, she was in the opera and she sang opera. Then, after she met my father she stopped. I don't know if somebody actually said to my mom, "You shouldn't be singing opera," or if she felt somehow that it was just not the right use of her voice anymore so that ended and she didn't sing at all. She did sing at a lot of weddings and sang in the church choir and led children's choirs but she never performed again after that.

WOMAN 2
My mom was a teacher. Said she chose it so she could be with my brother and me when school was out. But I think she'd have been a teacher anyhow. She was one of the best in the school!

WOMAN 3
What did my mother want to be? A nurse! Always did. She did her nurse's training in Chicago and kept up her license through the years. When us kids went to school, she did some home health care and hospice work, but wives and mothers were supposed to take care of their husbands and children first. So she never really practiced the way she wanted to. Well, when she turned sixty, she went back to college and now has her degree in gerontology. Even though all her friends are retiring, she's a full-time working-woman now!

WOMAN 1
My real mom died when I was ten. I don't know what she wanted to be or do.

WOMAN 2
My mom wanted to be a wife and a mother. She didn't want to have to work.

(Woman 1 and 4 step forward)

WOMAN 1
Mom loved dressing up and going to the dances when she was a teenager. One time she shared this story with me.

WOMAN 4 (in scene)
I would go out on a date earlier in the evening with one boy and after he brought me home, I'd get him out of the house and a half an hour later the other one would come along. And they both knew about each other.

WOMAN 1 (in scene)
They knew!?!

WOMAN 4 (in scene)
(laughing at herself)
They did. I'm not sure why they put up with me. I just liked them both so much! I couldn't choose.

WOMAN 1 (in scene)
But you did choose…

WOMAN 4 (in scene)
Yes. Yes, I did. Finally. I chose the most handsome one. It was the war and he had a uniform.

WOMAN 1 (in scene)
Mom!

WOMAN 4 (in scene)
Robert, the other one, the one I didn't pick, would probably have been a more long-lasting, loving person. But he had a limp. And I liked to dance. I know, I know. I was quite shallow.

(Woman 1 and 4 step back into line or half circle)

WOMAN 2 as LUCY
(step forward and away from others)
My mother came to California during the depression with all the other displaced Okies. They came with little more than a truckload of kids, some clothes, canning jars, and some quilts. Everyone worked in the fields—picking whatever was in season. Their fingertips would be scraped raw from the cotton and their backs ached from long days in the heat and dust. One day when she was just eighteen, Mama was putting up some green beans with her mother when her little sister Cora came racing in the door,

(Woman 1, 3, and 4 step forward and turn into each other to form a V shape)

WOMAN 1 as LUCY'S AUNT as a young teenager (in scene)
Naomi! You got a package from Europe!!

WOMAN 4 as LUCY'S MOTHER (in scene)
Now Cora, stop waving that around! You're gonna spoil the beans!

WOMAN 1 as LUCY'S AUNT (in scene)
Naomi, look! It's from William!

WOMAN 2 as LUCY (to audience)
Mama hadn't heard from her fiancé for months. He was off fighting in the war. Almost too afraid to see what was in the package, she untied the string and unfolded the paper. Yards and yards of billowing white parachute fabric tumbled onto the floor with a letter.

WOMAN 3 as LUCY'S MOTHER (reading the letter) (in scene)
"Dearest Naomi, Would this do for your wedding dress? I'm sure you and your mother can work around the rips. Please say you'll marry me as soon as I get home.
Your loving William.

WOMAN 4 as LUCY'S GRANDMOTHER (in scene)
(Shaking the fabric out further so it covers the stage) This will be lovely. Imagine what a dress this will make!

WOMAN 2 as LUCY
William did return home and their first baby was born a short ten months after the wedding. (Beat) No one remembers what happened to the dress.

(Woman 2, 3, and 4 step back into line or half circle)

WOMAN 1
(step away from others to indicate a different character)
My mother married a naval officer right out of high school; I think she barely graduated. He was transferred to duty in Oregon and one night a call came in that a plane had gone down in the hills. He and his other duty officers went out in his jeep to go and find this plane. When they swerved to miss a porcupine in the road, the jeep overturned and killed everybody. My mother was only nineteen or twenty and she was a widow. They had to bring her husband's body back on a train for the funeral and two naval guys went with her all the way across the country from Oregon to Pittsburgh. She didn't even know these men! I think it's the bravest thing she ever did.

WOMAN 4 as KATIE
My mother was a Forest Service wife. Every two years, she'd have to up and move to a new post, in a different forest.

WOMAN 3 as KATIE'S MOTHER
Each of my three babies was born in a different state. The worst was baby number 2. We had to move when I was eight months pregnant. If it wasn't for the other forest wives, I'd have laid down on that porch and never got up again. We rarely saw one another, but wrote regular letters to each other.

WOMAN 2 as BETSY
My dear friend Sarah, Look for us to arrive on the sixth of next

month. Kathleen, Ann, and I will be arriving by train to help you pack up the house and mind the little one. When my husband told me that John had to go ahead of you to the new post, we decided you needed us! You shouldn't have to do that all alone in your condition. And do not cook for us! We will feed you.
With love, Betsy.

WOMAN 3 as KATIE'S MOTHER
During the packing and the eating, we created our first Forest Service Wives Collection of writing. We wrote out the stories of how we met our husbands and became Forest Service wives, typed up some of our favorite recipes and included advice for the newest wives. I'll never forget those friends or that week together with them!

WOMAN 4 as KATIE
And mom still makes Betsy's homemade dinner rolls every year at Thanksgiving!

(step back into line or half circle)

WOMAN 1
When my first baby was born, my mom was right beside me. I remember holding my new little daughter with my mom sitting next to me on the hospital bed. She wrapped her arms around me and the baby. I have never felt closer to her than I did at that moment.

WOMAN 2
My sister Ginny was born on a Saturday and my dad, brother, and I were driving to the hospital to see my mom and the baby and our car was rear-ended. So we had to call my mom in the hospital an hour or two after having the baby to tell her that the car was totalled—that her other kids had been in a car accident.

WOMAN 3
Mom was actually in labour most of the day on July fourth in 1976 with my brother so we thought we were going to have a bi-centennial baby. But he didn't come and he didn't come and he

didn't come till the twelfth. When mom was ready to come home, I drove down to the hospital to check her out of the maternity ward. I was only a teenager. She always said that marked the end of my girlhood and the beginning of our friendship as women.

WOMAN 4
My mom was so sick after my little sister was born. Cindy's baby book is nearly empty. No dates recorded for her first tooth, first step.

WOMAN 2
Motherlines reach forward to our daughters and back to our grandmothers

WOMAN 3
Not always in a straight stitch though. Sometimes the lines zig-zag and spiral and sometimes break

WOMAN 2
but the lines connect us just the same.

WOMAN 1 as POLLY
When my grandmother died, mom (gesture toward Woman 3) was right there beside her.

WOMAN 3 as BEATRICE
I sat for hours holding her hand. Breathing with her. Each time I thought mom was gone, she rallied for another long breath. It seemed to go on for hours. I wondered if she was holding herself back and remembered the midwife's words when I watched my daughter give birth,

WOMAN 2 as MIDWIFE (in scene)
(Woman 2 reaches for Woman 3's hand and they deliver the next two lines holding hands)
Breathe deep. I'm here. You can let go. You're not alone.

WOMAN 2 as MIDWIFE and WOMAN 3 as BEATRICE (in scene)
You can let go. You're not alone.

WOMAN 3 as BEATRICE (to audience)
I wiped her brow, kissed her cheek. Gave her permission to leave me. In the stillness, she took one long last breath.

WOMAN 1 as POLLY
My mother—midwifing her mother through that final transition.

WOMAN 4
Where does one story end and another begin?

GAYLE
Do we ever finish our mother's story?

WOMAN 2
The slippage of stories

WOMAN 1
The slippage of "I" and "She"

WOMAN 3
Is best seen in the story of three generations of mothers.

WOMAN 1 as DEIRDRE
When my brother was two he was stricken with polio. Within a matter of hours—it literally happened that quickly. Mom was on the telephone with my grandmother and the phone fell out of her hand when she saw my brother struggling. She realized something wasn't right, took me to a neighbour's house, put him the car and by the time they got to the hospital my brother couldn't move at all. She was pregnant with my sister, and my dad was out of town so she had to go through all of that alone. He eventually recovered—had a few lasting problems with breathing and walking but she took him to therapy for years. I remembered all this in new ways after Grant's birth.

WOMAN 4 as HANNAH
I was four when my brother was born. Mom noticed right away that his eyes weren't quite right; she couldn't really say why. I re-

member watching her loving him and taking him to doctor after doctor's appointments. Precocious little me, dancing all around the house, was only just aware of the great sadness that descended over our family when he was diagnosed with cerebral palsy and blindness. For many years, he lived at home and mom provided most of his care. When Grant was eleven, they decided to place him in a home for children with profound physical disabilities. As a mother now myself, I can only imagine how hard that must have been.

WOMAN 1 as DEIRDRE (in scene)
But it was the right thing to do. And not just for your brother. For you too. When things were really tough, I would just remember that if my mom could survive my brother's polio, I could get through this.

WOMAN 4 as HANNAH (in scene)
And that's how I got through my baby's surgery. I just remembered you and Gramma and knew that I would somehow be all right.

WOMAN 1 as DEIRDRE (in scene)
My sweet, sweet daughter.

WOMAN 3
Motherlines stretch across the backyards of our lives.

WOMAN 4
They crisscross our lives as we learn new things about our mothers

WOMAN 1
And the ways we want to mother

WOMAN 2
These motherlines provide the connections between generations and communities

WOMAN 3
giving us a thread to hold when we lose our way.

WOMAN 4

Sometimes we must leave our mothers—physically or emotional-ly—in order to be whole ourselves

WOMAN 3

Sometimes we watch helplessly while our mothers hurt deeply and we struggle to understand

WOMAN 2

Sometimes we find reconciliation and forgiveness

WOMAN 1

And find the threads of her stories that lead us to our own hu-manity.

* * * * * * * * * * *

This script grew out of transcripts from oral history interviews gathered in the summer of 2005. Inspired by a growing desire to see more mother-daughter stories written for the stage and a grandmother-in-law that shared the most amazing recollections of her mother's move from Oklahoma to California during the depression, I embarked on a journey to collect memories that could be woven into a full-length play. I was a young mother and a new feminist when I discovered Adrienne Rich's *Of Woman Born* and took to heart her lament that "whatever the individual mother's love and strength, the child in us, the small female who grew up in a male-controlled world, still feels, at moments, wildly unmoth-ered…. This cathexis between mother and daughter—essential, distorted, misused—is the great unwritten story" (225). I wanted to write this story. I wanted to find my way back to my mother through collective stories.

When I first began talking about the project, I started getting phone calls from women I didn't even know. "I want to tell you about my mother," they all said over and over. Some were cele-bratory stories and others were filled with sadness over estranged relationships but all sought the catharsis of sharing their stories with someone who listened and honoured the memories. These

daughters wanted their mothers, and themselves, remembered and performed on stage.

Folksinger Carrie Newcomer sings, "I've loved her and fought her and sometimes failed her / But I always come home to the rooms my mother made / Don't be afraid to look behind you / And take what's worth taking / Leave what needs leaving behind." The rooms our mothers made become part of the rooms we make for ourselves; we make sense of our own lives through the ways we listen to and remember our own mothers' stories—good or bad, positive or negative. Rich reflects: "It is hard to write about my own mother. Whatever I do write, it is my story I am telling, my version of the past. If she were to tell her own story other landscapes would be revealed" (221). Mothers break out of archetypes and stereotypes when we witness fully fleshed-out, three-dimensional characters as subjects of their own lives. The motherlines are made visible when we place them center stage, be it in a literal theatre or a more intimate performance space in our homes.

In the tradition of much feminist theatre, I employ several strategies for this project, namely utilizing actual women's narratives (Brody; Smith; Ensler) and collaborating on the revision process through workshops (Aston). Though the transcripts form the basis for the script, I used creative license in the actual writing. Some stories were strikingly similar and lent themselves to a condensation or synthesis to strengthen the dramatic elements and to honour parts of several oral histories. Other stories appear only in a brief narrative transition—a phrase, a sentence. Workshopping the draft with a playwriting group in Oregon, and then reading it aloud in the days before the conference with the readers in Toronto, provided critical feedback for revision before the performance.

Through *Motherlines,* I aim to fulfill Della Pollack's description that "performance as promise and practice is at the heart of oral history" (2). The transformational nature of oral history and of performance itself "translates subjectively remembered events into embodied memory acts, moving memory into re-membering" (2). Re-membering with and, at times, for our mothers helps us walk those lines that connect us to our mothers and daughters—biological, familial, and chosen. We embody our mothers' and our

own memories when we record these memories and also when we perform them with and for others.

Special thanks to Elizabeth Brandeis, Gayle Brandeis, and Andrea Doyle Hugmeyer who performed with me at the MIRCI International Conference on Motherhood, Activism, Advocacy, Agency in May of 2011.

And to the women who generously shared their mothers' stories with me.

WORKS CITED OR CONSULTED

Aston, Elaine. *Feminist Theatre Practice: A Handbook*. London: Routledge, 1999. Print.

Brody, Karen. Personal Interview. 20 June, 2008.

Ensler, Eve. *The Vagina Monologues*. New York: Villard Books, 2007. Print.

Fraden, Rena. *Imagining Medea: Rhodessa Jones and Theater for Incarcerated Women*. Chapel Hill: University of North Carolina Press, 2001. Print.

Newcomer, Carrie. "The Rooms My Mother Made." *My Father's Only Son*. Philo, 1996. CD.

Pollack, Della. *Remembering: Oral History Performance*. New York: McMillan, 2005. Print.

Rich, Adrienne. *Of Woman Born: Motherhood as Experience and Institution*. New York: W.W. Norton and Company, 1986. Print.

Smith, Anna Deveare. *Twilight Los Angeles, 1992: On the Road: A Search for American Character*. New York: Anchor Books Doubleday, 1994. Print.

11.
Liminal Families

Foster and Kinship-Care Mothers'
Narrative Performance of Family

CHRISTINE S. DAVIS

ACCORDING TO THE 2004 CENSUS, almost three million U.S. children live in a household with no biological parents present; 1.6 million of these children live in households with grandparents, over 600,000 with other relatives, over 500,000 with nonrelatives, and almost 300,000 with formal foster parents (Kreider 70-72). Other research counts 2.3 million children living with relatives other than their parents in 2002 (Urban Institute). A highly disproportionate number of these children suffer from poverty, as well as mental, emotional, behavioural, and developmental problems (Horwitz, Balestracci and Simms 1255; Keller et al. 915-20; Kreider 76; Miller et al. 1507-09; Rosenfeld et al. 449-50; Urban Institute). This chapter specifically looks at "liminal parenting" of children who have serious emotional disturbances (SED), identified either by the school system according to their behavioural criteria, or by a psychologist according to a DSM-III diagnosis, with diagnoses including ADHD, mood disorders, depression, conduct disorders, and/or anxiety disorders. The child's SED may be the reason for, or the result of, the breakdown of the child's "original" parenting system, and the child's placement with these "new" parents, and certainly would provide additional stress in their family situations. This research is unique in that it looks at several similar but different types of what I am calling "liminal" families (grandparent caregiver, adoptive, and foster families) that share the following characteristics: the grandparent caregiver/adoptive parent/foster parent is raising a child that is not his/her immediate biological child, and the child being raised has been diagnosed with SED.

The U.S. census defines "family" as "a group of two people or more (one of whom is the householder) related by birth, marriage, or adoption, and residing together" (1). They also define a "household" to be "all the people who occupy a housing unit, including lodgers, foster children, wards, or employees," and a "family group" to be "any two or more people (not necessarily including a householder) residing together, and related by birth, marriage, or adoption" (1). By U.S. census definition, "secondary individuals" are "people of any age who reside in a household, but are not related to the householder (except unrelated subfamily members)" (1). Guests, partners, roommates, and foster children are all considered to be secondary individuals. These complex and confusing definitions posited by the US Census Bureau to identify different family types points to the challenges in coming up with a definitive description of "family" in today's culture, and the added challenge of categorizing what this study is calling "liminal" families. I am using the term "liminal families" because these families represent a state of social ambiguity in which they are in-between being a family and not being a family. A liminal perspective studies the ambiguous space in relationships, social roles, and contexts, as liminality is manifested when we move through uncertainty and transition and linger in that in-between phase between social states, temporarily without and between identities (Turner; Van Gennep). This chapter, as does other research into liminal spaces, looks at the boundaries and borderlands between and around these spaces. The study of liminal spaces is important because it is at such places that we can deconstruct and critique hegemony, power, and marginalization (see Davis "Liminal" 485). It is how "we come to know ourselves and our world, to know how we know, and to reflect on our own interpretive processes" (Babcock 6). These families are liminal, I suggest, because of their uncertain and tenuous nature, as I will discuss later in this chapter.

To distinguish from liminal families, for the purposes of this paper, the term "traditional" families will be used to refer to consanguineous or biologic families, families with a biological mother, father, and one or more children, although, as John Gillis points out, our cultural construction of "traditional" family is a relatively new and short-lived phenomenon (3-19).

THEORETICAL BASIS

This chapter uses Erving Goffman's sense of "performance of self" within the theoretical construct of social constructionism (Berger and Luckmann; Goffman, *Presentaton*; Gumperz). The interviews in this research served as a sort of impression management, in which the stories told express the way the mothers wanted their families to be perceived, and describe the way the mothers speak of the family frame. Family stories give meaning and purpose to a person's life (Barclay 109-23), serving family sense-making functions of preserving the family's shared past, revising family boundaries, integrating shared life experiences, and creating familial identity (Barclay; Davis, Dollard and Vergon 16-18). This narrative performance of family provides a unique opportunity to observe what factors these liminal mothers thought important in their construction of the family frame—ways that social groups classify and interpret their actions (Goffman, *Frame Analysis* 10) and attach meaning to family (Gillis xvi). Rather than thinking of their descriptions of family as reports of actual behaviour, this paper instead looks at their discursive descriptions themselves as performances of family by these mothers as they talked about their liminal mother roles in interview accounts. I also discuss their performance of their family in the context of what the literature says about family identity behaviours. Della Pollack suggests, and Stacy Holman-Jones extends, the idea of "writing us in and out of being," the concept that it is through the performance of family narratives that a child's familial identity is formed, as, Holman-Jones says, family members "perform the relationship into being" (Holman-Jones qtd. in Davis, *Conversations* 301). This is important for all children, but as Holman-Jones suggests, is especially salient for adopted children, who don't have the immediate biological connections on which to rely for identity. I suggest that for these liminal families, whose family structure is ambiguous and tenuous, it is even more essential to use narratives to perform family identity. Thus, this research seeks to investigate how a sense of "family" is performed through family stories when there is no immediate (parent/child) biological tie.

LITERATURE REVIEW

Liminal families exist in relative placements ("kinship care"), or in non-relative placements. Kinship care is a type of foster care, either formal (kinship adoption or kinship foster care) or informal, in which children are placed with relatives other than their biological parent(s). Kinship care is believed to be advantageous to the child and family because it keeps the child "out of the system." Kinship caregivers, foster parents, and adoptive parents are often different from traditional parents in many ways. These parents may be older; the child's placement may be uncertain and may be purposely viewed as short-term or temporary; social workers and other professionals may be involved in their family system; the children have an additional challenge to their self-identity and sense of belonging; the family has to integrate a child (often older) into an already-established family system which requires role adjustments within the family; feelings of family belonging—related to family solidarity, identity, and culture—are a challenge; and there is a need for legitimization of their family (Barton 58-60; Rosenfeld et al. 452; Riggs, Autoustinos and Delfabbro 795-802; Sobol, Delaney and Earn 386).

There are quite a few potential problems inherent to kinship care, including role and boundary confusion, often exacerbated by ongoing interactions with the biological parent (Crumbley and Little 2,9). The caregiver may experience loss of life plans, privacy, and relationships with family members. There can be additional conflict arising from a biological parent seeing the caregiver as competitor for authority over the child. In addition, foster children have disproportionately higher rates of health care needs, mental health care needs, poverty, and juvenile justice problems, which are likely related to the reasons for the foster care placement among the children in this study. Perhaps related to their foster care placement or from the trauma of multiple placements, foster children also tend to have lower educational levels and lower employment rates than do the general population (Barton 59; Rosenfeld et al. 451).

All participants interviewed for this project were the female liminal parent. This could be considered appropriate to studying

family frames, as women have been the ones to traditionally hold primary responsibility for family communication (Gillis 124). As researchers suggest, the concept of a "good mother" is a social construction, politically (Butler) and culturally influenced and enacted (Heisler and Ellis 446-59), reflecting canonical cultural narratives (May 471-77). Performances of good mother include, among other traits, self-sacrifice (Douglas and Michaels 2-5; Heisler and Ellis 455-60), obedience to authority (Charchuk and Simpson 195-98), and moral responsibility for a child's care (Gunnarsson, Hemmingsson, and Hyden 447-55). Good mothers have to balance the expectations of obedience and passivity with their need to be assertive on behalf of their children (Charchuk and Simpson 199-201; Gunnarsson, Hemmingsson, and Hyden 447-55). In addition, in order to be a good mother, a woman must push her wants, wishes, hopes, and dreams to the side in exchange for unwavering devotion to her child (Douglas and Michaels 2-6).

RESEARCH OBJECTIVES

This study consists of analysis of data from a qualitative study designed to gather information about grandparent caregiver, adoptive, and foster families. The goal of this analysis was to study the narrative performance of "family" during in-depth interviews with grandparent caregiver, adoptive, and foster parents who were caring for children with serious emotional disturbances in an attempt to determine how they constructed a sense of family within their "non-nuclear" family structure and how they use narrative performances to talk about raising a child (with SED) who is not their own immediate biologically child.

METHOD

Sample

For this study, a purposive sample of participants was chosen from those enrolled in a longitudinal study of children with SED and their caregivers in a children's mental health system of care in a medium-sized, southeastern city in the United States.

The studied site was a community-based initiative intended to integrate mental health, social, and human services for children with serious emotional disturbances (SED) and their families. The children in the database ranged in age from four to eighteen years (the average age was twelve), and had a history of psychiatric hospitalizations, physical abuse, sexual abuse, running away, suicide attempts, and/or substance abuse. Their biological family histories included family violence, mental illness, psychiatric hospitalization, crime convictions, and/or substance abuse. At the time of this research, this site enrolled 376 families, including 169 families who had children in the custody of grandparents, other relatives, adoptive parents, or foster families. Older grandparent or other relative caregivers, adoptive parents, or foster parents who were 55 years of age or older in the database were poorer and had less education than younger caregivers (see Burton, Davis, Dollard, Elrod, and Vergon; Davis and Dollard; Davis, Dollard, and Vergon, for more extensive discussions of the database and other related research).

This research looked at five of these families. Three of the five families were headed by females alone; two were headed by heterosexual couples. Three of the household heads were grandparent caregivers and two were foster parents who had adopted foster children previously under their care. Their fifteen adopted and foster children had diagnoses of ADHD, Asperger's Syndrome, and/ or other behavioural problems. The children ranged in age from eight to fifteen years.

Data Collection

This study used a qualitative methodology in which in-depth interviews were conducted at the families' homes with the children's liminal mothers. Participants discussed and told stories about their family life. I did not observe the family in action but instead gave the liminal mother an opportunity to "perform family" in the interviews through the stories used to frame, portray, and construct family as part of a performance to an outsider. For most of the interviews, only the liminal mother and I were present. The children were in the home during two interviews, but did not participate in the interviews.

Data Coding and Analysis

Discourse analysis looks at how meaning is produced through discourse (Starkes and Trinidad 1373). Coding and analysis in this method consists of reflecting on meaning, themes, and roles constructed through language, and finding examples of the ways that language constructs that reality. In this study, this involved categorizing the discourse into themes, and connecting these categories to their social context, looking especially for places the discourse had disunity and discontinuity (Grbich 149; Starkes and Trinidad 1373-1375). Conversations were read in their entirety and line-by-line to provide a close reading of themes and meanings. Using a method of constant comparison, I read through the data, letting themes and categories emerge and cluster, grouping for similarities and meaning. As themes emerged, I compared and contrasted each category and cluster, and adjusted my analysis as I identified linkages between categories, the discourse, and the social context. As I analyzed the data, I focused on how language, or discourse, was used to construct meaning.

DISCUSSION

Family Liminality

I suggest that these families represent a state of social ambiguity, a family liminality, in which they are in-between being a family and not being a family. In fact, research on family identification among foster families has found a tension between the categories of "family" and "foster family," with foster families wanting to identify as "families," but social workers wanting to make the "foster" distinction (Riggs, Delfabbro, and Augoustinos 792-93). For the families in the population represented by this study, one of the challenges in raising a child with SED is maintaining the household. It is not uncommon for the child to be removed from the foster, adoptive, or kinship care home, either temporarily or permanently, if her/his behavior is so severe that the child needs professional residential treatment. This uncertainty of permanency adds to the liminality of the family arrangement. In U.S. American culture, family as a cultural unit is typically based on the premise of living together (Schneider 46) in a home, with the

home functioning as symbolic of family unity (Gillis xviii-xix). Therefore, if family members, especially the minor liminal children, of necessity move in and out of the family home, this blurs the boundaries of family, as home is (according to Schneider) "both a place and an activity" (46). Another source of liminality is in periodic interaction with the biological parent. With kinship caregivers and foster parents, the biological parent may come in and out of the children's lives, disrupting boundaries, roles, and routines. Unfortunately, the addition of the child in a family's life can disrupt their already-formed family, sometimes to the point of its disintegration; one grandparent caregiver's spouse left the family because he didn't want to help support the grandchildren. The liminal nature of the situation, coupled with the age of some of the liminal mothers, causes additional legal, custodial, financial, and guardianship concerns for these families. These issues—fear of legal and income repercussions, for example—reinforce liminality and limit their establishment of family. I suggest that the liminal state inherent in these family units makes the performance of family all the more important to study.

Birth stories provide a beginning point of performative belonging for children (Derrida; Holman-Jones 113-14, Pollack 68), but the identity stories of the children in this study do not begin at birth and do not begin with belonging. Unlike more traditional families in which the performance of belonging stems from a place of stability (a biological child belongs because of a biological bond, or in more traditionally adopted families, the child belongs because of a legal bond), for these families, performance of belonging originates from a more tenuous and conditional space. As with other adoption stories, these children's lives begin with loss and abandonment (Holman-Jones 113). However, these liminal mothers don't perform loss stories. They instead perform stories of activity and agency—stories of performing the family into being—through acting the family into being, acknowledging the family into being, and speaking the family into being.

ACTING THE FAMILY INTO BEING

Korzybski's theory of general semantics reminds us that language,

thought, and behaviour are intertwined, and our actions always precede our responses to them and the meanings we attach to them. In this sense, these families act as a family, and therefore are a family. These liminal mothers perform family in their interviews through detailing stories of doing things that families do—playing together, going to church, gathering for holidays, eating meals, providing for their children, and disciplining their children. The following quotes come from four different families:

Adoptive grandparent: *He and I play basketball sometimes. We had played tennis. He's taken an interest in cooking. He is interested in food, Oriental food. When he's had interest, I've tried to navigate that.*

Grandparent caregiver: *Sometimes I take them to the park. [Youth] used to do cheerleading.*

Grandparent caregiver: *I make them go to church with me.... My son comes home for lunch every day. He loves my cabbage, macaroni and cheese.*

Foster/Adoptive parent: *We have Christmas when everybody comes together. And Thanksgiving. And birthdays. They're all around.*

These are activities that families traditionally do—family ritual celebration of birthdays and holidays dates back to the early 1900s. These gatherings provide a sense of community, history, identity, and identification (Gillis 92-94). They connect liminal family members together in a continuum that bridges time, space, and history. Eating together is a way to socialize children to both the family and the culture at large, while ritual family vacations root the children to the family history. Food is a social code and, in U.S. culture, eating together constructs ideas of friendship and community. Food is also an identity marker—marking, for example, relationship status, such as the use of family or holiday meals to mark family relationships. Foods are especially resistant to social change, and can serve as childhood security symbols

and memory cues (Leeds-Hurwitz 83-99). The idea of family meals link generations, even if the actual meals themselves do not replicate the meals performed in previous generations.

In U.S. culture, time is a scarce commodity, and making time for family members is a valuable gift. Historically, family time has been associated with mothers (Gillis 93). Finding common interests, doing things together, and supporting the children in their activities are ways that these liminal mothers create a sense of family. It is interesting to note that the liminal mothers may or may not be actually performing the activities they described. For example, it is not likely that the frail 75-year-old grandmother of the 15-year-old boy actually played basketball and tennis with her grandson as she mentioned in her interview. What is important, however, is that this is one of the ways she thinks family is performed. Susan Shaw and Don Dawson found that parents highly value family participation as a social construct to create and enhance family communication, family cohesion, and a "strong sense of family," and to socialize children in the family's values (229); these families use activities as a way to perform family into being.

Another way of "acting like" a family is to provide for the children, both necessities and luxuries. These liminal mothers talked about providing the necessities for their children. Many of them talked about purchasing clothes for their children, often in the context of the expense of purchasing clothes for teenagers. Unfortunately for the grandparent caregivers, social security was not meant to support a family with teenage children. In most situations, collecting social security plus a retirement pension makes the liminal family ineligible for food stamp assistance, yet may not be enough to cover the costs of raising children. In addition, social security benefits limit the amount of employment income older adults can earn, restricting their ability to obtain additional employment to make up the increase in expenses resulting from caring for their grandchildren. In the following quote, the grandmother is explaining how she struggles and manages to provide the necessities for her teenage grandchildren even within her tight budget.

Grandparent caregiver: *[Youth] is really hard on clothes.*

*For her brother, I can get things at thrift shops for him. I
even go to garage sales.*

The third way these caregivers act their families into being is
through discipline. These caregivers speak of giving the children
"normal" rules and boundaries. They voice expectations, and,
perhaps like many a biological parent, complain about their ado-
lescent's reluctance to follow rules. Undoubtedly, struggling over
child discipline is another "family" thing to do, as these parents
indicate:

Adoptive grandparent: *She watches Power Rangers in the
afternoon. I ask them to do their homework before they
start these other things.*

Grandparent caregiver: *They know I demand respect. I
don't let them yell at me.*

These activity narratives resist the liminal state by performing
family as family is traditionally performed—playing, eating, pro-
viding, and disciplining. However, the liminality lurks beneath
the surface of the narratives, in stories of an elderly grandparent
attempting to play basketball with an adolescent boy, a kinship
caregiver trying to convince a teenage boy to wear clothes pur-
chased at garage sales, and a grandparent whose original parenting
was decades ago trying to understand how to parent a teenager
in the twenty-first century. In addition, through the narratives
themselves—the stories of acting a family into being—these liminal
mothers reinforce the need to construct a family where there is
none; to energize the family essence out of its absence.

ACKNOWLEDGING THE FAMILY INTO BEING

We assign meaning to the extensional world through classification,
providing a common cultural referent to our experiences (Whorf).
Through acknowledging their families into being, these liminal
mothers classify their families as "family." They perform stories
of acknowledgement—having pride in the child, praising the child,

acting as an advocate for the child, encouraging the child, believing in the child's abilities, and having unconditional love for the child. In this way, the liminal mothers are constructing an element of worthiness—these children and these mothers are worthy of being part of this family, and, thus, are part of the family.

One way caregivers "act as" parents is telling stories of pride in their children. Given the children's physical, cognitive, and emotional issues, it was not always easy to find something about which to be proud, but, like any good parent, these liminal mothers did:

> Adoptive grandparent: *He is functional. He is making 40 points every day [of progress in his work]. He's doing all the work. He needs to be back in regular school. I'll fight the system for it.*

> Foster/Adoptive parent: *We try to praise [youth] on how good he is doing ... because he needs to know that we are really pleased with the progress that he is making.*

Research indicates that parental encouragement and challenge, including love, support, direction, discipline, and stimulation, helps children develop self-confidence and achievement (Luke and Coyne; Schmidt and Padilla). Like many parents, these parents want the best for their children and want them to accomplish as much as they can. They have developed future narratives for these children in which they are happy, successful, and self-actualized.

> Adoptive grandparent: *I'd love to have him somewhere where there's some adventure in it. He wants to be a Navy Seal. That's high expectations.*

> Foster/Adoptive parent: *Now he's been getting private art lessons; he is really talented in art. He wants to go into graphic arts.*

Under the canonical marriage discourse, family is unconditional: "Until death do us part." Families endure (Schneider 46-47).

These caregivers talk of the struggle to provide unconditional love to these children, some of whom have multiple, severe problems and may, frankly, be difficult to love. In an acknowledgement of their liminality, these mothers talk about resisting the removal of the children from their homes, but that potentiality lingers over their family continually.

> Foster/Adoptive parent: *We don't want him taken away. We don't want to give up our parental rights. We love this kid; we've been through with him all the way. We're not giving up now but we need help.*

In the context of these liminal families, as foster children "age out" of the system of care, as adoptive parents prepare their adopted children to be self-supporting, or as kinship caregivers contemplate returning their children to their biological parents, they are constructing a narrative of liminal family that at least partially ends when the child leaves their home.

> Foster/Adoptive parent: *You just have to love them anyway and keep on going, and do the best you can for them because I feel like we've given these kids everything we can give them. We've got as much help as we could possibly get for (youth) and we're just doing the best we can. Hopefully, he's going to mature enough in the next year to where at eighteen if he's out on the street, he's going to know to make the right choices.*

The liminal mothers spoke of fighting the system or advocating for these children, much as a biological parent might do. They make sure they know the child's teachers and visit the schools on a regular basis.

> Adoptive grandparent: *He's a special needs child. They will not let him get into the Special Olympics.... The swim teams, tennis at the parks, they refuse to keep him.... He is handicapped. They're not accepting it. I have fought this all the way. I am still trying to find a space for him.*

Grandparent caregiver: *Right now she's in regular school. I know the principal real well. She lets me know how she's doing; I sign something every day.*

These parents have to fight regularly to overcome their family liminality—they have to advocate for rights, services, and legalities. Under the watchful eye of social services, and the jealous eye of the biological parent (who frequently remains in contact with the children and may watch for opportunities to regain custody, reinstate parental rights, or retain his/her parental control), they have to prove their worthiness to care for the child and prove the child's worthiness to receive services. They construct family through displays of worthiness but, in so doing, contradict the very idea of unconditional family-ness, thus using the same argument to, in essence, argue both for and against their family's liminal state. They fight for family but, in so doing, acknowledge the liminal state that necessitates the fight. The special needs status reinforces the liminal state of these families. Children brought into the home may be removed into state custody if the child's behavioural and emotional disturbances become too severe. Parents who lost custody or parental rights to kinship caregivers may still live nearby and drop in regularly, disrupting routines, roles, and rules.

Acknowledging a child as worthy takes extra effort when school or recreational programs use the child's emotional or behavioural problems as reasons to exclude him/her. Acknowledging worthiness is a challenge when "problems" are the first impression the child performs.

SPEAKING THE FAMILY INTO BEING

Whorf said that a person's language influences the way in which he/she understands reality, and how he/she behaves as a result of that understanding. Via the use of language, we assign meaning to our extensional world. Another way that caregivers perform family is to talk about incorporating these children into the rest of their extended family network. They're a family because they say they are. They seem to transcend the "biogenetic" definition of family

(father, mother, children), which is a more recent conceptualization (Gillis 3-19), for a cultural or relational definition (extended family and/or family friends), which is characterized more by its patterns or rules of behaviour than by biology (Schneider). These liminal mothers talk about "family" in extended terms—children, grandchildren, cousins, family friends—and although it is not clear if the liminal families' broadened definition of family preceded the liminal (perhaps having a broad definition of "family" makes a parent more inclined to become an adoptive or foster parent), it is clear the addition of the liminal child is part of a more inclusive definition of family.

> Grandparent caregiver: *All my children come home every day to see me. We always have large gatherings. I've got a big family. We're close. They come here all the time, I cook. Everybody comes home. They're always here.*

It is through performance of these behaviors—both with their children and with me in their interview account—that these liminal mothers stake their place on one side or the other of their liminal space between family-not family, but in so doing, reinforce both family and liminality. They use communication as boundary markers of family, and perform family as a resistance to the liminality of their liminal nature. In a situation in which family boundaries are strained, pushed, and pulled, family stories set and reinforce new boundaries. They talk about the frequent changes in family configuration—how the children may move between their foster parents' and bio parents' homes; how the bio parents may move in and out of their children's lives. Aging liminal parents can move out also, sometimes by choice, sometimes not. Their families are split (biological parents are estranged and removed, yet return), yet they are described as close. The children have problems, but these parents are proud. Families are forever, except when a foster child turns eighteen and has to leave home, or when a child is considered a danger and is removed from the home. These liminal grand/parents perform love for their children unconditionally, but talk about being frustrated at having to raise them. Thus, these liminal

families are family because of their extended boundaries, but they are liminal for the very same reason. Ironically, in a family with extended boundaries in which everyone is family, it may be possible, then, that no one truly is.

LIMITATIONS AND IMPLICATIONS FOR FUTURE RESEARCH

As I mentioned in the methods section, this research looked at the narrative discourse of liminal mothers in in-depth interviews to understand how they create a sense of family. This gave me a chance to observe the stories used to frame, portray, and construct family as part of a performance to an outsider. I did not observe the actual construction of family in their naturalistic setting, nor did I observe the family stories passed on within the families, and these would be natural next steps for research into this issue. It would be very illuminating to conduct an ethnographic study, using participant observation, of liminal families such as these, to see how they perform and construct a sense of family in their day-to-day lives.

CONCLUSION

Regardless of how society defines family, the liminal families in this study fit their own definitions of family. Performance of social roles such as "mother" is based on the social institutionalization of standards or programmed actions for that role (Berger and Luckmann). Family roles are performed whether or not the family is biological, nuclear, or liminal. As framed by the liminal mothers in their stories of family, families are constructed through narratives of activity, worthiness, and inclusion. These liminal mothers are proud of their children, act as advocates for them, encourage and discipline them when necessary, provide for them, and spend time with them when possible. They keep going even when frustrated and tired. The cultural constructs of family, as performed by these liminal mothers, symbolize what each mother believes turns her household into a family, and are similar to the way more traditional families perform family. Yet, true to their liminal state, these liminal families have to both reach out and pull back to perform many

of these behaviours, requiring them to extend boundaries as they perform pride, advocacy, and discipline, and as they strain their provisions and modify their activities. Through communication, they both perform liminality and resist it. Their narrative performances reify their liminal identities at the same time that they resist them. As these families "perform their relationship into being," they are performing a relationship that is—and isn't—a family. In the end, I suggest liminal families can move beyond their liminality through intentional storytelling that includes a longer-term focus on the permanence of their relationship and the belongingness of their boundaries.

WORKS CITED

Babcock, Barbara. A. "Reflexivity: Definitions and Discriminations." *Semiotica* 30.1/2 (1980): 1-13. Print.

Barclay, Craig R. "Autobiographical Remembering: Narrative Constraints on Objectified Selves." *Remembering Our Past* Ed. D.C. Rubin. New York: Cambridge University Press, 1996. 94-125. Print.

Barton, Sharon J. "Promoting Family-Centered Care with Foster Families." *Pediatric Nursing* 25.1 (1999): 57-61. Print.

Berger, Peter L., and Thomas Luckmann. *The Social Construction of Reality: A Treatise in the Sociology of Knowledge.* New York: Anchor Books, 1966. Print.

Burton, Beverly, Christine S. Davis, Norín Dollard, Brent Elrod, and Keren Vergon. "Intergenerational Caregiving: University-Community Partnerships Improving Systems of Care for Grandparents Caring for Grandchildren." 29th Annual Conference of the Association for Gerontology in Higher Education. St. Petersburg, Florida. 7 March 2003. Presentation.

Butler, Judith. *Gender Trouble: Feminism and the Subversion of Identity.* New York: Routledge, 1990. Print.

Charchuk M. and C. Simpson. "Hope, Disclosure, and Control in the Neonatal Care Unit." *Health Communication* 17.2 (2005): 191–203. Print.

Crumbley, Joseph and Robert L. Little. *Relatives Raising Children:*

An Overview of Kinship Care. Washington, DC: Child Welfare League of America, 1997. Print.

Davis, Christine S. *Conversations About Qualitative Communication Scholarship: Behind the Scenes with Leading Scholars.* Walnut Creek, CA: Left Coast Press, 2013. Print.

Davis, Christine S. "Liminal Perspective." *The Sage Encyclopedia of Qualitative Research Methods.* Ed. L. Given. Thousand Oaks, CA: Sage, 2008. 485-86. Print.

Davis, Christine S., and Norín Dollard. "THINK Team Observation: A Mixed Methods Approach to Assess Service Delivery in a Community Mental Health System of Care." *The 16th Annual Research Conference Proceedings, A System of Care for Children's Mental Health: Expanding the Research Base.* Ed. C. Newman, C. Liberton, K. Kutash and R. M. Friedman. Tampa: University of South Florida, The Louis de la Parte Florida Mental Health Institute, Research and Training Center for Children's Mental Health. 2004. 12-14. Print.

Davis, Christine S., Norín Dollard, and Keren Vergon. "The Role of Communication in Child-Parent-Provider Interaction in a Children's Mental Health System of Care." *Parents and Children Communicating with Society: Managing Relationships Outside of the Home.* Ed. Thomas J. Socha and Glen H. Stamp. New York: Routledge, 2009. 133-153. Print.

Davis, Christine S. "Final Stories: The Ultimate Sensemaking Frame." *Storytelling, Self, and Society.* 4 (2008): 1-19. Print.

Derrida, Jacques. *Writing and Difference.* Trans. Alan Bass. Chicago: University of Chicago Press, 1978. Print.

Douglas, Susan J. and Meredith W. Michaels. *The Mommy Myth: The Idealization of Motherhood and How it Has Undermined All Women.* New York: The Free Press, 2004. Print.

Gillis, John R. *A World of Their Own Making: Myth, Ritual, and the Quest for Family Values.* New York: Basic Books, 1996. Print.

Goffman, Erving. *Frame Analysis.* New York: Harper & Row, 1974. Print.

Goffman, Erving. *The Presentation of Self in Everyday Life.* New York: Doubleday, 1959. Print.

Grbich, Carol. *Qualitative Data Analysis: An Introduction.* Thousand Oaks, CA: Sage, 2007. Print.

Gumperz, John J. "Contextualization and Understanding." *Rethinking Context: Language as an Interactive Phenomenon* Ed. A. Duranti and C. Goodwin. Cambridge, UK: Cambridge University Press, 1992. 291-310. Print.

Gunnarsson, Nina Veetnisha, Helena Hemmingsson and Lars-Christer Hyden. "Mothers' Accounts of Healthcare Encounters: Negotiating Culpability and Fulfilling the Active Mother Role." *Discourse and Society* 24.4 (2013): 446-460. Print.

Heisler, Jennifer and Jennifer Butler Ellis. "Motherhood and the Construction of "Mommy Identity": Messages about Motherhood and Face Negotiation." *Communication Quarterly* 56.4 (2008): 445-467. Print.

Holman-Jones, Stacy. "(M)othering Loss: Telling Adoption Stories, Telling Performativity." *Text and Performance Quarterly* 25.2 (2005): 113-35. Print.

Horwitz, Sarah McCue, Kathleen M. B. Balestracci, and Mark D. Simms. "Foster Care Placement Improves Children's Functioning." *Archives of Pediatrics and Adolescent Medicine* 155.11 (2001): 1255-60. Print.

Keller, T. E., et al. "Competencies and Problem Behaviors of Children in Family Foster Care: Variations by Kinship Placement Status and Race." *Children and Youth Services Review* 23.12 (2001): 915-40. Print.

Korzybski, Alfred. *Science and Sanity: An Introduction to Non-Aristotelian Systems and General Semantics*. 5th ed. Brooklyn, NY: Institute of General Semantics, 1994. Print.

Kreider, Rose M. "Living Arrangements of Children: 2004." *Current Population Reports*. Ed. Bureau, U.S. Census. Washington, DC, 2008. Print.

Leeds-Hurwitz, Wendy. *Semiotics and Communication: Signs, Codes, Cultures*. Hillsdale, NJ: Lawrence Erlbaum, 1993. Print.

Luke, Nikki, and Sarah M. Coyne. "Fostering Self-Esteem: Exploring Adult Recollections on the Influence of Foster Parents." *Child and Family Social Work* 13.4 (2008): 402-10. Print.

May, Vanessa. "On Being a 'Good' Mother: The Moral Presentation of Self in Written Life Stories." *Sociology* 42.3 (2008): 470-486. Print.

Miller, B. C., et al. "Adopted Adolescents' Overrepresentation

in Mental Health Counseling: Adoptees' Problems or Parents' Lower Threshold for Referral?" *Journal of the American Academy of Child and Adolescent Psychiatry* 39.12 (2000): 1504-11. Print.

Pollack, Della. *Telling Bodies/Performing Birth: Everyday Narratives of Childbirth.* New York, New York: Columbia University Press, 1999. Print.

Riggs, Damien W., Martha Augoustinos, and Paul H. Delfabbro. "Role of Foster Family Belonging in Recovery from Child Maltreatment." *Australian Psychologist* 44.3 (2009): 166-73. Print.

Riggs, Damien W., Paul Delfabbro and Martha Augoustinos. "Negotiating Foster-Families: Identification and Desire." *The British Journal of Social Work* 39.5 (2009): 789-806. Print.

Rosenfeld, Alvin A., et al. "Foster Care: An Update." *Journal of the American Academy of Child and Adolescent Psychiatry* 36.4 (1997): 448-57. Print.

Schmidt, Jennifer A. and Brenda Padilla. "Self-Esteem and Family Challenge: An Investigation of Their Effects on Achievement." *Journal of Youth and Adolescence* 32.1 (2003): 37-46. Print.

Schneider, David M. *American Kinship: A Cultural Account.* Chicago, IL: University of Chicago Press, 1989. Print.

Shaw, Susan M. and Don Dawson. "Purposive Leisure: Examining Parental Discourses on Family Activities." *Leisure Sciences* 23.4 (2001): 217-31. Print.

Sobol, Michael P., Sharon Delaney, and Brian M. Earn. "Adoptees' Portrayal of the Development of Family Structure." *Journal of Youth and Adolescence* 23.3 (1994): 385-401. Print.

Starkes, Helene, and Susan B. Trinidad. "Choose Your Method: A Comparison of Phenomenology, Discourse Analysis, and Grounded Theory." *Qualitative Health Research* 17.10 (2007): 1372-80. Print.

Turner, Victor W. *The Ritual Process: Structure and Anti-Structure.* Chicago: Aldine, 1969. Print.

United States Census Bureau, U.S. Department of Commerce. *Current Population Survey (CPS) – Definitions.* 29 October 2013. Web. 16 September 2014.

Urban Institute. "Kinship Care." 2003. Web. March 1, 2013.

Van Gennep, Arnold. *The Rites of Passage.* Chicago: University

of Chicago, 1960. Print.

Whorf, Benjamin Lee. "Relation of Habitual Thought and Behavior to Language." *ETC.: A Review of General Semantics*. (1956): 197-215. Print.

12.
Those Eyes

KELLY JESKE

"**D**OES SHE HAVE AN ETHNICITY?**"** Standing near the door of our apartment, the neighbour looks at my sleeping newborn. I am stunned silent.

Later, my partner and I grunt out bursts of incredulous laughter as we try on retorts: "Do *you* have an ethnicity?" "We're not sure yet? Can you usually tell by now?" "Well, of course she does! And so do you!" My neighbour noted difference and asked me to quantify it. This tiny creature, just becoming, must belong to some discrete category. Same or different? Like you or not?

On the street, black men comment on the likeness they see between my daughter and me. "Aw, she looks just like her mama!" they say, usually smiling big. Our brown eyes and full lips, her light skin, build the possibility of our relation by blood. In those moments, I find myself at once flattered by the comparison of myself to this child, and uncomfortable with the erasure of her first mother. I scramble for footing, trying to figure out if I can insert her into the space between myself and my daughter, into the conversation with this stranger. I have the keen sense that I owe it to my daughter to make her first mom real in this moment—that accepting credit for our likeness communicates disregard for their kinship. But some days, I also just want to be recognized as her mama.

Because she has very light skin, I often fear that my daughter won't be read as a person of colour. I ache with the knowledge that, as a white person, I cannot give my daughter racial identity. There's so much that she won't get from her white parents. We won't pass on a cadence of speech that might be recognized as

black; we can't give her the ease of shared history and generations of family experience; we can't build our own family culture of blackness; we can't offer an embodied sense of what it means to be a person of colour.

When she was smaller and had little hair, we adorned it with colourful barrettes, and styled it into puffs and nubs of braids. We used her first and middle name in tandem—her middle name more identifiably African American. We moved to a neighborhood with more black folks and a racially diverse childcare center. We learned to braid and bead her hair. I felt the tug of dissonance as I created visual contrast between myself and my child, while working at the same time to foster our emotional connection.

During our most recent visit with our daughter's first mom, we had professional photos taken together: me, my partner, my daughter, her mother. I looked on, through tears, as we captured images of mother and daughter together. Huddled around a computer screen, picking photos from proofs, the three of us exclaimed over expressions they share and features that are mirrored on their faces. We joked about the little girl with her three mothers and chose the shots that flatter all of us the most. I was eager to adorn our home with pictures of our daughter and her mother, pulling in another way to make their relationship more tangible to our four-year-old. I was excited to show the photos to friends and family, concretizing my daughter's connection to her first mom in a way my words can't manage. Their deep brown eyes, their widow's peaks at the top of their foreheads, the kiss of toast that colours our daughter's skin—to me, their likeness is obvious, irrefutable, beautiful. My favorite pose is with our daughter in her mother's lap, my partner and me kneeling behind them. Our group is centered by our daughter's mother, with all of us connected to and surrounding her—just as our smaller family has been brought to life through her body and choices.

When I share the photos from our visit, I'm astounded by a repeated refrain: "Now, do you see a likeness? I don't really see it." Several times over, individuals profess that my daughter doesn't look like her first mother. They don't say so with disdain or contempt, the people who utter sentiments like this. But they say it with a resolute certainty that makes me think they're saying

something different altogether. Something more like: *She doesn't really look black.* Or something like: *She looks like she's really yours, so don't be worried that she's not.* Or maybe even: *I can almost pretend this weird open adoption thing doesn't exist if I see how much this kid looks like you.* Families claim members by discussing physical likeness; they keep departed beloved close by seeing their characteristics in subsequent generations. When newfangled families come along—mixing up race and gender and blood and circumstance—this comfort in appearance gets shaken. When we keep our daughter's first mother in the picture, we're demanding that a new lens be used—one that recreates possibilities for familial relationship.

I recently watched a video clip of our one-year-old daughter being held by her first mom. They're gazing at each other and she's saying: "Where'd you get those eyes, baby, huh? Who gave you those eyes?" Their eyes are locked as she asks again: "Who gave you those eyes?" My own eyes fill at her tenderness, at this claiming of their connection. As our daughter grows—even primarily apart from her first mom—I watch as her face takes on expressions I've seen cross her first mother's face. I hear tones in her voice, ways that she expresses her thoughts, rhythms in her sentences that remind me of her mother.

When her three mothers talk about this beautiful child, we refer to her as "our daughter." She is my ex-partner's and mine, as we move through our days, navigating parenthood, love, and family. She is her first mom's, once part of her body and living in skin, heart, brain, and cells that are informed by this lineage. As she walks through this world, crafts her own identities, and refines her allegiances, she'll exist in the borderlands—the overlapping places where relationship is complex and origins aren't obvious. My daughter's brown eyes may be similar to my own, but it isn't me who gave them to her. Pushing her into the world, placing her into my arms, holding onto her after she said goodbye, our daughter's first mother shifted tides and created a harbour. By blood and by soul, we navigate in love.

13.
Mothers' Reports of Challenging Conversations with their Adopted Children

Performing the Social Role of Mother

ELYSE M. WARFORD AND LYNNE M. WEBB

ADOPTION CAN BE VIEWED as a rigourous performance of motherhood. Adoptive mothers are deprived of the traditional form of legitimatization of motherhood—birthing their biological children—and instead claim legal and social rights to maternity. In multi-racial and/or multi-cultural adoptive families, mothers routinely can face regular challenges to the legitimacy of their claim to motherhood from people outside the family (Docan-Morgan; Harrigan and Braithwaite; Suter; Suter and Ballard). Furthermore, the mother's partner in her role enactment, her child, can raise issues that challenge the legitimacy to her claim (e.g., "How could I grow in some else's tummy if you are my mom?"). Thus, adoptive mothers face the challenge of designing effective talk for their children, spouse, extended family, and outsiders to socially construct the role often identified as the foundational basis of the species, society, and the family. Of course, in addition to talk, adoptive mothers also engage in behavioural performance of nurturing, as does any care-giver. However, it is the talk through which the mother claims her maternal performance ("I chose you as my child; you are my son") and constructs the social reality of her maternity to those who challenge the claim ("This child is my legal daughter; I have the papers to prove it!"). Our study examines that talk in conversations between adoptive mothers and their adopted children about their children's adoptive status—conversations that the mothers identified as challenging.

When mothers are called upon to make such talk repeatedly, both to multiple audiences about the same issues (such as multiple

strangers who inquire about their child's adoptive status) or to the same audience but multiple times (such as children who repeatedly ask to hear their entrance story), mothers have the time to reflect on the efficacy of their discourse, refine their responses, and in essence develop a scripted response that they can perform in such moments of inquiry. Thus, performance theory (Bell; Goffman; Langellier; Schechner; Strine) guided and informed our research. Since the 1950s, communication scholars examined "the performance and practice of persons communicating" (Eicher-Catt 104). Drawing on the many traditions of performance theory (Bell), previous communication scholars examined performances of culture (Alexander), disability (Scott), gender (Hans, Selvidge, Tinker, and Webb; Morris), identity (Litt), nationality (Woronov), and race (Aleman; Mease and Terry) in a wide range of settings, including anti-drug programs (Hecht and Miller-Day), children's organizations (Woronov), classrooms (Alexander), religious rituals (Ward), school boards (Mease and Terry), social media (Hans et al.; Litt), traditional mass media (Aleman), and, most relevant to our study, families (Eicher-Catt).

We selected the performance theoretical paradigm for three reasons: (1) "Performance is the product and process of communicative actions" (McIntosh 267). (2) To the extent that we view motherhood as a social role, it is entirely fitting that we think of communicators as performing the maternal role; indeed, Goffman's notions of misrepresentation, stigma, passing, and covering in role performance seem apt descriptions of phenomena potentially experienced in adoptive families. (3) Performance theory would argue that answering challenging questions from children in the role of mother would likely include preparation, including rehearsal and enacting cultural scripts (Meng). Given how often little girls "play house," and given the widely known cultural texts surrounding motherhood, such as mothers sacrificing for their children, a reasonable argument could be made that every adoptive mother prepared for such conversations. Furthermore, social scripts are culture-specific; it could be argued that the adoptive families form a unique culture with specific scripts perhaps differing somewhat from those of the biological families (Meng).

REVIEW OF LITERATURE

Like all enduring social phenomena, adoption is the subject of intense scientific examination. Forty years of adoption research has identified multiple issues unique to adoptive families, including the stigma of adoption, developing a positive identity as adoptee, and desire for unification with birth family when such unification is often impossible. Given the documented issues associated with adoption and the popularity of adoption in the US, we were surprised to discover no previously published study examining mother-child scripts in the adoptive family.

Key role of communication in the adoptive family

Many scholars have acknowledged the key role communication plays in the adoptive family. As Perrin affirms, "Children's optimal development seems to be influenced more by the nature of the relationships and interactions within the family unit than by the particular structural form" (341). Komar states, "The shared experience of communication has special importance for members of an adoptive family, for [communication] is the tie that binds them together" (253).

Knowledge claims about communication in the adoptive family

Despite multiple scholars' acknowledgment of the key role communication plays in the adoptive family, few existing research reports address communication in the adoptive family (Galvin, "International"). The lack of published research on communication in adoptive families is curious, given that adoption presents families with a set of unique communication challenges and given that information about scripts for adoptive families could prove useful. While some communication and adoption research focuses on intrusive conversations with people outside the family (Docan-Morgan; Harrigan and Braithwaite; Suter; Suter and Ballard) and the use of internet technology (Baxter, Norwood, Asbury, Jannusch, and Scharp; Gill; Norwood and Baxter; Wahl, McBride, and Schrodt), only a very limited body of research examines communication *in the adoptive family*; our analysis of this research yielded four knowledge claims relevant to our study:

Importance of openness. Adoptive parents are encouraged to disclose known information regarding children's adoption and birthparents whenever children request information (Galvin, "International" 244; Wrobel, Kohler, Grotevant, and McRoy 77). Parents in an adoptive family vary widely in their willingness to self-disclose (Weir 61). However, openness correlates in a positive way with children's psychological adjustment (Brodzinsky 10), their adolescent adjustment (Rueter and Koerner), and to greater degrees of perceived closeness in the family (Sobol, Delaney and Earn 400).

Importance of language. Families can routinely use language that provides a positive image of adoption, laying the groundwork for children to understand adoption-related terms and concepts (Borchers and Committee; 1439; Galvin, "International" 247; Kaye 132). Such positive language provides a counterpoint to the stigma of adoption, typically assigned through the use of stigmatizing language. For example, when adults label biological parents "natural parents," they imply that adoptive parents are "unnatural" (Borchers and Committee 1440). Peers may call the adoptive child's biological parents his/her "real" parents, thus rendering the adoptive parents "fakes." Similarly, many parents find themselves, in conversations with their adopted children, discussing the meaning of such terms as "abandonment," "leave," "relinquish," or "place" (Galvin, "International" 247). Thus, effective scripts about adoption may involve discussing language and framing the differences attributed to adoption as neutral or positive (Galvin, "International"; Kaye).

Identity as adoptee. Previous research documents adoptees' unique issues of identity (e.g., Borders, Penny, and Portnoy; Grotevant, Dunbar, Kohler, and Lash Esau); adopted children must incorporate the life-long adoptive status (Borders, Penny, and Portnoy 415) into their self-images to cope with the social reality they inhabit. While adoption typically is obvious only because of real or perceived differences in physical appearance, abilities, or personality (Grotevant et al. 383), family members employ communication to develop and enact an identity inclusive of adoption (Harrigan; Harrigan and Baithwaite 138; Suter 142).

Importance of adoption stories. Multiple studies document the

benefits of adoption stories (i.e., narratives that parents tell an adoptive child to construct meaning about how s/he was born, separated from birthparents, and integrated into the adoptive family). For example, Krusiewicz and Wood concluded that entrance stories affirm family identities, validate adoption as a legitimate way to form a family, and address the needs of adoptive parents and their children (797). Telling the adopted child the story of how s/he joined the adopted family legitimizes the adopted family structure and positively impacts the child's sense of belonging (Ballard and Ballard; Baxter et al.; Colaner and Kranstuber; Galvin, "Joined by"; Harrigan; Jones; Kranstuber and Kellas; Krusiewicz and Wood; Powell and Afifi; Wrobel et al.).

Each knowledge claim validates the notion that adoptive mothers perform maternity. Indeed, such a performance involves complex scripts and practicing the scripts in preparation for the challenging conversations that inevitably can occur. Such complex scripts involve advanced planning to maintain openness about the adoptive status, to choose scripts that include positivity surrounding aspects of the adoption process and status as an adopted child, to mold a strong self-identity through inclusion and effective communication strategies, and, finally, to develop the adoption story that will be told and retold numerous times to multiple audiences.

Galvin's Six Concerns. Based on her read of the relevant research, Galvin hypothesizes the existence of "six communicative concerns within the adoptive family" ("Joined by" 143): secrecy versus disclosure, language, narratives, addressing physical concerns, cultural socialization practices, and artifacts and rituals. Note the many overlaps with the four previously identified knowledge claims. Our research project attempted to explore challenging mother-child conversations in the adoptive family, in part, to discover if any of Galvin's six hypothesized communicative concerns manifest in reports of maternal scripts in the adoptive family.

THE FOCUS OF OUR STUDY

Previous research indicates that the following ideas may manifest in challenging conservations between mothers and children in

adoptive families: the four knowledge claims distilled from previous research on communication in the adoptive family (openness, issues of language, identity as an adoptee, adoption stories) and Galvin's ("Joined by") six hypothesized communicative concerns (secrecy versus disclosure, language, narratives, addressing physical concerns, cultural socialization practices, artifacts and rituals). Given this background, we undertook a study to answer one simple over-arching question: how do adoptive mothers perform maternity and what scripts do they employ? Specifically, what communication strategies do adoptive mothers report as the most effective ways of addressing issues that arise in mother-child conversations about their child's adoptive status?

We interviewed 27 adoptive mothers, asking them to describe their most challenging conversations with their adoptive children about their adoptive status. The 27th and final mother interviewed provided no new information and thus we deemed the categories saturated. We recruited participants, hereafter called simply mothers, from four sources: (a) students enrolled in a multi-sectioned, freshman-level, basic communication class at a large, public, flagship university, (b) subgroups on two internet websites specifically designed for adoptive families (i.e., familyforums.com and families.com), (c) the listserv of parents who adopted children through a local adoption agency, and (d) "snowballing" our sample by asking each participant to recommend additional adoptive mothers as participants.

Only 22 of our 27 mothers elected to complete a brief demographic questionnaire. Based on data from those 22, the mothers resided in four U.S. states (Arkansas, Missouri, North Carolina, and Oklahoma) and one additional country (Saudi Arabia). Two ethnic groups were represented in the sample (three Saudi Arabians and the remaining were White, non-Hispanic). The mothers ranged in age from 37 to 63 years ($M = 49.77$, $SD = 7.36$). Four mothers reported completing high school; nine reported earning a bachelor's degree; three completed some post graduate work; and six reported obtaining advanced degrees.

The majority of mothers (69.57 percent) reported being married; 13 percent reported being single; and 13 percent reported being divorced. At the time of the interviews, mothers' adopted children

ranged in age from 4 to 33 years. Thirteen of the adoptees (59 percent) were male and 9 (41 percent) were female. While the majority of the mothers' adopted children were Caucasian (59 percent), the children originated from six countries (Ethiopia, India, Korea, Russia, Saudi Arabia, U.S.) and represented six ethnic groups (Asian American, African American, Hispanic American, Middle Eastern, Indian-American, White, non-Hispanic American).

While mothers could select either a face-to-face or telephone interview, only one mother elected a face-to-face interview. All participants granted permission to tape-record the interview. Three telephone interviews were conducted by a female Arabic-speaking student with contacts in Saudi Arabia; she translated the interview protocol and wrote down the mothers' responses in English. Data collection was completed in a six-week period.

One interviewer (23 years old, Caucasian, female, native-born U.S. citizen in her second year of graduate work) conducted the U.S. interviews using the same open-ended, semi-structured interview protocol. She asked each mother to recall and describe her scripts—how she responded in challenging conversations with her adoptive child/ren on topics related to the child/ren's adoptive status. As recommended by Kvale and Brinkmann, the interviewer added probing questions, when needed, to facilitate specific answers to the protocol questions. Mothers were invited to discuss as many challenging conversations and scripts as they desired. They readily recalled challenging conversations with their adoptive children. Most mothers provided detailed descriptions of their scripts as well as their child's responses.

A professional transcriptionist transcribed the recorded US interviews. The transcription, together with typed and translated answers from the Saudi-Arabian interviews, comprised 59 typed, double-spaced pages. Using a grounded theory approach (Corbin and Strauss), the U.S. interviewer subjected the data to deductive thematic analysis to discover common themes that emerged from the interviews. She read through the transcripts seven times, searching for ideas expressed by three or more mothers in their characterizations and descriptions of their scripts in challenging conversations with their adopted children.

RESULTS

Analyses revealed 27 themes that we organized into four categories, i.e. *Conversation Management Strategies* (begin early; initiate conversation; consistency; child-driven conversation; consider age of child; add details with age), *Strategies with General Applicability* (honesty/truthfulness; express feelings; openness; normal/natural; positivity; embrace adoption; acceptance; depends upon audience and circumstance), *Strategies for Specific Topics of Conversation* (belongingness; language choices; explain circumstances; respect birthparents; pregnancy/birth; tell adoption story; willingness to help find birth family; prepare), and *Non-conversational Strategies* (outside resources; religious; contact with birthparents; environment; mementos). Table 1 contains examples of each theme.

Table 1 Communication Strategies Mothers Report as Effective in Challenging Conversations with Adopted Children	
Theme/Number of Mothers	**Examples of Strategies**
Conversation Management Strategies	
Begin early (15)	Told from the beginning (8); known he's adopted since birth (6)
Initiate conversation (8)	Initiate conversations about adoption; must talk about adoption
Consistency (6)	Honesty, so it will never have been inconsistent

Consider age of child (5)	Provided details that were age appropriate (4)
Add details with age (4)	Every year build on story with more details
	Filled in more blanks as he got older and able to handle it
Child-driven conversation (3)	Only give details that are asked for; let the child drive the conversation
	I left it up to her to approach me
	Let her come to me with questions; take the lead (2)
Strategies with General Applicability	
Honesty/truthfulness (12)	Be honest (6); tell the truth (7)
Express feelings (13)	You're special, you're adopted; let them know they are special (5)
Openness (11)	Be open as you can; be very open (11)
Normal/natural (7)	Made it normal (2); make it very normal (3)
Positivity (5)	Made it positive (2); very positive; make it a good thing
	Talk positively about country of origin
Embrace adoption (5)	Don't be afraid of the questions; be willing to answer questions
	Whole family embraced adoption process; embrace adoption culture
Acceptance (3)	Make it no big deal (3); talk about it just like "whatever"
	It's different, but it's not bad or weird

Depends upon audience and circumstance (4)	Every child is different (3); no right or wrong answers
Strategies for Specific Topics of Conversation	
Explain circumstances (15)	Your parents died (4); your mom wasn't able to take care of you (4)
	Your biological mother was too young to raise a child
Belongingness (10)	She is a part of our family and always will be
	"You were hand-picked to be a special part of our family"
Language confusion (9)	Use the word adoption in your home vocabulary early on
	Use word adoption in the story
	Let them choose language; You're vanilla, I'm chocolate, we're swirl family like a Dairy Queen ice cream cone
Respect birthparents (7)	She must have loved you very much to make hard decision
	Never let child hear you say anything negative about birthparents
	Biological mother made sacrifice for her (2)
Pregnancy/birth (7)	You were in her stomach, but I'm your Mom
	You came out of a tummy but not mine
Tell adoption story (6)	Loves to hear her adoption story (2); became bedtime story (2)
Prepare (6)	I prepared myself before the adoption; read books about adoption
	Husband and I talked about it before adoption; had adoption counseling

Willingness to assist in search for birth parents (3)	We'll help you find birthparents when you're 18
Non-Conversational Strategies	
Outside Resources (9)	Counseling (2); books (2); googled his birth father's name
Religious (4)	We believe God's hand was involved
	God made you to be brown and tan
Contact with birthparents (3)	Communication with birth mom simplifies things dramatically
	He has photo albums of biological family
Environment (3)	Kids have friends who were adopted; two cousins were adopted too
	In multicultural environment at school and church
Mementos (3)	Showed videotape of him being adopted in Russia
	Has a plaque on wall about legacy of adoptive child

Note: Numbers in the theme column indicate how many Ps reported the strategy. Numbers in the example column indicate duplicate phrases.

DISCUSSION

Interpretation of Results

We note considerable overlap between the list of 27 emergent strategies and Galvin's ("Joined by") six hypothesized communication concerns in adoptive families (i.e., secrecy versus disclosure, language, narratives, addressing physical concerns, cultural socialization processes, artifacts and rituals) as well as the four knowledge claims distilled from previous research on commu-

nication in adoptive families (i.e., language, openness, adoption stories, contact with birthparents). This provided confirmation that mothers see these ideas at work in challenging conversations with their adopted children, especially in their select scripts. In our analysis, we separated topics of conversation or *issues* from the *communication strategies* or scripts mothers report employing in response to the issues. This chapter contains a report of the emergent *communication strategies* or scripts. Because we separated issues from communication strategies or scripts, it becomes obvious that previous researchers identified primarily categories of communication strategies or scripts rather than the topical content of challenging conversations between parents and their adopted children. Our findings advance this line of research by identifying very specific scripts and communication strategies for the performance of these ideas as they appear in challenging mother-child conversations in the adoptive family.

We found that 14 of our 27 identified strategies overlapped with previous findings. However, our analysis revealed 13 new ideas for coping with the challenging conversations. The "new" strategies or scripts involved one of four approaches:

Painting a *positive picture of adoption* beyond mere language choices (positivity, respect for the birthparents, seeing adoption as normal and natural), as exemplified in the following quotations from the transcripts. We assigned our interviewees fictitious names to protect their anonymity.

> Abby: *Without fail since he was old enough to talk, on his birthday, he always says a prayer for his mother, and brings Philippine egg rolls instead of cupcakes to his classmates. His birthday is dedicated to his birthmother and his culture.*

> Beth: *We have pictures on the wall downstairs of all of our family, and we have included a picture of their birthparents on the wall as well.*

> Carol: *I just told her that her mother was twenty years old and already had two kids and they were just very poor*

and she just couldn't take care of another kid. I've just always tried to instruct her that I didn't think that that was something she should hold against her [birth mother] because, I mean, I can imagine that that must have been a very hard decision, especially having other children. I just tell her that I feel like she [birth mother] did her a big favor because she has it good with us.

Deborah: *His story became a bedtime story when he was little. Here's the deal, if you adopt and you always intend to tell your child that he's adopted, when do you do it? When are they ever ready? You always think your baby is too young. What is he going to do, wake up at eighteen and find out? Or are you going to just sit them down and tell them sporadically? Just always talk to the child from the beginning. Keep it in their mind so you know they don't forget. So he would say "tell me the story momma about how I was adopted." So I would tell him, "well I went to pick you up and I cried." He says, "why did you cry?" and I'd say, "because I was happy."*

Ellen: *He knows he's special because he was chosen and we celebrated "gotcha day" for years. He was born on June 5th and we adopted him on July 22nd. So we celebrated not only his birthday, but the day we became a family.*

Talking honestly and truthfully (consistency, honesty/truthfulness, pregnancy/birth).

Fran: *I talked to her about it [adoption] and told her yes that sometimes when a mommy can't provide a good home for their baby then another mommy and daddy will provide that good home. And then I just reinforced the things that she already knew. That we were tickled to get her, that we got her because my tummy was broke, that she was a part of our family, that she'd always be a part of our family, and I just didn't focus on the other assets. But I also got permission from the school principal and*

the teacher to come and read a book about adoption and talk to her class a little bit about adoption to make her feel more like, I don't know, just to give a little more acceptance I guess is the word.

Approaching the task rhetorically employing the appropriate scripts at the appropriate time (consider age of child, add details with age, child-driven conversations, depend on audience and circumstances).

Georgia: *I would say start early. I liked my husband's approach, which was to be honest but not give all the details until they're asked for. So we only answered what was age appropriate by how she drove the conversation. So because it was always honest, then every year that we build on it with more details, like she doesn't understand HIV. I think that she thinks that her mom has cancer, because we had a friend living with us who died of cancer and I think that that's what she relates it to. But we have been honest so someday when we say it's HIV it will never have been inconsistent. So starting early and honest, but not giving so much information that they can't understand for their age.*

Acquiring conversational resources (preparing, outside resources, religion).

Hannah: *I remember that my sister gave me a little scene that she had cross-stitched with "Not flesh of my flesh, or bone of my bone, but still miraculously my own" and she gave that to me to give to him. I think when I gave that to him it touched him a lot. I think he was really happy.*

Many of these strategies or scripts can be performed simultaneously; for example, mothers can honestly describe helpful resources. However, other specific strategies may not pair well, giving rise to the question of how mothers select the scripts or strategies they will employ. The mothers reported two key factors that guided

such decisions: the age of the child and the topic itself. In their minds, certain strategies "went with" certain challenging topics and all scripts needed to adapt to the age and developmental stage of the child.

While the approaches and scripts enumerated above (i.e., painting a positive picture, talking honestly and truthfully, approaching the task rhetorically, and acquiring conversational resources) are not new to students of public speaking or public relations, they are rarely discussed in the family context. Perhaps their emergence in our data speaks directly to the performance-nature of the role of adoptive mother. As with any role, the successful communicator must prepare, as well as provide a positive and honest performance designed to appeal to her audience.

A closer examination of the 27 strategies reveals further details of maternal performance. For example, many of the verbal strategies our interviewees reported as successful (e.g., explain circumstances of adoption, employ language that respects birthparents, select inclusive language, tell arrival story) assisted children in the social construction of motherhood based on choice and emotional attachment rather than mere biology. The mothers spoke of assisting children to bridge/join two families by finding positive ways to portray biological mothers who enacted the role of caring mother when relinquishing parental rights, as well as positive portrayals of adoptive mothers who enact the role of caring mother when providing day-to-day care for children. Finally, the mothers encouraged their children to develop positive self-identity as adoptive children—children with two loving mothers and multiple loving family members. In sum, our findings are consistent with both previous research on communication in the adoptive family and also with a performance orientation to adoptive mothering. Thus, similar to Eicher-Catt, we found evidence of communicative role performance within the family, specifically mothers preparing scripts that they performed often repeatedly (such as in the arrival story) to an important audience of one, their adopted child. Such scripts allowed the mothers to engage in a relatively challenging performance of motherhood, specifically engaging in the social construction of family bonds in the absence of shared biology.

WORKS CITED

Aleman, Sonya M. "Americans in Brown Bodies: An Analysis of Journalistic Performances of Whiteness." *Southwestern Mass Communication Journal* 26.1 (2010): 1-18. Print.

Alexander, Bryant Keith. "Performing Culture in the Classroom: An Instructional (Auto)Ethnography." *Text and Performance Quarterly* 19.4 (1999): 307-331. Print.

Ballard, Robert L. and Sarah J. Ballard. "From Narrative Inheritance to Narrative Momentum: Past, Present, and Future Stories in an International Adoptive Family." *Journal of Family Communication* 11.2 (2011): 69-84. Print.

Baxter, Leslie, Kristen Norwood, Bryan Asbury, Amber Jannusch, and Kristina M. Scharp. "Narrative Coherence in Online Stories Told by Members of the Adoption Triad." *Journal of Family Communication* 12.4 (2012): 265-283. Print.

Bell, Elizabeth. *Theories of Performance.* Thousand Oaks, CA: Sage, 2008. Print.

Borchers, Deborah and the Committee on Early Childhood, Adoption and Dependent Care. "Families and Adoption: The Pediatrician's Role in Supporting Communication." *Pediatrics* 112.6 (2003): 1437-41. Print.

Borders, L. Diane, Judith M. Penny, and Francie Portnoy. "Adult Adoptees and their Friends: Current Functioning and Psychological Well-being." *Family Relations* 49.4 (2000): 407-18. Print.

Brodzinsky, David. "Family Structural Openness and Communicative Openness as Predictors in the Adjustment of Adopted Children." *Adoption Quarterly* 9.4 (2006): 1-18. Print.

Colaner, Colleen Warner, and Haley Kranstuber. "'Forever Kind of Wondering': Communicatively Managing Uncertainty in Adoptive Families." *Journal of Family Communication* 10.4 (2010): 236-255. Print.

Corbin, Juliet and Anselm Strauss. *Basics of Qualitative Research: Grounded Theory Procedure and Techniques.* Newbury Park, CA: Sage, 1990. Print.

Docan-Morgan, Sara. "Korean Adoptees' Retrospective Reports of Intrusive Interactions: Exploring Boundary Management in

Adoptive Families." *Journal of Family Communication* 10.3 (2010): 137-57. Print.

Eicher-Catt, Deborah. "Advancing Family Communication Scholarship: Toward a Communicology of the Family." *Journal of Family Communication* 5.2 (2005): 103-121. Print.

Galvin, Kathleen. "International and Transracial Adoption: A Communication Research Agenda." *Journal of Family Communication* 3 (2003): 237-53. Print.

Galvin, Kathleen. "Joined by Hearts and Words: Adoptive Family Relationships." *Widening the Family Circle: New Research in Family Communication.* Ed. Kory Floyd and Mark T. Morman. Thousand Oaks, CA: Sage, 2006. 137-52. Print.

Gill, Jungyun. "Constructing and Enhancing the International Adoptive Family through Communication Technology." *Marriage and Family Review* 45.6 (2009): 783-806. Print.

Goffman, Erving . *The Presentation of Self in Everyday Life.* New York: Anchor, 1959. Print.

Grotevant, Harold D., Nora Dunbar, Julie K. Kohler, and Amy M. Lash Esau. "Adoptive Identity: How Contexts Within and Beyond the Family Shape Developmental Pathways." *Family Relations* 49.4 (2000): 379-87. Print.

Grotevant, Harold D. and Ruth G. McRoy. "The Minnesota/Texas Adoption Research Project: Implications of Openness in Adoption for Development and Relationships." *Applied Developmental Science* 1.4 (1997): 168-86. Print.

Hans, Mark L., Brittney D. Selvidge, Katie A. Tinker, and Lynne M. Webb. "Online Performances of Gender: Blogs, Gender-bending, and Cybersex as Relational Exemplars." *Computer Mediated Communication in Personal Relationships.* Ed. Kevin B. Wright and Lynne M. Webb. New York: Peter Lang Publishers, 2011. 302-323. Print.

Harrigan, Meredith Marko. "Exploring the Narrative Process: An Analysis of the Adoption Stories Mothers Tell Their Internationally Adopted Children." *Journal of Family Communication* 10.1 (2010): 24-39. Print.

Harrigan, Meredith Marko and Dawn O. Braithwaite. "Discursive Struggles in Families Formed through Visible Adoption: An Exploration of Dialectical Unity." *Journal of Applied Commu-*

nication Research 38.2 (2010): 127-44. Print.

Hecht, Michael L. and Michelle A. Miller-Day. " 'Applied' Aspects of the Drug Resistance Strategies Project." *Journal of Applied Communication Research* 38.3 (2010): 215-229. Print.

Jones, Stacy Holman. "(M)othering Loss: Telling Adoption Stories, Telling Performativity." *Text and Performance Quarterly* 25.2 (2005): 113-135. Print.

Kaye, Kenneth. "Acknowledgement or Rejection of Differences?" *The Psychology of Adoption* Ed. David M. Brodzinsky and Marshall D. Schechter. New York: Oxford University Press, 1990. 121-43. Print.

Komar, Miriam. *Communicating with the Adoptive Child*. Lincoln, NE: iUniverse.com, Inc., 2000. Print.

Kranstuber, Haley and Jody Koenig Kellas. " 'Instead of Growing Under Her Heart, I Grew in It': The Relationship between Adoption Entrance Narratives and Adoptees' Self-Concept." *Communication Quarterly* 59.2 (2011): 179-199. Print.

Krusiewicz, Erin Shank and Julia T. Wood. "He Was Our Child from the Moment We Walked into That Room: Entrance Stories of Adoptive Parents." *Journal of Social and Personal Relationships* 18.6 (2001): 785-803. Print.

Kvale, Steinar and Svend Brinkmann. *Interviews: Learning the Craft of Qualitative Research Interviewing*. 2nd ed. Thousand Oaks, CA: Sage, 2009. Print.

Langellier, Kristen M. "Personal Narrative, Performance, Performativity: Two or Three Things I Know for Sure." *Text and Performance Quarterly* 19.2 (1999): 125-144. Print.

Litt, Eden. "*Knock, Knock*. Who's There? The Imagined Audience." *Journal of Broadcasting and Electronic Media* 56.3 (2012): 330-345. Print.

McIntosh, Dawn M. "The Forest of Performance Theories: A Review of Theories of Performance." *The Review of Communication* 9.3 (2009). Web. 23 Feb. 2014.

Mease, Jennifer J. and David P. Terry. "[Organizational (Performance] of Race): The Co-Constituted Performance of Race and School Board in Durham, NC." *Text and Performance Quarterly* 32.2 (2012): 121-140. Print.

Meng, Hong Dang. "Social Script Theory and Cross-Cultural

Communication." *Intercultural Communication Studies* 17:1 (2008): 132-138. Print.

Morris, Rosalind C. "All Made Up: Performance Theory and the New Anthropology of Sex and Gender." *Annual Review of Anthropology* 24 (1995): 567-592.

Norwood, Kristen M. and Leslie A. Baxter. "'Dear Birth Mother': Addressivity and Meaning Making in Online Adoption-Seeking Letters." *Journal of Family Communication* 12.4 (2011): 198-217. Print.

Perrin, Ellen C. "American Academy of Pediatrics Technical Report: Coparent or Second-parent Adoption by Same-sex Parents." *Pediatrics* 109.2 (2002): 341-44. Print.

Powell, Kimberly A. and Tamara D. Afifi. "Uncertainty Management and Adoptees' Ambiguous Loss of Their Birth Parents." *Journal of Social and Personal relationships* 22.1 (2005): 129-51. Print.

Rueter, Martha A. and Ascan F. Koerner. "The Effect of Family Communication Patterns on Adopted Adolescent Adjustment." *Journal of Marriage and Family* 70.3 (2008): 715-727. Print.

Schechner, Richard. *Performance Theory.* New York: Routledge, 2003. Print.

Scott, Julie-Ann. "Stories of Hyperembodiment: An Analysis of Personal Narratives of and through Physically Disabled Bodies." *Text and Performance Quarterly* 32.2 (2012): 100-120. Print.

Sobol, Michael P., Sharon Delaney and Brian M. Earn. "Adoptees' Portrayal of the Development of Family Structure." *Journal of Youth and Adolescence* 23.3 (1994): 385-401. Print.

Strine, Mary S. "Articulating Performance/Performativity: Disciplinary Tasks and the Constingencies of Practice." *Communication: Views from the Helm for the 21st Century.* Ed. Judith Trent. Boston: Allyn and Bacon, 1998. 312-317. Print.

Suter, Elizabeth A. "Discursive Negotiation of Family Identity: A Study of U.S. Families with Adopted Children from China." *Journal of Family Communication* 8.2 (2008): 126-47. Print.

Suter, Elizabeth A. and Robert L. Ballard. "'How Much Did you Pay for Her?' Decision-making Criteria Underlying Adoptive Parents' Responses to Inappropriate Remarks." *Journal of Family Communication* 9.2 (2009): 107-25. Print.

Wahl, Shawn T., M. Chad McBride, and Paul Schrodt. "Becom-

ing 'Point and Click' Parents: A Case Study of Communication and On-line Adoption." *Journal of Family Communication* 5.4 (2005): 279-94. Print.

Ward, Richard F. "Mourning at Eastertide: Revisiting a Broken Liturgy." *Journal of Communication and Religion* 20.2 (2008): 15-24. Print.

Weir, Kyle N. "Multidimensional Aspects of Adoptive Family Social Disclosure Patterns." *Adoption Quarterly* 5.1 (2001): 45-65. Print.

Woronov, T E. "Performing the Nation: China's Children as Little Red Pioneers." *Anthropology Quarterly* 80.3 (2007): 647-672. Print.

Wrobel, Gretchen Miller, Julie K. Kohler, Harold D. Grotevant, and Ruth G. McRoy. "The Family Adoption Communication (FAC) Model: Identifying Pathways of Adoption-Related Communication." *Adoption Quarterly* 7.2 (2003): 53-84. Print.

14.
Punjabi Matriarchs

Demonstrating Intergenerational Cultural Preservation

PAVNA SODHI

Matriarchy means nothing less than the end of oppression.
—Jane Alpert

FOR THE LAST DECADE, since the day I learned that I was pregnant with my firstborn, I have had the opportunity to reflect upon my childhood and its relevancy to my role as a mother to my two daughters, Nadya and Ameya. I have realized that my diverse personal experiences, my interaction with several familial and community mother figures, and my education have further shaped my current cultural matriarchal identity. As mothers, we are given the gift to bear, raise, nurture, and positively influence our children (Hays). Intergenerational practices performed by my mother, maternal grandmother, older sister, and six maternal aunts have not only played a integral role in my cultural matriarchal identity formation but have also been passed down to my daughters. I have a better appreciation of motherhood; understanding it is a critical part of my own womanhood.

In the following narrative, I explore the covert intersection of cultural feminist theories and intergenerational, bicultural identity formation with family and community women who affected my bicultural identity formation. I will demonstrate how familial and community matriarchs have seamlessly exhibited these aspects of performance in my life. For me, the term Punjabi matriarch represents an influential and prominent familial or community member. Performance, as Goffman describes, represents "all activity of a given participant on a given occasion which serves to

influence in any way any of the other participants" (24). Mothering is a cultural practice in that it becomes an everyday aspect of one's being; as a result it is viewed as a mother's responsibility to communicate, model, and improvise mothering to future generations of mothers (Oyewumi; Ruddick; Woollett). According to Goffman's concept of "expressions given," communicating culture can often be more of a "theatrical and contextual kind, the non-verbal, presumably unintentional kind, whether this communication be purposely engineered or not" (4). Not surprisingly, I feel performing "ethnic" or culturally-infused mothering activity requires creativity, consistency, rehearsing, and spontaneity for long-term cultural preservation to transpire.

Utilizing a cultural feminist framework (Butler; Collins; Corey; Mitra), my intentions here are to demonstrate the importance of performing cultural and maternal practices to third-generation children. My maternal practices and activity have been primarily based on my observations of influential women in my life, including my mother. By emulating these women, I have been selective with what to script, transmit, and preserve with my daughters.

According to Carolyn Enns, cultural feminist theories discuss the impact of interdependence over individualism, the endorsement of feminine values, including collectivistic ideologies, mutual respect, consistent encouragement, unconditional positive regard, and empathy. Additionally, Jane Alpert's term "mother right" strongly resonates with me as I have adopted a more collectivistic, empathic, and intuitive Punjabi platform for my daughters to learn about their ethnic heritage (92). I have been culturally conditioned to function in a collective manner. On a familial and community level, I have discovered it truly takes a village to raise a child and to successfully preserve and nurture culture in younger generations (Moore). It requires patience, respect, and a non-judgemental mindset.

What I have learned from my experience over the years is that mothers teach and transmit culture in distinctive ways. I have applied past experiences and made a concerted effort to effectively amalgamate Canadian and Punjabi cultures in our home. As a Punjabi matriarch, I continue to remain enthusiastic, while spending time and energy with my daughters to help them successfully learn, appreciate, and respect their cultural heritage. I have made

tremendous progress with Nadya regarding the development of a bicultural identity; she declares being proud of her Punjabi-Canadian culture. I have already observed her "passing on" and modeling intergenerational cultural values to her younger sister, Ameya.

Thus, this chapter will address three central and interrelated issues: first, it shares the evolvement of my maternal and bicultural identity formation; second, it describes how culture is re-scripted, modelled, and performed to the third-generation in order to promote long-term cultural appreciation and preservation; and last, it will examine the cultural feminist-infused strategies that encourage past, present, and future matriarchs to impart culture to subsequent generations.

ON BECOMING A PUNJABI MATRIARCH

Matriarchs within the family and ethnic community are bearers of tradition who believe in consistent cultural preservation, whether it is by creating experiences or simply performing (Das and Kemp; Naidoo; Sodhi, "Respecting the East"). In my life, these women have shown me how to be strong and resilient, and how to make family a priority. In essence, I was taught to spend ample time with my children in order to invest in their future personal and academic wellbeing.

My story simply begins in Halifax, Nova Scotia, where I was born a second-generation Punjabi-Sikh. I was raised by two educated and voluntary immigrants who initially migrated to Northern Alberta, Canada in the early 1960s, nine years before I was born. The main reason voluntary immigrants migrate to a new country is to provide a better life for themselves and their family (Sodhi, *Punjabi Women*). My parents were no different. After they upgraded their education in Alberta, they found relevant employment in Newfoundland, and later moved to Halifax, Nova Scotia, where they established themselves personally and professionally within the Maritime community.

Both of my parents played a unique role in transmitting culture to their three children; my mother was responsible for teaching language (by telling us Punjabi folktales at night), communicating religious traditions, making us Punjabi meals, and reinforcing family

togetherness and sibling camaraderie. Holidays from Canadian and Punjabi cultures (e.g., Christmas, Easter, Thanksgiving, Diwali, Gurpurab, Rakhi, Baisakhi, Holi, Lohri) were celebrated in our home. Thus, my mother's determination to preserve culture were transmitted experientially rather than being enforced upon us. The result was that more time was spent on religious and cultural preservation than on language preservation.

Everyone transmits culture differently. My mother had a propensity to "create experiences" and utilize cultural props at home. Between the ages of twelve and fifteen years, I learned how to cook Punjabi cuisine from my mother. She would encourage me to get involved by sharing stories about her childhood memories of being in the kitchen with her mother. I would often watch her magically add spices from her *masala dubha* (spice container) to her Punjabi culinary creations, and I hoped that one day I would have the same confidence and passion for cooking Punjabi cuisine that she regularly presented throughout my childhood.

My mother believed in the importance of family and extended family, respect for others/elders, and modelling compassion and empathy. As a family, we travelled frequently to India to remain connected to our grandparents, extended family, and Punjabi culture. A whole other dimension of identity formation took place in India where we had daily exposure to our vibrant Punjabi traditions and interaction with myriad extended family members. Aside from benefiting from my mother's efforts, I have been very fortunate to have influential and resilient women present in my life. I spent countless afternoons with my maternal grandmother, *Beeji,* learning about her worldviews and life experiences.

One afternoon *Beeji* explained in detail how women used to congregate and support one another at a *Trinjhan* (ladies' social get-together). She described a *Trinjhan* as a safe place where Punjabi traditions and customs were performed and passed down through the generations, thereby creating a sisterhood of participants. The older women from the village would transmit and teach cultural secrets and rituals to the younger women. At these gatherings, women would sing, talk, and share openly and honestly about life, marriage, and child rearing. Simultaneously, younger women would individually embroider their *phulkari*

(Punjabi tapestry). This allowed women a safe stage on which voice their concerns, confide in one another, and receive emotional support.

Beeji only had a Grade 8 education, the highest level of education women could attain in 1920s India. At the age of seventeen years, she was married and her new name was branded on her right arm. I remember asking why her name was tattooed on her arm. I was told that at the time of her marriage, she was given to another family and therefore renamed. By being subjected to modifying her identity in order to meet the expectations of her new family, *Beeji* realized she did not want the same for her seven daughters. Thankfully, *Beeji* was self-aware, progressive, and learned; she adamantly believed that women should be educated and financially independent; she was wise beyond her years.

My grandmother performed various aspects of mothering to her daughters, from how to be domesticated to teaching Sikh religious values. However, as with many Punjabi women (Forbes; Mitra; Sodhi, "Women and Education") empowering her daughters to become strong, educated women remained a priority for her. I still recall having conversations with my grandparents who reminded me of the importance of aiming high and setting realistic life goals. I have carried their sentiments with me for over twenty-five years and continue to remind my eldest daughter of the importance of hard work and putting the "best in every moment."

I promised my *Beeji* I would play two *shabads* (religious hymns) a day on a *harmonium* (Indian piano-like organ) and attend the morning prayer services at the nearby *Gurdwara* (Sikh temple) during our visits with her in India. I was also motivated to practice my spoken Punjabi and write letters in *Gurmukhi* (Punjabi alphabet) year- round to stay in contact with her.

My six maternal aunts, whom I individually and affectionately call *Massi* (meaning *was your mother* in Punjabi), played a dynamic cast in my cultural matriarchal identity formation. My *Massis* all graduated from university and went on to become educators, lawyers, or both. My childhood trips to India showed me models of positive female unity rather than cyclical trends of "women treating women badly," such as lack of professional encouragement and support, forced "intensive mothering" (Bell), and covert bullying

(Forbes; Puri; Sodhi, *Punjabi Women*). I witnessed the emergence of empowered familial matriarchs, a shift that I hoped would continue with my daughters and their future offspring.

Within my immediate family, Natasha, my older sister and lifelong mentor, has regularly encouraged me to be proud of my ethnic heritage. I remember her being actively involved in the Punjabi community while concurrently maintaining an A average throughout her schooling. Natasha's early ambitions influenced me and reinforced our family values about cultural preservation, hard work, and higher education.

I also learned *bhangra* and *giddha* (Punjabi folk dancing) from my sister and eventually taught dances to the younger Punjabi female children. Our relatives were often amazed at our ability and willingness to perform *bhangra* and *giddha* and sing *shabads*. We wanted so badly to be a part of the Punjabi way of life; we were motivated to speak Punjabi, act Punjabi, and demonstrate how we performed or preserved culture in Canada. Now, my mindset is occasionally situational, and sometimes I speak in Punjabi and often think in Punjabi. Fortunately, I can code-switch gracefully from one cultural experience to the next. I've realized that there is no better word than *raunuk*, which can be loosely translated as *positive excitement,* or *callara*, which means *clutter.*

Similar to experiences of African and Ghanaian women and children, my "intimate network of female relatives (e.g., aunts, cousins, grandmothers, and sisters) and friends not related by blood, provided parenting and advising help that tied women to larger networks and facilitated the creation of the extended family structure" (Gilchrist and Camara 84). Again, living in Nova Scotia, far away from family residing in India, community involvement also contributed to what researchers might consider my bicultural identity formation (Phinney and Rosenthal; Tiwana; Tomar). Cultural resources were limited in Halifax; fortunately, the local Punjabi community, *Maritime Sikh Society Gurdwara*, carefully filled that void.

The *Maritime Sikh Society Gurdwara*, established in 1978, enabled the *sangat*, (religious congregation) to preserve various dimensions of cultural identity. For many individuals, the *Gurdwara* is not only a place of worship, but also enables

first-, second-, and now third-generation women to thrive in a culturally positive, spiritual, and cohesive community milieu. Similar to participating in a theatrical production, women of our particular *Gurdwara* were responsible for preparing the *langar* (communal lunch), and teaching *shabads* and Punjabi school to the younger generations. These women have become "extended family" over time and gradually formed a sisterhood of sorts (Sodhi, "Respecting the East").

In 1995, when I moved from Halifax to Ottawa, Ontario, to pursue further studies, I noticed that my childhood cultural experiences and life script differed significantly from that of other Punjabi individuals. I thought I had preserved a tremendous amount of culture. At the time, my definition of preserving culture included: spending an abundance of time with my Punjabi peers on a regular basis, eating Punjabi food, listening to Punjabi music, and performing *giddha* annually at various cultural shows. I believed I had successfully combined "the best of both cultures."

All this was questioned during my marriage to another second-generation Punjabi Sikh individual in 1999, which also added another layer to my bicultural identity formation. I experienced ten months of intense Punjab traditions from the day my husband proposed to me until two weeks after our wedding. We were both overwhelmed by the diversity of traditions and at times were uncertain about the meaning or symbolism behind each of these rituals. As well, I began to see different traditions, beliefs, and value systems that were extremely foreign to me.

It only makes sense that I developed a fascination for, and affinity with, Punjabi women and cultural preservation, and therefore, in 2001, completed a doctoral dissertation entitled *Punjabi Women Living in Eastern Canada: A Study Exploring How Parental Attitudes Influence Intergenerational Cultural Preservation and Ethnic Identity Formation* (Sodhi, *Punjabi Women*). Since that time, I have continued to share my research about cultural transmission and preservation in Punjabi individuals (i.e. adolescents, women, and seniors) in assorted scholarly journals and books. I have had the opportunity to present my work in a variety of venues in hopes of heightening awareness about cultural preservation and reaching out to receptive audiences.

The matriarchs represented in my family and community, my education, and dominant cultural resources strengthened the importance of consistent cultural preservation. From my experiences with these women, I have reinforced my role as a Punjabi matriarch, and am making an effort to impart culture in a way that continues to inspire my daughters to be motivated to learn more about their colorful Punjabi heritage.

PERFORMING CULTURE TO THE THIRD GENERATION

In 2003, when I found out that I was pregnant, I envisioned how I would perform culture in my child's life. I reminisced about my mother's resourceful and immediate energy which she used to share her heritage with all three children. My eldest daughter, Nadya Swaran, was born in 2004. Her name is bicultural; it means *River* in Punjabi and *Hope* in Russian. *Swaran* was my *Beeji*'s name. Surprisingly, at a young age, Nadya expressed a preference for the Punjabi meaning and pronunciation of her name.

Goffman's term "dramaturgy" suggests that individuals live their lives similar to actors on a stage and need to socialize with others in order to gain life experiences. It is simply a fact that the cultural experiences of both my daughters, Nadya and Ameya, will be different from those of my childhood. I began my quest to preserve culture in Nadya by demonstrating the importance of, and nurturing her with, Punjabi food, introducing Punjabi words, and attending *Gurdwara* (local cultural shows) and Punjabi weddings. Really, anything remotely Punjabi! Like my mother, I was essentially trying to "create experiences" for Nadya to discern her Punjabi culture.

I have highlighted the value of grandparents in Nadya and Ameya's lives and can attest that so much can be learned from older generations. Thus far, extended family and cousins have played a huge role in both Nadya and Ameya's life. We typically celebrate most cultural holidays with their grandparents, who also impart their life experiences and memories with the girls. As our entire extended family lives on the same continent, we visit each other often to ensure the cousins develop strong familial and cultural bonds.

I have been cognizant of the fact that Nadya needed activities and other social outlets in her life. Early on, I registered her in music classes, swimming, soccer, skating lessons, piano classes, and ballet. Before she entered Punjabi School, I started staging bicultural holidays; the *Baisakhi* Bunny is a combination of a Punjabi harvest time holiday and the westernized version of the Easter Bunny. Nadya recognizes these efforts while simultaneously appreciating the best of both cultures.

Once more Punjabi resources became available in Ottawa, there was a further shift in my interest and enthusiasm concerning cultural transmission. In 2009, when Nadya turned five, I enrolled her in the *Ottawa Sikh Society Punjabi School*. Their program comprises three sections: Punjabi-Sikh culture and dance, language (written and oral), and Sikh religion and history. The classes run from September to May, and culminate in a cultural show or *Baisakhi Mela*. Nadya has completed four of eight levels of Punjabi School this year and is able to speak, read, and write Punjabi.

What has fascinated me the most is Nadya's ability to code-switch between Punjabi events and Canadian activities. One of my favourite examples is *The Bicultural Weekend*, which consisted of *Baisakhi Mela*/Piano Recital, in which Nadya demonstrated the innate ability to adapt and thrive in any setting. On the first day, Nadya performed a typical Punjabi dance at the *Mela* and the next day played two classical pieces at her piano recital. She has had several weekends such as the one mentioned above, and has wholeheartedly accepted these weekends as a way of life, accommodating again both cultures in her mindset.

Over the years, I have provided innovative approaches for Nadya to practice and learn about Punjabi culture, language, and religion via board books, puzzles, and games. I try to make all learning interactive and part of everyday life in our home. Be it anything from learning about Sikh traditions to playing piano, it is usually fun and spontaneous. Nadya is genuinely interested in her cultural background, takes her Punjabi books to school, and tries to teach her peers how to write *Gurmukhi*. More recently, she started wearing Indian suits to school to celebrate and acknowledge cultural holidays such as *Diwali* and *Holi*. I asked Nadya to wear a *kara* (Sikh bracelet), which represents

Sikh identity. As taught to me by my sister and elders, I now encourage Nadya to remain proud of her Punjabi-Sikh culture, and to share her traditions with others.

In 2011, when Nadya was almost seven years old, my husband and I had the pleasure of taking Nadya alone to India, as Ameya was not born yet. Our trip was completely spur-of-the-moment, planned in less than a month, as we realized this was a once-in-a-lifetime chance to reconnect with family in India. Nadya was able to experience the Punjabi culture first hand, visit Sikh temples, and, most importantly, socialize and learn from my maternal aunts. Nadya was finally able to link what she learned at home and Punjabi school with her visit to India, just as I had done during my upbringing. To this day, she fondly asks about the family she met and repeatedly inquires when our next trip to India will take place.

As Ameya is almost two years old, I intend to provide her with a variety of bicultural experiences/productions utilizing a similar cultural platform as I did with Nadya, where she too will be able to layer one experience after the next. Ameya will have Nadya to help her better comprehend cultural concepts, interpretations, and preferences. Ameya is fortunate to have Nadya as a positive role model and mentor, just as I had with my older sister, Natasha.

I feel fortunate that Nadya is a member of an ethnic community in Ottawa, and that she continues to learn more about her heritage from family and via *Ottawa Sikh Society Punjabi School*. Nadya has normalized both cultures in her mindset and demonstrated a sincere and genuine appreciation for her bicultural practices. Nadya was an only child until she was eight and a half years old; Ameya, her younger sister, born in 2012, will be the next Punjabi matriarch to learn from her older sister.

And the *bhangra* beat goes on....

FUTURE DIRECTIONS AND AFTERTHOUGHTS ...

My observations of developing a bicultural identity and nurturing the identities of my daughters led me to view our experiences through a feminist lens. Cultural feminist discourse includes research around cultural mothering via performance, intergenerational

communication, cultural curiosity, creation of cultural experiences, observing familial camaraderie, and sisterhoods (Moore; Sevón). These dialogues suggest a link with cultural matriarchal identity formation, including the responsibility of role-modelling.

Moore contends that the "younger generation understands motherhood as an aspect of personal development and the development of interpersonal relationships that are central to a woman's identity" (169). As a mother, I have learned a tremendous amount about my bicultural identity formation and family relationships, while re-experiencing it through my daughters' development. It is situational in that I continue to pick and choose traditions and values in given moments that I believe are worth recreating with my daughters.

What I observed during my adolescence and continue to note in my adulthood is that bicultural identity formation continues to evolve according to the cultural experiences (i.e. birth of a child, professional achievements, marriage) we accumulate throughout our lives. It is a never-ending process and could be defined as cyclical in that various stages of identity formation are revisited repeatedly over a lifetime when cultural milestones are accomplished (Sodhi, "Bicultural").

Regardless of how much culture or language one preserves during various stages of one's life, it is important to enthusiastically and consistently rehearse, perform, transmit, and communicate to one's children. Sometimes we hesitate and question the importance of cultural and language transmission, but the more we transmit the more we preserve in future generations.

Similar to Goffman's definition of performance, the Zone of Proximal Development (ZPD) described by Cummins "is the interpersonal space where minds meet and under new understandings can arise through collaborative interaction and inquiry" (26). In addition, meaning-making plays a significant role in culturally shaping individuals (Bruner; Newman and Holzman). I anticipate that Nadya and Ameya will develop their own understanding of certain cultural values prior to incorporating them into their identity. Meaning-making could be used as a catalyst to encourage movement in their ZPD whereby they learn more about their own culture while integrating a current understanding of other cultures (Levykh).

I continue to emphasize the need for cultural and linguistic preservation to be ongoing and genuine, with the purpose of promoting cultural curiosity and generating meaningful dialogue. I am encouraging Punjabi culture and language preservation through methods, props (e.g., puzzles and board books), or activities that motivate Nadya and Ameya each to learn more about, and augment their awareness of, their ethnic background.

Cultural transmission occurs through observing, performing, "creating experiences" (Sodhi, *Punjabi Women*; Sodhi, "Bicultural Identity Formation"), and frequent intergenerational communication. Punjabi-Canadian values such as compassion, openness, respect, and empathy/expression are essential to cultivate healthy familial relationships and intergenerational communication.

It is equally important to keep learning fun, interactive, and spontaneous. As a child, I noticed that parents occasionally force their children to participate in cultural events or speak Punjabi. Regrettably, this may lead to resentment towards to the culture, community, and family. Also, children may potentially question their ethnic identity and alienate themselves from cultural events. I found that language and cultural preservation occurred experientially and early with the assistance of interactive resources such as language puzzles and religious books. I wanted my children to learn about their heritage in this kind of enjoyable, creative, and relaxed environment. The cultural exposure seems to be received better when it is interactive and informal.

As a scholar, educator, and Punjabi-Canadian matriarch, I believe that by creating cultural experiences, I will enable my daughters to celebrate their culture(s) in an authentic manner. Although this continuous cultural journey involves occasional improvisations, obstacles, and challenging decisions, the end goal can be the nurturing of a child in a way that allows him/her to embrace a joyful and enriched bicultural identity.

WORKS CITED

Alpert, Jane. "Mother Right: A New Feminist Theory." *Ms.* 2.2 (1973): 52-55, 88-94. Print.

Bell, Susan E. "Intensive Performance of Mothering: A Sociological

Perspective." *Qualitative Research* 4.1 (2004): 45-75. Print.

Bruner, Jerome. *Acts of Meaning*. Cambridge, MA: Harvard University Press, 1990. Print.

Butler, Judith. *Undoing Gender.* New York: Routledge, 2004. Print.

Collins, Patricia Hill. *Black Feminist Thought: Knowledge, Consciousness, and the Politics of Empowerment*. 2nd ed. New York: Routledge, 2000. Print.

Corey, Gerald. *Theory and Practice of Counseling and Psychotherapy*. 9th ed. Belmont, CA: Brooks/Cole, 2013. Print.

Cummins, James. *Negotiating Identities: Education for Empowerment in a Diverse Society*. Ontario, CA: California Association of Bilingual Education, 1996. Print.

Das, Ajit and Sharon Kemp. "Between Two Worlds: Counselling South Asian Americans." *Journal of Multicultural Counselling and Development* 25 (1997): 23-33. Print.

Enns, Carolyn. Z. *Feminist Theories and Feminist Psychotherapies: Origins, Themes, and Diversity*. 2nd ed. New York: Haworth, 2004. Print.

Forbes, Geraldine. *Women in Post Modern India*. Cambridge: Cambridge University Press, 1996. Print.

Gilchrist, Electra S. and Sakile Camara. "Culture Dis/continuity in African and Ghanaian Mothers' Voices and Identities." *Journal of Intercultural Communication Research* 41.1 (2012): 81-108. Print.

Goffman, Erving. *Presentation of Self in Everyday Life*. Carden Garden City, NY: Anchor, 1959. Print.

Hays, Sharon. *The Cultural Contradictions of Motherhood*. New Haven, Connecticut: Yale University Press, 1996. Print.

Levykh, Michael G. "The Affective Establishment and Maintenance of Vygotsky's Zone of Proximal Development." *Education Theory* 58.1 (2008): 83-101. Print.

Mitra, Aditi. "To Be or Not to Be a Feminist in India." *Journal of Women and Social Work* 26.2 (2011): 182-200. Print.

Moore, Elena. "Transmission and Change in South African Motherhood: Black Mothers in Three-Generational Cape Town Families." *Journal of Southern African Studies* 39.1 (2013): 151-170. Print.

Naidoo, Josephine C. "Between East and West-Reflections on

Asian Indian Woman in Canada." *South Asian Canadians: Current Issues in the Politics of Culture*. Ed. Ratna Ghosh and Rabi Kanugo. India: Shastri Indo-Canadian Institute, 1992. Print.

Newman, Fred and Lois Holzman. *Lev Vygotsky: Revolutionary Scientist*. New York: Routledge, 1993. Print.

Oyewumi, Oyeronke. *African Women and Feminism: Reflecting on the Politics of Sisterhood*. Trenton, NJ: Africa World Press, 2003. Print.

Phinney, Jean S. and Doreen A. Rosenthal. "Ethnic Identity in Adolescence: Process, Context, and Outcome." *Adolescent Identity Formation*. Ed. Gerald R. Adams, Thomas P. Gullotta, and Raymond Montemayor. Newbury Park, CA: Sage, 1992. Print.

Puri, Jyoti. *Woman, Body, Desire in Post Colonial India- Narratives of Gender and Sexuality*. New York: Routledge, 1999. Print.

Ruddick, Sara. "Maternal Thinking." *Rethinking the Family: Some Feminist Questions*. Ed. Barrie Thorne and Marilyn Yalom. New York: Longman, 1982. Print.

Sevón, Eija. "Timing Motherhood: Experiencing and Narrating the Choice to Become a Mother." *Feminism & Psychology* 15.4 (2005): 461-482. Print.

Sodhi, Pavna. "Bicultural Identity Formation of Second-Generation Indo-Canadians." *Canadian Ethnic Studies* 40.2 (2008): 187-199. Print.

Sodhi, Pavna. "Respecting the East, Embracing the West: A Tribute to the Women of the Maritime Sikh Society." *Journal of International Women's Studies* 9.1 (2007): 285-296. Print.

Sodhi, Pavna. "Women and Education: Reinventing Schooling in Rural Punjabi Villages." *Lives in Transition: Authentic Living and Learning*. Ed. Peter Gamlin and Michael Luther. Toronto: Captus University Press, 2007. Print.

Sodhi, Pavna. *Punjabi Women Living in Eastern Canada: A Study Exploring Parental Attitudes, Intergenerational Cultural Preservation, and Ethnic Identity Formation*. Diss. University of Toronto, 2002. Print.

Tiwana, Jagpal. *Maritime Sikh Society: Origin and Growth*. Halifax, NB: The

Maritime Sikh Society, 2000. Print.

Tomar, Mukhtiar. "Contributions of Indian teachers to the educa-

tion in Nova Scotia." *Indo-Canadian: Their Backgrounds and Their Contributions.* Ed. Mukhtiar Tomar. Halifax, Canada: Jupiter Printing Company Limited, 1992. Print.

Woollett, Anne. "Having Children: Accounts of Childless Women and Women with Reproductive Problems." *Motherhood, Meanings, Practices and Ideologies.* Ed. Ann Phoenix, Anne Woollett, and Eva Lloyd. London, England: Sage, 1991. Print.

Act IV:
Performing Presence / Visibility

15.
The Invisibility of Motherhood in Toronto Theatre

The Triple Threat

TERRI HAWKES

"CASTING—LEAD: MOTHER, 30S, WORK/LIFE BALANCE AND KILLER BODY"

RECENTLY, A TORONTO PRODUCTION COMPANY issued a "casting call" for a new television series centered around a woman who is re-entering the work force after ten years of focusing on mother-work and domestic work in the home. Agents called clients, scripts flew, and scores of female actors vied for the role. One pseudonymous actor, Tawmi, whose resumé includes Off-Broadway, regional theatre-work, as well as leads in television and film, was in contention for the job and, when interviewed, she shared concerns about her ability to fulfill that professional role:

> Acting in theatre doesn't pay, though my heart is there—but TV will pay the bills. I really think that by also working in the home for the last ten years I've slipped into some traditional role whereby my partner is the primary income earner and I'm the spender—spending on groceries, kids' activities, household things. So if I get this role I'll be earning great money, but the logistics of shooting the lead role in a TV series are wild, so the irony is: the character is struggling to balance it all, to be home for her kids, AND have her own life, too ... ultimately they'll probably hire a 30-something with a super-toned body who looks great in a skirt.

As predicted, Tawmi did not get the gig, and temporarily faded

into the wings as another unemployed and invisible "mother-actor." My aim is to shine a spotlight on Tawmi, as well as other mothers who are actors, in order to help make visible an oft-overlooked segment of Toronto's acting community: mother-actors. I aim to rewrite the typical script by providing "post-production notes" for actors, agents, employers, and leaders in the theatre, television, and film industries that will suggest ways of increasing mother-actors' opportunities to be employed, to enhance their visibility and agency in theatre, and to maximize the contribution they can make through their professional skills.

CHARACTER STUDY: "MOTHER-ACTORS" AS SUBJECTS

Tawmi is one of thousands of Canadian actors I call "mother-actors." With this moniker, I avoid the gendered description of female actors as "actresses." I intend to cast the mother-actor as the mother-subject who acts with agency—a participant in an action or process—a double meaning that the term "actress" cannot provide. Theoretically, a mother-actor exercises agency and is able to make choices, for example, to accept or refuse roles, tour or not, balance the particular negotiation of mother-work and theatre-work, and to breastfeed or bottle-feed her child as needed in her work environment. Surely there are mother-actors with agency in the theatre world from whom there is much to learn. If examples are lacking, this may point to a need to support mother-actors in achieving greater agency. If this is the case, what forms of support are needed?

The lack of discourse surrounding mother-work in conjunction with theatre-work, alongside related challenges for female actors, necessitates research and intervention in this area. I concur with scholar Corinne Rusch-Drutz in opining that omission of maternal scholarship linked with theatre scholarship should no longer be regarded as an individual problem (Rusch-Drutz 271); here I resituate her claim within the multi-wombed discipline of maternal theories. Extending the concept of "maternal community" (Ruddick 28-56; Rich 124), I put into practice the theory that mother-actors and families will attain greater agency when we bring this discourse into the public sphere, building and strengthening a "maternal *the-*

atre community" within the larger construct of Toronto's theatre community.

SHINING THE SPOTLIGHT ON "MOTHER-ACTORS"

Is the institution and agency of motherhood largely invisible in Toronto Theatre, and if so, what can we do to address the problem? I suggest that there is a general lack of awareness and attendant social policy around the complex intersections of theatre-work and mother-work, and based on this assumption, I will offer possible solutions to redress these oversights. In addressing this concern, I am exploring themes that emerge from the woman as "subject," rather than "object." The abundance of plays and films representing women as "object" and the relative scarcity with mothers as "subject" have been partially documented by feminist scholars (Case 62-81; Kaplan 23-35; Hawkes, "Mother-Subjects" 1-32). I propose that a possible contribution to the current paucity of mother-subjects (and thus, mother-actors) onstage could be related to a relative shortage of mothers with young children employed in the theatre as playwrights, directors, and producers—an area that demands future research. Here I focus on actors, giving voice to women in real workplace situations. I accomplish this through ethnographic interviewing and subsequent interpretation of interview data alongside theoretical analysis. I anticipate that the three largest determinants in disengaging mother-actors from their theatre-work, and themes that problematize the acting profession will be: money, logistics, and body. I will also cross over occasionally into the sister-work of theatre: film, television, and radio, acknowledging that theatre artists often practice their craft and/or subsidize their love of theatre with better paid work in one of the other acting media.

REHEARSAL: MATERNAL STUDIES MEETS THEATRE AND PERFORMANCE STUDIES

This script is situated at that center stage intersection between mother-work and mother-actor-work through the prism of "intensive mothering." Many maternal scholars refer to the last

two decades in the global north as a period of "intensive mothering," defined as a media fuelled and unattainable standard of perfection, available to those with financial privilege, and leading to the ultimate label, the "good mother" (Hays; O'Reilly, "Introduction"). The freedom to choose "intensive mothering," as defined by these maternal theorists, is not necessarily compatible with the unique career requirements and the socio-economic position of many female theatre actors, as I will explore in my interpretation of the following interviews. I will position these thoughts alongside feminist theatre scholarship and what I deem to be the "patriarchal institution of theatre," given its systemic privileging of men (Fraticelli 1-67; Burton 1-115). Despite the dearth of scholarship in this area, I look to the theories of Rina Fraticelli, Rebecca Burton, and Corinne Rusch-Drutz, who have begun to examine gender equity and qualitative experiences of women in the workplace of theatre. Here, I extend their work to focus on the maternal by resituating maternal theories in the context of feminist theatre scholarship. Incorporating my own professional experiences as a mother-actor, director, and playwright, I will pose key questions and possible solutions in an effort to further explore the intersection between mother-actor-work and theatre-work.

"METHOD" ACTING/WRITING

As many actors employ "method acting" to draw on personal experience and passions, the "method writing" of this paper employs subjective experience and research in the areas of Gender, Feminist, and Women's Studies, and Theatre and Performance Studies. As with Rusch-Drutz's work, another primary method used here is open ended interviews, modeled after sociologist Dorothy Smith's "feminist standpoint theory"; in a nod to Smith (as cited in Hesse-Biber 11), I utilize women's everyday experiences in contrast to the context of expectations created by the "institution of theatre" in Toronto. In this way, I am also honouring Lorraine Code's critique of societal assumptions that place privileged white males in the position of "knower" when she "examines the cognitive practices that the epistemology of the mainstream legitimates and

denigrates to reveal their implications for the efforts of women ... to claim cognitive authority" (Code xi). The "stage setting" for this research locates this paper within continuous patriarchal forces in the institution of Toronto theatre over the last decade. The "characters" are revealed as I share my findings based on interviews with six female actors in the Toronto area. This study draws on a research sample group that has been culled from my relationships as a theatre practitioner. The subjects are women I have worked with, met through industry events, or competed with for employment; in honouring the privacy of my subjects, pseudonyms have been used throughout. All actors self-identified as white, working or middle-class, heterosexual, Canadians of Anglo, Jewish or central European descent, who have borne, raised, or significantly contributed to the raising of children during the last ten years. Future research could encompass maternal models that include queer and trans mothering, diaspora mothering, as well as expanded cultural and racial groups.

Here, I chose mother-actors with some diversity of life experience and created questions around mother-work and acting work; in particular I wanted to examine how the actors' experience of paid work might have changed subsequent to becoming a mother. Related questions explored identity, financial position, body image, partner parenting, and relationships with agents, directors, casting directors, and peers. These interviews were open-ended and were conducted either on the phone or in person, depending on the subject's availability. Some of the interviews were audio-recorded and later transcribed. Others were archived with the use of my laptop computer; I took general notes and occasional verbatim quotes. I also utilized e-mail correspondence with a colleague. In my analysis, I was looking for connections to my three suggested themes of money, logistics, and body; I was also open to discovering unexpected subthemes and/or extrapolating from my findings. Touching on theatre and performance studies methodologies, I draw inspiration from performance scholar Della Pollock, whose large body of research draws from oral histories. I have also been influenced by the late anthropologist and playwright Barbara Myerhoff, whose lifetime of work strongly relied on women's personal narratives and related ethnographies.

I have supplemented my literary research and interview data with an autoethnographic perspective culled from over twenty-five years of professional experience as a playwright, screenwriter, director, and actor across Canada and the U.S. alongside my role as the mother of fourteen-year-old twins. In fact, in the first sampling of oral history I shared, "Tawmi," was me. Thus, although I started my research from a biased, personal perspective, I learned that other mother-actors had experienced similar challenges. What most intrigued me were the creative solutions they exercised in response to these challenges; I contend that it is through sharing solutions that a collective and significant contribution to enhancing the agency of mother-actors can be made.

THE TRIPLE THREAT: MONEY, LOGISTICS, BODY

As I projected earlier and will examine in the following six case studies, three main areas where I anticipated that mother-actors lose their agency with regard to merging mother-work and mother-actor-work are: money, logistics, and body image.

Act I: Mommy and Money

In looking at the case studies of mother-actors through the lens of maternal and theatre theories, I begin with Andrea O'Reilly in acknowledging that maternal scholarship "remains largely invisible to a large number of academics ... and scholars who do research and teach motherhood often downplay and conceal their work" ("Inaugurating the Association" 11). My observation in the field of theatre parallels this: in an effort to provide financial stability for their children, mother-actors often downplay their children to avoid discrimination or lost job opportunities. In the realm of voice-work, a supplemental source of income for many theatre actors, one of my personal experiences supports this theory, as documented in my authoethnographic archives:

> I worked as a voice-over spokesperson for a major department store chain, and had held the job for almost a year. It was a contract job and I was extremely well paid at triple scale—a top salary for an experienced professional—with

reasonable hours. I looked forward to the continuation of that job after giving birth to my twins. One week before their birth, the producer asked when I might be able to return to work. I replied that I thought I might need to figure out nursing schedules and the learning curve of being a mother to two babies, but that I would be available in at least three weeks, in time for "back-to-school spots." I was not given the opportunity, as I was never called back to that job again.

Andrea O'Reilly argues that intensive mothering often plays out as a mother believing she must give up paid work to exclusively focus on her children, thereby placing this as a social issue regulated by economic class ("Introduction" 10). In light of my workplace example, one is left to wonder whether the producer believed he was doing me, the actor, a service, allowing me to stay home with my children, or whether he used the opportunity to justify hiring a less expensive actor. One thing is clear: job security for a new mother of two children was not a priority of this producer. Given the particular construct of the acting world and its unions, the prevalence of contract positions (rather than permanent employment) offers actors very little job security or protection for maternity leave, or the maintaining of paid work. In this case, I took a mentor's suggestion to let it go; I was too preoccupied with breastfeeding twins to consider lodging a protest. Years later, too late for any kind of legal discussion, it occurred to me that my act of resistance could have taken the form of writing a letter to the department store chain, commercial production company, and advertising agency, revisiting this unfortunate situation and bringing awareness around their discriminatory decision. Had this been explored further, I might have had a valid grievance, and possibly could have raised the issue externally in the form of a human rights complaint (Ontario *Human Rights Code* s.5).[1] Unfortunately, this decision would have required careful thought around how the marketplace might have reacted to such an act.

In another example, after giving birth, Kate, a single mother-actor of two children, applied to the Association of Canadian Television and Radio Artists (ACTRA) for financial support for a six week

"indemnity leave," the union's answer to maternity leave. When I interviewed Kate, she questioned ACTRA's policy: "Indemnity leave? Means that something bad had happened, but that's what it qualifies as under ACTRA; I hated that. I was so insulted by the thought of it." However, Kate exercised her agency by taking the indemnity leave and refusing to be deterred. She elaborates:

> *Economics? Nobody makes money in theatre ... really didn't approach it as a problem, I approached it as doable.... When I was seventeen [I met a] famous jazz singer and ... she looked at me and said: don't let anybody ever tell you that you can't have it all ... and I never forgot it. My step-mother was a working mom, single mom, so I'd seen that already; I think because I kind of grew up admiring Alice Munro's stories, and* Chatelaine Magazine *arrived, I had very positive happy role models. I think this superwoman phenomenon is recent. I'm just doing what you have to do to try to be a good enough mom, good mom, to just try, don't have to beat anybody out, just to let children know that somebody's there for them and cares, and that's my journey because when my mother left I think that she felt her best wasn't going to be good enough, so that's why she left. I think it's possible to be a mom and have a career, and one doesn't preclude the other.*

Kate does not see herself as an intensive mother or a good Mom, but rather "good enough." She also doesn't view her decision to combine mother-work and theatre-work as optional. As a single mother, Kate embraces both roles and "makes it work," while noting that "nobody makes money in the theatre." Although she puts up a brave front, perhaps using what Susan Maushart would call "the mask of motherhood" (460-481), Kate also speaks of a very full theatre acting career pre-kids, and later talks about managing financial stress by serving mac and cheese for dinner and having her child pick up household furniture from the side of the street. She has now set aside her acting career for an artistic/administrative job, which pays the bills and which she feels will lead to a more stable, satisfying, and long-term career.

Laine, mother-actor of two girls, parents with her partner, a male actor. First, they alternated taking jobs outside the home; later they debated full-time child care:

> *If only one [of us] had a theatre gig that was fine. If we both had theatre gigs and it still added up to next to no money ... well, we didn't feel we could commit to a year of payments.... Do we want to commit ourselves to full time day care when we'd like them home when we're home? And to pay full time when we didn't really need it and couldn't afford it?*

The economics of working in the relatively low-paid world of the theatre often precludes child care options such as full time day care. Moreover, during performance weeks, part time or night shift child care is hard to find. In Laine's case, it made economic sense for her to stay home with her children while her actor husband pursued work outside the home. Why not the reverse? She explains, "There's a conscious acknowledgement that he's more likely to work than me. When we first met, it was the [opposite]: I was the one who worked all the time and he was just starting." Thus, as a result of the economics of the combination of mother-work and theatre-work, possibly aggravated by the additional forces of ageism, patriarchal privilege for men within the institution of theatre, and family/social dynamics, which sometimes cast the heterosexual mother as the primary caregiver, Laine began her path towards invisibility in the theatre. I suggest that logistics played a large part in her role "offstage."

Act II: *"Logistics" of the Family Theatre Season*

Just as artistic directors plan their theatre seasons based on a plethora of considerations including box office, artistic relevance, audience subscription, and logistics of transitioning from one show to the next, parents who are involved in theatre may plan their "family seasons" as well, based on projected employment through regional theatre, summer stock (seasonal theatre companies), or a potential long term winter/spring trip to Los Angeles for "pilot season." In looking at the role that logistics play in the challenge of

combining mother-work with mother-actor-work or theatre-work, I refer to Sharon Hays who urges mothers to self-advocate for personal mothering choices, relating this to the way a businessman treats his career (408-430). Extended to the theatre world, I urge actors to reconsider/resist acceptance of the patriarchal world of theatre, whereby there is an ideological and physical separation of the public and private sphere. Since the work of an actor is very public, the social construction of the occupation of actor does not often allow her to easily bring her private sphere (i.e. breastfeeding, bottle-feeding, or tag-along children) into the open/public sphere, and still retain her agency and credibility as a "serious actor." The current fascination with celebrity actors and their baby accessories may prove me wrong, but I see this as an anomaly, in that it does not apply to the average crafts-person or mother-actor. In fact, this divide between celebrity and mother-actors may exacerbate the difficulties of mother-actors who do not have celebrity status. An e-mail exchange I shared with Lisa Sandlos, dance scholar and fellow chapter author for this book, highlights this point when she notes: "The pressure to maintain the ideal image of female celebrity actors' lives may also create tremendous pressure for lesser-known [mother-actors] in the theatre to hide any aspects of their personal family life that are not perfect."

It is not always the employer who limits opportunities by recalling work. Sometimes the mother backs off from logistics required to support "going back to work." In a telephone interview, Sandra, a widowed mother-actor of a single daughter, recalls her shift from intensive acting to intensive mothering:

> ... mostly it was being very single-minded and focused on career and then, after having her, shifting to not spending as much time focused on [career] ... you have this whole new focus on this little baby. Not that I hadn't wanted to do more theatre afterwards but there was this sort of shift over.... Before having her, I would definitely put acting as a priority: cancelling a vacation, keeping myself available for whatever would come up, going for anything that was a possibility and putting that first before anything else, and for me that completely shifted ... after she was born.

Sandra cites two attempts to work outside the home, one on an out-of-town television shoot in her mother's hometown:

> *My poor mother had to get up at four in the morning to come with me and Ruth because [Ruth] didn't eat anything for ten hours one day, so she had to be where I was because she would not take a bottle. So my mother had to get up for my four a.m. call as well. It wasn't a problem nursing Ruth in the Winnebago, but she and my mother had to come with me. That was the challenge.*

Sandra relays that before she was widowed, she discussed work/child care arrangements with her partner and fellow actor Meyer, strategizing in an attempt to participate in a non-paying theatre gig, a situation that actors often accept to generate future work:

> *I got this part in a small theatre company thing and Meyer encouraged me to do it. The role and piece was interesting but I found the person doing it was extremely unforgiving ... and also didn't realize the pressure put on me by having to organize babysitters ... especially with the small free showcase.... I had committed to a babysitter for a number of hours and it's a snowball effect, if [the rehearsal schedule changes and] it doesn't work out you have to take away the hours from the babysitter and a lot of stuff gets affected. And I definitely got cold feet after that and didn't look further, to be honest.*

As primary caregiver in their family, Sandra found that her dedication to the unpredictable, constantly changing, and demanding logistics of theatre-work was too difficult to manage with a child, and was compounded by her emotional adherence to the tenets of intensive mothering. The strain of juggling mother-work with theatre-work was more than Sandra was willing to negotiate at that time.

Creative thinking and persistence also play roles in decision-making. Interviewee Dorie, a mother-actor of two who works in Toronto and another city, reveals that her challenges while mothering with multiple sclerosis forced her to simplify:

I had read that actresses, back in the day, would carry their babies with them in performance, incorporating the child into the role. I don't know if that's true, but I thought I would try to experiment with that. My director was somewhat reluctant, but agreed to let me bring my seven month old to rehearsals.... The other actors enjoyed sitting with her or holding her. The guy playing Mercutio taught her to sit up. I would sometimes carry her in a sling or trekker while we rehearsed, even for fight rehearsals. But it became clear in rehearsal that I couldn't bring her onstage in performance. As a co-op, we organized our own volunteers for the show. So we created a volunteer position of "babysitter" to watch my daughter while we performed.... I simply insisted on it, presented it as normal and beyond question.

Dorie's experience is a powerful example of differently-abled and community mothering, set up through self-advocacy and peer cooperation to support the mother-actor in her role as theatre worker. This is an effective model of maternal theatre community—a template that maternal theorist Sara Ruddick has encouraged—a model to which those in theatre could aspire.

Kate created a similarly positive experience when she was pregnant and performing at a major classical theatre company. For the first time in the company's history, the director adjusted the role to incorporate Kate's pregnancy until the last performance. Kate shares this interview narrative:

My son was born early, so in fact I missed the performance. I had been in a matinee ... twisted my foot ... water broke, went into labour and had him within hours, and the artistic director came up to the hospital that day and asked if I'd be willing to go on stage that night, I thought about it, but—NO! [But I felt] very, very supported. I had this entire theatre be part of my pregnancy—the cast who watched my body grow ... once he was born, the entire cast came to the hospital. In utero, [my son] was listening to Shakespeare. He's now in [a respected] School of the Arts, in their drama program; [he's] very comfortable onstage.

Thus, with the challenges of touring and physically demanding work during pregnancy, Kate managed the logistics and prioritized her children's education *in utero* and beyond. Uncomplaining, she assumes that intensive mothering goes with the territory, even before giving birth. Kate was fortunate enough, for part of the time, to have worked at an established regional theatre company with a very supportive administration and company of artists. However, even with the theatre's deep pockets, there were no maternity benefits or onsite child care options available to her. Kate did respond to the director's plea to return to the show, since there was no understudy in place. After the cancellation of the first postpartum performance, Kate returned for the rest of the run. In this case, the mother-actor's management of the logistics of mothering in theatre was partially supported by her employer and community in combining mother-work with theatre-work; perhaps most important, Kate felt strongly supported by her colleagues and company.

Kate's experience with her physical maternal body in theatre seemed promising. I recall being in that audience when Kate was pregnant; she and her director had made the unusual choice for Kate to play the role as a very sexy central character who happened to be extremely visibly pregnant—leading me to conclude that some companies celebrate physical changes associated with the maternal. That is not always the case.

Act III: Post Baby "Body" of Work

I suggest that, in addition to the considerations of money and logistics, the mother-actor's body, or body image, is perhaps the most visible factor in contributing to the invisibility of motherhood in the theatre. My assertion goes beyond male-gaze theories and psychoanalytical models about what audiences look for in females as the sexual objects of much traditional theatre, film, and television. Here, I suggest that the mother-actor's body is torn between honouring the current intensive mothering ideal of long-term breastfeeding (generally in the private sphere), taking her infant feeding practice into the public work sphere (which has logistical implications in any work arena but has unique challenges in theatre-work), or reclaiming her pre-mothering body for the

purposes of auditions, rehearsals, and performance, often which include travel away from home. My interviews supported this complex dynamic between the body, the mother-actor, and her career. Sandra recounts breastfeeding on a film set, and some of the unique challenges found in the workplace of mother-actors: "It was a period piece so that was a challenge, you know, corsets and things; it wasn't exactly like casual wear so you'd have to time it so that when you were all done [up in your] costume you wouldn't need to nurse." Like Sandra, Laine has very specific memories of the impact of breastfeeding on her professional life. Laine recalls:

> There was the one day where I went to an audition where it was an hour and a half late and I didn't have a breast pump, and I walked into the audition and one side of my dress was completely soaked with milk ... it was luckily an all-female team ... I had a rapport with the director and years later she hired me ... so female camaraderie came out of that embarrassing moment for the most part.

Laine doesn't speculate as to why the director did not hire her from her initial interview. Could the visual of a lactating mother been at odds with the requirements of the role? Laine also noticed how changes in her body affected her personally and professionally.

> Having a child in my mid-30s—my body didn't rebound and I got significantly thicker and heavier, though I wasn't someone who moved from being the beauty. [In casting directors' minds, I] moved from being the friend next door to "we don't know where to put you because you're not the fat friend either," so it psychologically affected me because every time I go into an audition I have to talk my way through that. Nobody's taking into account that this is a mother's body but [rather] this is a slightly plump actress and we don't want that.

Further along the weight spectrum from Laine, Sandra says:

> I definitely got flack after having Ruth. I remember getting

comments from certain people: "Oh you're too thin, you've got to eat, you've got to eat," and it was funny—I was probably eating more than I'd ever eaten in my whole life because Ruth was a nurseaholic.

Sandra's body in her nursing/mothering state contributed to her awareness that people thought she was too thin, though she concluded it didn't likely cost her work, since the entertainment industry generally privileges lean physiques. Although not everyone interviewed felt that their bodily changes significantly affected work opportunities, it is clear that this was a major factor for some. Each of these women, by engaging in this dance, positioned herself as "object," her body to be viewed and reviewed as a tool of her profession—not for its expressive ability or agency, but for its appearance—thus "object" rather than "subject." I suggest that this is so ingrained in the actors' subculture that it's almost impossible to ignore the "body parts" or the "part" the body plays in hiring decisions, and even more difficult for employers and actors to think creatively in resisting those edicts. This systemic discrimination involves the collusion of actors as well as agents, managers, casting directors, directors, and producers.

THE TRIPLE THREAT: ACTS I-III

Most of these case studies revealed that the mother-actors were challenged in all three areas of money, logistics, and body. After one particular interview, I was led to reflect on the kinds of thinking that women sometimes do about their identities as women and potentially as mothers under what Douglas and Michaels describe as the tenet of the New Momism: "the only truly enlightened choice to make as a woman, the one that proves, first, that you are a 'real' woman, and second, that you are a decent, worthy one, is to become a 'mom'" (620). Applied to the theatre world, this perspective not only places a huge responsibility on the women who have become mothers, but potentially attacks the identity and self-esteem of those actors who have chosen not to become mothers or who may have wished to become mothers, but for economic, career, health, fertility, or other personal reasons, have

not followed that path. Nadia, 56, is a successful theatre actor who has no biological children. My telephone interview with her reveals issues in her theatre-work that contributed to her *not* having children; they include money, logistics, and body:

> *Had I gotten knocked up [it might have been different] … but when you're younger—say in your 20s—you're so focused on your career because you have many more opportunities for success, auditioning, working on getting the audition, and actually working, and the hours are all over. For film they're long days going into nights. For theatre it's daytime rehearsal and then [it changes] over to nights. No consistency. You're so busy running around trying to get the jobs and once things slow down you're at an age where the opportunities to become a parent with a partner and work suddenly are greatly diminished. So you find yourself in this position where you wonder if [you] wanted children…. When you're younger you don't see how things will change so drastically in that way. Work-wise and partner-availability-wise. So after 40, you start to question: what was that career that I had? Was it worth it? Because at the end of the day you've got a few [newspaper] clippings and an outdated reel. Whereas with children you know, hopefully you have that for your old age.*

In her 20s, Nadia was focused on making money through her employment as an actor, when she had the "opportunity." By this she could also be implying that the patriarchal institution of theatre often mounts plays that feature women as objects, usually young, stereotypically attractive and sexually desirable in a heteronormative way. She also refers to the logistics of trying to raise a child with erratic rehearsal hours and inconsistent job opportunities in the context of raising a child as a single mother:

> *I think a communal environment is much more amenable to that situation. My sister Lana, they all live on the same street, they have a [courtyard] … sense that there's much*

more of a community base. It's close ... but I live down-
town, my other sister lives in [a Toronto suburb] one in
[another suburb].... It's not as easy to pull that off because
of the distance factors in Toronto.

Even though Nadia's family emigrated from Europe, and she is familiar with the model of extended family parenting, she did not feel that would work for her in Toronto because of the distances, commute, and erratic schedule actors maintain. I might add that Nadia is part of my community and has been instrumental in her contribution to the raising of my children. She is also an involved and devoted aunt to her nieces and nephews. However, in her estimation, this is not necessarily a contribution to "community mothering." Nadia positions herself in the non-mother-actor category, yet implies that, similar to mother-actor discourse, issues around money, logistics, and body contributed to her life choices.

CLIMAX

Many women, mother-actors and non-mother-actors, continue to struggle with the negotiation of their roles as actors, mothers, or non-mothers in the patriarchal institution of theatre. In exploring the preceding six oral histories/herstories, I identified three major challenges—money, logistics, and body—which often adversely affected these women and their job opportunities. Conversely, the actors' narratives were often accompanied by creative acts of resistance. In terms of *money*, or the ability to earn a living as an actor, in many cases, the patriarchal institution of theatre and related work in television and film appears to privilege those without or those who appear to be without the assigned "encumbrance" of children. The unions of Canadian Actors' Equity Association (CAEA) and the Association for Canadian Television and Radio Artists (ACTRA) do not offer actors or demand of employers maternity or paternity benefits; financial support comes through the option of indemnity payments (ACTRA, Interview; CAEA). Since auditions and allocation of jobs are subjective, jobs can be granted or revoked based on an employer's whim. An employer concerned about the intrusion of parenthood into an actor's work

schedule could choose another actor who appears to be without children. Moreover, when actors do obtain the coveted contracts, the relatively modest income that most actors earn means that paid child care becomes a dear choice, especially in light of the unpredictable, fast changing, and inconvenient hours required for acting work. Many actors find the *logistics* of combining parenting and theatre-work to be a challenge; some have chosen not to have children partially because of this. The quickly changing schedules for auditions, rehearsals, and camera work—often in the evenings and well into the next day—may throw family schedules into disarray and make child care arrangements extraordinarily difficult. A woman's *body* as a site of resistance to employment discrimination is sometimes, but not always, successful. Mothers who chose to breastfeed and bring their children to work were often successful in garnering community and employer support for their breastfeeding and post-baby body. Other actors hid their commitment to breastfeeding (or tried to), and attempted to present themselves at auditions as childless—or at least unencumbered by parental responsibilities—their mother role neutralized and invisible. When others chose an act of resistance by being open about their pregnancy, motherhood, or infant feeding schedules, they were sometimes openly but mostly covertly penalized for their commitment. Since actors work on contract, many felt they had little recourse for these snubs.

In addition to the three central subjects of money, logistics, and body, other issues arose from these interviews and will require future attention. These include exploring how the practice and psychology of actors' work (memorization of scripts, imagination, emotional recall, sense memory) and schedules (shift work, body clock adjustments) might affect one's mother-work and vice versa. Postpartum depression, beginning as late as a year after the child's birth, was a factor that arose in more than one interview as a deterrent to mustering the courage for auditions. In many of the interviews, the mother-actor's social/business life, considered a major tool in securing work, often underwent a shift towards a different child-centered community in the private sphere and, like in many professions, the "out of sight out of mind" factor could have contributed to a loss of work opportu-

nities. The strenuous physical requirements, mental rigour, and emotional demands of the craft of acting also seem to have been affected by the multi-foci demands of motherhood, as well as by the actors' inevitable aging. Issues around ageism arose in a number of narratives. Thus, in a profession that often does not value the wisdom and beauty of age, mother-actors who have children later in life seem to be challenged with a number of factors simultaneously, exacerbating the difficulty of returning to the theatre work force. To reiterate, future research with larger sample groups and diverse models of mothering would offer a more comprehensive look at mother-actors and the intersection of their private and public worlds.

REWRITING THE TRIPLE THREAT OR ... POST PRODUCTION/POST PARTUM NOTES

In rewriting the triple threat, I suggest there is a need to resist three major challenges for mother-actors. We must address the mother-actors' implied goals of negotiating mother-work and the-atre-work, with full acknowledgment of the potential difficulties surrounding the triple threat: money—most actors earn moderate to low income; logistics—challenging professional schedules are often incompatible with affordable and available child care; and body—the function, form and reception of the maternal body often affects actors' employment opportunities. Potential solutions and opportunities for resistance may include:

•Creating community or workplace-based day care or co-op child care opportunities, either formally or informally, e.g., exploring partnerships with community centers and established day care centers.

•Developing funding for on-site child care through government subsidies, a portion of the box office revenue, or the creation of an audience-shared/audience-subsidized child care.

•Asking producers, artistic directors, agents, and managers to participate in the creation of collective child care support systems.

•Exploring the World Health Organization's "Baby Friendly Initiative" in advocating for child friendly work spaces.

•Thinking creatively, off stage and on, about logistical support

such as cooperative meal plans and take-home dinners similar to a model used by many factories during WWII.

•Advocating for more matinees and earlier evening performances (e.g., 7:00 p.m.).

•Supporting the work of directors and producers in preparing understudies to potentially relieve pregnant actors and mother-actors with young children.

•Lobbying performing arts unions for changes such as: (a) changing terminology so that maternal/paternal benefits do not fall under the category of "indemnity;" (b) utilizing union, profit or non-profit, and government-funded research studies (Fraticelli; Coles; Burton) to revisit policy around gender equalization/job opportunities; and (c) advocating for physical space for families— including babies, young children, and teens (e.g., family and/or study rooms for youth while parents are in evening rehearsals and performances).

•Exploring the psychological and emotional identities of mother-actors.

•Advocating to playwrights, directors, artistic directors and producers for more onstage stories about mothers; this may increase employment opportunities for mother-actors.

•Honouring existing research, and developing new studies around ageism (in light of the added complication of postponed pregnancies and a trend towards "older parents") and gender equity in the theatre work place that could also contribute to employment enhancement for mother-actors.

•Encouraging continued studies and interventions to address the structure, size, financial position, and "mother-actor awareness" of specific theatrical organizations.

•Supporting lofty goals for acts of resistance: I would like to include "Mommy Money," institutional financial support for parents in the theatre workplace; "Lactivist Logistics," functional and parent-friendly plans for infant feeding in the theatre workplace; and "Beautiful Maternal Bodies," a systemic change of perception and advocacy with regard to the physical beauty of mothers.

Thus, in working towards raising the voices of mother-actors, and decreasing their invisibility in the theatre, mother-actors must continue to share their stories with academics, historians, practi-

tioners, and leaders in the theatre world. I encourage mother-actors, fathers, caregivers, professional representatives, and peers to look to their communities for creative support in child care, and to use their power of contract negotiation for family friendly facilities and rehearsal/performance/on-site child care. Although these suggestions are constructed to enhance the agency and working conditions of mother-actors, I argue that this process has collateral benefits for others. Employers and colleagues will have a larger choice of available actors to work with who will bring greater focus and energy to their theatre-work. Furthermore, the mother-actor's journey is one that could positively influence the opportunities and experiences of other mother-theatre workers. Thus, I urge theatre companies, studios, rehearsal sites, agents, managers, casting directors, artistic directors, directors, and producers to examine their policies with regard to benefits, contract options, physical premises, and casting "against type." There is an opportunity to learn from the progressive maternal and community mothering examples explored here, which ultimately provided mother-actors and their communities with enhanced agency. I support mother-actors and community-mother-actors in eliminating the self-blame that can accompany mothering, and in embracing the possibilities for communal theatre mothering and parenting experiences; this would be a start towards strengthening the maternal theatre community. In the academic world, I also see a valuable opening here to further connect the discourses of maternal studies and theatre/performance studies. Although I found somewhat relevant material in both disciplines, it was rather a sparsely vegetated valley that connected the two fields; there is room for continued intervention there. My analysis of interviews and reflection on personal experiences in conjunction with written resources support the notion that further research and activism around the "Invisibility of Motherhood in Theatre" is required. We—mother-actors, , mother-theatre-artists, academics, activists, theatre workers, colleagues, friends, and families—must rewrite this script. In challenging the theatre's triple threat of money, logistics, and body, we will make a space for mother-actors to visibly enact greater agency in their work as both mothers and actors, throughout Toronto and the extended theatre world.

[1]To better understand possible legal recourse for discrimination in contract work, refer to "Ontario *Human Rights Code*: R.S.O. 1990, c. H.19, s. 5 (1): Every person has a right to equal treatment with respect to employment without discrimination because of race, ancestry, place of origin, colour, ethnic origin, citizenship, creed, sex, sexual orientation, gender identity, gender expression, age, record of offences, marital status, family status or disability." This section has been interpreted broadly to apply to those in independent contractor relationships.

WORKS CITED

Association of Canadian Television and Radio Artists (ACTRA). Newsletter. Toronto, 2005. Print.

Association of Canadian Television and Radio Artists (ACTRA) Representative. Telephone interview. June 10, 2013.

Burton, Rebecca. "Adding it Up: The Status of Women in Canadian Theatre – A Report on the Phase One Findings of Equity in Canadian Theatre: The Women's Initiative." Playwrights Guild of Canada, 2006. Web. 8 Dec. 2014.

Canadian Actors' Equity Association (CAEA) representative. Telephone interview. September 9, 2014.

Case, Sue-Ellen. *Feminism and Theatre*. New York: Routledge, 1988. Print.

Code, Lorraine. *What Can She Know? Feminist Theory and the Construction of Knowledge*. Ithaca, NY: Cornell University Press, 1991. Print.

Coles, Amanda. *Focus on Women 2013*. Canadian Unions for Equality on Screen (CUES) University of Melbourne: Interuniversity Research Center on Globalization and Work. Toronto: CUES Press Conference. 4 June 2013. Web. 22 Sept. 2014.

Douglas, Susan J. and Meredith W. Michaels. "The New Momism." *Maternal Theory: Essential Readings*. Ed. Andrea O'Reilly. Toronto: Demeter Press, 2007. 617-639. Print.

Fraticelli, Rina. *The Status of Women in the Canadian Theatre: A Report Prepared for the Status of Women Canada*. Ottawa: Office of the Co-ordinator, Status of Women, Federal Government of Canada, 1982. Print.

Hawkes, Terri. "Mother-Subjects: Off Focus or Offscreen?" *Motherhood in Contemporary World Cinemas*. Ed. Asma Sayed. Bradford, ON: Demeter Press, forthcoming 2015. Print.

Hays, Sharon. "Why Can't a Mother Be More Like a Business-man?" *Maternal Theory: Essential Readings*. Ed. Andrea O'Reilly. Toronto: Demeter Press, 2007. 408-430. Print.

Hesse-Biber, Sharlene Nagy. "Introduction: Feminist Research". *The Handbook of Feminist Research: Theory and Praxis*. 2nd ed. Ed. Sharlene Nagy Hesse-Biber. Los Angeles: Sage, 2012. 2-26. Print.

Kaplan, E. Ann. *Women and Film: Both Sides of the Camera*. London, Great Britain: Methuen & Co., 1983. Print.

Maushart, Susan. "The Mask of Motherhood." *Maternal Theory: Essential Readings*. Ed. Andrea O'Reilly. Toronto: Demeter Press, 2007. 460-481. Print.

Myerhoff, Barbara. *Number Our Days*. New York: First Touchstone Edition, Simon and Schuster, 1980. Print.

Ontario Human Rights Code: R.S.O. 1990, c. H.19, s. 5 (1); 1999, c. 6, s. 28 (5); 2001, c. 32, s. 27 (1); 2005, c. 5, s. 32 (5); 2012, c. 7, s. 4 (1).

O'Reilly, Andrea. "Inaugurating the Association." *Journal of the Association for Research on Mothering* 1.1 (1999): 7-15. Print.

O'Reilly, Andrea. "Introduction." *Mother Outlaws: Theories and Practices of Empowered Mothering*. Ed. Andrea O'Reilly. 1-28. Toronto: Women's Press, 2004. Print.

Pollock, Della. *Telling Bodies Performing Birth*. New York: Columbia University Press, 1999. Print.

Rich, Adrienne. *Of Woman Born, Motherhood as Experience and Institution*. 1976. New York: W.W. Norton and Company. 1986. Print.

Ruddick, Sara. *Maternal Thinking*. Boston: Beacon Press, 1995. Print.

Rusch-Drutz, Corinne. *Interviewing the Mothers of Invention: A Qualitative Analysis of Women Theatre Practitioners in Toronto*. Diss. University of Toronto, 2004. Print.

Sandlos, Lisa. "Celebrity v. non-celebrity mother-actors." Message to the author. 20 Sep. 2014. E-mail.

16.
Mother Mountain Ghost

SHEILAH WILSON

*Nothing could have prepared me for the realization that
I was a mother, one of those givens, when I knew I was
still in a state of uncreation myself.*

—Adrienne Rich

A S A NEW MOTHER, I desire to be a good mother, but I have
to chart my own map of what that looks like. I cannot stay
at home full time, nor do I want to. (Even in writing that, I realize
there is a certain level of guilt implicit in the statement.) Why are
we still so caught in this dilemma of identity? In *Of Woman Born*,
Adrienne Rich identifies patriarchy as the institution limiting and
defining women's maternal experience:

> I try to distinguish between two meanings of motherhood,
> one superimposed on the other: *the potential relationship*
> of any woman to her powers of reproduction and to
> children; and the institution, which aims at ensuring that
> that potential—and all women—shall remain under male
> control. (13)

I have found motherhood paradoxical, both celebration and
erasure. Verbal support is accompanied by expectations, unstated,
that my motherhood not impinge upon how I act in my profes-
sional, social, or outward-facing life. I try to make decisions that
affirm my self-determination, yet I would be lying if I said that
this is not deeply challenging.

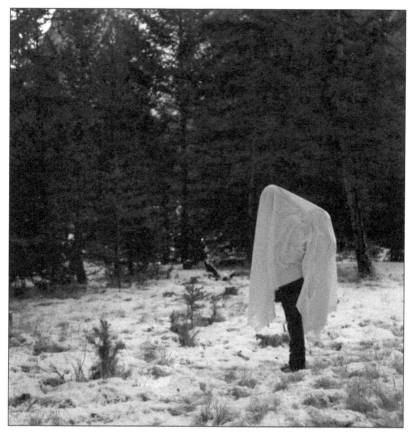

I made *Mother Mountain Ghost* in Banff, Alberta, while taking part in a thematic residency at the Banff Center for the Arts. As a primarily single mother, I brought my eighteen-month-old daughter. I asked my mother to come as well, so that I could participate in the residency.

My experience at Banff contained the familiar pressure to be two separate things: she who spends time with her own mother and daughter, and she who participates as artist in the intense lifestyle of a residency. Attempting to balance these two lives, I often felt neglectful of one or the other. There were nights of trying to maintain the social life of a residency participant, followed by early mornings with a sick child. I didn't feel I could explain to either world the dilemma of being two things. It is, as Ursula K. Le Guin states, "... the heroic myth demands that the two jobs be considered utterly opposed and mutually destructive" (174).

The myth perpetuates the mistaken possibility of calmly turning to one thing *or* the other.

In direct response to this residency experience, and, more generally, as I unravel the identity of mother and artist, I stood in front of a mountain with a sheet over myself and my daughter (*to be a mother and to be a mountain and to be a ghost*). The performance was a meditation on existence and erasure. The idea is that the performance of being there (as evidenced in the photograph) and being invisible (in the disappearance under the sheet) is the fold between absence and presence of my multiple identities.

Peggy Phelan states, "performance's being ... becomes itself through disappearance" (146). This idea implies a negotiation between the visible and invisible made manifest through performance. In this instance, the performative moment disappeared at the moment the image was taken, yet the ambiguous identity of that which exists under the sheet remains. The visible shape references ghost and human forms. It is more material than a ghost, yet not quite identifiable as mother and daughter. The *disappearance* of the performance and the refusal of stable identity of the subjects that remain create a space for something yet unnamed.

Philip Auslander speaks to the status of performance documentation as both documentary and theatrical. The question he poses is whether the event was for an audience or whether the performance was for the camera, and how this changes the result (2). In my case, the performance was for the camera and also for the audience, consisting of three generations of women. My daughter, me, and my mother created a document together, affirming each other's existence through collaboration. The photograph acts as proof of a performance, and also acknowledgement between the three generations of women who made it. The photograph is imbued with *the performance that has happened*, as well as my mother's and my *continuing performance* of motherhood. As such, the photograph acts as a portal to a radical experience of alternative motherhood through the split second image.

Mother Mountain Ghost holds a body to a space in a process of becoming and un-becoming. It is the pressure of a body with another body (who is my child and who is my mother) on the present tense. In this confusion of an extended present, where the

viewer must move backwards and forwards in time to regain their balance, there is a tiny tear in the

> ... continuous cloth of duration as well as miniscule faults in the surface of things, places and people. Like David in the den of Goliath: the glance is a slingshot that penetrates the armamentarium of duration and space, creating leakage in the universe that appears to us to form a single whole. (Casey 91)

The fragmentation of the whole occurs through the excessive present because the particular qualities of performance put pressure on a moment that exists more strongly for its implied and eventual disappearance. In this case, the performance points to that which exists further and beyond our boundaries of language. The present is made unstable by the lack of language to anchor it. We are left with an erased form holding a space, waiting to be called something. *Mother Mountain Ghost Mother Mountain Ghost.* I am many things and none. What do you *call* us? The image pokes a hole through time and meaning. Words leak out.

WORKS CITED

Auslander, Philip. "The Performativity of Performance Documentation" *Performing Arts Journal* 84 (2006): 1-10. Web. Accessed June 2013.

Casey, Edward S. "The Time of the Glance: Toward Becoming Otherwise" *Becomings: Explorations in Time, Memory and Futures.* Ed. Elizabeth Grosz. New York: Cornell University, 1999. 71-97. Print.

Le Guin, Ursula K. "The Fisherman's Daughter." *The Mother Reader: Essential Writings on Motherhood.* Ed. Moyra Davey. New York: Seven Stories, 2001. Print.

Phelan, Peggy. *Unmarked: The Politics of Performance.* New York: Routledge, 1993. Print.

Rich, Adrienne. *Of Woman Born: Motherhood as Experience and Institution.* New York: W.W. Norton and Company, 1986. Print.

17.
Grains and Crumbs

Performing Maternity

JENNIE KLEIN

THE MATRIXIAL BORDERSPACE AND PERFORMANCE ART

IN THIS CHAPTER, I explore the performance work of three feminist artists who engage in some way with maternal subjectivity/identity: Barbara T. Smith, Courtney Kessel, and Alejandra Herrera Silva. All three of these artists articulate a maternal language in their work through actions and objects; they highlight affect/emotion and embodied experiences of being a mother and being connected to another human being. Though they are biological mothers, the issues that they address in their work are not dependent on having given birth. Their performances invoke a state of being that originates with the bond between the mother and child, a bond that is understood through corporeal language, vocal utterances, and emotion rather than with words.

Julia Kristeva first articulated a maternal language in her 1977 essay "Stabat Mater," which became available in English in 1985. In this essay, Kristeva, herself a mother, proposed the idea of a pre-Oedipal, pre-cultural and linguistic state that she called the semiotic. The semiotic is a realm of affect in which the separation between self and other is not readily apparent. More recently, Bracha L. Ettinger argues for the idea of a Matrixial Borderspace, a psychic space in which identities are woven together in such a manner that the psychoanalytic distinction between self and other is not apparent. Matrix is the Latin term for womb, an organ that Ettinger invokes metaphorically to counter Sigmund Freud's now canonical narrative of castration and the Oedipus complex.

Ettinger's Matrixial Borderspace, like Kristeva's semiotic, exists prior to the Oedipal resolution of subjectivity, or the entry of the person/subject into language and representation. However, Ettinger's Matrixial Borderspace is profoundly different from the semiotic in that it is not pre-linguistic. Like Kristeva, Ettinger does not believe that there is a definite break between the pre-linguistic state of identity and the post-linguistic state, in which the child has learned to speak and identify herself or himself as separate from other people and objects. Ettinger also believes that art, poetry, and music originate in the Matrixial sphere, which is where connections and affinities between separate and seemingly unrelated objects and identities are best realized. Ettinger argues that this maternal/Matrixial language manifests itself as grains and crumbs in the post-Oedipal linguistic economy. In other words, the language of the Matrixial Borderspace continues alongside the phallic, binary language of the post-Oedipal subject. The language of the Matrixial realm manifests itself as points of connection and commonality. Significantly, the Matrixial encounter is one that is profoundly ethical—it is impossible to not share in the Matrixial encounter. For Ettinger, femininity is the kernel of ethical being, "that human possibility which consists in saying that the life of another human being is more important than my own" (84).

The Matrixial Borderspace is both feminine and maternal. It cannot be represented directly—only hinted at, performed, and iterated. An artist as well as a psychoanalyst, Ettinger argues that visual art represents the most efficacious path to access this maternal psychic space. Ettinger's ideas have profound implications for our understanding of identities, which hitherto have been theorized vis-à-vis the subject's relationship with the father or father figure, and for our understanding of maternity. Ettinger removes the maternal from its association with the biological aspect of giving birth and re-locates it as a psychic state that is accessible by men and women alike. I would argue that performance/body art, in which the representation cannot be separated from the body/identity of the artist, is even more likely to yield the grains and crumbs of Ettinger's Matrixial Borderspace than is traditional visual art, which is oriented to the object rather than the body of the performer. In what follows, I argue that Smith, Kessel, and

Herrera Silva are drawing upon the Matrixal sphere in their work, which is profoundly maternal.

BARBARA T. SMITH: *THE COFFINS, RITUAL MEAL,* AND *FEED ME*

From 1965-68, the southern California artist Barbara T. Smith made a series of prints using a Xerox machine that were eventually bound into artists books entitled *The Coffins* (fig. 1). Smith decided to make Xerox prints almost by accident. Having recently decided to once again take up her career as an artist, a career that she had put on hold in order to get married and have children, Smith approached Gemini G.E.L., a lithography studio that made prints for famous artists, including Joseph Albers. Told that she could not make a print there as she had no dealer and was an unknown artist, Smith was insulted. She decided that lithography was best left to the nineteenth century, and chose to make prints using a twentieth-century medium—the business machine. After researching the various types of machines, all of them now more or less obsolete (3m, ditto, blueprints, and Xerox), Smith settled on the Xerox machine, the newest form of copying. Smith leased a large Xerox copy machine and installed it in her living room. She used everything she could think of—found objects, lipstick, magazine images—and her own body, pressing every bit that she could against the glass and hitting the copy button. In some cases, Smith supplemented these images of herself and the found objects with excerpts of her poetry.

Smith's use of her body for the Xerox books suggests an embrace of the principles of Eros, life, creativity, and growth. Indeed, many of the images of Smith that are in these books suggest a playful insouciance that reflects the zeitgeist of the sixties. Many of the images are frankly sexual—Smith pressed her face, body, and genitals against the glass, in the hopes that her husband would join her in pushing the edge of the culturally permissible. Although her husband refused, Smith continued making work (see fig. 1).

Unfortunately he said no. So I continued alone. It was odd however that it seemed quite all right to him that I

Fig. 1. Barbara T. Smith, "Rick and Kate," *Bond (The Coffins)* 1966-67.
Bound Xerox Book. Collection of the Artist.[1]

[had] made these transgressive images, which sat about the dining room where visitors could casually see them. This made me feel violated and unprotected instead of daring because I was doing it alone. Odd that this seemed not to bother him, his wife so casually revealed. (Smith qtd. in McCullough n.pag.)

Smith made four booklets —*First Class Mail (All three children)*, *American Standard (Katie)*, *Mellon National Bank and Trust (Rick)*, and *Important/First Class (Julie)*— to entice her children

Katie, Julie, and Rick out of the corporate world of their father and into a life of joy, pleasure, and imagination. About the same time that she leased the Xerox machine, Smith engaged Jerry Mc-Millan, an artist photographer whose studio was near her own, to photograph her children for the project. Smith experimented with McMillan's images, going so far as to dye-cut a set with four different types of circular holes. Smith realized that she needed to organize all of this material, and she arranged to have it bound into black covers embossed with a cross in a circular logo. After the fact, Smith, the daughter of a mortician, realized that the black covers looked like coffins—hence the title for the entire series. The book containing the images of her children was different than the other books, however. The cover of the book with the images of her children had the word BOND embossed in silver, rather than a cross like the other books. This word, Smith felt, was particularly apt, symbolizing the bond between herself and her children ("The Coffins" 193).

Smith made the prints and individual books that would eventually be collected into *Bond (The Coffins)* as her marriage was ending. The books were finished in the same year that her divorce was finalized and Smith, who had not wanted the divorce, lost custody of her children. The images/representations of her children were stand-ins for her real flesh and blood children, to which she no longer had access. In contrast to the Xerox prints that Smith made with her own body, the images of her children were made by a photographer. Smith then copied a photograph, rather than putting her children on the machine and making images of them in the same way that she made images of herself. As she worked, Smith was overcome with grief. "It could not be put into words. What could not be said is in the artworks, the books. I was going to lose my family. It would never be the same. These books were coffins and memorials at once" ("The Coffins" 193).

Fifty years later, Smith's Xeroxed books retain their poignancy—a representation of the separation of mother and children, signified by Smith's indexical body portraits, found objects, poetry, and the iconic (and retrospectively somewhat formulaic) photographic images of her children. Writing about the Xerox books, Kristine Stiles argues that Smith's work was haunted by the idea

of death and trauma and suggests that "these images are indices of dissociation that would lead to performances in which Smith duplicated her haunting in metaphorical acts of death, the loss of identity, and the expression of emotional hunger" (40). Smith's performances often addressed emotional and physical hunger, seemingly originating from a pre-linguistic subjectivity rooted in trauma. Ettinger, a child of Holocaust survivors, has written that trauma and pleasure (*jouissance*) can be passed from one subject to another via the borderlinking that takes place from the Matrixial sphere (69-70).

Smith's work addressed the trauma of loss and separation. For her 1969 performance *Ritual Meal*, Smith engineered a feast for approximately twelve guests where meat was eaten with surgical tools and red wine consumed from test tubes, while a film of open heart surgery was projected on the wall. The performance began with the guests waiting outside, while a taped loop of Smith's voice repeatedly asked the guest to "please wait, please wait." Once inside, the guests were dressed in surgical garb and asked to paint their faces and bodies, changing their identities in the process. The sound of a beating heart could be heard throughout the meal. The guests, who were intensely uncomfortable throughout the meal (they couldn't put down their utensils in some instances, and in other instances were forced to eat with their hands), were finally dismissed when wreaths of flowers were placed on each of their heads.

In 2005, I wrote about this performance that it "did not so much reify the post-Oedipal scenario as expose the tenuous fiction upon which it is constructed by rendering it literal and immediate. The boundaries between self and other were dissolved when participants were forced to immerse themselves in otherness and abjection by eating the body/flesh" (Klein "Body's Odyssey" 11). Four years later, Smith performed *Feed Me* at Tom Marioni's Museum of Conceptual Art in San Francisco as part of a performance event entitled *All Night Sculptures*. In *Feed Me*, Smith sat alone and naked in a room for an entire evening surrounded by things that could be used to "feed" her such as body oils, perfume, wine, music, flowers, tea, books, beads, and marijuana, while an audiotaped loop of her voice repeated "feed me." For the duration of that

night in 1973, Smith waited in the room while visitors—mostly male—entered one at a time and interacted with her. During the course of the evening, Smith received a back rub, smoked the marijuana, drank the wine, and engaged in sexual relations with several of the men (26).

Smith's performances, in which she turned the body inside out (*Ritual Meal*), or emphasized the womb as the source of artistic creation (*Feed Me*), were made from the subject position of the archaic m/Other that Ettinger has articulated. With both *Ritual Meal* and *Feed Me*, Smith deliberately invoked the idea of the primitive, atropaic Goddess who is both a source of fertility and a devouring mother. For both of these performances, Smith's voice, which was delivered to the audience via tape recording, was central to the piece. This centrality was particularly the case with *Feed Me*, where Smith's voice beckoned viewers/participants to feed her for the entire evening. Interestingly, Ettinger views the voice as a way that the self and the other can be linked, writing that "when the Matrixial cavity of passage becomes an acoustic resonance *camera obscura*, partial-objects and partial-subjects are not separated by a cut but are borderlinked by resonances and vibrations" (80). Unlike the written word, the spoken word is connected to the body that speaks it. Voice is indexical—it leads back to the person who first makes the utterance, even when, as in the case of Smith, the utterances were tape-recorded. Like Smith, Courtney Kessel has used voice as a strategy to link and connect herself with her daughter and with others around her. It is to her work that I now turn.

COURTNEY KESSEL: THE SPACES IN BETWEEN

Courtney Kessel, based in Ohio, has also used the voice as a linking strategy, although, in this case, it is the voice of her daughter Chloé rather than her own. Kessel has been concerned in her work with literalizing language, making words out of sugar, flour, break, glitter, Styrofoam, and metal—words that can be eaten, carried, stepped on, or moved. Intrigued by the idea of a language that is also an object, she has explored the idea of writing the feminine through an engagement with objects that pays homage to the craft-based

work associated with second wave feminism and the art associated with the Feminist Studies Workshop, the art school for women only that was part of the Los Angeles Woman's Building founded in 1973 by Judy Chicago, Sheila De Bretteville, and Arlene Raven. In her most recent work, she has begun to collaborate with her daughter by exploring the space/psychic territory that exists between the two of them. For the most part, this takes place through a process of verbal negotiation. Chloé is on the other side of the Oedipal divide, able to speak, read, write, and play an instrument. Influenced by Kristeva's idea of the semiotic and Ettinger's theorization of the Matrixial sphere, Kessel has attempted to make work that underscores the continuing play between maternal language and patriarchal, cultural language. Her 2012 installation *Spaces In Between* is comprised of flat plywood sculptures outlined in hot pink paint. Kessel and Chloé made the shapes by posing while holding hands, photographing the poses, and then tracing the negative space onto the plywood. Placed against the wall, they take up very little space and look more like an ancient language whose meaning has been lost over time. The installation, a record of a performance that no longer exists, is all but unreadable as a silhouette of the negative space between mother and daughter.

Kessel's work is also inspired by the artist Mary Kelly, whose *Post-Partum Document* (1973-1979) is one of the most important pieces to have addressed the representation of the maternal in recent years. *Post-partum Document* charts the first six years of the life of Kelly's son, Kelly Barrie. It ended when Barrie learned to write his name. In this installation, which comprises six broad sections and 135 smaller units, Kelly documented what Barrie ate, the consistency of his feces as a result of what he ate, her anxiety about separating from Barrie, and finally, Barrie's early attempts at writing. In Part VI, the capstone (literally) to this seven-year piece, Kelly installed fifteen granite stones (along with three more wall pieces with text) inscribed with Barrie's writing, her commentary on the words that Barrie was beginning to use, and a passage from the psychoanalyst Jacques Lacan's *Ecrits* that provided a meta-commentary on Kelly Barrie's normative development.

Kessel began making work with Chloé when she was about seven years old—the same age as Kelly Barrie when *Post-partum*

Document was finished. Kessel was fascinated by the shift that she observed in Chloé between her earlier, pre-verbal stage and her post-cultural, linguistic stage. Kessel was also interested in thinking about her relationship to her daughter at this point when Chloé was beginning to need her mother less and less (Kessel, "Interview"). In Kessel's sound installation *Monstration* (2012), she replays a tantrum that Chloé had, a moment at which Chloé literally lost her words and was unable to utter anything other than primal screams. The origin of the screams, which lasted almost ten minutes, stemmed from Chloé's frustration at her inability to find clothing that suited her that morning. The sound installation, divorced from its original domestic context and played in the gallery, is incredibly affective—the sounds of a child unable to be consoled or even seen. In stark contrast to *Monstration* is Kessel's 2013 sound installation *Symphony of the Domestic*, a short sound installation during which Chloé can be heard speaking against a background of ambient noise. The ambient sounds of the domestic space, including Kessel's voice consoling Chloé and the sounds of Kessel working in the kitchen, serve to envelop Chloé, making it difficult to discern her words from those of her mother.

For the ongoing performance *In Balance With* (2011 ongoing, see fig. 2), Kessel has constructed a very long teeter totter, with a seat at one end. The performance consists of placing Chloé in the seat and then giving her work to accomplish—such as practicing her violin, writing in her journal, or drawing pictures. Kessel might offer Chloé something to eat, or Chloé sometimes requests something from an audience member, such as a pen to write in her journal. Each time an object is added, Kessel sits on the other side of the teeter totter until her weight is in balance with Chloé and the changing pile of objects that represent what they need to co-exist. The performance ends not when Kessel has achieved balance, but when Chloé decides that the performance is finished.

Kessel's performance is an example of feminist mothering, defined by Andrea O'Reilly as "an oppositional discourse of motherhood, one that is constructed as a *negation* of patriarchal motherhood" (794). Feminist mothering, a profoundly ethical practice, is rooted in Matrixial subjectivity in which subjects are woven together. Chloé's use of language—her writing and reading, her playing of

her violin—become incidental to the corporeal connection between the two of them, a connection made literal by the board of the teeter totter and in Kessel's subsequent installation of *In Balance With*, which includes the material objects—food, toys, instruments, and a bicycle. In short, it is a compilation of the "stuff" that comprises their life together.

Fig. 2. Courtney Kessel. *In Balance With.* 2011 ongoing. Photograph Documentation of Performance in Trisolini Gallery, Ohio University. Collection of the Artist.

Kessel's interest in representation extends to language, which she makes literal by sculpting it so that it becomes three dimensional, object-like, a conflation of the iconic/symbolic and the indexical/real. Influenced by semiotics and psychoanalytic writing on language, as well as representation and psychosexual development, Kessel's material words are always more and less than what they signify.

For a fall 2012 exhibition at Roy G. Biv Gallery in Columbus, Ohio, Kessel spent much of her time on opening night with her back against the gallery window, carving and puncturing words into the dry wall of the gallery while balancing precariously on a ladder. Kessel's performance, *How Do You Get Through Words?* is based on Kessel's inner dialog about her decisions as an artist and mother. Part diary and part letter, *How Do You Get Through Words?* recalls the materiality and indexicality of Smith's Xerox books made over forty years earlier. The text, legible from the street, becomes illegible in the gallery space for which it was intended—a backwards text of jumbled letters. At the time that she made this piece, Kessel was reading Ettinger's book *The Matrixial Borderspace* (Kessel, "Interview").

Kessel's foregrounding of the materiality of the language is meant to suggest a different representational economy, one grounded in caring for another person. According to Kessel, "the work transcends the local binary of public/private and extends into the repositioning of the ongoing, non-narrative, excessive dialogic flow that occurs within the domestic space" ("Artist's Statement"). Repositioning the "excessive dialogic flow" of the Matrixial sphere so that it has larger domestic and sociocultural implications has motivated the Chilean artist Alejandra Herrera Silva, whose work relies on the voice—or lack thereof—to imprint the trauma of religion, politics, and debilitating sexism on the psyches of her viewers/participants. Like Kessel, Herrera Silva materializes images and language through the agency of her body. In the final section of this essay, I turn my attention to Herrera Silva's body-based performance work.

ALEJANDRA HERRERA SILVA: *WEAPON / NATALITY* AND *INTOLERANTE AL GENERO*

Herrera Silva uses her body as well as substances such as milk, eggs, and wine in order to suggest maternity, blood, violence, and religion. Her performances, which can last anywhere from forty minutes to several hours, require the audience to endure and sometimes contribute to her discomfort, becoming unwitting accomplices in the degradation of her maternal body. Herrera

Silva's performance *Weapon/Natality*, performed while she was pregnant with her third child for the 2009 incarnation of City of Women in Ljubljana, Slovenia, referenced both the history of conflict in the Balkans—a conflict that included rape as a means of control—and the history of political violence in Chile, Herera Silva's birthplace (fig. 3). Visibly pregnant, her eyes bandaged, and wearing only a bandeau and white underpants, Herrera Silva bathed herself in substances that suggested both the feminine abject—the blood of menstruation and childbirth—and the bliss/ *jouissance* of the semiotic, in which the mother and child co-exist through the agency of amniotic fluid. Ettinger argues that the knowledge of pleasure/*jouissance* and trauma can be passed from one person to another within the Matrixial Sphere, and that the language of the Matrixial Sphere, a language of voice, sound, and gesture, rather than words, can subsequently represent that pleasure and trauma without repeating it exactly (74). Herrera Silva's work comes from that pre-Oedipal, but not pre-symbolic, position in which trauma and *jouissance* are imprinted upon the child through the sharing of the mother's body. What does a mother pass to her child? What did Herrera Silva pass on to her unborn child Diamanda? Is it possible to experience unspeakable trauma as an after-effect of an event imprinted upon collective memory? As a native speaker of Spanish, a language that Herrera Silva continues to use for the titles of her pieces, what are the implications of performing maternity in Slovenia? Or, for that matter, in Herrera Silva's adopted city of Los Angeles, a city of immigrants and the displaced? Herrera, who is married to an American citizen, is herself displaced. As an artist of international status, she often finds herself performing in other countries, whose language she does not share. Even more so than Smith and Kessel, Herrera Silva is motivated to use the corporeal and affective language of the Matrixial sphere, a poetic language that is more accessible than the written language of the country in which she is performing.

For *Weapon/Natality*, Herrera Silva began the performance by breaking eggs into her mouth and smearing the viscous liquid on the glass panels of the door separating the performance space from the foyer, forcing the audience walk through the egg-smeared doors

Fig. 3. Alejandra Herrera Silva. Photo Documentation of *Weapon/Natality*. 2009. City of Women, Ljubljana, Slovenia. Collection of the Artist

to the sound of a beating heart. They entered and took seats on a stage that included Chile's national flag and six ceramic cups in a row that spelled out WEAPON in English. Meanwhile, Herrera Silva, holding a plant, was doused with water. Herrera Silva then sat on a toilet filled with roses, holding aloft two egg-shaped vessels from which she drank red wine that trickled down her body. Finally, while two audience members shouted, "For the Honor of Being a Woman" in English and Slovenian, Herrera Silva, repeating the phrase in Spanish, was doused with milk from three balloons hanging overhead. The audience, made up mostly of women, was confronted with the political violence against women in Latin America and the Balkans.

In 2006, just about the time that she became pregnant with her twin girls, Herrera Silva performed *Intolerante al genero* as part of *Depicting Action* at the 18th Street Art Complex in Santa Monica, California. The performance began with Herrera Silva, garbed in her trademark white clothing and wearing eye bandages, performing before a mirror that was hung over a narrow shelf full of small wine glasses. Carefully, so as to not break the glasses,

Herrera Silva began grinding rose petals in her hands and then filling the glasses with the petals. In the video posted on YouTube of the performance, visitors to *Depicting Action*, unbeknownst to Herrera Silva, could be seen in the mirror. At one point, Barbara T. Smith, a founding member of the 18th Street Complex, appears in the mirror, a haunting of the blind Herrera Silva, who does not know that she is there. Through the medium of video, a connection between m/other and mother-to-be was made—is made, as the moment can be endlessly replayed on the video. It is, as Ettinger would no doubt argue, a moment of metramorphosis, a co-poïetic process of affective-emotive swerving, of inscriptive exchange between/with-in several Matrixial entities. It is as well a serendipitous encounter that suggests the possibilities of art beyond/alongside of/and different from the phallic regime of representation. It is the potential of art made from a maternal identity. As such, it points to a new way of making and thinking about art from a maternal perspective.

CONCLUSION

Natalie Loveless, curator and theorist whose 2012 exhibition on maternity, *New Maternalisms*, was premised on the performance of motherhood, writes that "thinking *(m)otherwise* means remaining attentive to webs of material-semiotic enmeshment that tack back and forth between labour, affect, autobiography, and embodiment. This is, I argue, a very powerful place from which to investigate any social and ecological ethics organized around care" (12). In this essay, I have attempted to demonstrate the ways in which Smith, Kessel, and Herrera Silva have thought "motherwise," in their performance work. Julia Kristeva began "Stabat Mater," her essay on maternity and the semiotic, by lamenting the lack of attention contemporary second wave feminists had paid to maternity and motherhood:

> When feminists call for a new representation of femininity, they seem to identify maternity with this idealized misapprehension; and feminism, because it rejects this image and its abuses, sidesteps the real experience that this fantasy

obscures. As a result, maternity is repudiated or denied by some avant-garde feminists, while its traditional representations are wittingly or unwittingly accepted by the "broad mass" of women and men. (33)

Smith, Kessel, and Herrera Silva have embraced the real experience of maternity through their invocation of corporeal affect/emotion, their use (or non-use) of the voice, and their willingness to embrace the materiality and objecthood that had been eschewed by feminist artists labelled poststructuralist, such as Barabara Kruger and Jenny Holzer. The position of the maternal is a powerful position from which to investigate an ethical economy of care that can recognize the humanity in all of us. The position of the maternal, or the Matrixial sphere, is premised upon affinities and connections. It is premised, as well, upon a poetic and visual language that acknowledges difference. As Loveless suggests, the maternal has been disavowed for too long. It is time that we follow the example set by these artists, and began to recognize what it might mean to work from a position that is premised upon caring, ethics, and acceptance.

[1]Permission to reproduce Barbara T. Smith, "Rick and Kate" from *Bond (The Coffins)*, 1966 has been obtained from the artist. Permission to reproduce Courtney Kessel, *In Balance With*, 2012, has been obtained from the artist. Permission to reproduce Alejandra Herrera Silva, *Weapon/Natality*, 2009 City of Women, Ljubljana, Slovenia, has been obtained from the artist.

WORKS CITED

Ettinger, Bracha Lichta. "Weaving a Woman Artist With-in the Matrixial Encounter Event." *Theory, Culture, and Society* 21.1 (2006): 69-93. Print.

Herrera Silva, Alejandra. *Intolerante al genero*. Depicting Actions. 18th Street Complex, Santa Monica, CA. 2006. Performance.

Herrera Silva, Alejandra. *Intolerante al genero*. 2006. *YouTube*. YouTube 15 November 2011. Web. 19 May 2014.

Herrera Silva, Alejandra. *Weapon/Natality*. City of Women. Ljubljana, Slovenia. 2009. Performance.

Kelly, Mary. *Post-Partum Document: Documentation I: Analysed Fecal Stains and Feeding Charts*. 1974. Perpsex Units, White Card, Diaper Linings, Plastic Sheeting, Paper, Ink. Art Gallery of Ontario, Toronto.

Kelly, Mary. *Post-Partum Document: Documentation II: Analysed Utterances and Related Speech Events*. 1975. Perpsex Units, White Card, Wood, Paper, Ink, Rubber. Art Gallery of Ontario, Toronto.

Kelly, Mary. *Post-Partum Document: Documentation III: Analysed Markings and Diary-perspective Schema*. 1975 Perpsex Units, White Card, Sugar Paper, Crayon.Tate Modern, London.

Kelly, Mary. *Post-Partum Document: Documentation IV: Transitional Objects, Diary and Diagram*. 1976. Perpsex Units, White Card, Plaster, Cotton Fabric. Zurich Museum.

Kelly, Mary. *Post-Partum Document: Documentation VI: Pre-writing Alphabet, Exergue and Diary*. 1978. Perpsex Units, White Card, Resin, Slate. Arts Council of Great Britain, London.

Kelly, Mary. *Post-Partum Document: Introduction*. 1973. Perpsex Units, White Card, Wool Vests, Pencil, Ink. 4 Units. Collection Eileen Norton, Santa Monica.

Kessel, Courtney. Artist's Statement. 2012. Print.

Kessel, Courtney. *How do You Get Through With Words?* 2012. Drywall. Collection of the Artist.

Kessel, Courtney. *In Balance With*. 2011-present. Trisolini Art Gallery, Ohio University 2011, The Dairy Barn, Athens, OH, 2014, Museum of Contemporary Art, Santiago, Chile, 2014. Performance.

Kessel, Courtney. Interview with Jennie Klein. December 2013.

Kessel, Courtney. *Monstration*. 2012. Sound Installation. Collection of the Artist.

Kessel, Courtney. *Spaces In Between*. 2012. Plywood and Paint. Collection of the Artist.

Kessel, Courtney. *Symphony of the Domestic*. 2013. Sound Installation. Collection of the Artist.

Klein, Jennie. "The Body's Odyssey." *The 21st Century Odyssey Part II: The Performances of Barbara T. Smith*. Ed. Jennie Klein

and Rebecca McGrew. Pomona: Pomona College Museum of Art, 2005. 9-22. Print.

Kristeva, Julia. "Stabat Mater." Trans. Arthur Goldhammer. *Poetics Today* 6.1-2 (1985): 133-152. Print.

Loveless, Natalie. *New Maternalisms*. Toronto: FADO Performance Space, 2012. Print.

O'Reilley, Andrea. "Feminist Mothering." *Maternal Theory: Essential Readings*. Ed. Andrea O'Reilley. Toronto: Demeter Press, 2007. 792-821. Print.

McCullough, Danielle. "Looking At Los Angeles: Barbara T. Smith Cheek To Glass: Electric Impressions of the Material Body." *Art 21 Magazine*. 19 March 2013. Web. 26 March 2013.

Smith, Barbara T. *American Standard (Katie)*. Los Angeles, CA: Self-Published, 1966-67. Print.

Smith, Barbara T. *Bond (The Coffins)*. Los Angeles, CA: Self-Published, 1966-67. Print.

Smith, Barbara T. "The Coffins." *The M Word: Real Mothers in Contemporary Art*. Ed. Myrel Chernick and Jennie Klein. Toronto: Demeter Press, 2011. 189-193. Print.

Smith, Barbara T. *Feed Me*. All Night Sculptures. Museum of Conceptual Art, San Francisco, CA. 1973. Performance.

Smith, Barbara T. *First Class Mail (All three children)*. Los Angeles, CA: Self-Published, 1966-1967. Print.

Smith, Barbara T. *Important/First Class (Julie)*. Los Angeles, CA: Self-Published, 1966-67. Print.

Smith, Barbara T. *Mellon National Bank and Trust (Rick)*. Los Angeles, CA: Self-Published, 1966-67. Print.

Smith, Barbara T. *Ritual Meal*. Home of Stanley and Elise Grinstein, Los Angeles, CA. 1969. Performance.

Stiles, Kristine. "Barbara Turner Smith's haunting," *The 21st Century Odyssey Part II: The Performances of Barbara T. Smith*. Ed. Jennie Klein and Rebecca McGrew. Claremont, CA: Pomona College Museum of Art, 2005. 37-50. Print.

18.
Our Films, Our Selves

Performing Unplanned Motherhood through Videographic Inquiry

J. LAUREN JOHNSON

I DISCOVERED THAT I WAS UNEXPECTEDLY pregnant in the midst of a doctoral program in psychology. At that time, I was caught up in a frenetic whirlwind of performing my duties as student, sister, daughter, psychologist-in-training, and bourgeoning academic. I use the word performance here in the Butlerian sense (Butler 179), in that the outward performance of these multifaceted roles has constructed my internal identity. With these established performances already at play, the prospect of performing motherhood struck me as an impossible contradiction. Performing motherhood, as well as—or in lieu of—these other roles simply did not fit into my life, nor my established sense of self.

I turned to the research literature on unplanned pregnancy in the hopes of discovering helpful information about how women cope with this life-altering event. Unfortunately, the literature I came across was greatly disheartening. However, a voice of resistance rose within me and implored me to imagine a future beyond that painted in the literature. This voice noted that anecdotal evidence, such as my own life history and the stories of several women I knew who had unplanned pregnancies, suggested that this doom-and-gloom literature did not tell the whole story. What stories, then, was this literature missing? It seemed that women's stories about ourselves—first-person, female perspectives—and, most notably, our stories of hope were missing.

Much of the existing literature on unplanned pregnancy has focused on justifying prevention programs and setting policy (Obstfeld and Meyers 68) . The condition of having an unplanned

pregnancy has been described in much of the literature as the reason for, and efficacy measure of, sexual education programs for youth (Allen 389; Burgess, Dziegielewski, and Green 380). Literature on unplanned pregnancy posits that it is associated with mental illness (Eastwood, Phung, and Barnett 1042), female victimhood (Coker 170), negative long-term consequences for children (Crosby et al. 257; Hayatbakhsh et al. 203), and maternal poverty (Sharan et al. 56). I wanted my research to move away from that focus and to inquire into the human, feminine accounts of unplanned pregnancy. What might happen if I used my dissertation research to ask women themselves, ourselves, to perform our own stories through the creation of first-person videos about our own experiences of unplanned pregnancy? What might happen when women, so long the objects of research and art rather than the authors, turn a lens upon ourselves? As such, I set out to respond to the following queries: how do women perform unplanned motherhood through the medium of video, and how do our performances compare to the existing literature's representation?

In the following pages, I describe the process of engaging women in their creative responses to the above questions and present my concluding interpretations derived from this work. I began by identifying a gap in the literature that I intended to address with this study, and in this paper will introduce the notion of a "grand narrative" (Clandinin and Connelly xxv) of risk and fear in unplanned pregnancy. To this end, I offer a representation of the grand narrative based on much of the literature I examined. Later, I respond to this grand narrative with a hopeful "narrative of resistance" (Gray 651), defined as a personal narrative that provides "social and political critiques of oppressive social structures" (651), and, in this case, is presented as a resistance to, and critique of, the grand narrative as derived from the literature.

THE GRAND NARRATIVE

Clandinin and Connelly defined a grand narrative as a story scripted by some authority—whether it is an academic, a policy-maker, or the apparent consensus of a majority of people—that is "so pervasive, so taken for granted, as the only valid story" (xxv) that it

becomes a socially constructed truth. As I turned to my first foray into the literature on unplanned pregnancy, I learned how pervasive negative depictions of unplanned motherhood were. It occurred to me that what I read could be construed as a grand narrative of unplanned motherhood.

Using this literature as the basis for the pervasive, taken-for-granted grand narrative of unplanned pregnancy as perpetuated by this field of research, a story emerges about the women who carry these pregnancies and the children they bear. This story negatively contributes to the social construction of who these women are and what we and our children experience. Piecing these elements together, I describe the grand narrative of unplanned pregnancy as follows:

> Women who experience unplanned pregnancies are generally young and are not yet ready for motherhood. They are often poor and uneducated, and are often minorities. Because of these factors, they do not take proper care of themselves throughout the pregnancy and in doing so they put themselves and their foetuses at risk of complications. Unplanned mothers have difficulty coping with the stress of their unplanned pregnancies and, as such, are prone to pre-natal and post-partum depression, as well as other mental health concerns including addiction and psychosis. In addition, their heightened stress puts their foetuses further at risk of complications that may impact them into their childhood and adult lives. Unplanned mothers are not likely to be good mothers due to poor attachment patterns with their babies, existing and emerging mental health issues, and their lack of social supports and economic resources.

It is understandable, given the literature and the grand narrative that it implies, why my first emotional reactions to my unplanned pregnancy were guilt and shame. I sensed a deep fear of what others would think of me, of how friends and family might react. I feared that they might think I was irresponsible for not taking the proper precautions and letting it happen in the first place. I

feared that they would assume I would not love my child. I feared above all else that they would think I would be a terrible mother. Statistically speaking, according to the literature, would they not be right to think so? The voice of resistance within me, and the voices of countless other mothers who faced the challenges of unplanned pregnancy with courage, resilience, and hope, urged me to respond to this grand narrative with a story of our own making. As such, I delved into the work of performing our own story of unplanned pregnancy.

METHODOLOGY

The question posed in my study regarding how women perform their own stories of unplanned pregnancies was not best served by traditional research methods. Traditional definitions of legitimate research stress rationality, control, predictability, and falsification (Brooks and Hesse-Biber 6). Instead, this study required a methodology that was holistic, that honoured women's experience and knowledge, and proceeded in the interest of the generous co-participants who were willing to share their truths. Further, inspired and informed by other researchers practicing in the area of arts-based qualitative research, it seemed appropriate to bring myself into the research, not just as a co-participant sharing my own story of unplanned pregnancy, but also to design my study to reflect who I am through the media with which I work. As such, I used a methodology I referred to as *videographic inquiry*. Influenced by visual ethnography (Pink), narrative research (Clandinin and Connelly), and arts-based methodologies (Eisner and Barone), videographic inquiry is a form of reflexive arts-based research that is informed by feminist practices in psychology, research, and filmmaking. More specifically, it is an arts-based method of inquiry that involves co-participants, including lead researchers such as myself, creating video projects about their life experiences. Faced with the task of exploring women's experiences of unplanned pregnancy, starting with my own intimate relationship with it, I sought out a methodology of resistance (Finley 77) to claim a feminine, feminist voice on a topic that is uniquely feminine in an academy that, at least historically, is not.

Responding to Susan Finley's (72) description of arts-based methodology as lending itself well to feminist research, videographic inquiry allowed me to conduct research outside the restrictive masculine ideas of legitimate research (Brooks and Hesse-Biber 6). Meanwhile, it allowed me to engage with an artistic medium with which I connect deeply—creative video—to provide information about unplanned pregnancy from an entirely different perspective than that found in the literature.

Using the snowball method, I recruited participants from a medium-sized western Canadian city, requesting co-participants who were 18 and older who had experienced an unplanned pregnancy and chosen to parent their child. I posted an invitation for participation on an online discussion board for new mothers that was associated with the local YWCA's pre- and post-natal support groups for women. I was also connected with a small social group of young adult mothers who made a point of meeting one evening per week without partners or children, and I extended an invitation for participation to this group as well.

Two participants responded to my call and the three of us worked together as subjects for the study. One of the co-participants who agreed to participate in this research was Terri, who chose to use her real name in the study. She was married, in her mid-thirties, and had two children, a six-year-old and a four-month-old. She described both of her pregnancies as unplanned, though she chose to focus on the first pregnancy because it was the most salient to her. At the time of her unplanned pregnancy, she was recently engaged and was not yet committed to the idea of having children in her future. Despite this lack of commitment, Terri had not considered abortion or adoption as options for her unplanned pregnancy due to her fiancé's enthusiasm, and her subsequent agreement with him, to have children.

Another co-participant, Lexi (pseudonym), was married, in her late-twenties, and pregnant with an unplanned pregnancy at the time of her participation in the study. This was her first pregnancy. She was committed to having children in her future and described herself as always having wanted to be a mother. As such, Lexi did not consider abortion or adoption as options for her unplanned pregnancy.

As the lead researcher and a co-participant myself, I also created a short video about my unplanned pregnancy. At the time of my participation, I was single, in my mid-twenties, and my unplanned child was less than one year old. Prior to my pregnancy, I had committed to having children in my future but intended to wait several years, as I planned to finish school and get married beforehand. I did consider abortion and adoption as options for my unplanned pregnancy, with abortion being the most salient alternative to parenting for me; however, I chose to parent.

The participants in this study were of European descent and middle class, representing a relatively privileged perspective on unplanned motherhood. Though I would have preferred a more diverse representation of unplanned motherhood in this research, I must acknowledge that this small, qualitative, arts-based study was never intended to represent the diversity of unplanned pregnancy experiences. Rather, the intention was to provide a first-hand perspective on this phenomenon as an alternative to the majority of research that tends to speak for mothers from the perspective of an objective other, and as such this small and relatively homogenous sample achieved that goal.

Information was collected using the method of creative video production, during which I guided each co-participant in the development, shooting, and editing of a short (3-5 minute) video about her unplanned pregnancy. Throughout the production of these videos, I video-recorded ongoing conversations about our pregnancy experiences and research processes with each participant. All of us used voiceover and screen text to narrate our stories, and illustrated them with archival photographs and original digital video footage. When the videos were completed, we made two DVD copies of each video: one retained by the co-participant as a keepsake and one retained by the lead researcher for analysis.

Six months after the completion of the creative videos, I invited the co-participants back for a screening and discussion with me about our videos. We watched all three of our videos consecutively. I then led a video-recorded, unstructured discussion around what our reactions were, what similarities and differences we noted between the videos, and what it was like for us to watch these videos again six months after production. A total of six hours of

discussions were video-recorded and transcribed. I also took field notes about the content and process of our conversations during and after these meetings.

Analysis of the gathered information involved techniques borrowed from visual discourse analysis (Rose), narrative inquiry (Clandinin and Connelly), and critical film analysis (Bordwell and Thompson). I followed several methodological steps in the interpretive process, which involved: (a) gathering an eclectic array of resources, (b) immersing myself in the gathered information, (c) re-viewing source material in light of developing analyses and looking for contradictions/complexities, (d) writing interim texts, (e) requesting feedback on the interim texts from the co-participants, (f) writing the research text (the narrative of resistance), and finally, (g) reviewing the literature in light of the research findings.

THE NARRATIVE OF RESISTANCE

The analysis of the gathered information resulted in the research text presented below: a narrative of resistance about of unplanned pregnancy. This interpretive story, based on the representations we gave through our videos and ongoing conversations, is intended to be an honest and hopeful alternative to the fearful, hopeless story of unplanned pregnancy suggested by the grand narrative. This research text is then followed by the final step of the analytic process, a review of the literature in light of the research findings.

In the beginning of this paper, I argued that when taken as a whole, much of the existing literature on unplanned pregnancy depicts a negative grand narrative. In conducting this research, I was curious about whether a collective narrative derived from women's personal and intimate stories of our own unplanned pregnancies might tell a different story than the grand narrative depicted in the literature. Although the stories we performed differed from each others' in many ways, they all demonstrated a clear storyline during which the mothers' expected life trajectories were interrupted by the discovery of pregnancy, causing some fear and trepidation. This fear caused us to resist the pregnancy, and for one of us to consider terminating it. However, sharing

the news of our pregnancies with significant others in our lives, such as partners, family, and friends, reframed our pregnancies as a shift in life trajectory instead of a disastrous disruption. Having integrated this new development into our expected life stories and identities, we were able to continue moving forward on our life trajectory with at least as much, and perhaps even more, purpose and hope as before. A composite of our performances of unplanned motherhood, our narrative of resistance, might read as follows:

> I have always known what I wanted. I wanted to do well in school and graduate with honours. I wanted to go to university and get a good job. I wanted marriage and children, a typical middle-class life for a typical middle-class woman. I am privileged with a good family, a good education, good health, and a bright future.
>
> I was at the doctor's office when I first heard the words: "Congratulations, you are pregnant!" Time stood still as a wave of disbelief washed over me. This could not possibly be right. I did not know what to do. I did not know where to turn. What would happen to the life I loved so much? What about my plans?
>
> The first person I told was my partner. He thought it was happy news, and his enthusiasm was helpful. I selectively started telling other people in my life, at first only very close family, then very close friends. My reticence melted away with every new person I told.
>
> The pregnancy presented some challenges, but in some ways I was grateful to have those months to wrap my head around the idea of becoming a mother. It allowed me to develop a relationship with the foetus growing within me. Now it is the size of a gummy bear; now it is an apple; now it is a grapefruit. I do not know why they always described foetal size in comparison to food, but it sure made going to the grocery store a more thought-provoking experience than ever before.
>
> Holding my baby for the first time, all I could think was, "There you are." This is the moment that changes

everything. Of course, parenthood has its ups and downs, but I have realized that accomplishment is not always measured in dollars and titles and degrees earned. It can also be measured in having a child who knows that it is loved.

I still have ten-year plans. In fact, I see farther down my future path than ever, towards not just my future, but my child's, too. It is not only a ten-year plan anymore, it is twenty, forty years long, stretching far into the future and down through generations. It is still my life, I am still me, and I am someone's mother.

DISCUSSION

As is apparent in reading the above composite narrative of resistance, we encountered an unwelcome interruption in our lives that, for various reasons, we were able to reframe from a hindrance to a change of plans. This raises the question: Why did our pregnancies feel like such a hindrance to begin with? Further, what helped us shift our perspectives about our pregnancies from ones of fear to ones of hope? Throughout our video-making processes and the myriad conversations we had along the way, I remained curious about what elements contributed to the most difficult parts of our unplanned pregnancies, and also what elements helped us move past those challenges.

One way I approached this question was to turn to the concept of genre in film studies, as I recognized some forms of genre in our video performances. Genre is described as "a fundamental tool to discern the ways in which films articulate their meaning and their take on society" (Tarancon 14). Lexi used elements of the fairy tale genre in her rendering, using language such as "once upon a time" to begin her video and narrating her story with a lyrical, whimsical voiceover. Juan Tarancon described the existence of genre as a means of communication and meaning-making, perhaps functioning somewhat like a grand narrative, arguing that "our ingrained propensity to make haphazard information *appear* rational and coherent only serves to create an *illusion* of understanding" (19). Did we use genre in our stories to convey

certain meanings and messages implicitly? If so, what did we say?

Lexi decided to tell her story as a fairy tale, but despite the elements of fairy tale within her video, she offered some contradictions to the genre as well. She rejected the idea of "happily ever after" early on in her story, engaging in a process of writing beyond the ending (Bloom 74). In so doing, she turned what began as a fairy tale into something new—a representation of herself as the fairy tale princess who meets her prince, but then also as a student, then teacher, and as a daughter and a wife and a soon-to-be mother. In representing her story this way, as subversion of the fairy tale genre, Lexi may have communicated her rejection of the grand narrative of unplanned pregnancy and asserted her capacity to live (and represent herself) as a nonunified subject.

This multiplicity—the "and" rather than the "or"—reminded me of Leslie Bloom's writing on feminist narratology and the nonunitary subject. She described feminist subjectivities as being "active and continually in the process of production within historical, social, and cultural boundaries" (4), borne through experiences of contradictions and conflict, and "produced both collectively and relationally" (5). She described feminist subjectivities as always multiple, in progress, ambiguous, and messy. Others working in the fields of hope and narrative (Gergen; Larsen and Larsen; White and Epston) have also drawn attention to the existence of multiple selves. Indeed, our experiences of unplanned pregnancy demonstrated that we came to understand ourselves as mothers and students, mothers and daughters, and mothers and wives, with all the conflicts, contradictions, and fluctuations inherent in these roles.

Literature from the field of counselling psychology offers another perspective on how we unplanned mothers reframed our experiences. In conducting research with clients engaging in hope-focused counselling, Denise Larsen and Rachel Stege found that the therapeutic intervention of reframing (along with highlighting client strengths, focusing on the future, recognizing possibilities, and making hope intentional) contributed to hope-enhancing counselling experiences (51). That is, by fostering clients' changed perspectives on their problem stories, clients were able to engage with their problems in more hopeful ways.

These findings complemented the results of a pilot study I conducted on therapeutic filmmaking (Johnson and Alderson), wherein I concluded that one of the mechanisms of change that contributed to positive therapeutic outcomes was clients' changed perspectives on their situations. These findings are also supported by writings in the area of narrative therapy, where it is argued that clients who reframe (or re-story, or re-author) their problem story achieve positive therapeutic outcomes (Neimeyer; White and Epston). Denise Larsen et al. write about their innovative writing group for women with cancer: "periods of transition ... carry with them the invitation for a shift in self-understanding as the client moves from an earlier story of self to a story that includes the life altering experience" (289). Referencing existentialist Yalom's concept of a boundary situation and feminist Heilbrun's metaphor of liminality to describe such moments of transition, Larsen et al. argue that narrative therapy might provide a means for clients to write a new story to live into, and thereby successfully complete a helpful therapeutic shift. From this perspective, the shift towards a more positive interpretation of our unplanned pregnancies might have stemmed from a re-imagining/re-writing/reframing of our situations. Rather than seeing our unplanned pregnancies from the perspective of the grand narrative (that is, as a problem story), we reframed our stories to reflect a more hopeful, multifaceted self that included motherhood.

As described above, one way that we resisted the grand narrative was to write more positive interpretations of our storied experiences. Another way we resisted the grand narrative was to exclude negative aspects of our experiences. Stemming from Gillian Rose's visual discourse analysis technique of looking for what remains unsaid or left out (156-166), I noted that we chose to exclude or gloss over some of the negativity in our stories (e.g., Terri's significant pregnancy complications), and I interpreted this as an act of consciously choosing hope over fear. Laura King et al. found that those who wrote stories about their lives that glossed over conflict and difficulty (e.g., by writing a story with a happy ending) tended to be happier both during the difficult time and two years later. The authors stated that "one way in which individuals construct a happy ending for the story of a life trauma is through

the belief that they have grown through or been transformed by the experience" (512). Perhaps we chose to represent our stories in a way that communicated our feeling—or, at the very least, our hope—that the challenges of unplanned pregnancy allowed us to grow and transform in positive ways. As such, this may represent another way that we resisted the negative grand narrative, through our conscious decisions to exclude negative representations of our stories.

In a further effort to gain some perspective on how and why we chose to represent our stories the way we did, I reviewed *In Her Own Image: Women's Self-representation in Twentieth-Century Art* (Knafo). So many of the images therein were of pain, loss, or victimization, and I wondered why they were so different from the way we represented our pregnancy stories in our videos? Danielle Knafo wrote that although woman

> has been held captive by the structures and dictates of patriarchal culture, controlled by presuppositions both spoken and unspoken, and even wounded by the violence and rage directed at her body and self, her power to captivate, inspire, frighten, and interrogate has not been diminished. (15)

From this perspective, our video performances can be interpreted as our desire to captivate audiences and inspire them; as Terri stated, her goal in making her video was to inspire hope in other women by offering her story as an exemplar. Our videos may have reflected a resistance to the grand narrative of unplanned pregnancy by speaking openly about our experiences without shame, victimhood, or fear of judgment. We reclaimed unplanned pregnancy, normalized it, and even made light of it to reject the grand narrative's spoken and unspoken presuppositions of what pregnancy and motherhood ought to be. It is possible that our efforts to find the positive aspects and even the humour in poten-tially traumatic experiences were acts of resistance and rebellion.

The concept of humour as resistance is not new. In a study on working-class students' interactions with middle-class teachers, the students' use of humour was cited as a form of resistance to

the educational system that perpetuated their lower-class status (Dubberley 120). The author argued that "humor highlights power in particular by its ability temporarily to distort social relations and structures and point to their absurdity" (121). More recently, Owen Lynch stated that humour can be used (among other purposes) as tension relief during difficult times (e.g., while disclosing difficult information), and as political and social resistance that can at times lead to meaningful structural changes (424).

In reviewing the literature in light of our self-representations of unplanned pregnancy, we resisted the grand narrative and offered a narrative of resistance in several ways. Through our creative use of genre, we wrote beyond the ending of the taken-for-granted story of unplanned pregnancy, and in doing so represented ourselves as nonunitary subjects capable of dynamic, multiple subjectivities that allowed space for the addition of motherhood into our lives. We also chose to represent our stories positively, leaving out or glossing over the at-times negative experiences we faced, and offering humorous representations of events that may have otherwise been experienced as traumatic. In doing so, we resisted the grand narrative by representing ourselves as hoping and coping. In these ways, we made specific efforts to resist the grand narrative of risk and fear, and perform unplanned motherhood as an act of resiliency and hope.

CONCLUSION

In this chapter, I have described how three mothers used video performances of unplanned motherhood to represent our experiences in our own ways. Although I cannot say that our stories reflect what most women experience with unplanned pregnancy, this was never my intention. I sought to introduce different voices—our own, first-person, female voices—into the larger discussion on unplanned pregnancy. I believe this introduction has been long overdue. I do not doubt that there are indeed women who struggle with difficulties associated with unplanned pregnancy, and I believe strongly that public education about birth control and planned parenthood is essential so that informed women can make meaningful personal decisions about their lives and their

families. However, I was deeply disheartened to find so little discussion in the existing literature on the resilience of women who have faced this challenging circumstance. Through this research, I have argued that there must be alternative ways to look at this issue, namely from a woman's perspective on herself. Further, I have argued that not only must there be these alternate perspectives, but that we must explore them and offer a first-person narrative of resistance to the grand narrative that supposedly speaks for us. It is my most sincere hope that this research may represent one step in that direction.

This research was conducted as part of a doctoral dissertation that was funded by a Social Sciences and Humanities Research Council of Canada (SSHRC) Doctoral Scholarship. The study was approved by the University of Alberta Research Ethics Board and adhered to the ethical standards as set forth by that body. For a short documentary video on this research, please view the video "Shifting Focus: A Short Documentary on Hope and Unplanned Pregnancy" on YouTube.

WORKS CITED

Allen, Louisa. "Say Everything: Exploring Young People's Suggestions for Improving
Sexuality Education." *Sex Education: Sexuality, Society and Learning* 5 (2005): 389-404. Print.

Bloom, Leslie R. *Under the Sign of Hope: Feminist Methodology and Narrative Interpretation.* New York: SUNY Press, 1998. Print.

Bordwell, David and Kristen Thompson. *Film Art: An Introduction.* 9th ed. New York: McGraw-Hill, 2009. Print.

Brooks, Abigail and Sharlene Nagy Hesse-Biber. "An Invitation to Feminist Research." *Feminist Research Practice: A Primer.* Ed. Sharlene Nagy Hesse-Biber and P. L. Leavy. Thousand Oaks, CA: Sage, 2007. 1-26. Print.

Burgess, Valerie, Sophia F. Dziegielewski, and Cheryl Evans Green. "Improving Comfort About Sex Communication Between Parents and Their Adolescents: Practice-based Research Within a Teen

Sexuality Group." *Brief Treatment and Crisis Intervention* 5 (2005): 379-390. Print.

Butler, Judith. *Gender Trouble: Feminism and the Subversion of Identity.* 10th Anniversary Edition. New York: Routledge, 1999. Print.

Clandinin, D. Jean. and F. Michael Connelly. *Narrative Inquiry: Experience and Story in Qualitative Research.* San Fransisco, CA: Jossey-Bass, 2000. Print.

Coker, Ann L. "Does Physical Intimate Partner Violence Affect Sexual Health? A Systematic Review." *Trauma, Violence, & Abuse* 8 (2007): 149-177. Print.

Crosby, Richard A. et al. "Correlates of Unplanned and Unwanted Pregnancy Among African-American Female Teens." *American Journal of Preventive Medicine* 25 (2003): 255-258. Print.

Dubberley, W. S. "Humor as Resistance." *International Journal of Qualitative Studies in Education* 1 (1988): 109-123. Print.

Eastwood, John G., Hai Phung, and Bryanne Barnett, B. "Postnatal Depression and Socio-demographic Risk: Factors Associated with Edinburgh Depression Scale Scores in a Metropolitan Area of New South Wales, Australia." *Australian and New Zealand Journal of Psychiatry* 45 (2011): 1040-1046. Print.

Eisner, Elliot W. and Thomas E. Barone. "Arts-Based Educational Research." *Complementary Methods for Research in Education.* Ed. Richard M. Jaeger. Washington: American Educational Research Association, 1997. 73-99. Print.

Finley, Susan. "Arts-based Research." *The Handbook of the Arts in Qualitative Research.* Ed. J. Gary Knowles and A. L. Cole. Thousand Oaks, CA: Sage, 2008. 71-82. Print.

Gergen, Kenneth. *The Saturated Self: Dilemmas of Identity in Contemporary Life.* New York: Basic Books, 1991. Print.

Gray, Jan. "Staying at School: Reflective Narratives of Resistance and Transition." *Reflective Practice* 10 (2009): 645-656. Print.

Hayatbakhsh, Mohammad Reza et al. "A Longitudinal Study of Child Mental Health and Problem Behaviours at 14 Years of age Following Unplanned Pregnancy." *Psychiatry Research* 185 (2011): 200-204. Print.

King, Laura A. et al. "Stories of Life Transition: Subjective Well-being and Ego Development in Parents of Children with

Down Syndrome." *Journal of Research in Personality* 34 (2000): 509–536. Print.

Knafo, Danielle. *In Her Own Image: Women's Self-representation in Twentieth-century Art.* Cranbury, NJ: Rosemont, 2009. Print.

Johnson, J. Lauren, dir. "Shifting Focus: A Short Documentary on Hope and Unplanned Pregnancy." Online video clip. YouTube. YouTube, 31 Oct. 2012.

Johnson, J. Lauren and Kevin G. Alderson. "Therapeutic Film-making: An Exploratory Pilot Study." *Arts in Psychotherapy* 35 (2008): 11-19. Print.

Larsen, Denise J., et al. "Innovating a Writing Group for Female Cancer Patients: A Counselling Field Description." *Canadian Journal of Counselling* 37 (2003): 279-294. Print.

Larsen, Denise J. and Janine E. Larsen. " 'I Am a Puzzle': Adolescence as Reflected in Self-Metaphors." *Canadian Journal of Counselling and Psychotherapy* 38 (2004): 246-259. Print.

Larsen, Denise J. and Stege, Rachel. "Client Accounts of Hope in Early Counseling Aessions: A Qualitative Study." *Journal of Counseling and Development* 90 (2012): 45-54. Print.

Lynch, Owen H. "Humorous Communication: Finding a Place for Humor in Communication Research." *Communication Theory* 12 (2002): 423-445. Print.

Neimeyer, Robert A. "The Language of Loss: Grief Therapy as a Process of Meaning Reconstruction." *Meaning Reconstruction and the Experience of Loss.* Ed. Robert A. Neimeyer. Washington, DC: American Psychological Association, 2001. 261-292. Print.

Obstfeld, Lisa S., and Meyers, Andrew W. "Adolescent Sex Education: A Preventive Mental Health Measure." *Journal of School Health* 54 (1984): 68-70. Print.

Pink, Sarah. *Doing Visual Ethnography.* 2nd ed. London, UK: Sage, 2007. Print.

Rose, Gillian. *Visual Methodologies: An Introduction to the Interpretation of Visual Materials.* 2nd ed. London, UK: Sage, 2007. Print.

Sharan, Haviva et al. "Sociodemographic Characteristics of Unmarried Mothers Giving Birth in a Large Tertiary Care Hospital in Israel." *International Journal of Risk & Safety in Medicine* 16 (2003): 51-57. Print.

Tarancon, Juan A. "Genre Matters: Film Criticism and the Social Relevance of Genres." *CineAction* 80 (2010): 13-21. Print.

White, Michael and David Epston. *Narrative Means to Therapeutic Ends*. New York: Norton, 1990. Print.

Contributor Notes

Courtney E. Brooks has worked as an advocate and trainer in violence prevention and has taught Appalachian and Gender Studies. Courtney is a doctoral candidate in the Sociology program at the University of Kentucky, where she researches women's representation, resistance, and reclamation as subjects and performers in music from Appalachia.

Christine S. Davis is Associate Professor in the Communication Studies Department at the University of North Carolina at Charlotte. She is a critical narrative scholar who studies family and patient-provider communication in health-related liminal spaces such as children's mental health, end-of-life, and disability. Her PhD in Communication Studies is from the University of South Florida. She is a US citizen.

Kelly A. Dorgan is an Associate Professor at East Tennessee State University in the Department of Communication and Performance. She earned her MA at the University of Kentucky and her PhD at the University of Georgia. For fifteen years, she has studied the intersection of health, culture, gender, and communication, authoring/co-authoring nearly thirty publications. She focuses much of her research on Southern Appalachia.

Laura Endacott is a practicing Montreal artist and art educator whose research explores women's contemporary identities by focussing specifically on the subject of motherhood. Her art practice

is located in re-imaging maternal space. She holds a BFA (1984), and an MA S.I.P. (Specialized Individual Programs) (2010) from Concordia University. She is a part-time faculty member in the Studio Arts Department of Concordia, where she has taught for twenty years.

Kryn Freehling-Burton is a Senior Instructor in the Women, Gender, and Sexuality Studies program at Oregon State University. She minored in theatre as an undergraduate and graduate and [NOW?] looks for ways to incorporate performance into classes and life. Kryn is a playwright, actor, and director whose favourite roles include partner to Eric, whom she met in the theatre, and mother to their four children.

Martha E. Gonzalez is a *Chicana artivista* and Assistant Professor in the Intercollegiate Department of Chicana/o Latina/o Studies at Scripps/Claremont College. A Fulbright and Ford Fellow her academic interest in music has been fuelled by her own musicianship as a singer/songwriter and percussionist for Grammy Award-winning band Quetzal. Gonzalez is currently working on her first manuscript, titled *Chicana Artivistas: East Los Angeles Trenches Transborder Tactics.*

Terri Hawkes is a PhD student (Gender, Feminist and Women's Studies — York University), holds a BA, MA, and MFA (Honours/Theatre, Film, TV–UCLA), and works across Canada and the U.S. as a playwright, screenwriter, actor, and director (ACTRA, Gemini, and Herman Voaden National Playwriting Award Nominee). She researches the maternal in the performing arts and cherishes her role as a feminist mother to two terrific teenagers, Alexa and Jake.

Kelly Jeske is a queer femme, mama, and social work graduate student living in Portland, Oregon. Her writing appears in *Who's Your Mama? The Unsung Voices of Women and Mothers, Storied Dishes: What Our Family Recipes Tell Us About Who We Are and Where We've Been*, and *Queering Motherhood: Narrative and Theoretical Perspectives.*

J. Lauren Johnson is a psychologist, filmmaker, and mother. Her areas of research and practice include pregnancy/motherhood, hope, and the intersection of film and video with psychology. She founded the Therapeutic Filmmaking Institute and developed videographic inquiry as a qualitative methodology. She is currently working as a private practice psychologist specializing with Aboriginal girls and women in central and northern Alberta.

Amber E. Kinser is Professor and Chair of the Department of Communication and Performance at East Tennessee State University. She works at the intersection of family, gender, and communication. She is author of *Motherhood and Feminism* (Seal Press, 2010) and editor of *Mothering in the Third Wave* (Demeter Press, 2008). She is currently conducting grant-funded research on motherhood and family meals, and is mother to a teen son and young adult daughter.

Jennie Klein is an associate professor of art history at Ohio University. She is co-editor, along with Myrel Chernick, of *The M Word: Real Mothers in Contemporary Art* (Demeter Press, 2011) and the catalogue essayist for *Maternal Metaphors*, curated by Chernick. Klein is presently working on a book on the performance work of Marilyn Arsem.

Natalie S. Loveless is a Canadian conceptual artist, curator, writer, and professor of contemporary art history and theory in the Department of Art and Design at the University of Alberta. She is currently working on a book on research-creation as interdisciplinary method, and a chapter on feminist art and the maternal for the forthcoming *Companion to Feminist Art Practice and Theory* (Wiley-Blackwell).

Joani Mortenson is a queer mama, therapist, and yoga instructor living, practicing, and playing by the ocean in White Rock, British Columbia. Her doctoral project mapped queer-identified families' conception and birth stories. Joani's current practice focuses on social, emotional, sensory, and somatic learning for children and their families. Joani traded the ivory tower for glorious old growth forests. JMTY.ca.

Bronwyn Preece lives off-the-grid on Lasqueti Island, British Columbia. An improvisational performance artist, she is currently undertaking a PhD through the University of Huddersfield. She holds an MA and BFA in Applied Theatre and is the author of *Gulf Islands Alphabet* (2012) and *In the Spirit of Homebirth* (forthcoming 2015). She can often be found eating kale, fermenting batches of kombucha and sauerkraut, and wandering through the woods. www.bronwynpreece.com

Lisa Sandlos is a doctoral candidate in Gender, Feminist, and Women's Studies at York University. She has an MA in Dance and is a Certified Movement Analyst. A faculty member in the Department of Dance at York, Sandlos teaches Modern Technique, Improvisation, Ecstatic Dance, and Pilates. Some of her most joyous dancing moments happen in her living room together with her daughter (12) and son (9).

Pavna Sodhi is a psychotherapist and professor residing in Ottawa, Ontario. She continues to explore topics pertaining to identity formation, celebrating diversity, and immigrant mental health issues. She presents her work at national and international conferences. She may be contacted by e-mail at psodhi@alumni.utoronto.ca.

Elyse M. Warford is a communication instructor in the LA Community College District. She has been a scholar and instructor for the past ten years, and her research focuses mainly on interpersonal communication. Her interest in adoption research developed from a fascination with her father's adoption story. He lived in the Texarkana Baptist Orphanage until the Warford family adopted him at age nineteen.

Lynne M. Webb is Professor of Communication Arts at Florida International University. Her work has appeared in numerous national and international journals including the *Journal of Family Communication, Journal of Applied Communication,* and *Health Communication,* as well as in prestigious edited volumes including the *Handbook of Family Communication* (Sage, 2014) and *Communication for Families in Crisis* (Peter Lang, 2012).

Sheilah Wilson was born in Caribou River, Nova Scotia. She received her BFA from NSCAD (Nova Scotia) and MFA from Goldsmiths (London, UK). Her daughter Rose was born in 2010. Most recently, Ms. Wilson has been working on projects investigating traces between history, emotion, place, and personal mythologies. She is currently an Assistant Professor of Studio Art at Denison University in Granville, Ohio.